Cinema's Alchemist

VISIBLE EVIDENCE

Michael Renov, Faye Ginsburg, and Jane Gaines, Series Editors

(continued on page 271)

VISIBLE EVIDENCE, VOLUME 25

Cinema's Alchemist

The Films of Péter Forgács

Bill Nichols and Michael Renov, Editors

 University of Minnesota Press

Minneapolis

London

Published by the University of Minnesota Press
111 Third Avenue South, Suite 290
Minneapolis, MN 55401-2520
http://www.upress.umn.edu

Library of Congress Cataloging-in-Publication Data

Cinema's alchemist : the films of Péter Forgács / Bill Nichols and Michael Renov, editors.
 p. cm. — (Visible evidence ; v. 25)
 Includes bibliographical references and index.
 ISBN 978-0-8166-4874-0 (hc : alk. paper) — ISBN 978-0-8166-4875-7
 (pb : alk. paper)
 1. Forgács, Péter—Criticism and interpretation. I. Nichols, Bill. II. Renov, Michael.
 PN1998.3.F655C57 2011
 791.4302'33092—dc23

 2011028094

Printed in the United States of America on acid-free paper

The University of Minnesota is an equal-opportunity educator and employer.

17 16 15 14 13 12 11 10 9 8 7 6 5 4 3 2 1

Contents

BILL NICHOLS

Introduction

▶

Background

In 1964 the respected film scholar Jay Leyda published an invaluable little book, *Films Beget Films: A Study of the Compilation Film*.[1] It was the first sustained effort to explore the effects of reusing footage originally intended to convey one meaning to convey a different meaning. In his foreword Leyda likens such films to H. G. Wells's *Time Machine* as a way to return to and comment on the past: the "compilation machine," as he termed this form of filmmaking, "offers itself for the communication of more abstract concepts than can be expected of the more habitual fiction film, more complex propaganda arguments than can be hoped of radio or newspaper—but only artistic imagination and skill bring these bare newsreel actualities to the spectator in any way that will remain in his consciousness."[2]

The Cinema's Alchemist offers a sustained exploration of the various forms of imagination and skill with which Péter Forgács has reshaped home-movie footage, originally intended for the private and personal use of very few, into extraordinary films, intended for the general public and dedicated to remembering the past in ways that matter for our future. His achievement is a form of alchemy, transforming the dross of home movies into the gold of social history and philosophic meditation. As Leyda reminds us, Forgács is not the first to make such a stunning transformation of old found footage into something fresh and revelatory, but he is certainly one of the most distinguished.

This collection provides what is, in effect, a midcareer review of Forgács's remarkable work. Since these chapters were written, he has already completed several new works, including *I Am von Höfler*, which

is the fifteenth film in Forgács's ongoing Private Hungary series—films that chronicle aspects of Hungarian history by means of home movies; *Own Death* (2007), his first fiction film; and *Hunky Blues* (2009), the story of Hungarian immigrants to the United States in the early 1900s. Forgács also served as Hungary's representative to the fifty-third Venice Biennale in 2009, where his installation, *Col Tempo*, explored the various uses of the camera to examine, categorize, classify, and otherwise encounter the human face. In 2007 Forgács received the Erasmus Prize—an honor he shares with Martin Buber and Claude Lévi-Strauss, among others—for his contributions to European culture. In due course his more recent work will surely deserve a book of its own.

Péter Forgács trained at the Budapest Academy of Fine Arts and the Hungarian College of Arts, graduating in 1971 as a student of sculpture. He made his first film and video at the Béla Balázs Film Studio in 1978, *Children's Movie* and *I See That I Look*, respectively. He is a self-professed minimalist, strongly committed to the modernist tradition and influenced by the conceptual arts movement in Hungary and elsewhere, as well as by the situationists and the Fluxus artists. His early career was primarily as a musician and performance artist. He worked with Group 180, where he first began to collaborate with Tibor Szemzö, who has since created the musical score for many of Forgács's films. Among his early video installations and performance pieces, *The Case of My Room* (1992), *Hungarian Totem* (1993), and *Pre-Morgue* (1996) all reveal a fascination with video and the power of the image, especially in relation to domestic and institutional environments. It is also notable that *Hungarian Totem* also features the pig as a symbolic beast; it is an animal to which Forgács will return in his later film work.

Because of his political views and actions in opposition to the Communist regime and its ties to the Soviet Union, Forgács was not allowed to travel abroad in this phase of his career. This restriction may have encouraged his pursuit of the forgotten history of Hungary itself and his early films in the Private Hungary series. These films explore the period from the 1930s to the 1950s by reediting and otherwise manipulating home-movie footage that Forgács managed to collect and preserve. Forgács is currently the director of the Private Photo and Film Archive Foundation (PPFA) and a researcher with the Sociological Institute at the Hungarian Academy of Sciences.

Moving into Film

In 1983 Forgács created the PPFA as a repository for the material he collected. During the post–World War II period when Stalin remained in power in the Soviet Union, all motion picture cameras were confiscated and controlled by the Hungarian government, including amateur cameras. Such measures were not uncommon in the Eastern bloc countries; in Romania, for example, all typewriters had to be registered with the state. When this restriction was relaxed in the 1960s, it allowed for a rebirth of home-movie footage and provided Forgács with an opportunity to recover footage that the government clearly had no interest in preserving. He had the support of the Soros Foundation and various Hungarian institutions to do so.

Figure I.1 *A Bibó Reader.* The midframe sprocket holes of 9.5 mm film are evident in this clip of four frames showing István Bibó and a companion.

In many cases, Forgács gained access to extensive amounts of footage from a single source. It is this material that has formed the core of some of his most important films, such as *The Bartos Family* (1988), using the footage of Zoltán Bartos; *Free Fall* (1996), with footage by György Petö; *The Maelstrom: A Family Chronicle* (1997), with footage by Max Peereboom; and *Angelo's Film* (1999), with footage shot by Angelo Papanastassiou. Forgács has also collected newsreels, sometimes shot by the same people who made the home movies he collected, and other forms of archival footage, including home movies of the Reich's commissioner for the Netherlands, the Austrian Nazi Arthur Seyss-Inquart, which are woven into *The Maelstrom: A Family Chronicle*. Forgács's archive contains over three hundred hours of footage, often in anachronistic gauges such as 9.5 mm, along with recorded interviews with relatives and friends of the individuals who shot the original footage. From these interviews Forgács has gained much of the factual information about the individual family members that he places in his films as commentary or graphic titles. Forgács's own formidable knowledge of European history allows him to add yet other layers of commentary that suggest some of the linkages between private, family experiences and the larger historical forces that surround, and sometimes engulf, them.

▶──

The Films of Péter Forgács

Over the past twenty years, Péter Forgács has created more than thirty films. (Most circulate primarily in video or DVD formats, but they have all been made from material that was originally film.) Most of these films examine the private histories of European families, from the Nazi era of the 1930s and 1940s to the Communist era of the postwar period. The home movies from which he compiles his films are by people who don't know what the future will be but who now offer their images to those who know what the past has been. We yearn to see in what they saw evidence of the history they had yet to encounter. We also yearn to see the world as they did, with serenity and innocence blind to its own future. Watching these films can produce a certain sense of panic: *where are we* as we watch this footage and note Forgács's emendations? Here or there, now or then? And if we are, in some paradoxical sense, both here and now *and* there and then, how is it that such a divided position is both desired and disturbing? The chapters that follow take up questions such as these in their analysis of selected works.

Forgács's work figures in two major series of films that have aired on European television. Each takes up the private history of European families in the 1930s and 1940s: the international The Unknown War series to which Forgács contributed *Meanwhile, Somewhere*, composed of footage shot by a variety of individuals in different countries during World War II, and the fifteen-part Private Hungary series that Forgács made on his own and to which *The Bartos Family* and *Free Fall* belong. (A third series, *Conversations on Psychoanalysis*, also done by Forgács on his own, consists of five one-hour parts; it deals with Freud, Ferenczi, and the psychoanalytic legacy.)

The films that have revolved around the home-movie footage of a single individual, who in several instances happens to be a European Jew, have struck a particularly strong chord with North American audiences. *The Bartos Family*, *Free Fall*, and *The Maelstrom* all tell the story of Jewish families who go about their lives as Nazi tyranny grows around them and finally devastates the families themselves. *The Bartos Family* traces the fate of one family over two decades. We see bodies erode, hope fade, and losses occur, but we also see moments of exuberance and gusto, of men and women living life to the fullest. As Michael S. Roth said during a panel discussion, "I get a strong sense of the sheer physicality of this family; it would take a hell of a lot to kill people like this."[3] *Free Fall* chronicles the experience of György Petö from the early 1930s to World War II. Petö was a wealthy Hungarian Jew whose home movies provide the bulk of the film's footage. From them Forgács fashions a mesmerizing portrait of a family and a way of life, the pleasures and privileges of which are being relentlessly eroded at the very same moment that Petö persists in enjoying them.

The Maelstrom traces the Peereboom family, a Jewish Dutch family, over a similar period through the home movies of one of the family patriarch's three sons, Max. The father was editor of a Jewish newspaper, the *Nieuw Israelitisch Dagblad*, and Max worked for the family of his wife, Annie Prin, in a retail business. We see Max and his relatives mature, marry, have children, and prosper until the parallel world of the Nazi's Final Solution collides with their own—a parallel rendered with cinematic force through Forgác's inclusion of home movies by Reich's commissioner for the Netherlands's Seyss-Inquart shot on his elegant estate, Clingendael. Whereas Max's footage conveys the innocence of the unsuspecting victim, Seyss-Inquart's suggests the confidence of the overbearing victor. Complicating the picture yet further is footage Forgács was able to recover of young Dutch men training to join the Nazi-led army and shot by a Dutch member of the Nazi SS.

Miss Universe, 1929 recounts the remarkable story of a young Viennese Jewish woman, Lisl Goldarbeiter, who eventually becomes crowned Miss Universe in Galveston, Texas. Using home-movie footage shot by her cousin Marci Tenczer, Forgács traces her life as she moved back to Europe. She appeared to become enmeshed in a ménage à trois with her playboy husband, heir to a necktie fortune, and another woman before finding a more stable relationship when she married the very cousin who has so devotedly chronicled her life, Marci. Forgács finds many elements of wry humor and human triumph in this tale and, along with that, another perspective on the utter devastation wrought by Nazi doctrines of conquest and anti-Semitism.

Three films that do not involve Jewish protagonists have also attracted considerable attention: *Danube Exodus, Angelo's Film,* and *El Perro Negro: Stories of the Spanish Civil War* (2005). These works explore a question posed by *The Bartos Family, Free Fall,* and *The Maelstrom* as well: how can the turbulence of European history be read from the home-movie footage of specific individuals? *Danube Exodus* uses footage by riverboat captain Nándor Andrásovits of the *Erzsebet Kiralyne* (the Queen Elizabeth), a Danube riverboat. It follows his fitful voyages up and down the Danube, through Bulgarian and Romanian territory, transporting Hungarian Jews to the Black Sea for passage to Palestine and returning with German farmers, driven out of Bessarabia by the Soviet army, for eventual relocation in occupied Poland. These Germans were the descendants of settlers who moved to Bessarabia in 1843. Although their passage to Germany was far less eventful than the passage of the Jews out of Europe, their evacuation was only the beginning of a long series of displacements and relocations. Many of them perished in the German army during the war, and those who survived the war were never able to return to their homes in Bessarabia. In 2001, Forgács created a multichannel installation piece based on this film and additional footage exhibited at a variety of sites, which is discussed further in the chapter by Marsha Kinder.

A Greek resistance fighter, Angelo Papanastassiou, shot *Angelo's Film* during World War II. He risked his life to record the murderous actions of the Nazi occupation forces in Greece. (If caught, his filmmaking activity would have warranted his execution; similar clandestine footage appears in *The Maelstrom* of a Jewish family being evicted from their home by German troops.) Mr. Papanastassiou used his camera to document an occupation he detested as an affront to Greek sovereignty. Like Joan Salvans Piero, a Catalan industrialist whose footage is central to *El Perro Negro*, Papanastassiou was a conservative patriot, not a leftist, but his footage testifies to his sharp opposition to the actions of the Nazi

occupiers and possesses a degree of historical consciousness absent from the more strictly home-movie footage shot by others. This relieves Forgács of some of the task of providing context and commentary. In a time and place where filming such as Angelo's was punishable by death, Forgács allows us to witness the very *act* of filmmaking as a form of defiant resistance, not unlike his own act of recovery and reassembly by means of his own compilation machine.

El Perro Negro explores the complex and not generally well-known history of the Spanish Civil War through a variety of source materials, principally the home-movie footage of Joan Salvans Piero and Ernesto Diaz Noriega. In this film, Forgács does not recount the more or less familiar story of the government's republican forces, supported by the independently organized Abraham Lincoln Brigades from the United States, and more officially by the Soviet Union, against the attempted coup fomented by General Franco, who was supported by Nazi Germany and Fascist Italy. Forgács instead dwells on the fate of the anarchists. The anarchists fought against Franco but were often considered a threat to the elected government as well, since they were distrustful of any hierarchical political structure. Some anarchists advocated violence against civilian supporters of Franco's forces, some did not, and Forgács's film offers a fascinating glimpse into an aspect of the war that makes it harder to apply black and white, good and evil labels.

Another group of films discussed to different degrees by Scott MacDonald, Catherine Portuges, Tyrus Miller, Kaja Silverman, Tamás Korányi, and László Földényi focus on life in postwar Hungary. The country fell under the dominance of the Soviet Union and went from being an ally of Nazi Germany (which did not stop Hitler from sending Adolf Eichmann to oversee the transportation of Hungarian Jews to extermination camps in the final, losing stages of the war) to being a satellite in the Communist empire. Democratic principles and capitalism did not begin to emerge until after the fall of the Berlin Wall in 1989. János Kádár was the dictatorial head of state from 1956 to 1988 and was famous for the cooptive saying "Anyone not against us is with us," which compelled any opponents to speak out, a sure way to face arrest. Kádár attempted to negotiate a fine line between capitulation to the Soviets and the preservation of national autonomy. Many felt ambivalence toward his rhetoric of liberalization and the pragmatic necessities of repression. Forgács explores such contradictions in films like *Kádár's Kiss* (1997), in which pornographic images are juxtaposed with footage of Kádár and other state dignitaries carrying out official functions.

Through the eerily effective music of Tibor Szemzö, laconic commentary, titles, zooms and pans, tinting and toning, slow-motion, freeze-framing, and oratorio (used to articulate the details of the Nazi laws that limited participation by the "Israelite denomination" in public life), Forgács turns salvaged images into a vivid glimpse of a lost world. The spontaneous gestures, improvised scenes, and concrete situations we observe were not designed as indicators of broad historical forces but as animated mementos of personal history. But the social actors in these home movies who mime gestures to each other now incite our response rather than the response of those to whom they originally addressed themselves. Forgács, the archaeologist-cum-salvage anthropologist, conducts a séance in which these figures serve as mediums through whom we see and hear the voice of times past speak again today.

▶

The Chapters

The three parts of the book attempt to survey the breadth of Péter Forgács's work by beginning with an interview and a dialogue with the filmmaker. Scott MacDonald's interview is a wide-ranging survey of his overall oeuvre and revolves around a set of probing questions that tease out the particular qualities of individual films. The dialogue with Bill Nichols was conducted mainly in writing and explores a more limited number of works by focusing on particular moments and specific qualities. Together they help set the stage for the chapters that follow.

Part II, "The Holocaust Films," contains five chapters that explore issues of trauma, memory, and representation in relation to the Holocaust. In "Toward a New Historiography: The Aesthetics of Temporality," Ernst van Alphen explores the question of memory as a social practice. Has there been a recent crisis in the status and function of memory, and if so, why? How do the films of Forgács, along with the work of numerous other artists, working in a variety of media, address this crisis? In what ways do the private quality and the partial, fragmentary record left behind by home movies provide effective source material for confronting the presumptions of historicist writings that attempt to provide a complete picture of what happened in the past? Using Siegfried Kracauer and Walter Benjamin as springboards for his own exploration, van Alphen tries to demonstrate how Forgács's work makes an important contribution to our understanding not only of memory but also of the historical past as a continuing, even haunting part of the present. Van Alphen turns to *The Maelstrom* and *El Perro Negro* as the primary focus for his investigation of these questions.

Michael S. Roth and Michael Renov both write in depth but from distinct perspectives about what may be Forgács's most widely seen and frequently discussed work, *The Maelstrom*. Michael Renov raises many of the questions the remainder of the volume explores further: why is there such a need to return to the question of the Holocaust when it risks distorting Jewish history into one of victimhood? How can this monstrous event be represented so as to make it comprehensible even though it remains, at its heart, utterly incomprehensible? Is any form of representation acceptable for such a task? Renov argues that Forgács tackles these issues directly in films like *The Maelstrom* by finding a way to represent neither the real (what really happened during the Holocaust, which never appears in his films) nor the imaginable (a fictional representation of what this event might have been like). Instead, Forgács develops a distinct strategy to represent the unimaginable, drawing on the resources of modernist avant-garde and performance art to achieve this feat. The paradoxical act of giving form to what cannot be imagined is, for Renov, precisely what Forgács does by his careful reworking of the Peereboom home movies that constitute *The Maelstrom*.

Michael S. Roth's chapter on the same film probes the everyday and ordinary qualities of the footage that are nonetheless reworked by Forgács to achieve a rich, complex resonance with larger issues. Among these, Roth pays particular attention to the question of trauma and how this very concrete form of experience can be reworked and mastered over the course of time. Trauma is one of those forms of experience that, although it may happen at a particular moment, refuses to retreat into the past: it continues to haunt the present, and it is this quality that makes the ordinary lives of the members of a Jewish Dutch family that almost totally perished during the Holocaust so powerful today.

In her chapter, "Waiting, Hoping, among the Ruins of All the Rest," Kaja Silverman scans across a large swath of Forgács's work in relation to the work of Maurice Merleau-Ponty, Martin Buber, Eugène Atget, Jean-François Lyotard, and others. Merleau-Ponty's considerations of the world as it is experienced rather than conceptualized become central to her exploration of the physicality of relationships captured in home movies and to her reflections on what form of memory is necessary for catastrophic, traumatic crimes such as the Holocaust. Silverman examines a number of Forgács's films, both those that are more philosophical in their organization and those that recount the private histories of individuals and groups from the 1930s to the 1960s. She probes the ways in which he makes memory a focal point of any effort to be there where we once were—in other words, to return to, reinhabit, and reinterpret the past.

Silverman contrasts the Nazi "war against memory," which sought to eradicate that which they could not abide, such as Jewish culture and history, with the crucial importance of remembrance in any struggle against fascist or totalitarian tendencies.

Silverman is particularly sensitive to how Forgács responds to the forgotten images he retrieves from his remarkable archive of home movies and how he sees what is there to be seen before it is, finally, too late. Silverman gives Forgács's strongly antiauthoritarian political perspective a philosophic underpinning but also firmly attaches this perspective to the tangible vicissitudes of everyday life that form the foundation of his work. "Histories from above" (traditional histories that tell of the march of history in terms of leaders, nation-states, decisive moments, and key strategies) become linked to a departicularizing tendency that is a hallmark of totalitarianism. Hence the reliance on home movies and a stress on "history from below" become a crucial aspect of Forgács's overall worldview.

Malin Wahlberg takes up a specific philosophic notion, the trace, and explores its implications, particularly in relation to *Free Fall*. The trace, like the concept of the liminal, alludes to something that is not wholly fixed or fixable or not wholly present. Some philosophers have found themselves drawn to questions of the elusive, mysterious, ambiguous, or indeterminate, and for them the trace is a useful tool. It displays a material presence, like the photograph, but it simultaneously suggests incompleteness. It alludes to something that was once more full or complete but that is now represented only by a fragment—often worn, frayed, or eroded. For Wahlberg this concept fits perfectly with the fragments of home movies with which Forgács works. They provide traces of the families from which they came, and they yield a trace of the historical world in which they were made. Forgács, Wahlberg argues, creates a trace of a trace by means of his own active process of reworking these fragments into a new whole that remains incomplete and suggestive more than definitive and final. A sense of loss or death haunts films like *Free Fall,* yet in animating a complex series of traces from the past, Forgács positions death and extermination in tension with life and restoration.

The type of animation Wahlberg refers to is not the animated film genre but the process of restoring an experiential aura to traces that, by themselves, may seem little more than inanimate scraps, their meaning and value eroded by the relentless passing of time. Forgács reanimates them by collecting them into a greater whole, yet he avoids conveying the sense that what has past can now be fully recovered. Just as Marsha Kinder describes the process of converting Forgács's film *Danube Exodus* into a multichannel installation work as reorchestration, Wahlberg

describes Forgács's conversion of home movies into a new form of historical narrative as reanimation.

Part III, "Other Films/Other Contexts," examines Forgács's Private Hungary series and his perspective on Eastern European history, his more philosophically informed films, the distinctive contribution of Tibor Szemzö's music for many of his films, and Forgács's extensive achievements as an installation artist, including the transformation of his own film, *Danube Exodus*, into a multichannel installation.

Roger Odin, a French scholar working in Paris who specializes in the home movie, explores the textual dynamics of *The Bartos Family*, particularly the ways in which Forgács reworks the original footage. How can questions of national identity be drawn out of family footage? How can the socialization process for a bourgeois male be inferred from home-movie footage that focuses on the Bartos family's male members? What role do home movies play in their original context, and how is this role altered by Forgács to overcome the frequently boring quality of home movies for anyone who is not a member of the original family? As more than one of the chapters indicates, Forgács is a master at creating suspense and identification, qualities that make the charge of boredom seldom heard in relation to his films.

In "Found Images as Witnesses to Central European History: *A Bibó Reader* and *Miss Universe 1929*," Catherine Portuges expands the field of investigation by discussing two of Forgács's works that deal with the historical forces that have shaped twentieth-century Eastern Europe, particularly Hungary. *A Bibó Reader* utilizes found footage to reassemble fragments of the political commitments and philosophical thoughts of István Bibó. Bibó stressed an ethics of engagement and participatory democracy at odds with the collaborationist government of the war years and with the postwar Communist government. His resistance to the Soviet occupation of Hungary in 1956, which put down a nascent movement toward greater independence and democracy, led to his arrest and removal from public life, and his works fell into neglect. Forgács's film represents a vigorous attempt to bring his dissident and provocative ideas back into public view. The other film Portuges examines, *Miss Universe 1929*, chronicles the life of the modest, unassuming, Viennese Lisl Goldarbeiter, whose subsequent life was not altogether happy; it clearly stands in for the turmoil that swept Europe for the next several decades. Following her divorce from the necktie heir, World War II, and the Holocaust, Marci and Lisl, his cousin and the subject of his home movies, were finally united, but not before another remarkable tale of "private history" had unfolded.

Tyrus Miller and Whitney Davis continue the philosophically informed exploration begun by Kaja Silverman by turning to two films with a pointed philosophic bent. Miller and Davis emphasize the work of Ludwig Wittgenstein, Maurice Merleau-Ponty, and Martin Heidegger. Wittgenstein's attention to the nature and limits of ordinary language resonates with Forgács's interest in home movies. Wittgenstein was constantly aware of what lay beyond language as such but knew that language could only seek to evoke or suggest. This is just what Forgács stresses in the mysterious richness of seemingly banal home movies.

Tyrus Miller examines two films, *Wittgenstein's Tractatus* and *Bourgeois Dictionary*, with an emphasis on what they reveal to us about the historical specificity of Wittgenstein's ideas and their implications for documentary film. Calling *Wittgenstein's Tractatus* a "poetic montage," Miller explores how it demonstrates the potential split between what can be said linguistically and what remains beyond the range of words. He argues that this split was particularly acute in twentieth-century Europe and even more so for the European Jewish community to which Wittgenstein belonged. The linkage that best accords with Wittgenstein's sense of how words relate to the world they address is a documentary project attuned to analogical relationships rather than mimetic ones. Miller, through extremely close and revelatory readings of specific images, shows how their full resonance occurs not when they can be linked to a specific time and place but when that time and place can be linked to the larger cultural, national, and historical forces at work at that moment. An analogy emerges, but it exists at the edge of speech, in the felt apprehension of something that exceeds the specificity of the referent, yet it also depends on knowing that specificity as a first step toward understanding what cannot be said more directly.

Forgács seeks out the inexpressible, affective quality of images and conditions, states of mind, and the sense of what it might feel like to occupy a certain body or live in a certain time and place. Wittgenstein wrote that "everything we see could be otherwise," and for Miller this sense that every apparently factual observation, or image, could be seen and understood "otherwise" is a crucial factor in Forgács's decision to use home-movie footage as the raw material for his efforts to reconstruct a "private history" of European life.

Whitney Davis asks how Wittgenstein conveys the paradoxical problem of a form of discourse that cannot contain what it refers to in his *Tractatus Logico-Philosophicus* of 1921, where the unusual structure of the text as a series of numbered and tiered statements seems to express this central idea. Davis then extends his examination to Forgács's

Figure I.2 *Wittgenstein Tractatus*. In this film Forgács frequently unpeels layers of image as if to suggest that a still or moving image exists beneath the obscuring force of history and rests atop yet other mysteries.

Wittgenstein's Tractatus, a work that, for Davis, attempts to *do* philosophy in film. For Davis, Wittgenstein's statement "Die Welt is alles, was der Fall ist," often translated as "The world is all that is the case," is more accurately translated as "The world is all, what the case is." The latter, clearly more clumsy, eliminates the crucial pronoun "that," as Wittgenstein also did. Film also eliminates relative pronouns and other conjunctions. Shots follow shots, and we must infer their connection. "Which," "although," "not," or "instead of," to name a few possible connectives, cannot be expressed in images. An image is also of something very specific and concrete, whereas many words, like "that," have no specific referent. How can images of specific things be used to suggest everything that could be otherwise about that image? Like Miller, Davis examines how Forgács uses images from his home-movie archive to arrive at positions similar to Wittgenstein's in this unusual film, which does not tell a history so much as explore the nature and condition of cinema itself.

Tamás Korányi discusses the extraordinary music of Tibor Szemző. Szemző's minimalist but highly expressive and contrapuntal music adds notes of foreboding, lament, tension, suspense, and wonder to the images

Forgács brings together. Korányi locates Szemzö's music within a larger context, identifying a number of composers whose work bears resemblance to Szemzö's, but, equally important, he indicates what is distinct to this crucial aspect of Forgács's films. Unlike the scores that have been created in the last couple of decades for silent feature films such as Dziga Vertov's *The Man with a Movie Camera*, Szemzö's scores do not give musical accompaniment to preexisting works. Forgács and Szemzö collaboratively bring into being an entirely new work from the preexisting shards of home movies and other footage that they assemble into a distinct entity. The difference may appear subtle at first, but the result is anything but. Szemzö's music emphasizes the way in which footage originally destined for one purpose now takes on entirely new meanings and distinct effects.

László F. Földényi takes up the question of Péter Forgács's installation work. His film *Danube Exodus* has served as the basis for a remarkable installation, first presented at the Getty Research Institute in 2002 and then presented at a variety of venues around the world for the next four years, but Földényi examines a number of Forgács's earlier European installations that were not film based. These works demonstrated an artistic breadth that is not self-evident from the films alone. Földényi gives particular stress to how Forgács adopts an analytic method of denaturalization and mediation. His approach invites extended comparison with the methods of psychoanalysis but also departs from this tradition in its determination not to expose the unknown and mysterious to the light of reason but to allow it to shine forth with a new, compelling radiance. Földényi is especially attentive to how the viewer enters into a performance that revolves around her entry into the charged space of the installation. He finds something quite powerful and even spiritual at work that respects mystery as it deploys a technological apparatus and the means of mechanical reproduction to achieve it.

Marsha Kinder's chapter describes what happens when *Danube Exodus*, along with hours of outtakes and new interviews, become assembled into an installation work, *The Danube Exodus: The Rippling Currents of the River*. The installation couples a large, five-screen, interactive display that draws from footage of the riverboat that plied up and down the Danube with Jews in flight to Israel and Germans in flight from Bessarabia. It combines this immersive display—accompanied by a rich, evocative soundtrack—with smaller computer stations where individuals can follow one or more of the narrative strands in greater detail, gaining information that extends before and after the voyage in or out of central Europe.

The shift from a film to an installation led to the realization that a new form had come into being: the documentary database, as Kinder calls it. Positioned between an archive (a vast array of data that can be retrieved in almost any order) and a narrative (a single story that moves from beginning to end with a sense of coherence and closure), the installation raised new questions about reception and identification. It also led to the creation of a team of specialists, akin to the traditional film crew in the old studio system but with a radically different array of skills, rather than of an individual artisan filmmaker. And central to this team is the viewer. Kinder describes the installation as "interactive" due to the large degree of choice afforded the viewer, who not only views but also chooses what to view and for how long to view it. Closure is far less certain, but the careful work of structuring choices means that the installation is not a sea of infinite possibility. In fact, for Kinder it refutes the common idea that a neutral, value-free archive gives rise to emotionally charged and ideologically loaded narratives as it is taken up and used. She points out how the archive itself results from value-based, hence politically significant, decisions that cannot be ignored or neutralized. The installation becomes a new way of reanimating the past. It becomes what Kinder terms a "reorchestration." As such it lends added density and scope to the already extraordinary legacy offered by the films of Péter Forgács.

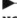

NOTES

1. Jay Leyda, *Films Beget Films: A Study of the Compilation Film* (New York: Hill and Wang, 1964). The book draws heavily on work from the Soviet Union and the eastern bloc countries and can be understood as an extension of Leyda's deep commitment to the principles of montage into the realm of nonfiction film.
2. Ibid., 10.
3. Panel discussion at the Skirball Cultural Center, Los Angeles, California, April 21, 2001.

Part I Setting the Scene

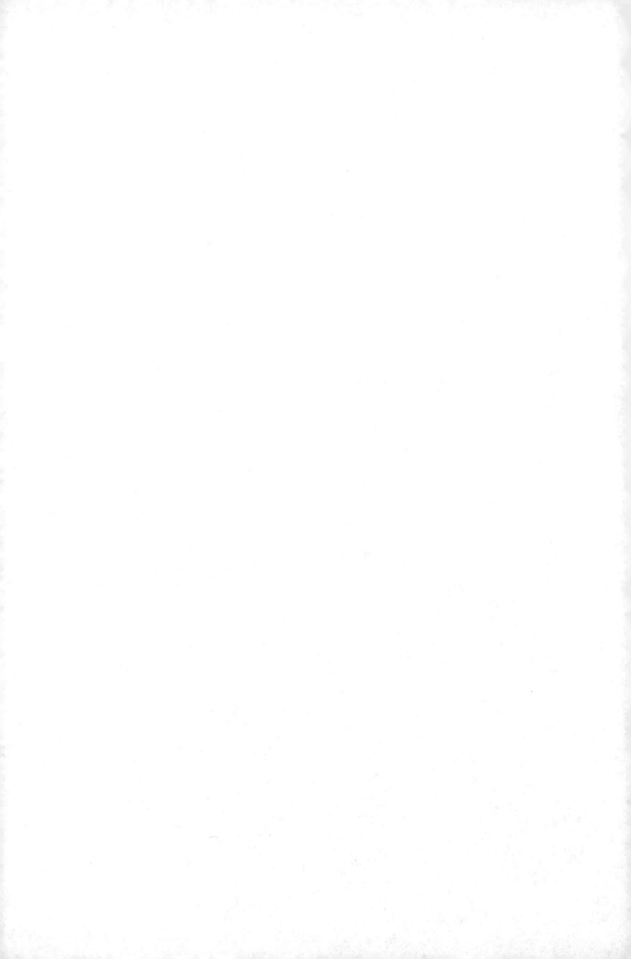

SCOTT MACDONALD

[**1**] *Péter Forgács*
An Interview

In recent decades, some filmmakers have made remarkable films and videos that, in one way or another, retrieve films that are endangered, either because of their physical fragility or because of historical factors, and make them available to audiences in a new form. Instances of this approach include Alan Berliner's *A Family Album* (1987), made up of excerpts from American home movies recorded in the United States during the 1930s, 1940s, and 1950s; Lynne Sachs's *Sermons and Sacred Pictures* (1989), which recycles excerpts of films made during the 1940s and 1950s by L. O. Taylor, an African American Baptist preacher based in Memphis; and Robert A. Nakamura's *Something Strong Within* (1994), which recycles and recontextualizes home movies made by Japanese Americans imprisoned in internment camps during World War II. The series of films made by the Italians Yervant Gianikian and Angela Ricci Lucchi, including *From the Pole to the Equator* (1986), recycle films by Italian cinematographer Luca Comerio into a work that simultaneously comments on cinema's complicity in imperial conquest and offers subtle comments on contemporary life. The most prolific and arguably the most accomplished filmmaker who works in this way is the Hungarian Péter Forgács. In his Private Hungary series of videos, and in much of his more recent work as well, Forgács has been dedicated to the retrieval of home movies and amateur films made in Europe from the 1930s to the 1950s and to recycling these films into memorable excursions into places and moments not available in official histories of this momentous era.

While some of those who work with home movies and amateur films focus on the typicality of this material—that is, the ways in which it exemplifies general historical developments or the human condition— Forgács does considerable research into the particular films he works with so that he can provide us with specific information about these

nonprofessional filmmakers and, often, about the family members and friends recorded in the imagery. The resulting films create very unusual experiences during which we are able to experience, seemingly from the inside, the real lives of families not our own.

For Forgács, the people who document their personal and social experiences from the inside are heroes of cinema for at least two reasons. First, the amateur filmmakers who most interest Forgács are often deeply committed to their filmmaking. In some cases, we see footage they recorded in their communities at times when all such recording was forbidden and could have led to serious consequences. In *Angelo's Film* (2000), for example, Angelo Papanastassiou made a commitment to document as much of the German-Italian occupation of his native Greece as he could, knowing that were his clandestine filmmaking discovered, he and his family would surely have been arrested.

These filmmakers are also heroes to Forgács, regardless of whether their activities were clandestine or whether their filmmaking was politically motivated, because their decision to make films has resulted in our having forms of information about real lives during a particular turbulent era, unavailable in any other form of filmmaking. The popular cinema can suggest what large numbers of people enjoyed or were moved by when they stepped into public movie houses. The documentaries of that era can show us something about what was officially understood about the societies of the time. And avant-garde filmmakers can suggest what some of the aesthetic trends of an era were. But home movies and other forms of amateur film are a window not only into an earlier era but also into how everyday life in those places and times was different and similar to everyday life in our own. Of course, we recognize that in home movies, those who are filmed and those doing the filmmaking are performing their lives in accordance with the social mores of the moment, but a half century later, the very nature of these performances is revealing.

Forgács's videos often allow us insights into dimensions of everyday experience and history that cannot have been possible during the era when the films he works with were made. One particularly memorable instance has to do with the physical appearance of many of the people in the Peereboom family in *The Maelstrom: A Family Chronicle* (1997), and especially of Annie Prins. Max Peereboom's imagery of his family reveals people who seem comfortable with themselves and remarkably unafraid of the camera. We see them cavorting at the beach, seemingly unconcerned with their physical appearance. Annie Prins, who is lithe and athletic, but whose face is reminiscent of the anti-Semitic cartoons I remember seeing during my youth, has a carefree attitude about

appearances as she well might in home movies made by the man she loves. It is obvious that Annie is a confident, happy person who sees herself, and is seen by her husband and the rest of her family, as very lovely. All this is put into a larger perspective when, during the second half of *The Maelstrom*, we see home movies of the Seyss-Inquart family. Seyss-Inquart's family is both better looking in conventional terms than the Peereboom family and far more constrained in front of the camera. Indeed, if it were not clear they were Nazis, many viewers might consider them much more normal in the way they relate to each other and to the camera.

My experience of *The Maelstrom* reveals a painful paradox: while the Nazis were defeated (though not until they had destroyed everyone in Max and Annie's family, other than the youngest brother Simon, who was freed from Buchenwald at the end of the war), their way of understanding human appearance and behavior seems—certainly in America and apparently in increasing numbers of places—to have won. We see the lovely Peereboom family through a training in media imaging that seems to require nose jobs and straightened teeth; we can only wonder what it might be like to be as comfortable with ourselves as Annie Prins and her mother-in-law appear to be.

Forgács's videos are full of surprises, both technically and ideologically. In the Private Hungary series Forgács learned to work with the

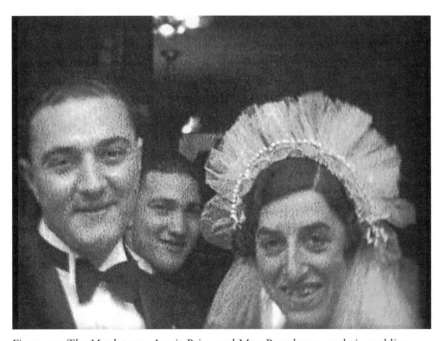

Figure 1.1 *The Maelstrom*. Annie Prins and Max Peereboom at their wedding.

standard devices of nonfiction film—visual text, narration, music—but he uses each of these with unusual inventiveness. Many of his tapes have been made in collaboration with composer-musician Tibor Szemzö, whose compositions are consistently evocative and powerful. Forgács sometimes calls his pieces "video operas," a term that suggests the overall musicality of his presentation of text and image and the ways these tapes position the microcosmic lives of individuals within the macrocosm of societal change and cultural history.

While Forgács was confined to Hungary during his early years as an artist and established his reputation by exploring the private lives of Hungarians, his videos are thoroughly transnational in spirit. At the least, they contextualize Hungarian lives within international political events, and once the Iron Curtain was dismantled, the crossing of national borders becomes a central issue in some films. *Meanwhile, Somewhere* (1996), made as part of The Unknown War series and a coproduction of La Camera Stylo (Hamburg), RTBF (Charteroi), the Béla Balázs studio (Budapest), and Hans Bosscher (Amsterdam), is perhaps the most remarkable instance. *Meanwhile, Somewhere* surveys life in a broad range of locations (the Netherlands, Belgium, France, Germany, Poland, Hungary,

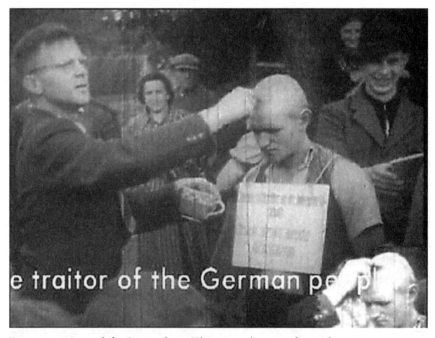

Figure 1.2 *Meanwhile, Somewhere*. This pivotal scene of punishment recurs through the film, and in this still Forgács's insert of another portion of the same event is evident in the lower right-hand corner.

Austria, Czechoslovakia, the Ukraine, Greece, and Portugal) during the years from 1940 to 1943. Forgács creates a kaleidoscope of events by moving from one place to another, from one kind of human experience to another, from one home movie–amateur film style to another, and even from one balance of formal devices to another—and provides viewers with an opportunity to meditate on the remarkable surreality of what we call everyday life.

The most obvious motif in *Meanwhile, Somewhere*—many of the elements of the film are repeated so that we grow familiar with particular families and particular amateur filmmakers—is a ritual punishment of a young Polish girl and a young German boy, lovers apparently, in occupied Poland in 1941. In the nine sequences that detail this moment of ethnic cleansing, the boy and girl are paraded through the town, wearing signs (the boy's, "I'm the traitor of the German people"; the girl's, "I'm a Polish pig"); their hair is cut off, and they are lectured to by townspeople. During each of these sequences, Forgács includes a formal device that can stand as a metaphor for a crucial dimension of his work. In the lower right-hand corner of the frame, we see, in a triangular insert, a tiny detail of the scene that is unfolding in the full frame before us. These details are not central to these events—at least, they're not what the original filmmaker wanted us to notice—but Forgács's reframing of these details causes us to watch the imagery more thoroughly and helps us become aware of the fascinating, troubling surroundings of these activities. For Forgács the home movies and amateur films he has spent so many years working with are important for the surface reality they document *and* for the many levels of experience that are inscribed on the filmstrip, from the original amateur filmmakers' apparent interests and assumptions, to the dimensions of this personal history that subsequent political history has awakened us to, to the various forms of damage the filmstrip has endured and what this damage can tell us.

While most of Forgács's work has explored particular collections of home movies and amateur films, he has also done other kinds of videos, including two that engage philosophers whose writings have been particularly important to him: *Wittgenstein Tractatus* (1992) comprises seven short essays inspired by Ludwig Wittgenstein's *Tractus Logico-Philosophicus* (1922) and *Culture and Value* (1980); *A Bibó Reader* explores the life and work of Hungarian writer-statesman Istvan Bibó.

The interview in this chapter began when Forgács toured with his videos as a guest of the Central New York Programmers Group in October 1999 and continued by e-mail. During the years since the interview was completed, Forgács has continued to explore cultural history using

home movies and amateur films—in *El Perro Negro: Stories from the Spanish Civil War* (2005), for example—and in 2007 he completed one of the more remarkable experimental narrative films of recent years: *Own Death*, a feature-length adaptation of Péter Nádas's short story "Own Death," which was published in an elegant book-length version illustrated with Nádas's own photographs of trees in 2006.[1] *Own Death* is the story of a man who has heart failure and then nearly dies of anaphylactic shock in the hospital, something Forgács himself has experienced. Nádas's story is recited by Peter Meikle Moor and functions as a score illustrated and interpreted by Forgács's imagery, mainly still photographs interspersed with moments of live action, accompanied by a musical composition performed by Barnabás Dukay, Lázlo Melis, and Mihály Vig. Formally, *Own Death* is reminiscent of Chris Marker's *La Jetée* (1963). Though Forgács does incorporate bits of material from home movies and amateur films, *Own Death* is composed primarily of material he generated himself, using actors; the visuals and sounds are presented in a manner that allows Nádas's story to meld with Forgács's own experience. We experience the story as if from inside the consciousness of the protagonist.

SCOTT MACDONALD: You mentioned earlier that you were kicked out of university for political activity. Now you make an unusual kind of political film. Could you talk about your sense of political filmmaking?

PÉTER FORGÁCS: I was brought up in an intellectual family—leftist. Books were always at hand and I loved them. I wanted to be an artist from the time I was five. The world was always very visual for me. This was the period of Leonid Ilyich Brezhnev. The Russian Communist czar was not as brutal as his predecessors, but he was part of the whole frozen Communist–Nazi system.

The notion of being politically involved is very different in the States than in Eastern Europe, even today. In the sixties during the civil rights movement and the anti–Vietnam War demonstrations, America became politically mature and recognized, for a generation at least, that civil rights movements and international politics are related. In Hungary during the sixties such movements were not fully developed, but I was taking part in left-wing cultural activities. We wanted to make a better Communism, a purer Communism. We wanted to go back to the ideals of Marx and Che Guevara and the Vietnamese peasants.

In 1973, because of this work, I was completely cut off from all Hungarian universities and institutional support. As a result, I didn't have my first one-man show in an official Hungarian institution until I

was forty-five (my documentaries did begin to appear on TV when I was thirty-eight). I had no passport, so I couldn't even leave Hungary. I gave up on leftist ideals in 1973.

I never thought of myself as a resistance fighter; in Hungary it just felt like one's duty to resist Russian and Communist state control. When the Berlin Wall came down, the bubble of political activity burst for me. I don't mean I no longer cared about civil rights problems—that's the duty of all human beings—but certain kinds of resistance were no longer relevant.

My first son, Christopher, had already been born, so I had to keep myself and my family alive and had to work at various low-paying jobs. I taught for fifteen years, mostly in elementary school. I was a regular teacher for two years but after that only worked with experimental schools. I stopped teaching finally because I realized that what I was doing in the classroom did not have an effect outside the classroom walls.

In 1978 I became a member of a minimal music group called Group 180. I was a singer and a narrator. I also had a part-time job in a research institute. And I was producing graphic works, illustrating and designing books, and making a lot of photographs. I lived an artist-ghetto life, which, until the mideighties, was more or less focused on a young artists' club in Budapest. Ultimately, of course, the clubs were controlled by the Communist regime, so it was an Orwellian life; but this artists' club was where I spent my time and where I learned about minimal music and listened to John Cage, Philip Glass, Terry Reilly, and other minimalists. Concept art was also very hot in Hungary, and I knew about Fluxus.

Hungary is a complex society, a Western–Eastern civilization; and you could always sense—even under Soviet rule—that there was a past, a Hungarian culture, behind what you saw. I came to feel that political and economic growth and change are not the most important things and that cultural habits and traditions and roots are more significant. Of course, this does not mean that I am a fundamentalist who wants to keep everything exactly as it is. But I became much more a kind of archaeologist—largely because of my inability to break free from the restrictions on my personal mobility. I couldn't go *elsewhere* to study culture, so I studied my own. So it was *1984* in Hungary, and for me, finding the vanishing culture of Hungary, and later of Europe, was a form of resistance. Of course, we know from Orwell that whoever controls the past controls the present.

Somehow, my background in concept art and minimal music became very important to me in this study of Hungarian culture. I began to collect home movies as a way of exploring the history of my culture,

and after I had collected home movies for six or seven years, somebody suggested that I apply for a grant to the film department (it was also the film censor department) of the Ministry of Culture. The guy saw part of my collection and was amazed and interested in the things I had gathered under the name of the Private Photo and Film Archive, and I got the grant. Now the archive is a foundation.

As soon as I got the grant, I made the first Private Hungary pieces. This involved much research. I did interviews with the owners of the films in my archive and with their families. It was a pleasure to do research on civilian life in Hungary during the years before and during World War II; since it was in the past, it was outside the realm of Communism.

Then I began performing with Tibor Szemzö, who was the founder of Group 180.

MACDONALD: Where does the name come from? Were you all doing a one-eighty?

FORGÁCS: No. The name of the group was invented when they had to give their first concert. These were just young musicians coming out of the academy; they hadn't thought about names. One day, five of them were in a taxi; the piano player was a tall girl, and the others asked, "How tall are you?" She said, "180 centimeters," and the flute player, my friend, said, "I'm 180 centimeters, too." It turned out that everybody in the taxi was 180 centimeters (well, one was 176), and that became the name.

As I said, minimal music was in the air, along with Fluxus art and concept art. It was all the same radical change. I learned a lot at rehearsals and performances, especially about the handling of time. Tibor and I toured Europe in 1984, 1986, and 1987, doing performances. He was the composer; I was doing text, dance, and screenings. The use of music in my work is more understandable if you consider that it was performance work first.

MACDONALD: The imagery was screened on stage and you performed in front of it?

FORGÁCS: Yes. Our performances came from Fluxus and from psychoanalysis. They especially came from our awareness of the vanishing part of Hungarian history, from the feeling that the semantic context of Communism not only was a big lie but was fake in every manifestation. Over the years, Tibor and I worked out, on stage, our special relationship between his music and my found footage; our method was an effective tool, well

before I even dreamed of *The Bartos Family* [1988], the first episode of what became Private Hungary.

And there was also the Béla Balázs studio, a unique organization in Eastern Europe—an independent film studio. "Independent" here does not mean it was not financed by the state, just that it had postproduction rights. The people who worked at the Béla Balázs studio elected their own board; the board decided which work should be produced.

When a film was produced, the film censor did see it. There were three categories: *A*, *B*, and *C*. *A* meant a film was banned once and forever; *B* meant you could show it on a closed circuit, in cultural houses and at film clubs; and *C* meant you could go wherever you wanted and show the film.

MACDONALD: But you could *make* what you want?

FORGÁCS: Yes! People could make the films they wanted to make.

All the other Hungarian filmmakers in all the other studios (there were five), plus the animation studio, plus the documentary studio, had to show their scripts to those who ran the studio and, of course, there was also a great deal of self-censorship. There was pervasive doublespeak in Hungarian film culture during that era: you might understand what I wanted to say, but you also understood that I couldn't say it directly to you because of these guys over there—but we both knew what we knew! I think it was Miklós Jancsó who originally broke through this metaphoric doublespeak.

But the Béla Balázs studio *was* a place where independent filmmaking happened. People were making films that were unthinkable in any other Eastern European country, except for Poland—but the Polish filmmakers *left* Poland.

MACDONALD: Your mentioning Fluxus opens a certain dimension of your films. Fluxus was about allowing whatever comes out to *be* the art; it gets the artist-as-master-craftsman out of the way. Home movies do that, too.

FORGÁCS: Exactly! What *is* a readymade? It comes from Marcel Duchamp's *Fountain* [*Le Pissoir*, 1917]. It comes from Joseph Cornell. These artists re-presented objects that had meaning within their culture, allowing us to see them in new ways. The same is true of my work with home movies. Of course, for many years, the Hungarians questioned whether my work was *art*. They thought I was just another kind of amateur home-movie maker.

A lot of filmmakers all over the world work with home movies and recycle other kinds of film because they find the *surface* of culture interesting or amusing. On the other end of things is the documentary filmmaker who uses archival materials to illustrate ideas, ideology, or a particular interpretation of historic events. My approach is different from either of these.

I'm interested in going beneath the surface of the home movies and amateur films I have access to, not because I want to patronize these films or to see them merely as examples of some idea, but because they reveal a level of history that is recorded in no other kind of cinema—a level of history that governments and large commercial enterprises don't see as important or valuable but that can show us a great many things about the realities and complexities of history as it is lived by real people.

MACDONALD: What originally led you to begin archiving home movies and amateur films?

FORGÁCS: A friend of mine, Kardos Sándor, was collecting bad photographs; his was a kind of Fluxus collection, enormous and beautiful. He had a perceptive eye, and his collection is amazing. It had a big influence on me and on many other artists because the collection was *about* the decomposition process.

He used to say, "These are the moments when God, not man, pushed the button." Very inspiring. I thought I had the possibility to do something like this with film, under the cover of the cultural resurgence that was going on in Hungary. And it became a part-time job, four or six hours a week at this institution that was a safe haven for radical guys like myself, as well as for normal researchers. It didn't pay enough to live on, but it also had advantages: since there was an institution behind me now, I could advertise in the papers that I was collecting home movies and ask that people bring their home movies to me. Of course, it didn't work until I started offering free videos!

They would bring in their films, and I'd make two video copies, give them one and keep one. I started making contracts with the people that would allow me to work with the material, and I started doing interviews with them. I went into these family histories one by one. It was in-depth, anthropological research into my own culture in my own terrain.

A second important thing was an experimental film made in 1978 by Gábor Bódy at the Béla Balázs studio. It was called *Private History* and was made with found footage—a very interesting and aesthetic film, but more about the pleasures of cinema than about the lives recorded in

the found footage. Bódy was a very good filmmaker and very influential because he organized experimental filmmaking events. But I felt more could be done with his approach.

What I saw that was still to be done had to do with the message that comes up from home-movie material. What does it reveal about the culture and the times, not just about how things *look*, but *underneath*? These films are very exciting to explore.

One other element needs to be added. Psychoanalysis is part of American culture, but it's still not part of Hungarian culture because Communism was very thorough in killing off decadent, bourgeois, Freudian analysis. There was a psychologist in Budapest who had been in prison because of the 1956 revolution. He had studied at the Sorbonne, and he taught me psychology and group therapy. I was around him for eleven years; he was a private university, the best.

For me it's a revelation to read the faces of people in home movies and the context we see them in and to consider what this reveals about human psychology. The face is an extraordinarily sensitive surface, and these faces are not just objects like we see in Eadweard Muybridge or in the Edison or Lumière films; and they're not just acting, like in Méliès films. In this case, even if it's an artificial situation, they're representing themselves. As a result, these films are full of revelatory moments about how it *was* there, about how they felt, about what they felt the need to represent. If these revelations of self are then placed in a context where you can sense the whole culture, its history and background, and how particular personalities fit into it, the results become very dynamic.

We humans are always struggling with aging and death; we are full of questions. "Granny, how was it in 1928 when your father committed suicide because of the bankruptcy of his bank?" "Mama, how was it when your dad came into the U.S. and sold his cows"? "Why did you divorce?" We're always struggling with our own existential problems. We watch our children grow up and then suddenly we see the same gestures and same idiotic rebellion as *they* struggle with many of the same things.

MACDONALD: A general question about your collecting and using home movies. What exactly happens to the films you find between the time when you locate the work and when you use it in your own video? How is the material preserved?

FORGÁCS: First, all the films are preserved by the Photo and Film Foundation, on Beta SP professional videotape. Then, most of the time, the owner gets the films back.

MACDONALD: Do other moving-image artists work with this same archival material?

FORGÁCS: Anyone can use the archive, but up until now I'm the only one who's used it—the material is not tasty enough for most filmmakers, who have a professional need for crisp, clear images. Since much of the archival material is scratched and not in good shape generally, it doesn't fit their needs.

MACDONALD: How did you decide to begin the Private Hungary series with *The Bartos Family*? I assume that some of it had to do with Zoltán Bartos's inventiveness as a filmmaker and as a songwriter.

FORGÁCS: The Zoltán Bartos film collection was a mess when his nephew, Tamás, gave it to me in 1983, following the newspaper announcement of my archives. It was a huge collection: about 29 twelve- to fifteen-minute reels of film, full of interesting subjects, covering the period between 1928 and 1964. And they gave me Zoltán's songs. Not one reel of film was labeled correctly; it was like a time maze. I started with this collection because it posed the greatest challenge.

That same collection of films was known and used by Gábor Bódy and Timár, the makers of *Private History* (1978). One of Bódy's assistants at that time was my brother András, a writer and film and theater critic, and when he saw my final Bartos film, he recognized the family and confessed to me that when he was working for Bódy, *he* was the one who messed up the labeling of the reels! We laughed about that a lot.

The widow of Ödön, the second brother, told me who was who in the imagery.

MACDONALD: I'm wondering how much liberty you take with a given collection of home movies. In *The Bartos Family* there are a number of little films within the film, many of them clearly constructed by Zoltán: *Flirt*, for example. In other instances, there are titles that I assume are yours— "Ottó" and "Zoltán"—that introduce the histories of particular Bartos family members. Did *you* create these minihistories of the family members, or did Zoltán?

FORGÁCS: The little films within the film, like *Flirt*, were all created by Zoltán, and in those cases I kept his intertitles; all the other titles are mine.

MACDONALD: Obviously, any given family records more or less film during different time periods, depending on what is going on in and around the

family. How carefully do your films provide an analogy for the amounts of footage available? In other words, if a family has a lot of footage from 1930 to 1933 and very little from 1940 to 1943, do your videos reflect that, or do you ignore the amount of footage the makers provided you with when you construct your videos?

FORGÁCS: I do ignore the amount of footage. The inner story line is what is most important and exciting to me. However, more film usually equals more variation. In the case of the Bartos material, Zoltán was childless, and so his subjects are widely varied. Filmmaker fathers regularly lose their interest in the world outside when their babies are born: the baby's first steps, the baby's new dress become the new subjects for the camera. This becomes boring and monotonous. So the Bartos collection was a treasure.

MACDONALD: A related question: clearly, one of the themes throughout the Private Hungary series is the way in which family life is shattered by the rise of Nazism and the Anschluss (annexation), the Second World War, the Holocaust, and the arrival of Stalinist Russia. Often, we get a more or less continuous picture of family life, which becomes increasingly disjunctive as these major events engulf Hungarian society. You could visually create this idea even if you had a consistent amount of footage throughout the years, but I assume that the activity of private filmmaking does in fact reflect the traumas of the surrounding society.

FORGÁCS: The activity and vision of private filmmaking does focus on their private lives, but, of course, indirectly it also reflects their present historical time. I think that the relation between public and private life was radically changed *before*, *during*, and *after* the Second World War, and then *again* in the Communist years. And the trauma of the war experience was radically different for each class and different for the Christian and the Jewish middle class. By 1938 the Jews were persecuted, and they were mostly destroyed by 1944. The Christians had to deal with the trauma of the lost war, of lost privilege, and then with the Soviet invasion and the trauma of dictatorship.

During those times there was often not enough film on the market for films to be made, and also, because of the harsh red terror in Hungary, people were not likcly to film outside the family circle.

MACDONALD: In *The Bartos Family* just after we see the death of the mother, and the father crying at her grave, we meet the new wife (who

we remember from earlier in the film). This sudden second marriage makes it seem as if the Bartos father had already been involved with the second wife during his first marriage. Did you mean to suggest this as a possibility?

FORGÁCS: That is my suggestion. I learned from family members that immediately after the death of the first wife of old Ármin Bartos, the second wife (Klári) divorced her own husband, Mr. Déri, the executive director under Ármin Bartos, to marry the big boss and get rich. It was so disgusting to the other family members that they were relieved when, after the war, Klári and old Bartos divorced following long years of separation.

MACDONALD: *Dusi and Jenö* [1989] is a very strange video, in part because of the centrality of the dog in their relationship (after the first dog dies, things never seem the same), and later because of the sudden, strange arrival of the second wife, and Jenö's reading his favorite love poem at the end. This film feels almost surreal, even before the trauma of the war, the deportation of the Jews, and the devastation of Budapest. What led you to make this video the second in the series?

FORGÁCS: If the making of *The Bartos Family* was an attempt to create order from a seemingly confusing story—the editing took more than three months—the footage that I used in Dusi and Jenö grabbed my attention the first moment I saw it, and I was able to edit this collection's clearly composed, aesthetic, melancholic imagery into the form you've seen in three or four weeks. The music came later.

There was also a more personal motivation for me in this case. As you know, Budapest is a city of two parts: the Buda side with the hills and the castle is more wealthy; the Pest side is more urban, industrial, and commercial. Like Dusi and Jenö, I lived on Attila Street in Buda, about a thousand feet north of them, for twenty-eight years. I even remember the open-air restaurant that opened after the war on the place of their ruined house, and I played soccer in Tabán park, where Dusi walked her dog. I knew this neighborhood like the back of my hand, and the Buda of my childhood, the forgotten Atlantis, emerged through the devotion and love of Jenö's camera. Jenö must have been the opposite of Zoltán. *Dusi and Jenö* was a joy to edit.

MACDONALD: Often in the Private Hungary videos, the immensity of social change is evoked by the lack of imagery. Indeed, often the larger the temporal gap, the more radical the historical–personal change. One

of the implications is that major historical events—especially war, revolution, large-scale atrocities—are not exactly personal, at least not in the sense of personal suggested by home movies. It's as if they blow a hole in the personal, create wounds that must heal before an individual can rejoin domestic life.

FORGÁCS: Thanks. Very few statements so clearly communicate that aspect of my work. As in literature (see Umberto Eco), in cinematography, the *open* piece gives far more surface for the imagination than does the linear narrative. This accounts for the associative jumps in my work, the shifts from the personal to the public, back and forth, and for the frequent lack of imagery. It allows us to follow the biographical ego's, the *self's*, amnesia and its constant quest for joy, for nice things, happiness. We become the analyst of what in effect are the amateur filmmaker's dream sketches, the structures of an intimate CV. The *Private Hungary* series is an attempt at a new kind of film narrative because it is always fragmented, and while the videos don't fall apart, they do include vacuums, tabulae rasae, all kinds of mistakes, pauses, taboos, and black holes. These *discontinuities* offer the viewer an opportunity to reconstruct a narrative from the ruins of a filmic memory.

MACDONALD: *Either-Or* [1989] divides into two sections: "My Friend and His Wife" and "My Daughter's Baby." Was the original material divided this way?

FORGÁCS: No. It was not divided at all. The division is my analysis of the collection and of the game of love as revealed through the camera, especially in relation to two taboos: the first, the filmmaker's love affair—through the camera—with his friend's wife; the second, a quasi-incestuous relationship—again through the camera—of the father and daughter. Mr. G's camera expresses the father's authority over the family: it's always his choice as to what to shoot, and, of course, baby's exhibitionism and narcissism is performed for daddy.

The title of the piece, of course, is borrowed from Søren Kierkegaard.

MACDONALD: During the second section of *Either-Or*, you use superimposed texts that function as the voice of Mr. G. Are these texts your invention? Or are they based on something in Mr. G's archive?

FORGÁCS: The texts are completely my invention—a way to set myself behind Mr. G as a narrator.

MACDONALD: In the credits of this video (and others, *The Diary of Mr. N* [1990], for example) you list János Tóth as "Expert." What was his function?

FORGÁCS: János Tóth is a wonderful, talented director of photography, and an avant-garde filmmaker. He is over seventy years old now and almost forgotten. In the sixties and seventies he photographed several successful Hungarian feature films, and he photographed Huszárik's remarkable *Elegy* (1967), a landmark of Hungarian independent cinema.

We shared a love for old home movies, and he transferred 9.5 mm film onto video for me and helped me with advice from 1985 until 1991. Under better circumstances he could have been the Hungarian Pat O'Neill: their vision is quite similar.

MACDONALD: Why is Mr. G not identified more fully? The same question with Mr. N in *The Diary of Mr. N*.

FORGÁCS: I ask the filmmakers or their families whether they agree to my using their names in my video, and in some cases their ambivalence demands quasi-anonymity.

MACDONALD: The family of Mr. N is amazing. They seem to thrive despite what goes on around them. Their high energy is evident in the outdoor excursions they make and in the size of their family, which grows during the most traumatic periods in modern Hungary's history. At the end of the video, you thank Mr. N for his "generous support of this video." How did you find this material, and assuming you had dealings with him during the making of the video, how did he feel about the history he had lived through?

FORGÁCS: His name was Hideghkuty, and the most important feature in his home movies is the triptych thematic structure: family, ammunition factory, public events. This way of documentation was rare at that time.

They were very kind people. Of course, as devoted Catholics, they loved a big family. We saw the film together at least three or four times. The final time, they told me, "We didn't know that our life was so interesting!"

MACDONALD: At the conclusion of *The Diary of Mr. N* we see Mr. N and Ilona carrying apples. This seems a metaphor for the fertility of their lives together, and—since she seems very tired—a comment on the toll it's taken on her. Am I reading this the way you meant it?

FORGÁCS: Yes, exactly.

MACDONALD: *Bourgeois Dictionary* [1992] reminds me a bit of *Meanwhile, Somewhere*—though I don't think it's nearly as successful. Here you use several collections of home movies to move us through the major events of recent Hungarian history, using words and their meanings as a formal device to hold the diffuse history together. Of course, *Bourgeois Dictionary* does include interesting moments: the "My Sweet Parents" section, in particular, and the lovely woman we see nude in both this video and *Meanwhile, Somewhere*.

FORGÁCS: *Bourgeois Dictionary* was done after *Wittgenstein Tractatus*, and I was trying a related methodology as a way of assembling some of my favorite fragments—poems, little short stories. I agree that the result isn't as strong as *Meanwhile, Somewhere*. Sometimes I'd like to redo this or that part of a piece or a whole piece. *Bourgeois Dictionary* is one of those.

The music is also a crucial, even dominant dimension of *Bourgeois Dictionary*. Tibor had lost his mother earlier that year, and his passionate score fills up the empty spaces in the video. I would have preferred more silences, but I could not change Tibor's mind about the score. Music is always a major dimension of these works. Tibor and I collaborate on most every aspect of the music and on the placement of the music. It's always a negotiation between us. For *Angelo's Film* Tibor had to recompose and rerecord the music three times before it was satisfactory to me.

MACDONALD: The shot of a young girl peeing in public is a motif in your videos (and, I assume, in the home movies you have access to). But I've never seen such a shot in American home movies, at least not that I remember. So it strikes me as a particularly European idea. And it seems most of the time to be a little girl peeing.

FORGÁCS: Well, first of all, this suggests a difference between the limits and possibilities of a written diary and a filmic one. I think Mr. G didn't have enough self-reflection to keep a written diary, but even if he'd kept one, he would never have *written*, "My sweet daughter, Baby, pissed today at the National Gallery—oh so amusing!" But *filming* it, for Mr. G as for other filmic fathers, is a *joke*. Of course, we know jokes express the repressed subconscious. There is a limited time when fathers can film their human properties: their sons and daughters. After the age of twelve, thirteen, or fourteen, the children start to protest, and they disappear from the family albums or films. That's what happened here: suddenly Baby disappears

from the screen, and when we see her again, she is sixteen and climbing from one balcony to the other, a rebellious gesture.

It would require more research to find out if there is any difference between the USA and Europe in regard to this sort of imagery. But even without research, I'm quite sure it's not a question of European openness but has more to do with my luck in finding these home movies and my effort *to make them visible.*

MACDONALD: *Totem* [1993] was a surprise for me and seemingly a total departure for you.

FORGÁCS: *Totem* is basically part of one of my installation works. If you could see my other installations, this piece would not surprise you—though the content and message is brutal. In the installation, the film that you've seen is the stuffed pig's favorite TV program. It's my most successful installation; it's been shown in Hungary four times, and in Barcelona, Tokyo, Rome, Sao Paulo, New York, Graz, and in other places.

MACDONALD: It's very provocative.

FORGÁCS: It was a shock to some people, especially vegetarians, and it was also praised as a new provocation against the conventions of art. But butchering pigs is a folkway from Germany down to Serbia.

Figure 1.3 *Hungarian Totem.* The stuffed pig is watching its favorite TV program in this installation piece.

MACDONALD: The inventive use of reverse is surprisingly rare in film. Walerian Borowczyk [in *Renaissance*, 1963], Jean Cocteau, and a few other filmmakers have used it successfully. Which came first: the idea of working with reverse, or the idea to do *this* subject?

FORGÁCS: Before I had made a shot, I knew this subject would work in reverse, though if you look at the film carefully—if you *can* look at it again—you'll see it's not *entirely* in reverse.

MACDONALD: I definitely need help with the connection between the words and the imagery.

FORGÁCS: The text and all its various associations are there to drag you away from the concrete view of the slaughter of the pig and onto a metaphoric level. There are many ways of reading this imagery, especially since the pig's suffering is so like a human's suffering.

MACDONALD: Is there a Hungarian version of this film, or just the English version? And why the one non-English word, "*tekintély*"?

FORGÁCS: There are German, Japanese, Italian, Portuguese, and Hungarian versions. *Tekintély* means "authority." The same word appears in English once or twice in the piece. It was a mistake that I used the Hungarian in this instance, but I didn't correct it because I liked the presence of this Hungarian word as a little disturbance, as an enigma.

MACDONALD: One of the things that makes your work unusual and gives the videos their energy is your implicit attitude about what culture *is*. One standard American assumption, and maybe it's broader than just American, is that when you go back to your roots, the roots get narrower and narrower and end in a single, pure ethnic heritage. For you, the energy of the history of a culture seems to be its particular *intersection* of a variety of traditions. Each particular geographic–historical place has a different set of intersections.

Danube Exodus includes a story I didn't know. Of course, the first part of the film, about Jews escaping down the Danube, is part of a well-known history; but I didn't know that there were also, at nearly the same time and in the same place, Bessarabian Germans being displaced and going *up* the Danube, as a result of the dislocations caused by Nazi imperialism and by the war.

FORGÁCS: In *Danube Exodus* the Danube is a metaphor. We know the stories and myths that have grown up around the big rivers: the Mississippi, the Nile, and the Ganges. A lot of avant-garde filmmakers want to play with time or explore cinematic time and space and frustrate the conventional viewer. But very few of them produce contemplative art. My interest, and it's maybe something typical of European cultures or of Central European cultures, is the psychology of dreams. My work does represent particular moments, some of them new for the audience, in modern history. But in a sense, the films I make are also dream works; they're about cultural dreams and nightmares. And one can look at *Danube Exodus* that way.

I don't use film as a pastime. I don't like pastimes. I like art and sex and raising children and talking with other people—discourse. The ephemeral, everyday footage I'm collecting generally records idiotic pastimes, typical of middle-class life in Eastern Europe. But on the other hand, if you think of these movies as found objects for Fluxus art, then you see that what might otherwise be boring can also be understood as a series of sacred moments: nonhistorical, private footage becomes historic

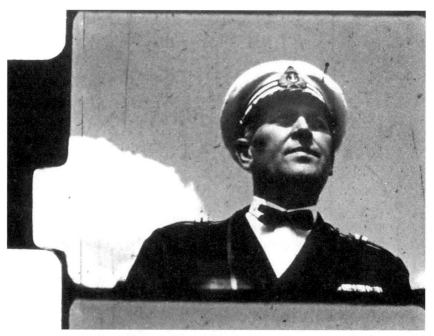

Figure 1.4 *Danube Exodus*. This shot of Captain Nandor Andrásovits was taken by someone else on board his ship, but the bulk of *Danube Exodus* represents footage of both Jewish and German passengers taken by the captain on his voyages up and down the Danube.

evidence of a certain mood, of a background; a color or a gesture or a smile, the shape of a face, reveals dimensions of a society that are never visible in public art.

My whole procedure becomes a way of my inviting you to look at what I found to come sit beside me and think about it. Like good music, my work offers an opportunity for a contemplative experience. On the other hand, the pieces record primary facts about human history and have as many layers as dreams. You can peel them like an onion, layer by layer.

The early Private Hungary pieces were really experiments that I enjoyed showing to my friends. Since then, a lot of water has run down the Danube River: the river is the same, but the water is not.

MACDONALD: Who saw the ship captain's film?

FORGÁCS: He showed it to other Hungarian Danube steamer captains and also in an amateur film club. He made a little seventeen-minute version about Jewish refugees on the Danube; the outtakes were forty-seven minutes, so altogether he shot sixty minutes of the Orthodox Jews on the boat.

He was interested in showing Orthodox Jews because in most circumstances you cannot go so near Orthodox Jews with your camera, and one Orthodox Jew would never film another Orthodox family; an unwritten law forbids it. So it was for him a kind of anthropological document. He's a kind of amateur anthropologist.

MACDONALD: He would be condemned in American discourse these days because he has not been given permission to film these people. He's there by virtue of his power over these people, and yet only *because* he exerts that power do we know them. Of course, they might not care to be known.

FORGÁCS: That's the funny side of American law. Somebody who's a big liar can be president, and O. J. Simpson goes free, but this captain would be attacked for filming somebody without permission.

MACDONALD: You must have gotten that criticism in this country.

FORGÁCS: Yes, I have.

There is a very important legal step that I always take: I arrange with the filmmaker or the owner of the films that all the problems relating to the people filmed in the home movies fall back on him—if there are any. But there has never been a single problem, and there will be no such problems because I'm not harming people with these films.

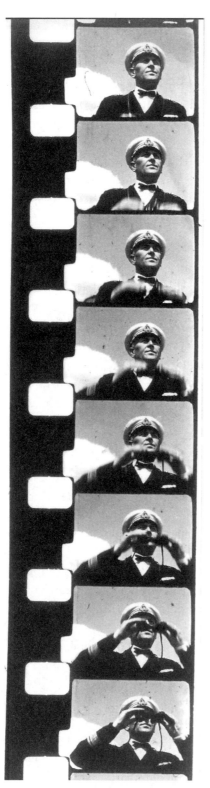

Figure 1.5 *Danube Exodus*. Forgács may have included this sequence of captain Andrásovits bringing his binoculars to his eyes as a reference to the captain's preoccupation with filming his own passengers as well as scanning the horizon.

There is a case going on now involving a very good Polish woman artist who went into a Turkish bath in Budapest, masquerading as a man, to make a video. She showed the results at the Venice Biennale, and now she will have to go to court because some people recognized themselves. But that's something else.

MACDONALD: That's about money.

FORGÁCS: No! That's about naked genitals!

Anyway, it *is* a big problem that those people who were happily cutting out the tongues and hearts of Bosnians, cutting off the balls of the men, can still go into the cafeteria and talk about their brave acts; it's *not* a problem that a riverboat captain was shooting film on his boat. He did have a position of authority, but without his authority and his willingness to shoot film, we wouldn't have news about a certain moment in the history of ethnic cleansing. And no one would have escaped on his boat.

MACDONALD: A question about your background in relation to this video. On one level, you have a Jewish heritage, but you also have a complex, non-Jewish European heritage, too. On some level, the two journeys in *Danube Exodus* could be seen as an emblem of your mixed heritage.

FORGÁCS: I *am* a Jew, by heritage, but, on the other hand, I'm not even circumcised! I didn't have any kind of Jewish tradition, unfortunately. The only religion I learned was Communism, and its god at that time was Brezhnev.

MACDONALD: So on some level, Bessarabian Germans and Orthodox Jews are equally distant from you and also equally related to you.

FORGÁCS: There's a wonderful book written by Randolph Braun, a historian with a Romanian–Hungarian–Jewish heritage, about the Hungarian Holocaust (my video *Free Fall* [1996] developed out of this book).[2] I was reading it and almost fainting—the film took me years to do because his book was so painful to read. I don't want to push our interview into the Holocaust because I don't want to exploit it. But if there *is* any cultural heritage in my Jewishness, it's the Holocaust. I am a descendant of German Jews. My grandfather spoke German and my family lived for hundreds of years in Germany. They didn't speak Yiddish; they spoke German, just like those big physicists who came to your country and made the atomic bomb.

So, you're right, I am the Danube; I'm the Germans *and* I'm the Jews. But I'm not the Nazi Germans, just like I'm not the Communist Hungarian butcher who destroys culture at any price or the right wing Zionist Jews on that ship who were planning to kill Palestinian Arabs because Betar ideology of settlement needed an empty land. And you're right, I'm also the German farmer who's traveling the opposite way on the Danube, but I'm also the captain who has this distant and open-minded perception. I've internalized it all.

MACDONALD: In some films you use vocal narration, as well as textual narration. Is that because the television companies that produce the videos, or show them, ask for the narration? Or are all such decisions entirely yours?

FORGÁCS: The television people never force me to do anything. I like to use different channels of information—for example, to vary the vocal and textual narrations in various ways. Often, I like to repeat them like rhymes, so that they create a certain rhythm, but also to present them in conjunction with different imagery, so that the meanings of both the texts and the images continually shift and recontextualize each other.

MACDONALD: There's an American film by the photographer Weegee called *Weegee's New York* [c. 1952]. Most of the film takes place on a Coney Island beach in 1949, and what comes across about that part of the film is that the people in front of the camera seem to assume that a holiday involves a freedom from socially required appearance. Watching the film, we learn something about how earlier generations related to the camera.

FORGÁCS: Of course, you're right, though I do think it depends on social class and on particular generations. Your mother might not do things *her* mother would do.

MACDONALD: Very true.

FORGÁCS: Basically, there's a tremendous anthropological difference between the public and private behaviors of different cultures, and there are cultural barriers between generations and between men and women. Family rituals are often different in each section of a culture. There are unanimous gestures and there are subcultural gestures. There are codes that we can read and others that we can't read. Sailors have their own codes, as do gay people. Twins have a separate language. Middle-class Jews have communication codes different from middle-class Christians.

The question is, who has the camera and who is recording what we're seeing? And how do the codes within which the filmmaker is working—in the case of my films, the filmmakers who recorded the home movies and the amateur films *and* the filmmaker who is re-presenting what these earlier filmmakers did—affect what we're seeing in what is recorded on the filmstrip?

The central dynamic in the films I work with is that the people making the films and the people in the films were never planning to be shown on the big screen here in your city. They meant to have fun, to record the fun, and to see it later. Their recording is a slice out of the constant flow of time, made from a certain angle with certain material, and then it stops. These slices out of the constant, linear flow of time are full of gaps, but the filmmakers didn't care about the gaps. On the other hand, for us, the gaps, and their meanings, are part of what gets revealed by the films once they're recycled into my films.

MACDONALD: Since we see the films differently than their makers did, we become part of the process of constructing a story.

FORGÁCS: Yes, but that's not only true of home-movie footage; we look at Griffith's or Dziga Vertov's work in a different way than we did forty years ago.

MACDONALD: Actually, I was thinking of Vertov last night during those moments in *The Maelstrom* where you switch from motion to still images. They reminded me of similar moments in *The Man with a Movie Camera* [1929].

FORGÁCS: Yes, but Dziga Vertov, Kuleshov, and Eisenstein were working to *destroy* the culture that I'm trying to *recover*. I don't see myself as an agent of the bourgeoisie, but *they* would see me that way.

MACDONALD: I went to Riga in 1991, with the Flaherty Film Seminar. There were writers and filmmakers from the various Soviet states and various writers and filmmakers from the United States. The seminar was called "Flaherty/Vertov." What was fascinating was that the American leftists at the seminar loved Vertov but were somewhat embarrassed about Flaherty (Flaherty's romanticizing of Eskimo life and his focus on the exotic had come to seem a problem), and the representatives from the ex-Soviet states loved Flaherty and seemed to hold Vertov in contempt. Flaherty's focus on the individual was what *they* wanted.

FORGÁCS: Yes, very nice. Speaks for itself.

MACDONALD: We were surprised.

FORGÁCS: Well, before you went to Riga, you should have read Orwell. *Then* think of Dziga Vertov. If he hadn't died so early, he would have been one of the censors with the big scissors.

MACDONALD: There's a depressing thought.

FORGÁCS: Russian Communism was a Byzantine religion; it had nothing to do with Karl Marx—quite the opposite. Even if Karl Marx was wrong, he *was* an enthusiastic critic of the exploitation of people. But the Soviet regime was the most exploitative form of capitalism on earth. In twenty years of building up capitalism, it sacrificed millions of people. Soviet Communism was successful in industrializing, but at an incredible cost. Of course, Dziga Vertov and the avant-garde poets were not butchers, but they *were* blindly serving the devil. It might hurt some people's feelings to say it, but Vertov was Stalin's Leni Riefenstahl.

MACDONALD: Stalin's, or Lenin's?

FORGÁCS: Well, let's say Lenin, but Lenin for me is a butcher as well. I hate these little distinctions. Half a year after the revolution, Lenin executed his leftist friends because they said, "Now, what? *This* is not democracy." He just shot them. Comrade Jerenski included. Insane.

We know that the czarist regimes were awkward, underdeveloped, Byzantine shit. But what came afterward in Russia was just like the Kampuchea Communists. What the Khmer Rouge did in four years, Stalin did in twelve. What's the difference?

And I don't like the romanticizing of Bolshevik culture in the early Russian Communist films. Technically, the films are very interesting; even culturally they're interesting. Those guys were real maestros. But I think there's also a very, very important personal responsibility not to participate in butchery, no matter what it's called. This is something Anna Achmatova and Boris Pasternak *didn't* forget. Of course, if you're a writer, you can be quiet. You can stop serving the butchers, and no one really knows. It's harder in film.

So it may sound strange to you, but for me, Leni Riefenstahl and the Russian propaganda filmmakers are *exactly* the same.

MACDONALD: I've found it particularly useful to study *Meanwhile, Somewhere* because of the way in which it surveys Europe. It provides a particularly broad sense of the terrain in which you work and helps me understand both what you're doing and what I need to understand more fully about it. How did that project develop?

FORGÁCS: After creating the first six Private Hungary episodes, I became a member of Inedit, a European association of unedited-film maniacs. This group formed as a result of an initiative by Belgian TV director André Huet in 1990; participants are makers, archivists, programmers. In 1992 a number of Inedit members decided to create a series of programs on dimensions of World War II that are not known, based on amateur films and home movies. We divided Europe into research zones. I covered Eastern Europe and the Balkans. Each of us raised money for our episode. The research took more than a year, though during the same period, I continued to collect Hungarian home movies: since 1983, I've collected 550 hours of film and transferred it onto Beta video. *Meanwhile, Somewhere* was the third part of The Unknown War series.

MACDONALD: The structure is both precise and open.

FORGÁCS: If you look at my *Wittgenstein Tractatus* [1992], you'll understand the background for the structure of the piece. I felt that the traditional, historically oriented, documentary approach would be useless for the patchwork of emotional comparison I was interested in. The lesson here was *not* to provide new information or to educate viewers on the viciousness of the war and the Nazis but to see the everyday banalities of life during wartime. To do this, I needed to mobilize the viewers' existing historical knowledge but put it to a different end.

The rondo format seemed best for this material. I couldn't find a better way to show the normally invisible side of the war than by creating a loose necklace of film poems, short stories, and moving photographs of fun and pain, taken from home movies. The result is a loose, hopefully musical combination of ephemeral and eternal human acts.

MACDONALD: The punishment of the young Polish woman and the German soldier is the central thread that holds the piece together and, simultaneously, teaches the viewer how to watch your work: those little inserts on the bottom right of the imagery school us in seeing not just what the original filmmakers might have believed they were

recording but also what is visible and readable in all sectors of the image.

Children are at the center of the video; during the punishment sequence, we realize how the punishment of the lovers is aimed at young people. It functions as a warning for anyone who might not yet have bought into the assumption that Poles and Germans must be kept apart.

FORGÁCS: Yes, the irrational light in the kids' eyes—the result of National Socialist teachings about the evil of sex between Über- and Untermensch—is painful.

MACDONALD: The theme of social class is very strong in *Meanwhile, Somewhere*. The sequences where we see the kitchen for the Jewish workers camp at Kiszombor ends with the man shitting in the makeshift latrine; then you cut to the man, woman, and child cleaning what appears to be a shithole; *then* you cut to the Drugmans, a middle-class family.

FORGÁCS: Actually, that isn't a shithole but a cistern full of muddy water (they pour it out to fertilize the garden). I did want viewers to associate the mud with shit. We wonder why the old woman, who must be a servant, goes down the hole into hell, shit, and so forth, and we see how the little girl is following granny's pattern in her play, just as the little ones in the miscegenation sequence turn the punishment of the Polish girl and German boy into play.

MACDONALD: One of the most interesting dimensions of *Meanwhile, Somewhere* is the critique it provides of conventional assumptions about beauty and about beauty in cinema. Throughout the video, the imagery is stunning and evocative and moving, not only because its subjects are poignant or sad or horrific, but because of the way you treat the imagery. I assume you added the various tints to the material during the editing stage as a way of emphasizing particular aspects of the imagery and as a way of helping us distinguish between different locations and peoples.

FORGÁCS: Most of the time, the home movie tends to capture selected, beautiful moments of life. I consider all dimensions of the piece very carefully, including not only the particular identification of people and moments (the history of the piece), and the tinting (for providing emotional tone), but the use of slow motion, freeze-frames, blow-ups; the use and design of the visual texts; and all elements of the sound: voice-over, sound effects, music. Each of these is like an instrument in an orchestra.

MACDONALD: There are also several full-color passages, including the gorgeous Breslau material that sings the beauty of Nazism and the progress of National Socialism. This is the most conventionally beautiful imagery in the film (the garden most of all) and documents the ugliest political movement–system of the twentieth century. Did you mean to confront assumptions about cinematic beauty with these images?

FORGÁCS: Yes, I did.

But let me repeat, Nazism is one of the *two* ugliest systems of the last century; Stalinism was the other.

MACDONALD: The overall impact of *Meanwhile, Somewhere* is to create a memorable picture, from within events, of the mix of the mundane and the horrific, the separation and connection of the many events going on across Europe during those years. The surrealism of modern life comes to the fore. At the end of *Night and Fog* [1955], Alain Resnais theorizes that the horrors of the Final Solution (at least in the form of other events like the Holocaust) are always occurring, often right next to the events of daily life—though they remain invisible to the willfully myopic. Through your process of recycling and juxtaposition, you reveal the workings of that process: we see people trying to maintain some semblance of a normal life, sometimes even a decadent life (I'm thinking of the golf), within the catastrophe of the war era.

FORGÁCS: My first intention with this project in 1983 to 1984 was to show my friends what I'd found in the hidden, suppressed past—the *Atlantis*—of middle Europe. My recontextualizing of home movies is not just a rereading in the Derrida sense; it's more. A moving image tells more than a text can, and in the deepest senses. There's more cultural, personal, historic, emotional, sensual experience in the films I work with than in anything but the great novels of Kafka or Márquez or Bulgakov. Working with my films, as a maker or as a viewer, is like doing dream analysis, and when you fall into my work (if you're an ideal viewer!), you fall into your *own* imagination, dreams, feeling. You realize, *all this could have happened to us*. It's not an *actor* who dies; it's *him* and *her*. It's *us*.

In a dramatic narrative film, the actor never dies, only the role. But here it's the opposite; the people die, but their *roles* as people doing mundane things continue in our lives.

MACDONALD: One of the most dramatic moments in *The Maelstrom* is when Annie is with her stepmother during that terrifying moment when

they're getting ready to be deported to Auschwitz. They don't know what we know about where they're going, of course, but it's a traumatic moment nevertheless just because they're leaving home and don't know what comes next. And yet Annie does not stop smiling and trying to make the best of the situation. She wants to defy being depressed—"They won't beat me down!" And of course, on another level, what she's doing plays right into the hands of the process.

FORGÁCS: Yes, we know the truth, and that hurts. It's all part of the game that the Nazis created to make what they were doing seem understandable, rational. They ingeniously disguised their motives. This elaborate game was especially designed for the Dutch Jews because the Dutch Christians were protesting against the deportation of the Dutch Jews, which is clear in the film. There was even a rebellion in Rotterdam where dockworkers and students stormed the city hall and burned the lists of Jews. At one point, the Germans deported thirty thousand young Dutch Jews and among them two who were in the film. Three months later the family got a letter, along with ashes, saying that their sons had had heart attacks and died. Of course, this was absurd: why would young men die of heart attacks? But it was a way of not admitting what was really going on so that others wouldn't interfere with the process. It was absolutely different with the Polish Jews; there was much less disguising of the reality.

Annie, a Dutch, middle-class Jewish woman, believes in the law. She knows that they will suffer, but why *should* she think that what we now know happened *could* happen to her, even if she *has* heard news from Germany that terrible things are happening? The working title of *The Maelstrom* was "It Can't Happen to Us." And of course I'm exploiting the tension of the double knowledge we have as we look at these people: first, as if we were there, *and* from our position decades later. It causes tremendous tension.

You were saying this morning how shocked you and Pat were when your children were separated from you for seventeen years. But in life we often *don't* see what's coming. When my first son was born, I never thought that his mother would have a complete breakdown and that I'd have to bring him up until he was six. I was a revolutionary young lad, all optimism, and then suddenly completely tied down with a kid. We think we can secure ourselves and that nothing bad will happen. I'll drive to Ithaca today, and I'm sure there will be no car accident—but who knows? It's the same with Annie packing those little things they were permitted to bring. Two socks and no more—but hopefully things will be OK.

Sometimes I work with much less tension because history also plays with us in a lower dynamic, one that can still surprise us out of our complacency. The painter Lichtenstein has this beautiful paradox: "When I went home, I was expecting surprise, and when there was no surprise for me, I was surprised."

In *The Maelstrom* you see Annie's hands packing the suitcase, brownish like in a Rembrandt engraving. The whole film is in a yellowish tone because orange is the color of the Dutch royal house: the House of Orange. Sometimes the images I work with seem like time-based paintings or engravings.

MACDONALD: How did you get the Seyss-Inquart home movies? And how is it that the Peereboom home movies survived the war?

FORGÁCS: I saw the Seyss-Inquart material in the Dutch National Film Archive in 1993, when I was making *Meanwhile, Somewhere*.

As to the Peereboom home movies, they were saved by Chris, an assistant at the Bouman's shop in Vlissingen (Annie Prins was the Bouman's stepdaughter)—you can see him washing Max's car at the beginning of the video. I think Max gave that material to Chris before their deportation to Auschwitz in 1942. After the war, Simon and Chris met by accident in Amsterdam, and Simon got the films and the projector back. Later, in the early 1950s, Simon shot some 8 mm films in the Jewish ghost quarter of Amsterdam.

MACDONALD: If you look at old 8 mm films on an 8 mm projector in your living room, that's one experience, but to see the work projected large, in video, with an evocative soundtrack is something else. On one hand, it *is* still the original thing, but at the same time, it's more than the original because, for example, you can see the texture of the imagery in a way that the family wouldn't have seen it originally. It is *now* looking at *then*, and it's *video* looking at *film*, and at times, it's still photography looking at motion photography and vice versa. The most *they* would have done is turn the projector in reverse for a joke.

FORGÁCS: Or slow it down. Or put it away for twenty years and then show it and say, "Oh! Look at father!" Or screen it every year and create scratches—from the scratches you can tell how many times a family projected a particular film.

The scratches in the Jewish part of *Danube Exodus* show that it was screened at least ten or fifteen times. There are no scratches on the

German home movies. That's also part of the story of the film. In the video version you don't see the scratches all that clearly because the material went through a wet-gate system, but still, the Jewish episode is much scratchier than the German episode.

MACDONALD: At what point does Tibor Szemzö become involved with the videos?

FORGÁCS: During the early stages of editing, I listen to a lot of music in connection with the imagery—primarily the minimalist oeuvre of previous Szemzö works, and Philip Glass, Steve Reich, Brian Eno. After months of editing experiments, I grow tired of the particular musical pieces I've been working with, but they become signposts for the kind of music that will work with this and that imagery. At this point, Tibor becomes part of the procedure—once the overall style and structure are visible. He creates a new composition for each video, working step by step, first creating musical sketches, and then, working with me, finalizing the connections between image and music.

By the time Tibor joins me, I've already added in sound effects using a digital-editing system. Of course, the final mix is supervised by a sound engineer.

MACDONALD: In your films, you create a hierarchy of filmmakers, most of whom are not even recognized as filmmakers by conventional film history, but who are often heroic and sometimes cinematically accomplished in their recording of the life around them. They are your heroes.

FORGÁCS: Yes. In *Angelo's Film* [1999], the man behind the camera, Angelo Papanastassiou—a true twentieth-century patrician, an ex-navy officer, and a successful Athens businessman—decided during the very first days of World War II to record the sufferings of his fellow Greeks and his motherland. Risking his own and his family's lives, he filmed the Nazi atrocities all through the German–Italian occupation of Greece with a clandestine 16 mm camera. Meanwhile, his daughter Loukia was born, and we follow her growth in the family. He was a courageous filmmaker, as were so many of those whose imagery I recycle.

MACDONALD: One of the problems I have as an American viewer of *A Bibó Reader* [2002]—and I assume I'm not alone—is a function of my general ignorance of Hungarian history. Of course, many Americans are often

ignorant of their own history and remarkably ignorant about the histories of other nations and regions. But I'm often puzzled about how much of what we see in *A Bibó Reader* would be immediately recognizable to Hungarians and how much would be generalized historical imagery for them as well as for American viewers.

FORGÁCS: The combination of image and text offers a cultural–historical–poetical context for a Hungarian, but the text itself is probably as heavy for a Hungarian as for anyone else.

Bibó's writings were forbidden in Hungary until the mid-1980s. I first read him in the mid-1970s, during the time when I was banned from universities, and reading him was an intellectual turning point in my life. He completely dropped Marxism, which did not explain the actual, existing socialism and its exploitation, repression, and lies, and he gave me a new view on the world. He was totally independent of the repressive Hungarian state party.

His ideas aren't popular even today, though he was *the* reference from 1982 until 1992. He's too heavy and too ethical for most people. The right wing and the Communists are equally afraid of the meaning of his writings. He is known by intellectuals but was never, and probably never will be, popularly known. But the first public screening of *A Bibó Reader* on television had 160,000 viewers, a high number for a country with a population of only ten million.

MACDONALD: The title of the film can be read in more than one way. Most obviously, it suggests a video version of a literary anthology—like *A Faulkner Reader* or *A Kafka Reader*—but in addition, your formal strategy in the tape demands a good bit of reading on our part: we read the titles of Bibó's major works, excerpts from the quotations the narrator reads, your indications of who this or that person is. Third, you are certainly asking us, as you do in all your videos, to read home movie and amateur film imagery in ways we normally don't—that is, to read past their original functions as a means of understanding the cultural history they embody.

FORGÁCS: Selecting excerpts from the huge body of Bibó's works was quite difficult, and János Kenedi, who rediscovered Bibó for us and introduced Bibó to me in 1973 and 1974, helped to create thematic knots of Bibó that can still create an impact today. This part of the process alone took three months.

Of course, for those who rarely or never read theoretical works, my excerpts provide a once-in-a-lifetime encounter with Bibó, and for those who do read theory, the tape can function as an appetizer, a special non-academic invitation and interpretation of Bibó's work.

And yes, learning to resee the found footage through Bibó eyeglasses can reveal—it works this way for me—new aspects of the home movie, new aspects of my discourse on private and public history. Specifically, these ephemeral, faulty, scratchy images can't be appreciated as simple parts of a clear, single story. Do they mean anything at all? Do they help us understand what really happened in the past? What *is* the past? What *is* my memory? And what is collective memory? Or tribal memory? And do all these forms of memory correlate with one another? What is *private* and what is *public*? Which are the official and the nonofficial dimensions of history? All these questions are, I hope, raised by this tape, and my other tapes, and feed into an interest in doing more than just blindly accepting or avoiding the realities of our own existence.

MACDONALD: Bibó seems important to you because of what seems a paradox in his thinking. He is clearly Hungarian and he sees the history of Hungary as particular, and important, to some extent, as distinct from the histories of other European nations; but at the same time, he is entirely nonexclusive: he argues for the rights and dignity of all human beings inside and outside Hungarian society and places no value on someone's being more Hungarian than someone else.

FORGÁCS: If middle Europe weren't the quagmire it is, Bibó's message could be heard more easily, but why should Bibó do better at changing society than Socrates or Camus? In fact, Bibó is so unique in Hungary that when I was making this film, I used to joke that he was an alien placed on Earth by a UFO.

I think he would be outraged by the new rise of Hungarian nationalism and the increasing Balkanization of the region.

MACDONALD: I wonder if you know the work of Yervant Gianikian and Angela Ricci Lucchi and if you see relationships between their work and yours.

FORGÁCS: We are on the same ship; we sail with the same wind, and we eat the same food, chant the same prayers. Our quest is similar and our archaeology of time is much the same.

MACDONALD: When I've spoken with Gianikian and Ricci Lucchi, they've told me that when they make a film from archival material, they're usually trying to do two things: they want to be true to that material, to allow us to see what the material was saying at the time when it was made, *and* they want their use of the archival material to be a comment on current political events. Do you also mean for your tapes to comment on current developments? *A Bibó Reader* often seems particularly germane to the United States in the post-9/11 period.

FORGÁCS: I can't see or feel their comments on current political events since their work is so meditative.

Their approach is different from mine. I don't know how to be true to archival material if you touch it with an intention to do more than restore it. Of course, one tries not to create lies, but one can use a film, or the meaning of a film, for purposes very different from whatever the original purposes were (in my *Wittgenstein Tractatus*, for example, the pig you see rolling on the ground is *not* killed or harmed, though you might assume the pig is about to be killed; the imagery was from a veterinary school documentation of a case of nerve disease in a pig). I did most of the editing for *A Bibó Reader* in the summer of 2000, so any references to recent events are accidental. It is true that there are correlations between what Bibó wrote and said and the current terrorist threats, the war hysteria, and the oversized surveillance that have come in the wake of the attack in New York.

But, on the other hand, do you realize how intolerant fundamentalist Islamic culture and religion *is*?

MACDONALD: Please forgive me for asking about two other filmmakers. Do you know Alan Berliner's films? *The Family Album* [1987] seems especially related to the Private Hungary series.

FORGÁCS: I know Alan well and like his films—especially the ones on his grandfather [*Intimate Stranger*, 1991] and his father [*Nobody's Business*, 1996].

MACDONALD: Some of what Bibó says reminds me of some of the films of your countryman Béla Tarr, especially *Sátántangó* [1994] and *The Werckmeister Harmonies* [2000]. Do you know Tarr? What do you think of his work?

FORGÁCS: He is, along with Miklós Jancsó, the great Hungarian cinematographer-filmmaker. His way of thinking about and working with time and his uncompromising vision are very important to me.

NOTES

1. Peter Nadas, *Own Death* (Budapest, Hungary: Steidl, Gerhard Druckerei und Verlag, 2006).
2. Randolph Braun, *The Holocaust in Hungary* (New York: Columbia University Press, 1981).

PÉTER FORGÁCS AND BILL NICHOLS,
IN DIALOGUE

[**2**] *The Memory of Loss*
Péter Forgács's Saga of Family Life and
Social Hell

*It is not exactly the presence of a thing but rather the absence
of it that becomes the cause and impulse for creative
motivation.*
:: Alexander Archipenko

A film about the past can be a film for the future.
:: Erwin Leiser, director of *Mein Kampf*

What follows is the result of a series of exchanges conducted primarily
at a distance by e-mail. I wanted to pursue a set of topics that revolved
around what seemed to be nodal aspects of Péter Forgács's overall work.
These topics address the representation of historical events and the spe-
cific means by which Forgács sidesteps the conventions of both historical
narratives (fiction) and traditional documentary (nonfiction). Like early
documentarians in the 1920s, in that period before the practice of shap-
ing films drawn from the practice of everyday life were commonly called
documentaries, Forgács returns to the avant-garde, modernist tradition
for much of his inspiration. Can a work that wears its aesthetics on its
sleeve bring us face to face with the reality that appears to extend beyond
the reach of aesthetic invention? Forgács's work, to me, is a resounding
demonstration of what an affirmative answer might look like.

Through the eerily effective music of Tibor Szemzö, laconic com-
mentary, titles, zooms and pans, tinting and toning, slow-motion,
freeze-framing, and oratorio (used to articulate the details of the laws
used to limit participation by the "Israelite denomination" in public life),
all in evidence in his film *The Maelstrom: A Family Chronicle*, for ex-
ample, Forgács turns salvaged images into a vivid glimpse of a lost world.
The spontaneous gestures, improvised scenes, and concrete situations

we observe were not designed as indicators of broad historical forces but as animated mementos of personal history. But the social actors in these home movies who mime gestures to each other now incite our response rather than the response of those to whom they originally addressed themselves. Forgács, the archaeologist-cum-salvage anthropologist, conducts a séance in which these figures serve as mediums through whom we see and hear the voice of times past speak again today.

◂▬▬▬▬▬▬▬▬▬▬▬▬▬▬▬▬▬▬▬▬▬▬▬▬▬▬▬▬▬▬▬▬▬▬▬▬

Corresponding with Péter

BILL NICHOLS: The world to which you return us in so many of your films is the world of middle- and upper-class Jewish life in Hungary and other parts of Europe [these were the classes that could afford to make home movies] during the rise of Nazism and the harbingers of the Holocaust to come. Every frame of footage possesses the aura of a rare artifact. Zoltán Bartos, for example, compressed his life from the 1920s to the mid-1950s into a total of nine hours of film. You compress this into *The Bartos Family*, a sixty-minute film. What gets left behind? How much more do you become a member of the family than we do? Is it important that much of your archive comes from non-Jewish, as well as Jewish, families?

PÉTER FORGÁCS: It's always intriguing to imagine how somebody else would create a totally different cinematic meaning from the same stuff, and luckily the Bartos collection was in the hands of two filmmakers: Gábor Bódy and Péter Timár prior to my acquisition of it. Their inspiring approach in *Private History* [1978] emphasized the burlesque aspect of the Bartos' lives and expanded the boundaries of a found-footage collage. The in-depth interview with the last from the old generation, Klári, the widow of Ödön Bartos, clarified the family dynamics and gossipy aspects of their lives. When I took this first voyage, thanks to the film by Bódy and Timár, it made me a participant-observer on their anthropological team and put me into intimate contact with the Bartos family.

When the actual home movies fell into my hands it was a cathartic moment as I watched the small, jumpy images in my little office. Hungary blew my mind. The first feeling was a certain presence of a demon—my demon, the demon of the speaking Socrates: I know this is what I am going to do from now on. It was like the writer Gabriel Marquez's description of writing *One Hundred Years of Solitude*. He said that before he wrote a single page, he had envisioned the entire body of

the novel while driving down a long valley in South America. The second emotional and magnetic touch of this little private viewing was a mysterious and almost telepathic feeling of being a coroner. *All of them*—the personae appearing in this cinematographic image—*are dead*, and I am alive, perceiving here, in my local time, their past as a presence. It is their past, but at the same time, it is seemingly present.

NICHOLS: Your overall oeuvre does not focus exclusively on life before the Holocaust. In films like *Kádar's Kiss* you stress that a pornographic form of oppression continued for many of the inhabitants of Eastern Europe long after the Allies achieved victory over the Axis powers.

FORGÁCS: In only five of [the] twenty films of mine are the subject-heroes a Jewish family or tale, story. As a consequence it is more true to say *Christian and Jewish* families. The Christian Hungarian and the Jewish Hungarian middle classes suffered from Communism. As you know the sufferings of the two social groups is radically different, during and after World War II. Two-thirds of Hungarian Jews were gassed, tortured, and plundered in 1944 to 1945. The survivors had to live through the Communist oppression; the wealthy had to endure Soviet-style nationalization—they lost the remnants of their fortune. The plundering and oppression of the Christian middle and upper classes began with the first Soviet boot on Hungarian soil in 1944 and lasted almost until the fall of the Berlin Wall.

NICHOLS: I experience your films as a gift, an unexpected act of generosity or love, that establishes a relationship beyond obligation or duty. It is perhaps less a form of righteously bearing witness than one of discretely acknowledging the loves and lives of others. You do not recount atrocities or mount indictments so much as bring something very precious and almost lost back to life. But the films are also, inevitably, an act of hate. The hatred streams toward those figures and forces that brought an end to an entire way of life and its complex fabric. You single out killers like Reich commissioner for the Netherlands Arthur Seyss-Inquart, whose own home movies (of his wife and children, his estate and horses, his tennis court and games with Himmler, culled from the Royal Dutch Film Archive) you weave into *The Maelstrom*. You recount the heinous laws of exclusion promulgated by Seyss-Inquart in the Netherlands—in voice-over commentary, subtitles, and sometimes in sung oratory—laws that stripped Jews like the Peerebooms of the rights of citizenship, the very same citizenship to which their own home movies are such exuberant testimony.[1]

What about these laws? How did you choose to include them in the film? They have an oddly rational air, in the highly bureaucratic sense of trying to specify every possibility and to offer the hope of exceptionalism—that others will be affected but that *I* will remain exempt due to my profession, war service, medals . . .

FORGÁCS: I think *The Maelstrom* film could never have been born without the *Free Fall* [1996] piece. You mention the paradoxical feature of Jewish laws; they are even more nightmarish in *Free Fall*, as the Petö family's life goes on seemingly undisturbed while their social and human rights are *gradually* strangled. The complex history of assimilation and the economic role of the high and rich strata of the Hungarian Jews *demanded differentiation and selection* by this hypocritical legislation. It occurred in four stages between 1938 and 1944. When Eichmann strode onto the Hungarian stage, it became simple: no differentiation, just *final solution*.

Dutch society's resistance demanded a different Nazi psycho-script for that stage: the gradual introduction of Jewish laws [1940–1943] and the perfectly camouflaged *separation, plundering, and extermination* of the Dutch Jewry. This script was the masterpiece of Seyss-Inquart. This irrational abuse of law introduced a new terror in the context of war. The real provocation in both films for me was how to represent, how to tinge the *inner* experience of a Dutch or a Hungarian Jewish family during this period.

NICHOLS: Your quest for the inner experience seems to revolve, in part, around the discreet selection and placement of specific images. There are few of the iconic, unforgettable, larger-than-life type images that are so prevalent in histories from above and in photojournalism. Instead you pick and choose from the detritus of the everyday. You select shots that at first glance appear to be throwaways but that reverberate with overtones.

We encounter scenes in *The Maelstrom*, for example, that are like ruins or fragments, from which you construct new meanings and warnings. We see Max Peereboom's own footage of the construction of his and Annie, his wife's, home in Vilssingen, but the footage now appears in a story of a different order.

FORGÁCS: The footage fits into so many categories that it demands a dynamic *explanation*. First of all, it's a miniature film essay by the proud Max: his wife's stepparents are building (financing) a whole, big family house for them! (Annie was adopted as a poor child at age ten or eleven by the Boumann couple because they didn't have children.) So it is a dream of dreams for Max and Annie.

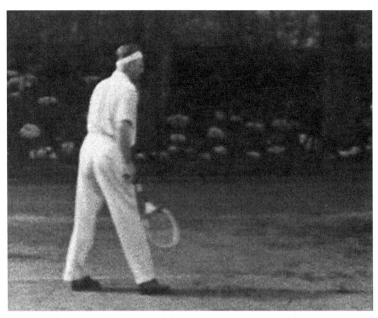

Figure 2.1a *The Maelstrom*. The film juxtaposes the home movies of the Peereboom family and the Seyss-Inquarts. An Austrian and early supporter of Hitler, Seyss-Inquart became Reich's commissioner for the Netherlands, the highest civilian authority.

Figure 2.1b *The Maelstrom*. Seyss-Inquart's partner in tennis, and in crimes against humanity, is Heinrich Himmler, who as Reichführer-SS was the head of the SS and responsible for carrying out the mass extermination of Jews and others.

Second, it's a brilliant occasion for Max to film the construction of a Dutch citizen's house—the site, the workers, the constructor, the family visit, and the working process. Third, it's also a record of the small moments of relationships: the mother-in-law lays a brick, clever movements, the hand shaking (meanwhile the constructor pulls Annie in the background), the cigar given to the foreman. . . . All of it flashes before me as a dynamic, psychological, multileveled structure in a time-based art. And in the wider range of storytelling possibilities, it serves as the building of the nest; it prepares the space for family expectations; it happens before the birth of their little girl, Flora.

The marriage-house-children plan, as a frame, makes their happiness. For us today, here and now, with our historical knowledge, we add an unforgettable and unforgiving dramatic perspective: the invisible shadows over their happy moments. This happy moment conjures in our mind other constructions as a deep undercurrent of unconscious expectations: torturous death in a gas chamber, an undercurrent hidden at this film moment to the future victims. It is therefore never realized, made visible, in my films.

This is not to say much about scenes as sources of fact, but it may explain the structure of a spiraling maelstrom: at which sequence, which episode, do you realize the swirl; when do you start to become anxious and feel their end?

NICHOLS: Your films revolve around the classic rhetorical figure of catachresis: they wrench meaning from home movies, from moments of everyday life that contest the notion of history as a national theater or grand stage upon which only the great or mighty strut.

FORGÁCS: Memories of the Bartoses are part of a collective Hungarian memory. Their life models a microcosm of life through a century in a nutshell. History is dynamic and tragic: the fall of the Hapsburg *Kaiser und König*, the revolutions and counterrevolutions, revanche and revisionism. Hungary as Nazi ally and later the victim of a *Totalen Krieg*, the Soviet liberation-occupation, and the revolution of 1956. After thirty-three years of pink Communism the Berlin Wall fell. The twentieth century happened between 1918 and 1989. The large *curtain of public history* provides the background for the Bartos family saga.

NICHOLS: A paradoxical form of speech seems to arise in many of the films in which what went unnamed and forgotten becomes the crux of an act of historical remembering. You resurrect what lies on the verge of total

loss and instill an awareness of historical consciousness per se more than a didactic perspective. Your films are not a documentary representation of national culture or indigenous Jewish or Christian life in the strict sense (they withhold facts; they confound assumptions). They are not a metaphor for symbolic loss (the lives we see remain anchored in their own specificity). They are not a deconstruction of types and stereotypes others have given to the period, its monumental war, its horrific genocide and numerous victims (this you leave to others). They have a strongly both–and quality as being both of the period and about the period similar to Esther Shub's compilation of archive footage into works such as *The Fall of the Romanov Dynasty* [1927].

FORGÁCS: I really love these scratchy, old films; this is a strong motive in itself. Hard to put it in words, but if you allow me, these are the rules of my patchwork game. First, no tautology of meanings, and no use of facts as illustration in the work. Second, find what is the magic of these unconscious home film strips, the magic of recontextualizing, layer after layer, to feel the graphic intensity of each frame. Third, I want to make films for my friends, the reference group: "Look what I've found for you" while I peel the source material to its roots. Fourth, do not explain or educate, but involve, engulf the viewer as much as possible. Fifth, address *the unconscious*, the sensitive, unspeakable, touchable, but mostly silent part of the viewer. Sixth, let the music orchestrate and *rule* the emotional story. Seventh, I had to learn how to hear my own *low inner voice*, the guide of creation—if I can chase away, or reduce, the noise in the channel.

 In general, the twentieth century's film languages have become enormously varied and sensitive, but the didactic documentary resides at some distance from the heights of this achievement. It is mostly part of the educational, entertainment wave, planning for infantile expectations. The general landscape of docs is awful, as it was always. Of course the commissioners and programmers are in the pincers of the media. With few exceptions I can't stand docs. I prefer Kienholz, Duchamp, alchemy, and psycho-archaeology.

NICHOLS: You reassemble aspects of an image repertoire that might have represented Jewish life and Hungarian culture, had it survived. This life and culture is a structuring absence that now speaks through you, perhaps more as a clairvoyant than a documentarian. If the home movies' makers adopt a posture something like "I speak about us to us," you provide a simultaneous overlay of something like "I speak about them to you." We feel we are onlookers—poignantly and erotically, for example,

when György films his fiancé, Eva, bathing and then disrobing in their bedroom, her eyes turned toward the camera and the man, her lover, behind it—as well as participants in your own effort to reframe their precious moments of private reverie within the historical context that will engulf them.

FORGÁCS: A short meditation on privacy, intimacy: The key to this genre is the paradox of a gentle viewing of the *forbidden, the taboo, even if it's an unimportant event, even in the framework of home movies*, just a smile. I seek a procedure to transfer toward a metaphysical level the banality of existence.

We are allowed to see, look under the pants, visiting the film diary of the anima and the animus. We observe the home of a local inhabitant, as the filmmaker is both witness to and naïve anthropologist of his or her own life. Don't forget we are in the realm of banality. The banality of selected life facts shines on the border of the public and private.

Our current, unlimited media transmits and creates hunger for the showbiz stars' privacy and for media-made heroes, but this is relatively new. I mean the limitless TV service of *peeping*. The visible bed secrets of dad and mom are rare in home movies. Much more often one sees *just* the first steps of the baby, but those can be as intimate as the bed-secret stories—the meaning of intimacy is quite relative.

Clinton's Oval Office cigar phantasm[2] breaks with historic limits; it dovetails with the wide-ranging exhibitionism of public performers who serve the customers' immeasurable hunger for what's behind the curtain. The rules of privacy versus publicity changed radically only in the last quarter of the twentieth century. Prior to this era religion, laws, common sense . . . the canter-*Taliban's* ruled life. For example, compare the length of the sixties' miniskirts to the length of these women's great-grandmothers' skirts. . . . The home movies represent a different world.

These recontextualized home movies—like Mr. Petö's—aren't planned for the public's eye. By saying Private Hungary, I am opening these capsules for the public eye. It is like lighting a cigarette in darkness: you see the smoker's hand and face for a few seconds; it becomes a vision we imprint, a secret. The other edge is the Peeping Tom's voyeuristic attitude: it reveals the torture and exploitation of the victim. Another aspect of intimacy in relation to these home movies is the collage technique, as the classic de- and recontextualizing process. The metaphysical level of meaning calls for the freedom to touch, alter, edit, combine, and readjust the original meaning toward a new context. Finding the images behind

the surface. All three aspects are embarrassing and alluring at the same time. How can I open up the private and intimate, not-for-public-eyes footage to a larger context? The psychoanalysis of film diary notes. I have to stay gentle to keep my distance right.

NICHOLS: Your films have many distinctive qualities, most notably their highly evocative reconstruction of artifacts in an ironic, modernist key. What are the models from which you work? Are modernist authors like Woolf or Joyce instructive for you in any particular way? What are the conventions you systematically shun, and why do you do so?

FORGÁCS: Joyce's method—a twenty-four-hour-per-day habit—was collecting words, colloquialisms, and language games. The concrete existence of a *real* Mr. Bloom at the Sunday market that we see in *The Maelstrom* links up, for me, with the Joycean Mr. Bloom.[3] The fiction, transferred back and forth with reality, marks *The Maelstrom* here for some Joyce readers. [It is] a real Bloom, transformed by allusion to the fictional one: documentary as fiction and fiction as documentary. Buñuel's *Land without Bread* (*Las Hurdes* or *Tierra Sin Pan* [1932]) proves the author's effort to create a fact—known to him—for the film. It is a fact, but it might not have happened in this specific way without the director's intervention. Reality is *created* for the film: they killed a goat to represent the Spanish rural drama. The smoking man's factuality in *The Maelstrom* is a *metaphor* for the year 1939, and Buñuel's goat sacrifice is a *fiction* that became the *reality* of Spain. The converse way of working is also possible: Jay Rosenblatt's extraordinary films such as *The Smell of Burning Ants* [1994] or *Human Remains* [1998] come to mind: amateur and archival footage becomes the fiction of an inner reality.

NICHOLS: Your films are not history from above, nor are they history from below. We see no concentration camps, no smoking chimneys, no Jewish ghettos or grinning Nazi doctors. Portents for us—foreboding signs of ominous destruction—are just another element in the stuff of everyday life for the original subjects and makers of these films. To watch Bela Liebmann, a noted photographer, in *Free Fall*, for example, mug for the camera while performing demeaning manual labor for the Volunteer Labor Service, a noncombat unit in which Jewish men were forced to serve during the war, brings a cringing pain. We watch other members of the unit playfully pretend to beat up Béla Liebmann while one of your titles informs us that the Nazis shot one of his friends, Bandi Kardos, four years later.

FORGÁCS: I met the ninety-six-year-old Béla Liebmann in 1996; he was the sole surviving source of information on Petö's generation, and an extremely rich source at that.

The innocent events become tragic signs for us now, as we are wise to the past (we possess *historic* knowledge). The home movie offers advantages to the historian. We have a retrospective *power* toward the past while we feel a powerless angst or tension toward our own unpredictable future. The played beating became more than cruel reality later for the Jewish Labor Force unit members on the Soviet front. The imitated playful brutality predicts the forthcoming sadism. The psychodrama of the *would be* is a predicament of hell. Keep smiling, it could be worse. . . .

NICHOLS: One of the most striking aspects of your style in this respect is the texture and density you wrest from relatively minor moments. Especially notable are throwaway transition shots, such as the brief shot of a man lighting a cigarette in front of the Amsterdam train station in *The Maelstrom*. We never see this man again, but the shot lingers in our minds, despite its apparent insignificance.

FORGÁCS: My smoking man [a shot in the film] film fragment (archive collection fragment) is like a signifying note on the abstract patchwork surface of a film-time game.

It's an ephemeral moment, indifferent, innocent, and yet the man is also a poetic figure, unintentionally, spontaneously walking toward the camera. The extended seconds of a lighting ritual, the smoke, *and the 1939 sign in the upper-right part of the main railway station together.* A moment of a dramatic year that an average family filmmaker would not appreciate but that a nouvelle vague filmmaker would some twenty years later. We know immediately what the date means, but the smoker does not foresee (in his local time) the historic time. Why can't we warn him and the others? This is a powerful motive and gives an uncomfortable feeling for the viewers.

It is like the suspense of a Hitchcock film. We know ahead of time that the innocent victim will fall into the hands of the killer. We want to warn her/him: Watch out! And our palms are sweating. We can't help, and here—in my films—it anticipates real blood, real suffering. We always have that in mind even if we never see it in my films. Our feelings aren't like after a Hitchcock screening; when lighting a cigarette, we know it was (just) a play. . . . And, of course, the film hero never dies in fictions . . . even while playing dead. On the contrary, the heroes of my

Figure 2.2a *The Maelstrom*. An anonymous figure in front of the Amsterdam train station in 1939.

Figure 2.2b *The Maelstrom*. As the man lights his cigarette and moves forward the numbers "1939" go up in smoke, metaphorically. Forgács chooses this random moment for its evocative power.

films, if you learn they'll die, or have died already, you are deadly sure it's a real thing.

NICHOLS: Your films use techniques of compilation—as filmmaker you shoot *nothing*—but do so to construct a view of the historical past that differs from so-called true historical narratives.

FORGÁCS: The home moviemakers shoot nothing, too, in the spirit of Sartre or Heidegger when they speak of the nothing, like the ephemeral, ambient, pastime nothingness of ordinary life and banalities. It is intriguing to see the tension/contrast between the important, exquisite, excellent, historical event horizon (visualized by newsreels, fictions, docs, reporters) on one side and the nothingness of banalities on the other—private Hungary, Holland, etc.

NICHOLS: Your own voice is very prominent in an indirect way, not only in the editing, tinting, reframing, voice-over commentaries, and titling, but also in the music that Tibor Szemzö composes for all your films. Could you elaborate on how you and he work together?

FORGÁCS: I met Tibor in 1978, when a member of a minimal musical ensemble asked me to be narrator (*recitivo*) to a Frederic Rzewsky piece, *Coming Together,* in English. Tibor was the founder of the Group 180 and I participated in different pieces for eight years. We performed together as well from 1983 to 1984 as a happening performance duo, and the whole idea of found footage and minimal music grew out of several stage performances (tour cities: Frankfurt, Budapest, Vienna, Cologne, Amsterdam, The Hague, Linz . . .). As a result we had already a common experience and a film-music language when by accident I received a grant in 1988 to make *The Bartos Family* and the next three Private Hungary episodes.

From the first day of editing I use already-existing music (mainly Szemzö, then Glass, Eno, or Monteverdi) to search and edit the silent cinema's rhythm and subconscious. This first-round choice is a tool and finally it becomes, after quoting and altering, a part of the collage. It offers guidance, like a street sign. Then Tibor enters into the project after I have a good rough cut; the structure and melody of the movie is there. The music street signs—integrated with the sound effects—express the *attitude* of the work in progress and provide guidelines for Tibor. He first creates sound models to accompany the image. After readjusting with the piece I can change the corpus, the dynamics. So we develop the image and

music in a permanent interaction, and we continue this way until we are satisfied.

NICHOLS: You provide incendiary hints of location and context that could subsume the particular in the general, in a historical narrative, and reduce it to illustration, for example, but you refuse to complete this gesture by spelling out a general history or by drawing a history lesson. This reduction is what I experience in most historical reenactments like *Schindler's List*. In a reenactment like Spielberg's every moment and every camera angle onto every moment serves to advance the narrative with the optimal degree of thematic resonance, character development, and suspense. The impression of authenticity, which persists with the delicacy of a butterfly wing in your films, evaporates into drama and allegory.

FORGÁCS: I have little to say on *Schindler's List* . . . as we find ourselves in the quagmire of the attribution of meanings.

The sentimental attitude is a resistance to the unbearable reality. Let us use the remarkable representations of Primo Levi, Jean Amery, Tadeus Borowski, or Imre Kertész for our comparison. Immediately it becomes clear to us that the *sentimental*, happy-ending, industrial, trivial, but successful approach covers with tears the dry fact of the existence of the inconceivable. In film our yardstick should be *Night and Fog* (*Nuit et Brouillard*, 1955) by Alain Resnais and *Shoah* (1985) by Claude Lanzmann.

To me the Holocaust-film industry, Shoah-kit interviews are dreadful examples, and most of these films are on the other side of the river. This goes back to the function and attribution of *meaning* in my films. A normal filmmaker does not like scratchy, decomposed, meaningless, amateur pictures (= bad). If they use archive footage at all it must be—with rare exceptions—crisp and clear to *illustrate* a fact, a place, a person. Even when a doc displays a character as an illustration of his or her suffering, they still *illustrate* themselves. We may presume they are *really* a self, a historical individual, but no, they are just imitating themselves. And in amateur films although individuals play themselves the mistakes, the bad images somehow relieve them from the scheme. So the signifier self—the self as illustration or generalization—is not a real person but a replacement for one. In *Schindler's List* the red-coated little girl in the Krakow ghetto *plays for the coat* . . . the girl herself is there to illustrate a metaphor. In my films, *The Bartos Family*, for example, I'd say Mr. Bartos is a concrete Bartos for family use (in terms of the footage as home movies), on the one hand, and for us he represents a man who went through this

and that in his own individual way without providing service as a symbol or metaphor, on the other hand. The story has a concrete and a substantial meaning at the same time.

NICHOLS: Your interventions allow us to *see* the roles in which we are cast whether we are aware of them or not. Individuals portray themselves in their home movies as they think they are or as they wish to be seen, but you complicate this representation by suggesting how others see the same individuals, often in the most instrumental and dehumanizing of ways.

FORGÁCS: A Bartos is not playing a Bartos, but eventually he or she will become a Bartos, and perform different roles in his or her own life script according to the different situations and scenes. The role of the citizen and the *citoyen* are, eventually, parts of a larger frame of roles we act. We are sons and daughters of our parents (till the end) and lovers and fathers, later grandfathers and grandmothers, and by social strata we are employers and employees, the voter, the consumer, the lover, the man and woman of secrets and dreams. . . . These are all roles, and we transform through one single day from one to another. The Bartos life script, like that of the other families in the other films, offers much more than an average home movie. It is a detailed and varied account of times and spaces in the roaring twenties and thirties in Hungary, the matrix of private and public histories.

NICHOLS: When you began assembling these films and working with the survivors of the filmmakers, what prompted you to refrain from making use of their own commentaries or those of family friends in the films themselves? What led you to use speaking or singing voices largely as a way to reiterate, verbatim, the anti-Semitic laws that were enacted by the Nazi regime?

FORGÁCS: I want to keep a minimalist attitude throughout the piece. I want the vision, the message, on all its levels and in its appeal to all the senses, to move you, along with the music, text, and image as well. Too many readings (subtitles) would ruin the fluxus, the whole float. In the editing process I position the subtitles and intertitles, I put them in and take them out, try a thousand times, then show it to others (friends, advisors, the *virgin* eyes) and listen to their reactions: the trial-and-error game.

NICHOLS: Barbarism exists at the boundary between brute, physical occurrences and plotted, historical events. It appears beyond the pale of

comprehension, beyond the realm of socially acceptable practice. This is the alibi we adopt to drive it from our midst. And yet if the barbaric is the work of others like us, if it belongs to the historical record rather than to occurrences of nature, we need the means—the voice, the form, the ethical stance—to represent it as a (dark, abominable) aspect of our own history rather than as a calamity outside of it. Your personal perspective provides such means. Despite the arguments of some that the recognition of such a voice detracts from our attention to the raw historical facts themselves, this personal sense of authorship and style seems absolutely vital if barbarism is to have a human face.[4]

FORGÁCS: On the larger scale of our present time interests and needs, is our motive to decipher in the films of a private past our historical sentiment? What is behind the background of our motives, our historical drama, of the time tour? Does the historical-archeological substratum reveal itself for today's viewer only, or will it show *other* meanings for other ages? Will other viewers decode the historical relevance by different signifiers, with or without sentiments like ours?

NICHOLS: You do not seem intent on demonizing Seyss-Inquart or Eichmann, who did so much in the final year of the war to transport Hungarian Jews to their deaths, although their actions clearly attest to an unspeakable, unfathomable moral blankness within. Hatred for the barbarism of Nazis such as these is certainly deserved, but I want to ask you if forgiveness is also possible, or important, for you. Jacques Derrida has made the bold argument that forgiveness need not depend on a request for forgiveness, on an act of contrition, but that forgiveness only fulfills its radical purpose when it forgives the *unforgivable*.[5] In doing so, forgiveness carries us beyond revenge and beyond the realm of law into an utterly different domain. Does forgiving serve to move us beyond the law and the duty it has to the preservation of the state? Is it something needed by the forgiver as much as by those forgiven?

FORGÁCS: Creating, comparing the incomparable duet of the German-Jewish exodus in *Danube Exodus* was revelatory for me. I found myself contrasting the Bessarabian German refugees' saga (indeed, many of them were later recruited to the Wehrmacht) with the happy Jews destined for Palestine dancing on the ship. Altogether it was a constant inner struggle for me. I was learning the acceptance of civil sufferings, even if it was German suffering. Although the story of the German refugees allowed me to use a different light on this historical moment, the two stories mutually

reflect and contextualize each other. So the Germans' sufferings and their forced exodus from Bessarabia underline the impossibilities of all inhuman atrocities. This saga invites nonselective forgiveness. For many years revenge justified the idea of hell for all Germans, but it's clear now: in human-rights questions there aren't differences of value among nationalities and races of man.

NICHOLS: The personal quality of your films, like the personal quality of the home movies on which they are based, turn us toward the authorial self. Roland Barthes, Hayden White, and others have stressed the centrality of a different, intransitive, or middle voice. This form of representation "becomes itself the means of vision or comprehension . . . a doing or making rather than a reflection or description."[6] "The subject is constituted as immediately contemporary with the writing, being effected and affected by it."[7] In other words, the author, as well as the viewer, is put at risk. We encounter an order of experience that possesses transformative power.

FORGÁCS: My emphasis is basically to guide you through—not only intellectually but also emotionally. Therefore, the meticulous but short selections from frustratingly lengthy laws and decrees are for your sake. To give enough time for the meditation over and over again, the subtitles are all part of the complex *palette* that grabs your guts, and maybe the second time you discover another, until then invisible layer. And, yes, I can say this staccato mode of information, this lack, black hole, the info blackouts function as in certain opera (*Lulu*, Bob Ashley's video operas, or Philip Glass and Bob Wilson's *Einstein on the Beach*), contrapuntally, yes. . . .

NICHOLS: As collage-like structures with musical forms, your films evidence a *work* of representation that refuses the realist conventions of classic modes of historical discourse. Realism provides no sanctuary; narrative offers no closure; characters achieve no resolution; they leave the end unstated and unachieved. That element of the story remains up to us. Are these films not a way for us to encounter the past not only with an intensified sense of the profundity of loss—both at the hands of the Nazis and, later, at the hands of the Soviets—but also with a restored sense of perspective? Can you say what aspects of that restored perspective seem most crucial to you?

FORGÁCS: "The banality of evil," as Hannah Arendt put it, is a very important feature for our times in light of xenophobia on one hand and the *commercial Shoah representation* on the other. The good father, the

loving husband, the horse-riding gentleman, the best grandfather—the mild, vegetarian, puritan, Austrian petit bourgeoisie (Seyss-Inquart)—is a cold breath near our neck. We can almost touch him and his *liebe Frau und so weiter* [Dear wife and so on], so it helps us to imagine—feel—the beast as a person, as a human being. It helps to understand (appreciate) the parallel stories of the Seyss-Inquarts and the Peerebooms, with different life finales for Seyss-Inquart's little Gundel and the Peerebooms' little Flora and Jacques Franklin, who was named after Jean-Jacques Rousseau and Franklin D. Roosevelt.

NOTES

1. Arthur Seyss-Inquart stood trial at Nuremberg and was executed as a war criminal at the conclusion of the war.
2. This is Péter Forgács's term for Clinton's relationship with Monica Lewinsky.
3. Forgács marks the brief appearance of this individual with a title that provides his name but no further contextual information.
4. Berel Lang makes this argument, for example, in his essay on the representation of the Holocaust. It is a variation on the dictum attributed to Adorno that after the Holocaust, representation is impossible. Any sense of style or voice can only work to contain or compete with the abominable audacity of the actual facts and deeds of the case. Since you do not address the Holocaust directly, you might claim an exemption, but Lang's argument—directed entirely at written accounts—stresses the location of the author in a post-Holocaust environment that would seem to make the representation of Jewish life and culture in a pre-Holocaust moment equally open to criticism. I clearly do not agree with Lang. See Berel Lang, "The Representation of Limits," in *Probing the Limits of Representation*, ed. Saul Friedlander (Cambridge, Mass.: Harvard University Press, 1992).
5. Jacques Derrida, *On Cosmopolitanism and Forgiveness* (London: Routledge, 2001).
6. Hayden White, "Historical Emplotment and the Problem of Truth," in Friedlander, *Probing the Limits of Representation*, 48.
7. Ibid., 49.

Part II The Holocaust Films

ERNST VAN ALPHEN

[3] *Toward a New Historiography*
The Aesthetics of Temporality

Since the 1990s, the spread of memory practices in art and literature has been enormous. These memory practices manifest themselves not only around issues such as trauma, the Holocaust and other genocides, and migration but also in the increasing use of media and genres like photography, documentary film and video, the archive, and the family album. These memory practices form a specific aesthetics. The major question raised by this flourishing of memory practices is, should we see this as a celebration of memory, as a fin de siècle, and in the meantime a debut de siècle, as an expression of the desire to look backward, or, in contrast, as a symptom of a severe memory crisis or a fear of forgetting?

Either way, this art practice so typical of our moment may point to the meaning of the present itself. Home movies form a particular genre, and as a genre they have specific properties in relation to memory. The genre focuses almost exclusively on the personal. The societal dimension of human life only figures obliquely, if at all. We get to see anniversaries, weddings, family outings, the birth and growing up of children. These personal moments in the life of families are restricted because they are selective on the basis of a specific criterion: they consist of memories of happy moments. But as Forgács points out in an interview, the home movie is personal in yet another way. It is structured like a dream. In the case of old home movies, it is exclusively visual. There are no words spoken; there is no voice-over. Visual communication is the only medium. Moreover, it contains many strange ellipses.

If Forgács is right in this view of home movies as analogous to dreams, Freud's explanation of the dream is also extremely relevant for an understanding of home movies. Take his film *Maelstrom*, for example. Although the macrostructure of *Maelstrom* is narrative, if you look at the fragments of footage, they are not so much telling as showing. For

this reason, I contend that the footage does not have the form of a family chronicle but of externalized memory. This shift is best explained in terms of temporality.

Whereas home movies are almost exclusively concerned with personal time, Forgács's montage edits the key moments of history into this personal temporality. History is present in *Maelstrom*, albeit necessarily in a decentered way. For example, the home-movie footage of the Peereboom family, the main archival source for *Maelstrom*, shows a visit of Queen Wilhelmina with Princess Juliana to the town of Middelburg; another fragment shows the celebration in Middelburg of the fortieth anniversary of Queen Wilhelmina's reign. When taken as personal, private footage, the fact that the family filmed this can be read as symptomatic for their assimilation into Dutch culture. They identified with the strong attachment to the Dutch royal family. But there are other insertions of history, and these are performed by the hand of the director. Sometimes we hear a radio broadcast, or there are titles or texts written on the screen pointing out to us in which historical moment the filmed family footage is embedded. At other times, a disembodied voice explains the historical moment. A voice chants in the mode of a traditional Jewish song the laws, rules, or articles proclaimed by Arthur Seyss-Inquart stipulating how to kill warm-blooded animals, regulating who is considered Jewish and who is not, stipulating what the Jews who were going to be deported were allowed to take with them, and so on. Whatever device Forgács uses to insert history, historical time is never part of the personal time of the home footage but always superposed, *imposed*, on it.

Characteristically, however, the imposition of history on personal time never works smoothly. As a result, the completely different temporal dimension of the home footage again and again strikes the viewer. Personal time and historical time are in radical tension with each other. We expect to see traces or symptoms of the dramatic history of those days in the home-movie footage. But we do not. While the history of World War II and the Holocaust progresses, the home movies continue to show happy family memories. But what does "happy" mean?

That "happy" is a slippery notion becomes clear when Max Peereboom films the moment that his family prepares for deportation to Auschwitz. First of all, it is remarkable that he decided to film this at all. We see his wife, Annie, and her stepmother around the table repairing the clothes they want to wear or take with them on deportation. They drink coffee and Max smokes a pipe. It is not the footage that conveys what they are doing (preparing themselves for deportation) but a written text imposed on the footage. What we see is a happy family situation. Nothing of the

history that will victimize them in such a horrific way is able to enter the personal realm of the home movie. This separation of the two domains is visible because the temporal dimension of the home movie does not unfold as a collective narrative but persistently as a personal narrative. In *Maelstrom* personal history is not represented as part of collective history, as synecdoche of historical time; it is in radical tension with it.

In her essay on Forgács's work, Kaja Silverman argues that his films are based on strategies of repersonalization instead of objectification or categorization.[1] His films evoke the phenomenal world: they are about vitality, enjoyment, and activities such as dancing and playing. Whereas the archival mechanisms of objectification and categorization strip images of their singularity, Forgács's archival footage keeps insisting on the private and affective dimensions of images. Silverman writes that this is first of all achieved through the many direct looks with which people face the camera. This seems to be a defining feature of home movies as such.

When people face the camera in a fiction movie, this kind of look is self-reflexive; for a moment it short-circuits the fictionality of the film by establishing direct contact with the viewer. The film shows its constructedness. In home movies the frequent looking into the camera is of a completely different order. Here, there is no clear distinction between the camera and the person behind the camera. *Maelstrom*, as well as *The Black Dog,* contains many examples of that interaction. Simon, the youngest brother of Max the filmer, makes fun of Max the cameraman again and again, making funny faces before the camera. He does this not to spoil the film but to make the cameraman laugh or to make him angry. His funny faces function within an affective relationship between two human beings.

There is another extreme example of this in *Maelstrom*, this time of a different order. At one of the many weddings, the two- or three-year-old daughter of Max and Annie is being filmed. When she turns her face to the camera, she expects to see the face of Max, her father, or one of her relatives. Instead she sees a monstrous object, namely the camera. She is clearly utterly terrified. In this negativity, this example shows that people in home movies are not posing for the camera but for the person who holds the camera. They let themselves be filmed, not to be objectified into a beautiful or interesting image, but out of love for the person who films. According to Silverman, people in home footage convey Roland Barthes's idea not only of "this has been" (*ça a été*) but of "I love you."[2]

Barthes was talking about still photographs; like Silverman I am discussing moving images. As Forgács explains in an interview, there is a fundamental difference between looking at a photograph and watching moving images. He intensifies this difference by his manipulation of film

time, by slow-motion or even stopping the moving image, reducing it to a film still:

> The slow-motion technique and manipulation of the film time, the movement and the rhythm, give an opposite dynamic or an opposite possibility than in the example of the photo explained in *Camera Lucida* by Roland Barthes. The frozen photographic second of the Barthes' thesis is a good example of why the photo is a tombstone, whereas the moving image is not. . . . If we made right now a black-and-white photograph of ourselves, we could observe the event as already-past time: history. . . . But while we have moving images of the past, we always have the fluxes of life, the contrapuntal notion between Barthes's photo thesis and the movement (= life) on film, which proves forever that we're alive. So my viewers—and you— know that they (the amateur film actors, my heroes) are physically dead, but they are still moving. They are reanimated again and again by the film.[3]

Hence, the effect of repersonalization brought about by Forgács's films is not only the result of the specific genre of home movies but also the result of his intensification of qualities of the broader genre of the moving image as such. His manipulation of moving images—slow-downs, movement back and forth, the stopping of the movement for a few seconds—creates a rhythm that makes the aliveness of the movements a deeply sensorial experience. It creates a distance between real time and the time of the moving images. This denaturalizes our reception of time and movement, as a result of which we become overwhelmed by the life embodied in these moving images.

Forgács works with the qualitative difference between historical time and personal time as we experience it. One could wonder if this quality also depends on the filmmaker and the kind of family that is being filmed. In this respect, the difference between the Peereboom and the Seyss-Inquart home movies, his second archival source for *Maelstrom*, is revealing. The distinction I have used so far between personal time and historical time does not automatically apply in the same way or same degree to the Seyss-Inquarts' footage. Seyss-Inquart's position in history is radically different from that of the Peereboom family. I am not referring to the fact that the one family occupies the victim position in history and the other the one of perpetrator. I am referring to the fact that Seyss-Inquart was appointed by Hitler; he represents him in the Netherlands. He is the representative of Hitler, of history; one could say he *is* history or, rather, the embodiment of it. This makes one wonder, can the embodiment of history make home movies of his family and friends? Or is the genre of the home movie disabled when history enters the realm of the personal?

There is, of course, also a class difference between the Peereboom family and the Seyss-Inquart family. Whereas the Peereboom family belongs to a Jewish–Dutch lower-middle-class family, the Seyss-Inquarts belong to an Austrian upper-middle-class family. This can explain the vitality of the Peerebooms and the more restrained behavior of the Seyss-Inquart family. It seems that the Seyss-Inquart family members are all the time aware of the fact that not only the cameraman but also anonymous, abstract, later viewers are looking at them. They embody history, and later as history will be judged, their role in history will be judged. When I watch the home movies of this family, I cannot avoid mobilizing the distinction between useful and useless. It is from the Seyss-Inquart footage that I get information. I become interested from a historical point of view when I notice that Reichsführer SS Himmler visited the Seyss-Inquart couple at their Clingendael estate in the Netherlands. They were not only fellow Nazi leaders; they and their wives socialized with each other and played tennis.

The fact that the Seyss-Inquarts' home movies evoke a mode of looking that this genre usually discourages only foregrounds differentially the more usual mode of looking at home movies. Forgács's combination and alternation of the Peerebooms' footage with the Seyss-Inquart footage, of personal time and of a personal time that is infected by historical time, sharpens our eye for the special qualities of the Peereboom home movies.

As I have argued so far, in *Maelstrom* personal time is shown to be in radical tension with historical time. In terms of my starting question, this tension suggests that the spread of memory practices since the 1990s is the symptom of a memory crisis rather than of memory celebration. It seems to be the expression of a situation in which memory is under siege. This conclusion concurs with that of other cultural critics. Scholars like Benjamin Buchloh and Andreas Huyssen have argued that this memory crisis is first of all historical and specific. According to Buchloh, mnemonic desire is activated especially in those moments of extreme duress in which the traditional bonds between subjects, between subjects and objects, and between objects and their representation appear to be on the verge of displacement if not outright disappearance.[4] In the 1990s especially, massive migration due to economical reasons or political wars, resulting in genocides, has caused such moments of extreme duress. But the memory crisis not only is historically specific in the sociopolitical sense but also is caused by media culture, by its overwhelming presence since the 1990s, and by the specific forms this culture develops. The enormous impact of photographic and filmic media culture has not worked in the service of memory but, on the contrary, threatens to destroy historical memory and the mnemonic image.

Buchloh elaborates this erosion of historical consciousness in the German context, specifically through a reading of Gerhard Richter's archival work *Atlas* as a critical response to that context. The photographs collected in *Atlas* belong to very different photographic registers, namely, both to registers that construct public and historical identity and to registers that construct private identity, such as the family photograph. Yet it is the continuous field of banal images more and more prevalent since the 1960s that levels out these different photographic formations into a general condition of amnesia. According to Buchloh, "Banality as a condition of everyday life appears here in its specifically German modality, as a sort of psychic anaesthesia."[5]

In the 1920s, German sociologist and cultural critic Siegfried Kracauer explained how media culture can have this devastating effect. In his essay simply titled "Photography," he makes a diagnosis of his own times that seems to be at the same time a prophetic diagnosis of our times:

> Never before has any age been so informed about itself, if being informed means having an image of objects that resembles them in a photographic sense. . . . In reality however, the weekly photographic ration does not all mean to refer to these objects or "ur-mages." If it were offering itself as an aid to memory, then memory would have to make the selection. But the Hood of photos sweeps away the dams of memory. The assault of this mass of images is so powerful that it threatens to destroy the potential existing awareness of crucial traits. Artworks suffer this fate through their reproductions. . . . In the illustrated magazines people see the very world that the illustrated magazines prevent them from perceiving. . . . Never before has a period known so little about itself.[6]

Relevant for our discussion, Kracauer sees historicism, the scholarly practice that emerged more or less at the same moment as modern photographic technology, as the temporal equivalent of the spatial mediations that take place in photography. In Kracauer's words, "On the whole, advocates of such historicist thinking believe they can explain any phenomenon purely in terms of its genesis. That is, they believe in any case that they can grasp historical reality by reconstructing the course of events in their temporal succession without any gaps. Photography presents a spatial continuum; historicism seeks to provide the temporal continuum. According to historicism, the complete mirroring of an intertemporal sequence simultaneously contains the meaning of all that occurred within that time. . . . Historicism is concerned with the photography of time" (49). How can we consider a medium and a scientific discourse as parallel? Photography and historicism regulate spatial and temporal elements according to laws that belong to the economic laws

of nature rather than to mnemonic principles. In contrast, Kracauer argues, memory encompasses neither the entire spatial appearance of a state of affairs nor its entire temporal course. Nor does memory pay much attention to dates; it skips years or stretches temporal distance (50). Kracauer writes in this respect, "An individual retains memories because they are personally significant. Thus they are organized according to a principle which is essentially different from the organizing principle of photography: memory images retain what is given only in so far as it has significance. Since what is significant is not reducible to either merely spatial or merely temporal terms, memory images are at odds with photographic representations" (50). Memory images are also at odds with the principles of historicism, concludes Kracauer later in his essay: "Historicism's temporal inventory corresponds to the spatial inventory of photography. Instead of preserving the 'history' that consciousness reads out of the temporal succession of events, historicism records the temporal succession of events whose linkage does not contain the transparency of history" (61). It is in the daily newspapers that photography and historicism join forces and intensify each other in their destruction of memory. In the 1920s daily papers are illustrating their texts more and more, and the numbers of illustrated newspapers increased. For Kracauer those

Figure 3.1 *El Perro Negro*. An anonymous soldier filmed at night. Do such images preserve memory or replace it with iconographic impressions?

illustrated journals embody in a nutshell the devastating effects of the representation of spatial and temporal continuities mistaken for the meaning of history.

Clearly, Kracauer's diagnosis of a memory crisis as caused by the phenomena of photography and historicism, relatively new in his day, seems also highly relevant for an understanding of the position of memory in the 1990s and after. His somber prophecy seems to have come true.[7] For Huyssen, the spread of memory practices, especially in the visual arts, is for him symptomatic of a crisis, not of a flourishing of memory. The memory crisis that started at the beginning of the twentieth century seems to have accelerated and intensified at the end of that century. The reasons for this are again twofold. First of all, there is a historical and specific reason. Second, this acceleration is a result of the impact of developments in media culture.

To address the second reason, the principles of mediating historical reality introduced by photography and historicism are intensified through film, advanced electronic technologies such as computers and the Internet, mass media, the explosion of historical scholarship, and an ever more voracious museum culture. It is among other things the abundance of information that explains the memory crisis of the 1990s. Huyssen writes in this line of argumentation, "For the more we are asked to remember in the wake of the information explosion and the marketing of memory, the more we seem to be in danger of forgetting and the stronger the need to forget. At issue is the distinction between usable pasts and disposable data."[8] Yet it is not only this very specific mediation of (historical) reality that has its devastating effects on memory but also the nature of historical and political reality of the 1990s itself. Historical memory used to give coherence and legitimacy to families, communities, nations, and states. But in the 1990s these links that were more or less stable links have weakened drastically. In the processes of globalization and massive migration, national traditions and historical pasts are increasingly deprived of their geographic and political groundings (4). Whereas older sociological approaches to collective memory, most famously represented in the work of Maurice Halbwachs, presuppose relatively stable communities and formations of their memories, these approaches are no longer adequate to grasp the current dynamic of the fragmented memory politics of different social and ethnic groups.

It is against this background of a century-old but now accelerated memory crisis that the memory practices in the visual arts should be understood. It is in these practices that memory becomes an issue of transforming aesthetics. To assess the social value of such transformations in

the aesthetics of memory, the question that remains to be answered is how effective these practices are in countering the threat of oblivion. I would like to address this question by taking a closer look at Péter Forgács's 2005 film *El Perro Negro* (*The Black Dog*). This film differs from his older work in that historical time rather than personal time is the main issue. At first sight this film can be mistaken as a conventional historical film, dealing with a specific national and political history, namely, the Spanish civil war in the 1930s. It is consistently chronological: it begins with the civil war's prehistory in 1930, when Alfonso XIII is still king of Spain. Then the first free elections to occur in thirty years in 1931 are held, when the majority of the people voted republican. The king left the country and the republic was proclaimed. Because of a series of new laws declared by the new republic—among which a law that allowed divorce and the separation of state and church—the clergy, the army, and the right-wing bourgeois became more and more opposed to the new republic. Ultimately this led to a civil war on July 18, 1936.

Most of this red thread of official historiographic storytelling is, however, told, not shown, in *El Perro Negro*. More than in most of his other films, there is a voice-over that imposes on the images the coherence of public, historical time. The film images we get to see belong, again, to the genre of home movies or they are made by amateur filmmakers. At the beginning of the film the voice-over (Forgács himself) declares, "We travel through Spain's violent decade with the images and stories of amateur filmmakers such as Joan Salvans from Terassa, Catalonia, and Ernesto Noviega from Madrid."

The films made by the amateur filmmakers can be home movies, but not exclusively. Ernesto Noriega, for example who is more or less neutral in the civil war, begins to document the civil war in 1936. It is only in 1938 that he becomes a soldier fighting in the Falangist (Fascist) army, not out of ideological conviction, but in order to survive. The angle from which he films remains personal, however. His adventures during the civil war, the events in which he participates, are the events that are filmed and shown.

I wish to discuss *The Black Dog* for its surprising contrast with the artist's preceding work. Compared to Forgács's earlier work, in *The Black Dog* the balance between personal time and historical time is reversed, so to speak. Whereas in his earlier work the viewer was completely immersed in the personal realm of weddings, anniversaries, and the home so that the continuity of historical time had to be imposed on it, in *The Black Dog* it is the other way around. The voice-over's storytelling leads the viewer through the filmic events. The filmic image substantiates this

narrative or refuses or fails to do that. And such a refusal or failure often occurs. The filmic image usually does not illustrate what the voice-over says, or it is the other way around: the voice-over does not explain or elaborate what the filmic image shows. Most of the time, the spoken word and the image are not continuous. This incongruity appears crucial.

Still, in *The Black Dog* Forgács is doing, or performing, historiography. In his earlier work Forgács was rather deconstructing historiography, exploring the limits or perhaps even the failure of historiography by showing the radical difference between personal time and historical time. In *The Black Dog* he seems to explore a possible remedy against that failure of historicism in order to develop an alternative historiographic mode. In order to understand the principles of this alternative historiography, I call again on Kracauer.

> After his devastating critique of photography as a medium and of historicism as a scholarly practice, he ends his essay "Photography" with a rather unexpected optimistic remark about the possibilities of film: "The capacity to stir up the elements of nature is one of the possibilities of film. This possibility is realized whenever film combines parts and segments to create strange constructs. If the disarray of the illustrated newspapers is simply confusion, the game that film plays with the pieces of disjointed nature is reminiscent of dreams in which the fragment of daily life becomes jumbled." (62)

Obviously, the kind of filmic aesthetics Kracauer is referring to differs radically from the kind of film that is dominant now. In the 1920s he would see the experimental films of the German and Russian tradition as defining the genre. But in spite of this historical specificity of Kracauer's view of film, it is precisely this historical background of the filmic medium that helps us to understand Forgács's attempts to force a new historiography.

The "pieces of disjointed nature" that film plays with, according to Kracauer, are in Forgács's work and time pieces that belong to personal time and pieces that belong to historical time. He presents these as radically disjunct. Although in *The Black Dog* there are certainly moments when personal history functions as synecdoche of history, usually the relation between the two realms is one of disjunction. These moments of clash between personal time and historical time are the ones that result in a different reading of the genre of home movies. Conversely, this clash makes the genre of home movies a key element in our understanding of time and of history.

So far I have characterized home movies and historicism as opposites. The home-movie genre embodies the realm of personal time, whereas historicism is the ultimate consequence of historical time. But

when we approach them from the perspective of the viewer or reader—in other words, as an issue of aesthetics—they have more in common than appears at first sight. Watching somebody else's home movies is usually a rather boring experience. This boredom stems not from the fact that the filmic quality of home movies tends to be rather bad and sentimental but because what we see does not concern us, but them. Watching conventional home movies does not establish a relationship of similarity but of difference; the genre makes us aware of the privacy of personal time and of the sentimentality of conventional ways of portraying the family.

Historicist historiography also establishes a relationship of difference, this time not a difference between personal and public, but between past and present. Memory, in contrast, is fundamentally connected to the present: it is again and again actualized *in the present*, and only those memories that are significant in the present can be activated. As Kracauer argues, the historicism of conventional historiography is fundamentally different from what characterizes memory. As we have seen, in his view historicism attempts to regulate temporal elements according to laws that belong to economic principles of nature rather than to mnemonic principles. For the viewer or reader of historiographic texts or images, this results in an awareness of difference between past and present, between that past political situation and ours, between their culture and our culture.

But when home movies are combined with the historiographic mode, as in the work of Péter Forgács, another kind of relationship with the viewer or reader is stimulated. The clash between—not harmonious blending of—the personal time of home movies and the historical time of historicism brings the situations in the home movies closer to us. Instead of sensing an uncomfortable alienation, as occurs usually when we watch other people's home movies, we begin to identify with the people in the home movies. The personal time of the home movies becomes an anchor within the historicist framework with which it clashes.

In Forgács's *The Black Dog* this strategy of establishing similarity between the viewer and the represented subjects is intensified by yet other means. The title points this out. Throughout the film, shots of animals play a crucial role. The title of the film refers to one of these shots, a clip of a black dog that recurs several times in the film. But there are many more clips of other animals, of pigs that are maltreated, of donkeys, of horses, and of rabbits being shot. All these animal shots have a heavily allegorical significance that sets them off from traditional use of animals in visual representation. The animals are never filmed as contextual details to produce a reality effect. In contrast, the animal shots, especially

of the black dog, are isolated within the film. This demarcation facilitates their allegorical functioning. The black dog becomes an allegory of destruction—of the evil of war.

At one moment the allegorical meaning of the animal clippings becomes more or less explicit. We see pigs maltreated by men. Then there is a voice-over. The identity of this voice-over is clearly not the same as the one who provides us with the historiographical narrative. When personal testimonies are quoted, another voice-over is introduced, clearly with another voice, in order to set the historiographic story apart from the personal stories. This personalized voice-over says, "The peasants hated the bourgeoisie because they treated them like animals. One of them said, 'Once we looked at the landowner, we thought we were looking at the devil himself.'"

At this moment it becomes impossible to see the clipping of the pigs maltreated by the men as unrelated to what the voice-over says. The image proposes an allegorical interpretation of how landowners or bourgeoisie treat the peasants and the lower classes.

These allegorical devices function on the basis of similarity. The similarity between the maltreatment of the pigs and that of the peasants

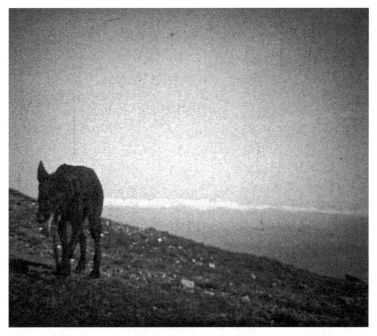

Figure 3.2 *El Perro Negro*. A stray dog, but what does it signify? The random moments of home movies retain their enigmatic quality. For Forgács history cannot be reduced to a simple tale, but its effects are no less palpable.

makes the one into an allegory of the other. This deployment of similarity is key to the polemic Forgács is conducting in this film. Similarity obstructs the principles of historicism, since historicism is based on the principle of radical continuity and on the temporal sequentiality within which each moment is unique and incomparable to other moments. The possibility of similarity within that logic would confuse the project of reestablishing temporal sequences. If similarity occurs, it has to be disentangled and repositioned into unique sequential moments. Similarity, hence allegory, is the enemy of historicism.

But in addition to the effect of the allegorical animal clippings, Forgács uses another device to reorient historiography toward the present. Again and again he uses footage in which we see people playact or where they are involved in events of a ritualistic nature. In both cases the represented moments or histories relate in a very ambiguous or complex way to the historicist attempt to establish a continuity of unique historical moments. The opening scene of *The Black Dog* provides the audience immediately with a powerful example of playacting history. We see two groups of young men, facing each other and performing a ritualized dance. Later, and retrospectively, we can read this dance as an allegorical representation of the two parties fighting each other in the Spanish civil war. The dance, then, formalizes the war as a conflict between groups of men. Because men they are: the event appears to be exclusively and deeply homosocial. After the dance the same young men play something resembling a lawsuit that ends in the execution of one of the men. With his arms tied up and blinded, he is pushed off a mountain into nothingness, seemingly into a gorge.

This event is amazing in many respects. First of all, it is amazing because a group of young men executes another young man by pushing him over the top of a mountain into a gorge. This happens after a dance, which turns out to have been a ritualized duel. Second, the film opens with this footage, even before we get to see the title sequence. This gives the whole scene extra significance. Third, this gruesome event surprises because it is not real—that is, it is not a historical event. It is playacted. Not history, but theater, is the context in which it happens. If this opening scene provides a prelude to the Spanish civil war, it is, again, only in an allegorical way.

This opening scene is, however, also a forerunner in a nonallegorical way: again and again in *The Black Dog* we get to see footage of scenes that are playacted or that concern moments or events that are repeated—that is, they are events of a ritualistic nature, such as weddings, banquets, or dances. It is not the unique historical moment at which the event takes

place that strikes the eye but the fact that the unique history of the Spanish civil war is so insistently represented through images that show events of a repeatable nature: plays, performances, and rituals.

At first sight, Forgács's use of the genre of home footage explains this: the home footage out of which *Maelstrom* consists also mainly shows events that are only unique on a personal level, not on a historical or historicist level. Weddings, births, and the like occur one after another. The Holocaust, or other violent events, does not intrude into the representational realm of this genre. The home footage of these two Spanish sources is, however, strikingly different, and this difference sheds a retrospective light on the relation between personal and historical time in *Maelstrom*. Many of the performed, ritualistic events, which are filmed by the two amateur filmmakers, provide us with images of the violence of the Spanish civil war, albeit it in an allegorical way. First of all there is footage of bullfights, the quintessential Spanish performance of ritualized cruelty. But there is other amazing footage comparable to that of the opening scene.

The voice-over tells us about a conflict between employers and militant anarchists in 1930. It specifies that Joan Salvans—one of the

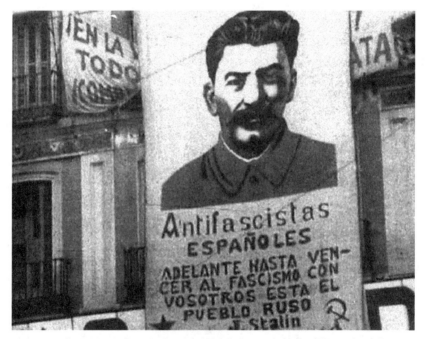

Figure 3.3 *El Perro Negro*. A recurring ritual or event in the film is the rally or political parade like this one. These rituals parallel the private rituals of weddings and dances.

filmmakers—apparently did not feel threatened by this conflict (he was the son of an important businessman): he went out camping in the Pyrenees with a club of mountaineers of which he was the chair. The footage shows first images of a bullfight, then of Joan dancing with his fiancée, Merce, and then of Joan and his friends and fellow mountaineers in the Pyrenees. As in the opening scene the young men are playacting: they perform another homosocial conflict resulting in yet another playacted execution. One of the men is rolled down off the mountain. In contrast with *Maelstrom*, a film that enacted the radical split between personal time and historical time, in *The Black Dog* the personal time at stake in these playacted performances provides access to the Spanish civil war by means of the device of allegory.

But if we are to assess the nature and effect of Forgács's attempt to transform the principles of historiography, we must account for the key fact that in his historiographic project Forgács does not obey the principles of historicism. He obstructs those principles by introducing devices based on similarity, the repeatable, and identification and deploying them on different levels. First of all, he uses allegorical motifs of animals standing for human subjects and of playacted performances that ritualize violence and cruelty. Second, he establishes a different relationship between the represented human subjects and the viewers. This is how he performs historiography without the overwhelmingly distancing effect of difference. As a result, a film about the Spanish civil war can suddenly affect us emotionally and politically in our present moment. When similarity becomes a leading device *within* historiography, the Spanish civil war suddenly becomes an experience close to us, although it happened more than sixty years ago, far away in the southwest corner of Europe. When it happened, we were not there. Now, we are.

Forgács's work is a strong example of what I called at the beginning of this reflection the spread of memory practices so prevalent since the early 1990s. Of course, it is impossible and undesirable to generalize about this art and the cultural practices that are performed in it. It is more important to distinguish productive from unproductive memory practices and try to understand in what respect memory practices are productive or unproductive. Because some and perhaps even most of these practices show a kind of naïve, nostalgic, and sentimental celebration of the past, usually limited to a personal past, without actively engaging this past in our political present, it is imperative to stop at attempts such as Forgács's to overcome these distancing practices. My reading of Forgács's films *Maelstrom* and, in relation to it, *The Black Dog* suggests, however, that the media and genres used for these memory practices are themselves

deeply implicated in the crisis of memory they appear to counter. If used conventionally and uncritically, media such as photography and film, the archive, and genres like documentary, the family album, or home movies lead to a memory crisis. They embody the principles of traditional historicism Kracauer criticized, for they are based on the kind of temporal or spatial continuities easily mistaken for the meaning of political situations or of personal lives. It is only when the use of these media and genres is performed critically and self-reflexively that they are transformed from embodiments and implements of that crisis to alternative practices that counter the very same crisis. It is only then, in the words of Jill Bennett, "that art does not represent what already occurred, but that art sets up conditions for relating to the event."[9]

This is a call for an aesthetics that subverts traditional temporality. Forgács's systematic clash between personal time and historical time is an example of such a productive practice. His staged clashes do not end up in a deadlock but result in an aesthetics that inserts personal time into historical time, or the other way around, without either false harmony or insurmountable incompatibility. Instead his aesthetics of temporality give personal time a broader historical significance. The genres and media he works with and in, genres and media that seem preconditioned for historiographic projects, no longer comply with the principles of historicism. This is how historiography can become relevant again for our political and personal present. This is how, in different words, historiography can return to its mission to serve and preserve, not dictate and erase what we are and do today, with that past in our present world.

▶

NOTES

1. Kaja Silverman, *Flesh of My Flesh* (Stanford, Calif.: Stanford University Press, 2009).
2. Ibid.
3. http://www.artmargins.com/content/interview/forgacs.html, accessed August 2006.
4. Benjamin Buchloh, "Gerhard Richter's Atlas: The Anomic Archive," in *Atlas: The Reader* (London: Whitechapel Art Gallery, 2003), 109.
5. Buchloh, "Gerhard Richter's Atlas," 112.
6. Siegfried Kracauer, "Photography," in *The Mass Ornament: Weimar Essays*, trans. and ed. Thomas Y. Levin (Cambridge, Mass.: Harvard University Press, 1995), 58.
7. Andreas Huyssen, *Present Pasts: Urban Palimpsests and the Politics of Memory* (Stanford, Calif.: Stanford University Press, 2003), 1.
8. Ibid., 18.
9. Jill Bennett, lecture at University of New South Wales, Sydney, July 18, 2005.

MICHAEL S. ROTH

[4] *Ordinary Film*
The Maelstrom

Maelstrom: A large, powerful whirlpool, often resulting in unusual reconfigurations of objects in its vicinity.

The opening of *The Maelstrom* presents a silent image of a small, seemingly fragile boat being tossed on a stormy sea. Silence draws us out—where are we and what are we looking at?—and then the film pushes us back. The remainder of the film, with only a few punctuations, uses sound (music, cries, and sound effects) to bring us along. But we start with silence and the sea drawing us out. Where are we being taken?

When the sound emerges near the beginning of *The Maelstrom*, we see people drawn to the waves that crash ominously against a flood wall. They are drawn to the raging sea, and then they retreat from the waves. They want to feel that power, but they fear being swept away by it. Wanting to be swept away, we approach. And then we run for our lives.

The figures in the grainy footage run up to the flood wall, seem to lean out to look at the churning sea, fascinated by its power. They are alive, and they are looking out into the death-tossing waves. How long can they stand there as the swell approaches? When is it too late to run for it?

The word "maelstrom" originally referred to a whirlpool off the coast of Norway, a whirlpool so powerful that it could draw down boats from miles around. If you could know this whirlpool, would that mean you had felt its pull, that you had been reconfigured? Would you want to approach it to be sure it was really pulling you, to feel more? How much pull would you want to feel before you lunged for escape?

Péter Forgács is the magician of the whirlpool. He is our navigator around the maelstrom. His maelstrom is what others have called "the

black hole of meaning" in the twentieth century: the Shoah, the Holocaust. It has reconfigured our ability to make sense of what led up to it and what has happened in its wake. He cannot bring us too close, for then we would close our eyes to what we have to see before us. But if he turns away too quickly from what he has found, we will see nothing that matters either to us or for us. How can he navigate in these waters?

Forgács finds films. That's simple. These are old movies, home movies. They were taken for no good reason; just to mark occasions, to create a record; to remember the daily life and the bodies and the people we used to be. Banal. The running joke of home movies is that you want to flee your neighbor (even your cousin) who inflicts on you the movies of the wedding, the children, the last vacation. And yet the neighbor is oblivious of the boredom he inflicts. He has no reason to be bored because he is looking at himself. But how can the home movies of other people hold any interest for us? How can we feel their pull?

Forgács warns us early on. After we see the waves, and after we hear them, we are given the subtitle of the film: *A family chronicle*. And the family that will be chronicled is the Peerebooms. We are introduced to several solid citizens. Why should I care about them? To label them (good bourgeois Jews) is already to begin to care, or at least to create a quality of attention. I am already framing them in this way because we are given a date: 1934. And then all the signs, from the name, to the profession, to the newspapers they edit, to the physiognomy (I know, but I can't help thinking about how Jewish they *look*)—all these signs spell doom. They are silent, these movies that Forgács found, but we can hear the maelstrom churning in the distance. Drawing us—or is it just the Peerebooms?—closer.

Forgács finds films from the 1930s. But it's not that simple. He buys them, trades them, and negotiates with people who are holding onto their private archives. And along with his great creator of soundscapes Tibor Szemzö, he turns these home movies into something else. He takes them out of the home, making them *unheimlich*, uncanny. But that is already to overdramatize, and Forgács consistently refuses this. He wants to remain with the banal and to draw us into it. He does not bestow on his films the dignity of historical, metaphysical, or even theoretical importance. When we approach a Forgács film, we have to allow ourselves another mode of attention, another rhythm of seeing. Why can't we just ignore these Peerebooms? What have they to offer us that we do not have already or that we do not know already? We know what it means that this is the 1930s in Europe: this will all be destroyed. How many stories of murdered Jews do we need? Yet here they are in front of

us: planning marriages, making babies, opening shops, and frolicking in the snow. We watch them, shocked not only by their own ordinariness (what, after all, can bring the ordinary to us here, now?) but also by their capacity to maintain those everyday lives even as the maelstrom sucks them closer and closer to its murderous turbulence. *"Why don't they pay attention?"* we ask as we watch them. *"Can't they feel themselves sinking?"* Who are we talking about?

Forgács's challenge as a filmmaker, as a film explorer, and as an archivist is to preserve the ordinariness of his subjects even as he frames them for us in extraordinary times. The Peerebooms are trying to maintain their normal rhythms of family life as Jews in the Europe of the 1930s. And when we see them in these pictures, it doesn't look that hard. They have the commerce, the family alliances, the work with the Red Cross, and the vacations. Jozeph edits the *Nieuw Israelitisch Dagblad*, eldest son Max finds a happy bride in Annie, while daughter Loes marries the strong-shouldered Nico (wherever did she find him?). We begin ominously enough because we begin in 1933. This is a date of great significance for the Peerebooms because it is the year that Max and Annie get married. Somebody get the camera to record the momentous event! We viewers bring different criteria of importance: 1933 is the year that Hitler becomes chancellor in Germany, and when we hear the weather forecast of the following summer, "sunshine all over," we know there is going to be trouble. We don't really need the frames of the black pet cat, but here is one of the few times that Forgács permits himself to emphasize the tension he more typically just allows to swell up into the viewer's consciousness.

Marriage and vacations. Sunshine all over. How to maintain that ordinariness? There is a danger in exposing it. The ordinary can be an embarrassment for those who notice it because to do so is an acknowledgment, maybe even a confession, of one's own banality. Artists, theorists, and philosophers often flee ordinariness or, as some like to say, try to make the ordinary extraordinary. I prefer Stanley Cavell's project, which he has called, after Wittgenstein, Emerson, and Thoreau, a quest for the ordinary, the ordinary being that place where you first encounter yourself. How are we to think about our lives and about the pictures from them without separating these images from ourselves and from our ordinary world? Are we prepared to run the risks of skepticism, of melodrama, or of the cage of irony? The skeptic might ask how we could be sure that our experiences of images have any meaning at all. What if they are merely found footage, the dreck of home movies, into which we pump significance that we later claim to discover? The seeker of melodrama might demand that we underline the lachrymose history of those pictured. Are

these not always already tragic figures, martyrs who cry out to us to act as their witnesses? The ironist might smile at our attempt to take seriously what we might normally glide by, artful images that we should see at a festival lubricated by drink and cryptic conversation. We do leave ourselves open to these questions and variations on them when we pay attention to the everyday. Skepticism, melodrama, and irony are three standard responses to the nonfiction film, responses that may have even more potency in regard to the reframing and rethinking of home movies that is part of Forgács's project. Leaving oneself open to these responses is a key to his project and is (as Cavell has taught now for more than thirty years) necessary for any kind of real thinking.

Real thinking about the ordinary is problematic because of the insistence of particularity. The problem of home movies is the problem of particularity—that is, of trying to find a way to make sense of something individual, on its own and distinct, without erasing its individuality, its oneness, and its distinction. This is a *problem* because making sense of something, knowing something, means to put that thing in relation to something else or to subsume it under some broader conceptual scheme. To the extent that we know something, we know it *in relation* to other things. There is a happy, optimistic side to this feature of understanding: our connection to the individual object of knowledge is enriched, made more complex, and deepened by enwebbing that object in the world that we know. But there is a frightening, sad side to this feature of our understanding, too: we lose the specificity, the particularity, of the object as we come to see it as one among many objects that are similar and different from it.

We know all this from our everyday experience. As soon as the home movie is taken out of its native environment, it has the capacity to become either senseless or *unheimlich*. We need to wrap the home movie in something else: filmmakers like Forgács and Robert Nakamura use music and history to bring the private film—the orphaned film—into the world of sense. Comparison, whether with other families, groups, or histories, is supposed to make the other person's home movie into *ours*. But comparison always involves a loss of meaning, as well as a gain, and persistent comparison with others can feel like a mode of erasure. We can see this in private life: think of the lover who tells you how much smarter and neater you are than all his or her exes; think of the sibling who is always measured by the brother or sister's achievements. The problem of particularity is a problem of the home, but it is not limited to the home. Think of the strenuous efforts to have a heinous crime labeled a crime against humanity; think of the contested use of the words "genocide" and "holocaust."

The problem of particularity is also apparent when we consider people or places of extreme beauty. We may be content to just take pleasure in these people and places, in other words, to leave them aside from our understanding. They invite delight more than comparison and knowledge. To engage in the attempt to *know* the beautiful often spoils our delight or, what's worse, spoils the delight of others. This issue is visible in the museum world when you ask academically minded interpreters to talk about beloved works of art. Curators and the general public often feel their pleasure being compromised by the savant. To hear the gray-bearded professor describe to you how Monet was really painting the bourgeoisie's sense of triumph over nature might seem like an assault on your own *experience* of the painting itself. This is no mere error of pedantry. It is, I think, a feature of understanding and of knowledge (but not of wonder). Understanding and knowledge demand that you move away from the intimacy of your relation with any object or event. Understanding may promise a richer experience in the end, but there is risk in the movement toward distance that knowledge entails.

Forgács, this filmmaker who has visualized with unprecedented attention the domestic horror of the process that led to extermination camps, Forgács is seduced by beauty. He revels in the joy of his subjects. Home movies are a medium of joy, and he wants us to feel that with his subjects. The movie camera comes out for the vacation, for the new baby, or for the first snow of the winter as if the ephemerality of those moments commanded us to record and capture them. Or is it that the sight of the camera triggers a certain glee—a universal commandment to smile and find the Esperanto for "Cheese!" The Peerebooms seem incredibly *happy*, full of a life force. Here they are skipping—no, dancing—down the street. (Forgács seems to delight in the sight of large, encumbered bodies leaping through space with joy. His short films around Wittgenstein's *Tractatus* return to this kind of image.) And then we see the clan on the beach leapfrogging one over the other. The comic failures of Mama are a total success as Peerebooms tumble to the sand. It is 1934, and for the rest of the decade, we see them building families, houses, and businesses. The vacation in Paris in 1939 would be the last trip abroad. And watching their ferocious play in the snow makes us feel how alive they were. It is the winter of 1940.

The problem of particularity, although evident in relation to beauty, can be seen in an especially acute way in regard to trauma. The modern concept of trauma points to an occurrence that both demands representation and refuses to be represented. The intensity of the occurrence seems to make it impossible both to remember and to forget. The traumatic

event, Freud wrote, is "unfinished"; it appears to the individual as "an immediate task which has not been dealt with." Contemporary psychiatry tends to define trauma as an event that overwhelms one's perceptual-cognitive faculties, creating a situation in which the individual does not really experience the event as it happens. This may be why victims often describe themselves as spectators of their own trauma. In any case, the traumatic occurrence is not remembered normally because it was not registered through the standard neurochemical networks. The lack of a reliable memory of the trauma is felt by many as a gaping absence, sometimes filled by flashbacks or other symptoms. Yet the occurrence was too intense to be forgotten; it requires some form of re-presentation.

The intensity that makes forgetting impossible also makes any specific form of recollection seem inadequate. The traumatic event is too terrible for words and too horrifying to be integrated into our schemes for making sense of the world. Yet any representation of the trauma may have to rely on words and will be limited by the very schemes that were initially overwhelmed. I have argued in various essays that a successful representation (a representation that others understand) of trauma will necessarily seem like trivialization or, worse, betrayal. The intensity of a trauma is what defies understanding, and so a representation that someone else understands seems to indicate that the event was not as intense as it seemed to be. No direct speech is possible.

If we ignore the traumatic event (if we try to leave it alone), we seem to have neglected a moral obligation to come to terms with horror and pain. If we understand the traumatic event by putting it in relation to other events (if we try to make it a part of our history), we seem to be forgetting the intensity that engendered the obligation in the first place. This, then, is the problem of particularity: you can't leave it alone, but it does not abide company.

Perhaps it is already clear how particularity is a problem for history in general and for translating home movies into historical or aesthetic objects in particular. The American historian Robert Dawidoff has talked about this in terms of the resistance we have against seeing something we love become *merely* history because this means it gets swept up with all sorts of things that reduce its distinctness for us. There is a tension between the distinct clarity of vision in the particular artifact and the comprehension that comes through establishing interrelationships. To treat something as historical means *at least* to connect it via chronology to events before or after. *Maelstrom* is punctuated by dates; the chronicle extends a bridge between private and political history. The singular, disconnected phenomenon cannot *be* historical; entrance into the historical

record requires a kind of contextualization that is a denial of singularity. Thus when we try to historicize an event that is dear to us because of its intensity, we necessarily reduce its singularity. As Carl Schorske has noted in his introduction to *Thinking with History*, "Thinking with history . . . relativizes the subject, whether personal or collective, self-reflexively to the flow of social time." Making something history means making it part of something else or placing it in relation to something else. That is why there can be no unique historical events except in a trivial sense (in which everything is unique).

There has been an effort to adopt a religious or sacralizing attitude vis-à-vis certain extreme events, which is in part an effort to keep a distance between them and the run-of-the-mill occurrences that we remember or write about as history. We can understand these efforts as aiming to prevent a catastrophic event from becoming merely historical— that is, something that fits easily into the narratives we tell about the past. But the efforts can backfire, creating an easy target for those who would confuse our caring about particular events with a refusal to pay attention to others. This, obviously, has been one of the sources of debate about how to understand the Holocaust historically. To do so means necessarily to understand it comparatively. Comparison can feel like a mode of erasure, as we noticed just a few moments ago; but it can also be a mode of memory and sustained attention.

Forgács introduces a mode of comparison into *Maelstrom* that is both delicate and extreme. The Peerebooms are not the only family pictured in the film. He also takes us—very briefly—into the world of the Seyss-Inquarts. Forgács has prepared us to meet this family by showing us earlier clips from an amateur film of a Nazi youth group in Holland in 1935 and by voice-overs that announce Hitler's welcome in Vienna in 1938 and the attack on Western Europe in 1940. In two of the rare instances in the film where sound is synchronized with image, a baby's cry is heard as we see an infant shriek. A carnival booth's target shooting suddenly erupts in an audible shot. We hear the "Sieg Heil!" as we watch a child walk down the street.

The Seyss-Inquart clan has its own home movies. We see them at more restrained forms of play—horseback riding or tennis with the Himmlers. And when we see the private life of the Reich commissioner, we hear about new laws affecting Jews: stopping the production of kosher meats (and the kindly humanitarian gesture of anesthetizing warm-blooded animals), forcing Jews to put their funds in special accounts, and creating a ghetto in Amsterdam for all Dutch Jews. Meanwhile, time is running out for the Peerebooms. We know that, and perhaps they begin

to also. It is so hard to tell from these glimpses into their lives. Here the viewer just becomes more sharply aware of a tension that has existed from the very beginning of the film: we have knowledge of history (of *their* history) that the families in the film lack. Did they hear the maelstrom pulling them? Did they feel themselves being reconfigured by its force? It is so difficult to tell from these found films because home movies have a logic of their own. The powerful conventions of home movies make the problem all the more acute. There is a strong imperative to show something positive. The home movie is something you will want to look back on. It is meant as a *nostodisiac*, a stimulant of nostalgia. We see the Seyss-Inquart grandchild playing while she eats; we see the Peerebooms again on vacation—this time just on the roof in the ghetto, no longer at the beach or in Paris. Images of happiness colliding in history.

Forgács introduces another kind of film clip into *Maelstrom:* chilling, clandestine recordings of Jews being led from their homes. These are not family chronicles but historical documents. We are into the 1940s and Nazi domination. Family members Louis and Nico have already died in Mauthausen when Jews are forbidden to appear in public in 1941. The home-movie cameras continue to record: the Nazi official's grandchild giving a kiss; the new baby born to Max and Annie, named, as an act of resistance or hope, Jacques Franklin. It is late 1941 when they record the last time they would light the Hanukkah candles. The following fall they film themselves preparing to leave for a work camp in Germany. As we have throughout the film, we know better. We hear the pull downward, even as we watch the women sew for the trip. Max, Annie, the children—Flora and Jacques Franklin—are going to die in Auschwitz. The home movie records the women sewing as if they were preparing for another vacation, another event to be remembered in the family chronicle. But can there be a family to look back on these events? From where do *we* watch and remember?

The only survivor of the Peereboom family is the youngest of the siblings, Simon. We have seen him throughout the film, playing the role of the baby, the jester, the wise guy. As a youngster, he is trying to look tough and cool, and we laugh as he blows cigarette smoke at the camera. As the film and family near their awful conclusion, in the month after Max, Annie, and the children are deported, Simon, the wise guy, marries—we don't know whether it was in defiance, for survival, or for love. But he does survive, and he returns to Holland. In discussions of the making of *Maelstrom*, Forgács has told how a postwar chance encounter led Simon to the family films. Walking down the street one day, Simon bumped into Chris, the non-Jew who worked in the family shop. Chris

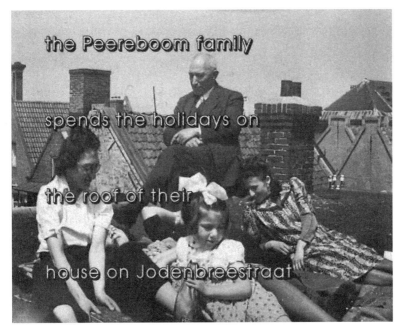

the Peereboom family

spends the holidays on

the roof of their

house on Jodenbreestraat

Figure 4.1 *The Maelstrom*. As Reich Commisioner Seyss-Inquart plays tennis with Heinrich Himmler (see Figures 2.1a and 2.1b), Seyss-Inquart's anti-Semitic laws deprive the Peerebooms of access to public spaces. An outing becomes a trip to their rooftop.

Figure 4.2 *The Maelstrom*. Simon, whose wink to the camera suggests his wise guy status, is the family's sole survivor of the Holocaust.

had buried Max's home movies. They, too, survived the war. The most banal images you might imagine had now become a buried time capsule from another world.

Forgács is fond of quoting and responding to Wittgenstein, that great philosopher of the ordinary. In describing why he makes films from found footage, the director cites the *Tractatus:* "Everything we see / could be otherwise. / Everything we can describe at all / could be also otherwise." This resonates nicely with the fragility of Simon's survival, of the film's survival, and of the montage that is *The Maelstrom.* But there is another ingredient in Forgács's work that is not captured in the philosopher's aphorism. When the figures run to the flood wall, they know that the waves will return. They must return. When we watch the Peerebooms go about their lives as Jews in the years of Nazism, *we* know that they will confront death in ways that *they* could never have conceived. We who live on the other side of that war have passed beyond a contingency, beyond when "it could be otherwise"; we look back with knowledge of a destiny we can never unlearn.

Forgács's films balance the feeling of contingency and ephemerality with the feeling of fate and necessity. We approach the maelstrom or the flood wall of our recent history wanting to have a closer look but knowing the horror beneath those swells. This was a horror, a history that was never recorded in Max's films of the lusty lives of his family. It may be a horror that Péter Forgács's films can provoke in us, but it was one that, perhaps until near the end, the Peerebooms were spared, bless their souls.

MICHAEL RENOV

[5] *Historical Discourses of*
the Unimaginable
The Maelstrom

In 2000, the Foundation for Jewish Culture sponsored a "First Confer-ence of American Jewish Film Festivals" in conjunction with the twentieth anniversary of the San Francisco Jewish Film Festival, the first of the American Jewish film festivals. One conference session devoted to "The Holocaust Film as Genre" was meant to grapple with the sometimes-uncomfortable fact that the Holocaust continues to be the source and subject of countless documentary films by Jewish makers. This obsessive return to the Shoah, generations after the event, is figured by some as an overinvestment in Jewish victimhood or an unwillingness to move on to other more contemporary and empowering topics. What is the source of the Holocaust's fascination for Jewish filmmakers? Has the Shoah simply become a template for Jewish suffering, or has the exploration of this topic by documentarists led to continuing historiographic or philosophic insights for filmmakers and scholars as it has for historians? And even if we grant the importance of the work of Alain Resnais, Marcel Ophuls, and Claude Lanzmann, are there any new lessons to be learned? Are we not suffering from Holocaust exhaustion? These are some of the questions that have prompted this chapter.

The intransigence of Holocaust memory is addressed quite brilliantly by James E. Young in his book *Writing and Rewriting the Holocaust: Narrative and the Consequences of Interpretation,* in which he exhaus-tively chronicles the extent to which the Holocaust has become a lens through which all Jewish experience in the second half of the twentieth century has been focalized. Historical representation has at times given way to archetypal depiction; indeed, the "Holocaust Jew" has become a figure familiar even in non-Jewish writing, as evidenced in the acclaimed poetic works of John Berryman, Anne Sexton, and Sylvia Plath, suicides all.[1] The power of the Holocaust as a trope is nowhere more notable than

in the rather recent appearance of the term "Armenian Holocaust" to refer to the genocide of one and a half million Armenians at the hands of the Turks between 1915 and 1923, an event occurring decades prior to the building of the Nazi death camps. The word "Holocaust," which entered critical and popular usage to refer specifically to the murder of European Jews only in the late 1950s, is thus retroactively applied to the Armenian context to signal the enormity of the crime.[2]

But if the Holocaust has become a name obsessively invoked (Hayden White, for one, has called the Holocaust "the paradigmatic 'modernist' event in Western European history"[3]), the terms of its representation continue to be scrutinized with unparalleled stringency. The stakes are high for Holocaust testimony (one only needs to recall the claims of Holocaust deniers); the desire is for the direct transcription of experience, with the scribe minimally functioning as a neutral medium, "an instrument of events."[4] But the notion that the text (literary or filmic) can produce a pure and normative rendering of events ignores the radical critique of mimesis offered by, among others, Robert Scholes: "It is because reality cannot be recorded that realism is dead. All writing, all composition, is construction. We do not imitate the world, we construct versions of it. There is no mimesis, only *poesis*."[5] The Holocaust as documentary genre is a particularly charged site for debates around the ontological status of documentary discourse. In this chapter I want to pose Péter Forgács's *The Maelstrom*, a film about a Dutch Jewish family destroyed in the Shoah, as also about historical representation itself and the dynamic border between testimonial transcription and aesthetic construction. Forgács, as we shall see, is at once scribe, witness, and poet. But first there is much to be said about the discursive field into which *The Maelstrom* is situated.

In Jewish tradition, the scribe has been seen as a sacred guardian. A Talmudic tale recalls Rabbi Ishmael's admonition to the biblical scribe: "Be careful. Should you omit or add one single word, you may destroy the world."[6] In the post-Holocaust era, a firestorm of debate surrounds the ethics of depiction. There have been memorable arguments made for why metaphor and indeed all efforts toward representation are an affront to the materiality of the horror of the Holocaust. In his book *A Double Dying: Reflections on Holocaust Literature*, Alvin Rosenfeld makes the case succinctly: "There are no metaphors for Auschwitz, just as Auschwitz is not a metaphor for anything else. . . . Why is this the case? Because the flames were real flames, the ashes only ashes, the smoke always and only smoke. . . . The burnings do not lend themselves to metaphor, simile, or symbol—to likeness or association with anything else. They can only 'be' or 'mean' what they in fact were: the death of the Jews."[7]

Yet the requirement to bear witness to the suffering and loss of life has repeatedly overruled these objections; it is, for many survivors, a compulsion. Listen to the words of Primo Levi in his preface to *Survival in Auschwitz*: "The need to tell our story to 'the rest,' to make 'the rest' participate in it, had taken on for us, before our liberation and after, the character of an immediate and violent impulse, to the point of competing with our other elementary needs. The book has been written to satisfy this need: first and foremost, therefore, as an interior liberation."[8] But traumatic experience is typically inaccessible, buried deep within the psyche; memory retrieval and retelling are complex therapeutic processes.[9] The act of a survivor witnessing, when credible, adopts a style that might be termed "documentary realism." But Young has argued that it may be "critically irresponsible" to insist that first-person Holocaust narrative actually establishes the documentary evidence to which it aspires.[10] It is the achievement of Forgács to provide a contextual framework within which an evidentiary claim can be made for a particular survivor discourse.[11]

Great controversy surrounds the ontological and ethical status of Holocaust retellings: are they history, memory, art, therapy, or even political tracts? Elie Wiesel, one of the best-known witness bearer–novelists, has, echoing Adorno's atavistic pronouncement ("To write poetry after Auschwitz is barbaric"[12]), written of the impossibility of Holocaust literature: "There is no such thing as a literature of the Holocaust, nor can there be. The very expression is a contradiction in terms. Auschwitz negates any form of literature, as it defies all systems, all doctrines." Yet Wiesel has also spoken of the inviolability of the need to remember: "For me, writing is a *matzeva*, an invisible tombstone, erected to the memory of the dead unburied."[13]

What are we to make of the apparent irreconcilability of Wiesel's statements? On the one hand, no literature—no aesthetic canons, no hierarchies of taste, no tracking of generic transformation; in sum, no pleasure from the pain—on the other, a desperate need to memorialize loss. Eric L. Santner has claimed that it is the narrativization of the Holocaust, the impulse to "tell the story," that raises the danger of "narrative fetishism," which is, in Santner's view, "a strategy of undoing, in fantasy, the need for mourning by simulating a condition of intactness, typically by situating the site and origin of loss elsewhere."[14] The narrative act, in this view, enacts an inability or refusal to mourn, displacing the loss or traumatic shock at the level of representation. Put another way, narrative takes the sting out of history. Santner's view resonates with many of the critiques leveled against both *Schindler's List* and *Life Is Beautiful*, films

that provoked very heated debates, numerous conference papers, and even entire books half a century after the events they depicted.[15]

As strongly felt as the injunctions against the aestheticizing, or enfabling, of the Holocaust are the calls to bear witness. Some critics find biblical support for the testimonial urgency we have noted. James Young cites Leviticus 5:1: "And he is a witness whether he has seen or known of it; if he does not utter it, then he shall bear his iniquity."[16] The burden to share the knowledge of catastrophe has dogged a generation of witnesses and survivors, continuing into the following generations, the children and grandchildren of survivors, who remember, recite, and teach their testimony or its impossibility. It is here that we encounter the special penchant of the documentary tradition for recording and amplifying the testimonial act. Since *Night and Fog*, produced in 1955 on the tenth anniversary of the liberation of the camps, a tremendous number and variety of nonfiction films have been made that treat some facet of the Shoah. Can it be that the documentary, long aligned (mistakenly in my view) with truth rather than beauty, has been considered immune to the threat of aestheticizing the horror?[17] Perhaps the concern for narrative fetishization is equally allayed by the use of nonfiction modes less identified with storytelling. One very significant strand of nonfiction media production has been the videotaping and archiving of survivor testimony at such places as the Fortunoff Video Archive for Holocaust Testimonies at Yale University and the Survivors of the Shoah Foundation Institute founded by Steven Spielberg, which has recorded more than fifty thousand unedited testimonies.

However, neither artlessness nor denarrativization can be assumed for any discursive account of history. Joris Ivens has written of his consistent efforts to deaestheticize the dire conditions of the strikers in *Misery in the Borinage* in 1932. ("Our aim was to prevent agreeable photographic effects distracting the audience from the unpleasant truths we were showing."[18]) In *Claiming the Real*, Brian Winston has vigorously argued that documentary is all but incapable of avoiding narrativity, which is a deep-seated requirement for human comprehension; other models for organizing nonfiction material, in Winston's view, work better in the head than on the screen.[19] Certainly documentary has long struggled to "enfable" its subjects: Allekorialak/Nanook, the struggling picketers of Harlan County, even the Louds of Santa Barbara. Finally, documentary offers little refuge from the antiaesthetic, antinarrative critique.

Some have argued that historiography itself (the disciplinarily patrolled writing of history) is far from immune from aesthetic and narrative determinations. In his highly influential essays, "Historical

Discourse" and "The Reality Effect," Roland Barthes asks, "Is there in fact any specific difference between factual and imaginary narrative, any linguistic feature by which we may distinguish on the one hand the mode appropriate to the relation of historical events . . . and on the other hand the mode appropriate to the epic, novel or drama?" To the dismay of many historians since, Barthes argues that historical discourse is not in fact linguistically distinguishable from other narrative forms. Barthes's comments have particular relevance to the documentary scholar or practitioner for, in his view, the makers of an "objective" history must stake their claims on a "referential illusion" by which a succession of techniques and institutions incessantly attempt to authenticate the "real" as though it were a self-sufficiency, "strong enough to belie any notion of 'function,'" as though the *having-been-there* of the document [or, for documentarists, the image] were an absolute and sufficient guarantee.[20] Such has been the position of one branch of documentary scholars, among them Noel Carroll, who celebrate documentary's ability to produce objective, certifiable knowledge.

For his part, Hayden White has coined the phrase "fictions of factual representation," by which he means to underscore the extent to which the discourse of the historian and that of the imaginative writer "overlap, resemble, or correspond with each other." In a manner scandalous to many professional historians, White has reviled the rationalism of a historical method begun in the nineteenth century that posed history as the realistic science par excellence. In this way, history could become the study of the real to be pitted against the study of the merely imaginable.[21]

The documentary tradition, in attempting to distinguish itself from the fiction film, its hegemonic other, has inherited this presumed dualism between the real and the imaginable. It is my belief that Péter Forgács's filmic practice, and here I will limit myself to his 1997 piece, *The Maelstrom*, actively deconstructs the institutionalized divide between the real and the imaginable by producing historical discourses of the unimaginable. Drawing his visual sources from the depths of the world's archives and, most tellingly, from recovered amateur footage, Forgács affords the viewer access to worlds unknown and unanticipated.

It is worth describing, if briefly, Forgács's working methods. Forgács's originating insight was that the Hungarian experience under Communism was largely inaccessible through the official accounts (i.e., the Sovietized, top-down view of history). Far better to approach an understanding of midwar and postwar social life in Hungary and elsewhere by way of the amateur footage that depicted the rituals of everyday life. So began Forgács's obsessive image-gathering. The found footage,

archival images, and home movies he collects are the raw material for his excavations of the past.

But it would be incorrect to imagine that Forgács is more historiographer than artist. Forgács's extensive filmic oeuvre (he has produced over thirty films)[22] is rigorous in its fidelity to certain structural and aesthetic principles. The films contain almost no footage shot by Forgács but consist of meticulously edited, indeed reorchestrated, archival material that may be temporally manipulated and even tinted. In this way Forgács signals his disinterest in a pristine retrieval of the past. He has, in every case, collaborated with noted Hungarian composer Tibor Szemzö whose remarkable scores place the sound track on equal footing with the visuals. These are films to be heard as well as seen; the encounter with history occurs by way of the often degraded images but also through Szemzö's haunting instrumental and vocal arrangements. In this way, Forgács's films emerge as more meditative vehicles than authoritative documents of a past time.

It might be said that Forgács is the creator of compilation films, a poorly understood filmic type; he is a master editor. In *The Maelstrom*, the rescued images are imbued with uncanny historical resonances through a stunning display of decoupage: the footage is displayed at varying speeds and with frequent freeze-framings that arrest gestures and glances, suspending the inexorability of time; Szemzö's affectively charged choral and instrumental phrasings impose a shifting tonality; the superimposition of graphic text or voice-overs explicitly quoting laws, public decrees, and political speeches of the period provides a progressive timeline and precise historical matrix.

We (the audience) know perilously more than the images' makers. We cringe with dread knowledge as we watch a Dutch Jewish family, the Peerebooms, embark on a Parisian holiday the day before Hitler marches into Poland. We are moved by the spectacle of Jewish worship at Amsterdam's Rapenberg Synagogue, a tableaux of a thousand-year-old tradition of European Jewish life soon to be destroyed. And we are stricken by the sight of a family (our filmmaker Max Peereboom; his wife, Annie; her stepmother; and their two small children) sitting around the table, sewing and packing, making last-minute preparations the *night before* their deportation to Auschwitz. As we watch, a female voice recites the list of personal articles to be allowed each deportee: a mug, a spoon, a work suit, a pair of work boots, two shirts, a pullover, two pairs of underwear, two pairs of socks, two blankets, a napkin, a towel, and toilet articles. In this intonation of the details of the everyday, Forgács brings us face to face with Arendt's banality of evil. This summons from the Jewish

Emigration Office, with its promised relocation to labor camps, is a rhetorical ploy to placate those being mobilized for the Final Solution. The cheerful resolve of the Peerebooms in these last images testifies to that tactic's success.

This last scene (and it is, for contemporary Jews, very much a primal scene) best illustrates Forgács's achievement. At the fifty-seven-minute mark, after nearly an hour of intensifying emotional investment (we are, after all, guests at Peereboom weddings, family outings, and the baby's first steps), we are privy to what feels like the final moments of European Jewish family life. It is a historical spectacle that is both general and particular. The Hungarian Marxist critic Georg Lukács once wrote that "the goal for all great art is to provide a picture of reality in which the contradiction between appearance and reality, the particular and the general, the immediate and the conceptual . . . is so resolved that the two converge into a spontaneous integrity."[23] *The Maelstrom* approaches that goal, evoking the fate of the 120,000 murdered Dutch Jews through the detailed depiction of one family in extremis. Max Peereboom's camera records his wife, his mother-in-law, his daughter, nothing more; these images are limited by an all-too-imperfect knowledge of events about to unfold. But Forgács has prepared the way for the metonymic leap to the world historical, craftily expanding the historical canvas along the way by counterposing to the Peereboom material scenes of Crown Princess Juliana's wedding, and amateur footage of a National Socialist youth storm camp and of a Dutch Nazi training camp in Terborg. Finally, and with increasing frequency, Forgács interweaves the home-movie footage of a second family: that of Arthur Seyss-Inquart, an Austrian Nazi Party minister appointed Reich commissioner for occupied Dutch territories.

By the late 1930s, Seyss-Inquart is, like Jozeph Peereboom—the pater familias and editor of a Dutch Jewish newspaper, the *Nieuw Israelietisch Dagblad*—a successful man, a proud father, and a doting grandfather. We are shown footage of them at play with their respective families; the home-movie tropes—the waving, the smiling, the skipping toward the camera arm in arm, the display of progeny—are nearly identical. But this parallel construction is also a collision course. In rapid succession, Seyss-Inquart's decrees limit Jews' participation in Dutch public life, deny them access to public places or institutions, expropriate their wealth, terrorize and arrest individuals in nighttime raids, evacuate and resettle Jewish families from across Holland to an Amsterdam ghetto, and finally deport them to death camps across Europe. (The fates of the elder Seyss-Inquart and Peereboom diverge dramatically before converging again in the premature deaths of each; Seyss-Inquart will be executed after the

Nuremburg Trials.) At one point, we even see a jauntily clad Seyss-Inquart playing tennis with Heinrich Himmler, master executioner and the very man who boasted that he would succeed in making the extinction of the Jews "a never-to-be-written page in history."[24]

It is in this way that Forgács succeeds in constructing the Peerebooms at the pivot point of the general and particular and as the agents of a fateful historical drama in the manner prescribed by Lukács in his influential essay "Narrate or Describe." Lukács is at pains to contrast the representational tactics of such naturalist novelists as Flaubert and Zola, who gloried in meticulous description, with the epic sweep of the master narrators, Scott, Balzac, and Tolstoy. In the great novels of the latter group, "we experience events which are inherently significant because of the direct involvement of the characters in the events and because of the general social significance emerging in the unfolding of the characters' lives. We are the audience of events in which the characters take active part. We ourselves experience these events."[25] No longer merely passive recipients of the facts of annihilation, in Forgács's film we are ushered into the heart of the maelstrom, shown something of what life looked like for those trapped within, and allowed to share the last moments of one Dutch Jewish family from among the tens of thousands sent to their deaths.

I would argue for Forgács's work as a radical intervention in the Holocaust film as genre; it also poses a challenge to canonical historiography. Hayden White has argued that the rationalist bias of history as discipline and institution has exacted a cost from its practitioners, who have tended to repress both the conceptual apparatus of their discourse and the poetic moment of their writing.[26] I would make comparable claims for documentary as it has evolved over the past fifty years. First through the emergence of direct cinema and then through the evolution of the interview-based history film (films, in short, of the observational and interactive modes), what I have elsewhere called the analytic and expressive functions of documentary have remained largely underdeveloped.[27] Forgács's work, indebted to a tendency Peter Wollen long ago identified with the European (as opposed to the North American) avant-garde (i.e., Straub, Godard, Kluge), engages both with formal innovation and analytic rigor. It is as Wollen described it in his influential essay "The Two Avant-Gardes": "In a sense, Godard's work goes back to the original breaking-point at which the modern avant-garde began—neither realist or expressionist, on the one hand, nor abstractionist, on the other. In the same way, the *Demoiselles d'Avignon* is neither realist, expressionist or abstractionist. It dislocates signifier from signified, asserting—as such a dislocation must—the primacy of the first, without in any way dissolving

Figure 5.1 *The Maelstrom.* The family gathers for their last meal before boarding a train bound for, they believe, a work assignment in Germany. Such trains carried Jews to their death camps organized by Heinrich Himmler.

the second."[28] *The Maelstrom* approaches one perilous slice of Europe's past without in any way attempting to encapsulate it. Its evocation of an irrevocable history—one family's demise—offers neither explanation nor escape. Yet historical meanings accumulate. Signification is dislocated but not dissolved.

Through his practice, Forgács displays an active concern for what White has called the conceptual apparatus (functioning as a reflexive historiographer deeply conscious of his methods) and for the expressivity of the ensemble of visual and acoustic elements. Furthermore, it is a collaborative poetic practice given the crucial role played by composer Tibor Szemzö about which much more deserves to be said. Instead, I will close by stressing Forgács's dual allegiance to historical accountability (his function as witness–scribe) and to the poetic. His work is best situated in relation to a range of allied, time-based art practices developing in Europe since the late 1970s: avant-garde theater and performance art, minimalist music, and experimental film.

In *The Maelstrom*, Forgács has concretized a metaphor of overwhelming natural disaster in which the films' protagonists are embroiled. It is the work of the film to show that these catastrophic events were, on

the contrary, wholly man-made. The film opens with grainy footage of massive waves crashing over the breakwater. Simultaneously attracted and repelled by the violence of the surf, a high-spirited throng races in and out of harm's way, testing themselves against the sea. This is the watery version of the oft-cited whirlwind of history into which Dutch Jewry will soon be caught. But it is Forgács's innovations with the film's temporality that most distinguish his efforts to materialize and concretize the maelstrom metaphor. Through the rigor of his conceptualization and the editing of so many densely layered visual and auditory elements, Forgács creates what he has called "time swirls."[29] The fictive Peerebooms are caught up in vertiginous temporal overlaps, loopings, and juxtapositions just as history had caught up the flesh-and-blood Peerebooms in its coils.

In a new century, the Holocaust remains a seemingly inexhaustible source of traumatic memory, psychical investment, projection, historical reinterpretation, and high-pitched debate. In his monumental book *Zakhor: Jewish History and Jewish Memory*, Yosef Hayim Yerushalmi has shown how, from the destruction of the second temple in 70 A.D. to the nineteenth century, the Jewish people have consistently chosen myth over history. It has been a mixed blessing. These myths have been life sustaining across centuries of diasporic dispersal; at other moments— including, Yerushalmi argues, at the brink of the Shoah—these myths have tragically hindered survival. At this moment, he writes, "the burden of building a bridge to his people remains with the historian."[30] The work of Péter Forgács is a bridge-building labor. *The Maelstrom* in particular functions both as a self-critical act of historical interpretation and as a formally innovative work of art, the affective powers of which engender both understanding and empathy. In it archetype is displaced by testimony, metaphor is actualized, and the unimaginable enters history.

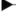

NOTES

1. James E. Young, *Writing and Rewriting the Holocaust: Narrative and the Consequences of Interpretation* (Bloomington: Indiana University Press, 1988), 127.
2. Ibid., 83–98. It is important to add that there have been passionate debates about the appropriateness of the term "Holocaust" ("Shoah" and "churban" have alternatively been proposed) to describe the catastrophe of European Jewry during World War II because the word is etymologically linked to notions of sacrifice and burnt offering closer to Christian theological traditions than to Jewish ones.
3. Hayden White, "The Modernist Event," in *The Persistence of History: Cinema, Television, and the Modern Event*, ed. Vivian Sobchack (New York: Routledge, 1996), 30.
4. Young, *Writing and Rewriting the Holocaust*, 21.
5. Robert Scholes, *Structural Fabulation* (Notre Dame, Ind.: University of Notre Dame Press, 1975), 7.
6. Young, *Writing and Rewriting the Holocaust*, 21.

7. Alvin H. Rosenfeld, *A Double Dying: Reflections on Holocaust Literature* (Bloomington: Indiana University Press, 1980), 27.

8. Primo Levi, *Survival in Auschwitz: The Nazi Assault on Humanity*, trans. Stuart Woolf (New York: Simon & Schuster, 1993), 9.

9. See, in this context, Shoshana Felman and Dori Laub, *Testimony: Crises of Witnessing in Literature, Psychoanalysis, and History* (New York: Routledge, 1992), 57–74.

10. Young, *Writing and Rewriting the Holocaust*, 18.

11. There has been a great deal of writing on the tradition of the *testimonio* in Latin American literature, which emphasizes the unique collaboration between the narrating source, a peasant or subaltern who is either illiterate or without access to writing, and the translator-facilitator who brings the story to a reading public. This tradition has been extended to include the testimonial writing from other marginalized positions (that of feminists, gays, and people of color), as well as the variability of the videographic testimonio. See, in this regard, John Beverly, "The Margin at the Center: On *Testimonio* (Testimonial Narrative)," in *De/Colonizing the Subject: The Politics of Gender in Women's Autobiography*, ed. Sidonie Smith and Julia Watson (Minneapolis: University of Minnesota Press, 1992), 91–114; Chon Noriega, "Talking Heads, Body Politic: The Plural Self of Chicano Experimental Video," in *Resolutions: Contemporary Video Practices*, ed. Michael Renov and Erika Suderburg (Minneapolis: University of Minnesota Press, 1996), 207–28. The status of *The Maelstrom* as testimonial discourse depends on seeing the Peerebooms as having access to the means of representation but, due to their premature deaths, having no access to the historical record. The film is akin to the diaristic accounts left behind by others who perished: Anne Frank, Moshe Flinker, and Chaim Kaplan. What sets this piece apart is the role played by Forgács, who, in exhuming the home-movie footage for a contemporary audience, facilitates the delivery of compelling testimony while forging from the Peereboom footage, other archival materials, and diverse acoustic elements a deeply moving work of art. From the perspective of the testimonial value of *The Maelstrom*, Forgács could be termed the artist-facilitator of the work.

12. Theodor W. Adorno, "Cultural Criticism and Society," in *Prisms*, trans. Samuel and Shierry Weber (Cambridge, Mass.: MIT Press, 1988).

13. Both Weisel quotations are cited in Rosenfeld, *A Double Dying*, 14, 27.

14. Eric L. Santner, "History beyond the Pleasure Principle," in *Probing the Limits of Representation: Nazism and the "Final Solution,"* ed. Saul Friedlander (Cambridge, Mass.: Harvard University Press, 1992), 144.

15. See in particular Yosefa Loshitzky, ed., *Spielberg's Holocaust: Critical Perspectives on "Schindler's List"* (Bloomington: Indiana University Press, 1997).

16. Young, *Writing and Rewriting the Holocaust*, 18.

17. Note that the Holocaust documentary escapes a recurrent critique of its own, namely, that it risks further dehumanizing the victims of Nazi terror through their imaging. Who is harmed by this presumed ethical breach? The dead, their surviving family members, and the audience.

18. Joris Ivens, *The Camera and I* (New York: International Publishers, 1969), 88.

19. Brian Winston, *Claiming the Real: The Griersonian Documentary and Its Legitimations* (London: British Film Institute, 1995).

20. Roland Barthes, "Historical Discourse," in *Introduction to Structuralism*, ed. Michael Lane (New York: Basic Books, 1970), 145–55; Roland Barthes, "The Reality Effect," in *The Rustle of Language*, trans. Richard Howard (Berkeley: University of California Press, 1989), 147.

21. Hayden White, "Fictions of Factual Representation," in *Tropics of Discourse: Essays in Cultural Criticism* (Baltimore, Md.: The Johns Hopkins University Press, 1978), 121, 124.

22. Seven of Forgács's films have been broadcast in Germany by Arte: *The Bartos Family, Dusi and Jenö, The Diary of Mr. N, Either–Or, Free Fall, The Danube Exodus* (also broadcast by ZDF), and *Meanwhile Somewhere* (also broadcast by NDR).

23. Georg Lukács, "Art and Objective Truth," in *Writer & Critic and Other Essays*, trans. Arthur D. Kahn (New York: Grosset & Dunlap, 1970), 34.

24. See Heinrich Himmler, "Himmler's Summation, October 4, 1943," in *A Holocaust Reader*, ed. Lucy S. Dawidowicz (New York: Behrman House, 1976), 133.

25. Georg Lukács, "Narrate or Describe," in Kahn, *Writer & Critic*, 116.

26. See Hayden White, "The Modernist Event."

27. Michael Renov, "Toward a Poetics of Documentary," in *Theorizing Documentary*, ed. Michael Renov (New York: Routledge, 1993), 12–36.

28. Peter Wollen, "The Two Avant-Gardes," in *Readings and Writings: Semiotic Counter-Strategies* (London: Verso, 1982), 100.

29. Personal correspondence with the author, July 11, 2000.

30. Yosef Hayim Yerushalmi, *Zakhor: Jewish History and Jewish Memory* (Seattle: University of Washington Press, 1982), 100.

KAJA SILVERMAN

[6] *Waiting, Hoping, among the Ruins of All the Rest*

"Atget . . . photographed [the deserted streets of Paris] like scenes of crime,"
Walter Benjamin wrote in 1939. "A crime scene, too, is deserted; it is
photographed for the purpose of establishing evidence."[1] These might not
be the first words that come to mind when we are looking at Atget's work,
but they do describe the kind of photography that tends to be accorded
historical value, especially when what is being reconstructed is an atrocity.
Péter Forgács's video films focus on periods of extraordinary upheaval and
cultural loss—World War II and the establishment of east-bloc Commu-
nism. They also attest to the "having-beenness" of what they depict. This
attestation, though, is ontological and psychic, not social, legal, or political.

Forgács's video films are constructed almost entirely of home-movie
footage shot by amateur photographers between 1929 and 1969. A home
movie is generally meaningful only for a small community.[2] It focuses on
emotionally charged moments, and with the exception of occasions like
weddings, when the private becomes public, it is more concerned with
personal than with social events. The home movie also perpetuates the
"cult of remembrance" that Benjamin associates with early photography;
the "fleeting expression" of a human face "beckons" from its images,
giving them "melancholy and incomparable beauty."[3] This beauty is mel-
ancholy not only because the "expression" is "fleeting" but also because
the *look* is; because those capable of recognizing this face will soon
disappear. For later generations, it will be as strange as the unremembered
grandmother described by Siegfried Kracauer.[4] Finally, as Forgács himself
notes, because of its mysterious ellipses and the primacy it gives to visual
communication, the home movie "recalls the structure of dreams, its sys-
tem of symbols, and the means of the dream work."[5]

Forgács uses home movies rather than more conventional kinds of
documentary images because he is not interested in recounting history

in any of the usual ways. The big moments of the twentieth century are always present in his films; we are never allowed to lose sight of the fact that the people whose images we see have been engulfed by the fires of National Socialism or Soviet power. However, these large-scale events remain curiously decentered. Forgács generally informs us about them only intermittently, and even then through a government announcement, the text of a law, a radio broadcast, white titles, or a disembodied voice-over. The image track is also almost always in thematic tension with official history, and the filmmaker throws his aesthetic weight behind the former rather than the latter, either through the music, the titles, or another, more personal voice-over.

Forgács marginalizes official history for several reasons. First of all, he wants us to understand that time does not unfold through a collective narrative. What Lyotard calls the *grands récits*[6] are in a sense tenant-less structures; no one really lives there, either when they are happening or later. This is not only because each of us inhabits a unique position in the world, both factually and mnemonically, but also because we all experience a different *duration*. For the couple in *Dusi and Jenö* (1989), time is measured according to the years of their dogs' lives rather than the length and defining events of the war. For the soldier-photographer in *Land of Nothing* (1996), time is defined by the time between battles and the brief periods at home instead of the time spent fighting. And for the mother in *Diary of Mr. N* (1990), the birth of a new child constitutes a far more important temporal marker than any contemporaneous political event. Because of the coexistence of multiple durations, there is a kind of inexhaustibility to the period 1929–1969 and hence a permanent open-endedness to Forgács's project.

The author of Private Hungary also refuses to give National Socialism and Hungarian Communism center stage because of what happened when its narratives triumphed over personal memory, and its time over subjective time. Both political systems attempted not only to kill everyone who did not fit inside their master narratives, psychically as well as physically, but also to eradicate every form of difference, whether social, political, philosophical, aesthetic, economical, domestic, or libidinal. The primary signifiers in Forgács's work for the totalitarianism of east-bloc Communism are the many shots of Hungarians marching in unison on the occasion of May Day and other political holidays in *The Bartos Family* (1988), *The Diary of Mr. N*, and *Either-Or* (1989). Over the images of a state-organized parade in the last of these films, Forgács says ironically, "Hurrah to the liberation, the Red Army. Hurrah, May the First. Hurrah to Stalin, the guardian of world peace. Death to imperialism."

The primary signifiers of National Socialist totalitarianism in Forgács's work are the shots in *The Bartos Family* and *Wittgenstein Tractatus* (1992) of citizens rapturously greeting Hitler after the German annexation of Austria with their arms raised in a group salute; the images of the Peereboom women sewing clothes in preparation for their trip the night before their deportation to Auschwitz in *The Maelstrom* (1997); and the words of a poem by the great Hungarian poet, János Pilinszky, read aloud by the poet himself near the end of *Land of Nothing*:

> Who is being led up? I don't know.
> Who is leading up? I don't know.
> Slaughter-house or scaffold? I don't know.
> Who kills and whom? Man kills animal,
> or animal kills man? I don't know.
> And the fall, the unmistakable,
> and the silence afterward? I don't know.
> And the snow, the winter-snow? Perhaps
> exiled sea. God's silence. ("Scaffold in Winter")

Forgács acknowledges that private life is often socially stage-managed. In *Kádar's Kiss* (1997), he cross-cuts between images of a Sovietized Budapest and erotic photographs and films clips from the same period. At first the well-endowed women are a welcome alternative to the bleakly industrialized city, but before long this opposition collapses. Their poses are all too predictable, and they themselves more and more inter-changeable. Forgács also acknowledges that private life can be a way of dodging responsibility for—or even acquiescing to—political horrors. In *Meanwhile Somewhere* (1994), his cross-cultural montage of private life in Europe during the war, he shows us civilians going about their customary business as pro-Nazi graffiti are written on walls, Jews are deported to Westerbork, and Greeks are injured and killed by the German occupying force. We also see a man playing golf before well-dressed and well-fed spectators at the 1943 Hamoire Golf Prix in Belgium; actors in eighteenth-century dress at the twelfth wedding anniversary of a wealthy couple's marriage; and topless French dancers performing at the Moulin Rouge during the German occupation.

But Forgács circles back repeatedly in this last film to a clip of a German boy and a Polish girl having their heads publicly shaved as a punishment for their amorous relationship.[7] (See Figure 1.2.) The boy is forced to wear a placard saying, "I am a traitor of the German people," and the girl one that reads "I am a Polish pig." The man shaving her head leaves one strand of hair on her head and twists it into an ursine curl.

Figure 6.1 *Kádar's Kiss*. Forgács creates a collage of erotic photography and documentation of the ruin of Budapest; the nude image may distract from the social destruction as well as comment on the obscenity of war.

Forgács also makes a lot of room in *Meanwhile Somewhere* for unorganized kinds of leisure activities. He directs an appreciative look at an old woman getting tipsy and dancing, a man and his son bathing in an outdoor bathtub, a wrestling match between a middle-aged man and woman, ice skaters moving elegantly across a frozen lake, and a bedridden mother and her loving daughter sharing a bunch of grapes. And he pits these scenes of private enjoyment not only against those that are culturally orchestrated but also against the sound of Goebbels saying to the German people, "Do you want a total war?"

Forgács also distinguishes between wayward desires and those that are socially compliant. In *Either-Or*, he cuts back and forth between erotically charged images and images that are evocative of Hungarian Communism, just as he does in *Kádar's Kiss*, but instead of showing us pin-ups, he focuses upon Mr. G's two loves, his daughter, Baby, and his best friend's wife, and rather than inserting these two figures into repetitive series, he singularizes them. Forgács slows down the footage of the friend's wife so that we have time to understand her beauty and freezes it at moments of special radiance. He also pays homage to Baby through one of the most exquisite sequences in all of his work. In this sequence, which comes at the end of *Either-Or*, Baby performs on a revue stage as a member of a chorus line. Forgács accompanies her movements with sounds evocative of stage music and dancing feet but isolates her from the other performers by means of a spotlight, as if she were the star of the show. He then turns this spotlight into a moonbeam by eliminating all sounds

Figure 6.2 *Either-Or.* During this sequence the baby looks up at the camera, establishing a complicity between father and daughter in her tawdry performance.

except those made by a lonely xylophone and showing Baby dancing alone on the stage, in slow-motion. This tawdry little performer consequently shines as brightly for us as she did for her photographer father.

It might seem shocking that Forgács would treat Mr. G's erotic objects so tenderly, given that one was married to his best friend and the other was his daughter. But it is precisely *because* of the social opprobrium that attends such desires that he privileges them; they constitute a space apart from normative culture, much like the German boy and the Polish girl in *Meanwhile Somewhere.* Both women are also impossible loves. Mr. G is separated from Baby by the fourth wall and from his friend's wife by both her husband and children.

Forgács makes his subtlest distinctions between the public and the private in *The Diary of Mr. N.* Mr. N, the photographer whose story the film recounts, was an engineer for a large Hungarian munitions company. Since this company helped to arm the Wehrmacht, it was directly linked to National Socialism, but it also functioned as a kind of collective, with group gardens, outings, and Christmas celebrations. Mr. N's photographic practice straddled the same divide; from 1938 to 1953, he shot newsreel-like footage of political figures and events *and* personal footage of himself, his wife (Ilona), and their children. During his and Ilona's

Figure 6.3 *The Diary of Mr. N.* The happy couple, Mr. N and his wife, Ilona, present their bounty of apples but Forgács juxtaposes these idyllic shots with Mr. N's far less sanguine shots of totalitarian repression.

extensive postwedding travels, Mr. N filmed several orthodox Jews in Carpathian dress. One of them attempted to cover his face, as if to protect himself against an evil eye, and Forgács freezes this image for a moment, marking its significance. He also juxtaposes the shot of a Ukrainian concentration camp with one of Ilona picking flowers on the side of a mountain, and he zeroes in on their children in Mr. N's documentation of a Soviet-style May Day Parade.

However, Forgács cuts from this parade to a long sequence of family shots that document the passing of the years. We watch the children grow up, and Mr. N and Ilona move into middle, and then old age. In the final shot of the film, the elderly couple walk slowly toward the camera, holding heaping baskets of apples. Forgács returns only once to the world of politics, and when he does, it is to show us images of resistance rather than acquiescence or capitulation. He cuts in the middle of the family montage to shots of the 1956 Hungarian Revolution—a revolution that was brutally crushed by the Soviets. No voice-over links the images of tanks and dead Russian soldiers back to Ilona and the family, but the conclusion that we are asked to draw is clear: this radiant mother and her eight children constitute at least a *potential* source for this resistance.

Most of the footage in Forgács's video films was intended to be shown only to family members and friends. By transforming this material into public texts, he exposes it to the eyes of strangers. This is, however, not merely ethically justifiable but ethically *imperative*. Because there is no one left to remember them, most of the people who appear in Forgács's source material have died twice—once physically and once mnemonically. The first of these deaths is irrevocable, but the second is not. The photograph, as André Bazin suggests, stores its forgotten referent in the "hold of life."[8] And like the souls trapped in an animal, plant, or inanimate object, this prisoner waits for someone to break the spell by recognizing her. If we are able to respond to this appeal, she "overcome[s] death and return[s] to share our life."[9] We have the capacity to provide this recognition even when we do not know the person who is soliciting it because it is *ontological* in nature; it is the kinship that follows from being "inscribed" in the "same order of being"—part of the same "flesh."[10]

I take this last concept from Merleau-Ponty, who uses it to account for the "art" of responding to the visible "according to its wishes."[11] The flesh is "the generality of the Sensible in itself"—the "incarnate principle" out of which both seer and seen emerge and makes each the "rejoinder" to the other.[12] Although Forgács does not use this language, he has a similar understanding of being. "I am the river Danube"; he says in an extraordinary conversation with Scott MacDonald, "I'm the Germans *and* I'm the Jews."[13] His work also helps *us* to experience *our* "intercorporeity."[14] How does a filmmaker who so consistently opts for the private over the public promote this kind of kinship? In two quite different ways: by depersonalizing affect and by making our psyches the receptacle for other people's memories. *Wittgenstein Tractatus* and *Bourgeois Dictionary* are striking instantiations of the first of these aesthetic strategies, and *Free Fall* (1996) of the second.

Wittgenstein Tractatus consists of seven sequences, each of which is a compilation of home-movie footage from a number of unidentified sources, accompanied by a hypnotic musical score by Tibor Szemző and Forgács's own voice-over, which hums along with the music, and recites a number of pregnant lines from Wittgenstein's *Tractatus*. Because the sands of the philosopher's thought are constantly shifting,[15] Forgács is able to use this text to represent three very different ways of being in the world. He begins with some of the philosopher's most famous utterances, all of which stress the primacy of human consciousness over the world ("the world is everything, that is the case"; "the world is the totality of facts, not things"; "the world is determined by the facts, and these being all the facts"; "what the picture represents is its sense"; and "the picture is

a model of reality"). Before long, though, this mental kingdom turns into a prison ("the limits of my language are the limits of my world"; "how hard I find it to see what is in front of my eyes"), and eventually the world asserts its priority over human thought. In this final series of quotations, what is important is the world's *being*, not the *meaning* we impute to it. "There is indeed an inexpressible," Forgács declares. "It shows itself. It is the mystical . . . not *how* the world is, is the mystical, but *that* it is . . . whereof one cannot speak, thereof one must be silent."

The word "picture" appears twice in the first cluster of quotations from the *Tractatus*, and both times it underscores the representational status of visual perception. Each of the seven sequences of the film begins with the pieces of an image coming together and ends with the dismantling of another image. Initially, this seems to be Forgács's way of extending the word "picture" to the home-movie footage—of saying that it, too, is only a representation. However, the people and animals in these images start to move before the images themselves are fully assembled, indicating that they were before we glimpsed them, and that they have been waiting for us to look at them. There are throngs of these unseen beings, and Forgács brings them and us together through three other lines from Wittgenstein: "no cry of torment can be greater than the cry of one man"; "no suffering can be greater than a single being can suffer"; and "the horrors of hell can be experienced in a single day—that's plenty of time."

Forgács delivers the second sentence immediately after the first and accompanies both of them with the shot of a man pushing a helpless pig back and forth on the ground with his booted foot. If no cry of torment can be greater than one man's cry, this must mean that each man's cry contains the cry of every other man. The next sentence broadens this claim by extending it to all beings and to pain that cannot express itself as a cry. The third line comes later in the film and is a temporal amplification of the second; through it, Forgács tells us that even an *instant* of another being's suffering contains all the horrors of all our hells. This sequence is also a numerical amplification of the earlier one; as Forgács speaks, we see two different men pushing around the pig with a booted foot.

These three lines I have just quoted derive a great deal of their intensity from the images that accompany them. The former also shape our reading of the latter. In his interview with MacDonald, Forgács reveals that this footage comes from a veterinary documentary about a nerve disease, but that is not how we read it. What we see—as Davis suggests—is "a dying pig rolled over and over on National Socialism."[16] And that is not all that happens when the three lines from Wittgenstein are combined with the shot from the veterinary documentary. Pigs are

very fleshy animals, and we recoil from them not only because our culture valorizes leanness but also because they materialize another kind of flesh: the kind out of which we all emerge. When we characterize someone as a pig, we not only dehumanize that person but also deny our own kinship to this lower species. Forgács undoes this denial when he says "no cry of torment can be greater than the cry of one man" over the shot of the pig being pushed back and forth by the human foot because it is impossible not to see its suffering as the carnal expression of the cry that contains all human cries—and this corporealization paves the way for the next two sentences.

In *Bourgeois Dictionary*, Forgács again assembles home-movie footage from a number of different sources, withholds the biographical information that would permit us to overcome its anonymity, combines it with a mesmerizing musical score by Szemző, privileges what escapes signification, and depersonalizes affect. This time he uses his material to create an encyclopedia of bourgeois Hungarian culture from 1930 until its demise in Communism by organizing his material into generic clusters, under verbal headings. It is, however, a very strange encyclopedia, because instead of slotting the footage into preestablished categories, Forgács allows it to determine what the categories will be. Most of them are sui generis and some as bizarre as the ones enumerated in a famous passage from Foucault.[17] "A as in amnesia, annexation. 1938 Graz," Forgács writes over the image of a flayed mouse. "Maid, maid, Hungary," he inscribes over an outdoor lunch scene.

Forgács trespasses on people's conversations by reading their lips and sharing the results with us, but he does not use these words to create psychological interiority. Nor does he attempt to extract any other kind of meaning from them. But although these scraps of speech are nonsensical, and there are no psyches to which we can refer them, they still convey a lot of affect.[18] And since *Bourgeois Dictionary* proceeds associatively, with each shot picking up on something in the preceding one, all these unlocalizable affects seem to be waves of the same being.

Although Forgács is as unwavering in his commitment to anonymity here as he is in *Wittgenstein Tractatus*, there are two occasions when he *singularizes* affect. In the first of them, a man in a white suit tries to type a manuscript, and his wife and children do their best to interrupt him. Forgács accompanies this sequence with the following words from Dezső Kosztolányi's *Autobiography*: "I was born and I will die. Light. Stairs. Decsi. Brenner . . . Greatest experience. Talent. Kidding. Shakespearean. Casino garden . . . Onanism. WC . . . Our maid, Maria, idol of my heart. My brother had a bump on the head. Poor teacher. My father.

Berlin. Love. Booze." Although the word "I" figures prominently in most autobiographies, it only appears once in this passage, and when it does, it takes an impersonal form; we *all* were born, and we *all* will die. Kosztolányi spends the rest of the passage enumerating the things he loves, most of which he evokes through simple nouns. But although there is no grammatical subject to whom we can refer this economy of desire, it still retains all its specificity.

There are also three little self-contained sequences in *Bourgeois Dictionary:* "Irma and Elza," "My Sweet Parents," and "The Lover." Each derives from a single source and focuses upon an intimate, set of intimates (family members), or (in the case of "The Lover") a mistress. The first two sequences are accelerated montages; "Irma and Elza" shows us emblematic moments from the childhood and early adulthood of twin girls, and in "My Sweet Parents," a shot representing each of the last nine years in the lives of the photographer's parents. Although in both cases the footage is full of unique details, it tells us nothing about the person who photographed it, and its structure renders it archetypal.

There is, however, nothing typical about "The Lover." It also has temporal ellipses, but instead of eliminating the intervals between a number of different occasions, these ellipses condense a single occasion. The sequence also unfolds syntagmatically rather than paradigmatically. In it, a woman enters an apartment, warms her hands at a brazier, removes her outer garments, tidies up a bed, removes the rest of her clothing, and takes a bath. After soaking for a while in the water, she climbs out of the tub, dries herself off, goes to the bedroom, drinks a little glass of liqueur, and slips into bed. Although we never see the photographer, he is narratively present because the woman interacts with him constantly. She looks at him, shows herself to him, and even speaks to him. She also salutes him before drinking her aperitif, and once she is in bed, she signals to him to join her.

The camera's unsteadiness also renders the photographer *optically* present, as does what it focuses on, how long it remains there, and its sudden movements elsewhere. Every detail of what we see attests to the particularity of his desire. This perceptual singularity does not diminish the generality of the sensible. It is, on the contrary, part of it. The look stylizes[19] even before there is subjectivity—and it does so in a way that is both utterly distinct and in constant communion with the visible world.

"The landscape thinks itself in me, and I am its consciousness," Cézanne is purported to have said.[20] If he were to offer to perform this service for us, most of us would be offended, since we are thinking beings. However, since we—like the landscape—can only be seen from the

outside, we cannot provide the consciousness for which our appearance calls; our body must also think itself in others. This is why Merleau-Ponty spends so much time talking about the "art" of responding to the visible world "according to its wishes." He offers his richest account of this art in "Indirect Languages and the Voices of Silence," and since it features an anonymous woman, I will reproduce most of it here:

> A woman passing by is not first and foremost a corporeal contour for me, she is . . . a certain manner of being flesh which is given entirely in her walk or even in the simple click of her heel on the ground . . . a most remarkable variant of the norm of walking, looking, touch and speaking that I possess in my self-awareness because I am body. If I am also a painter . . . there will be [in my painting of her] the emblem of [her] way of inhabiting the world . . . [And although this] truly pictorial style and meaning [will not] be in the woman seen—for in that case the painting would already be completed—they [will] be at least called for by her.[21]

Since we can only look in this way when there are stylistic affinities[22] between us and what we see, and since we often fail to do so even when there are, many beings disappear without ever having found the consciousness within which they can think themselves. The woman in "The Lover" is one of the fortunate few. She found the look for which her body called, and the camera did what no paintbrush can do: it recorded both the call and the response.[23]

Many of Forgács's other video films derive entirely (or almost entirely) from a single source. They also reconstruct the photographer's story, place this story within a larger historical narrative, and proceed in a linear fashion. Since I came to Forgács's work through *Wittgenstein Tractatus* and *Bourgeois Dictionary*, and I found their phenomenological project so immediately compelling, I was initially disappointed by the biographical specificity of these other films. However, when I returned to this work at a later moment in time, after reading Primo Levi and Charlotte Delbo, I saw how necessary it is. As Merleau-Ponty notes,[24] it is a "primordial property" of the world to be both a "universal" and an "individual"—and the most effective way of denying the first of these principles is by negating the second.

The death to which National Socialism subjected six million Jews and a vast number of other people was the last stage in a process of an extreme de-individuation. It occurred only after the deportees had been stripped of freedom, name, family, dignity, symbolic position, possessions, clothing, hair, and identity papers. And this was only part of a larger assault on temporality. Whether or not they were given over to mass murder, the Nazi camps functioned to abolish the future. The death

camps did so by terminating life, the concentration camps by abolishing tomorrow. In his book *Holocaust Testimonies: The Ruins of Memory*, Lawrence L. Langer quotes the following remark from a camp survivor: "In normal life, you think about tomorrow and after tomorrow and about a year, and next year a vacation. . . . Here you think on the moment what it is. What happen *now*, on the moment. *Now* is it horrible. You don't think 'later.'"[25] Primo Levi describes the same temporal constriction in *Survival in Auschwitz:* "For everybody, the moment of entry into the camp was the starting point of a different sequence of thoughts, those near and sharp, continually confirmed by present experience, like wounds re-opened every day. . . . For us, history had stopped."[26]

The aim of this project was not simply the erasure of the personal past but also its replacement by a series of standardized and undifferentiated recollections. As James E. Young puts it, "Hitler never planned to 'forget' the Jews, but rather to supplant their memory of events with his own. Total liquidation would not have come through the Jews' physical annihilation only, or in the expunction of all reference to them afterward," but only "by eradicating the Jewish *type* of memory."[27] Young's invocation of a "type" in this context may seem worrisome, not only because of its racial connotations, but also because the memories the National Socialists most desired to stamp out were individual. It should not be forgotten, however, that it was a Jewish writer who first described for us the operations of personal memory, and who helped us to understand its importance: Marcel Proust.

In *Swann's Way*, Proust insists upon the radical particularity of each of his unconscious recollections and upon his unwillingness to relinquish even the smallest of their details. "If I were seized with a desire to revisit the Guermantes way," he writes, "it would not be satisfied were I to be led to the banks of a river in which there were water-lilies as beautiful, or even more than, those in the Vivonne . . . what I want to see again is the Guermantes way as I knew it, with the farm that stood a little apart from the neighboring farms, huddled side by side, at the entrance to the oak avenue; those meadows in which, when they are burnished by the sun to the luminescence of a pond, the leaves of the apple-trees are reflected; the whole landscape whose individuality grips me . . . with a power that is almost uncanny."[28] This and other passages from *In Search of Lost Time* encourage us to understand the phrase "Jewish type of memory" as a synonym for that type of memory the essence of which is to be atypical—and there is, ultimately, no other kind.

The Nazi assault on its victims' memory was terrifyingly effective. The narrowing down of the forced laborer's optic to the now, along

with the routinized nature of her daily existence, meant that the only past to which she could have access was one that was a mirror image of the present. And the brutally public circumstances under which she was forced to eat, work, and sleep, along with the fact that the same activities were simultaneously repeated by countless others around her, meant that even this past was one to which she could make no personal claim. Even someone as determinedly protective of her past as Charlotte Delbo was could feel it fading away and being replaced by the "commonplaces" of the camp. "My memory finds only clichés. . . . Where are you, my real memory? Where are you, my earthly memory?" she cries at one point.[29]

It was not only during their internment that the inmates of German concentration camps had difficulty accessing and retaining what was most specific to themselves but also afterward. Levi writes that survivors generally belonged to one of two groups: those who could remember only their camp experiences and those who had virtually no access to the past.[30] It is hardly surprising, in light of National Socialism's attack on memory, that many of the first camp memoirs should have recounted the same story and adhered to the same formal conventions.[31] The crucial project with respect to this period is the recovery of these lost memories, not the establishment of an objective account of what happened in the camps.

The notion that it is only through remembering that we can achieve a lasting victory over National Socialism is hardly new. It is the informing assumption behind most camp testimonies, Jewish museums and memorials, and scholarly books on the Holocaust. The reasons for this are many. First of all, many camp memories were traumatic in nature. They retained the perceptual vividness of the experiences to which they attested and returned with compulsive and incapacitating regularity. These memories had to be repeated in a linguistic form in order to be domesticated or bound.[32]

Survivors also needed to rearticulate the terms of the group identity that had been imposed upon them by the Nazis—to effect the transition from thinking of themselves as helpless members of a despised race to seeing themselves precisely as survivors. They could only do so by recalling what they had lived through and somehow triumphed over. Verbal memories of the camp were also the primary means both of communicating with the others with whom one had shared so much and of escaping the isolation to which reentry into civilian life so often led. Almost immediately, for better or for worse—and it was in my opinion for the worse—they also became the legacy around which a new nation cohered: the nation of Israel.

For many survivors, verbal recollection also initially constituted a way of bearing witness about the camps to those who did not know—or

did not want to know—about the Final Solution. As Levi writes early in *Survival in Auschwitz,* "The need to tell our story 'to the rest,' to make 'the rest' participate in it, had taken on for us, before our liberation and after, the character of an immediate and violent impulse, to the point of competing with our other elementary needs. [This] book has been written to satisfy this need."[33] With the deaths of many survivors, and the aging of the rest, this project has assumed a renewed urgency. It has also assumed a new function: the function of transmitting a crucial legacy from the dying to those who will live on in their stead.

But can those who weren't there bear witness to what happened in the camps? Do they not lack the necessary experiential base? Levi suggests that this question could also have been posed to the survivors themselves. The simple fact that they were still alive when the camps were liberated shows that they did not touch bottom—that is, they never fully occupied the nonplace into which the Nazis attempted to insert them. Those who did were immediately consigned to death, first psychically, and then physically. The closest a survivor could come to witnessing this void at the heart of the concentration camps was to view it from the outside. This was a harrowing experience, since every concentration camp inmate feared becoming what the Nazis call a *"Muselman"* and because their captors preyed on this fear. Levi, however, bravely assumed this responsibility and testified to what he saw, underscoring the state of nondifferentiation to which National Socialism attempted to reduce its victims. "All the [*Muselmänner*] who finished in the gas chambers have the same story," he writes in *Survival in Auschwitz,* "or more exactly, have no story. . . . They . . . the drowned, form the backbone of the camp, an anonymous mass, continually renewed and always identical, of non-men who march and labor in silence, the divine spark dead within them. . . . They crowd my memory with their faceless presences, and if I could enclose all the evil of our time in an image, I would choose this image which is familiar to me: an emaciated man, with head dropped and shoulders curved, on whose face and in whose eyes no trace of thought is to be seen."[34]

But this is to present seeing and hearing in strictly negative terms—as a kind of second best when it comes to bearing witness. It is my view that these activities can give us not only rich and complex access to the past but also a unique kind of agency. By looking at and listening to what the victims of the camps have to tell us, we can lift them out of the nonplace to which the latter assigned them and return them to the world. We can thus make history happen again in a new way.

Dori Laub and Shoshana Felman provide us with a partial model for understanding the performative possibilities inherent in the activities of

looking and listening. They suggest that a camp testimony is more than a description of what happened there. It is also an appeal on the part of the speaker to be recognized in a way that restores her subjectivity to her. As Laub puts it in "Bearing Witness or the Vicissitudes of Listening," "Testimonies are not monologues; they cannot take place in solitude. The witnesses are talking *to somebody:* to somebody they have been waiting for a long time."[35] It is primarily by being this somebody that we can keep faith with those brutalized by the camps.

Laub invokes Martin Buber's notion of the "thou" in an attempt to describe the kind of listener for whom the survivor is looking.[36] For Buber, there are two kinds of pronominal units: the "I/it," and the "I/ you." They constitute radically different ways of relating to other people. The word "you" is constitutive of personhood. When we address someone with this pronoun, we acknowledge her right to say "I" in turn. However, when we refer to her through the third-person pronoun, we relegate her to the position of a nonperson.[37] Although Buber does not say so, it would be hard to find a more exemplary version of the second of these relations than that adopted by the Nazis toward their victims; Jewish corpses did not represent for them the remains of human beings but rather "*Figuren*"—objects in another form.[38] What survivors are waiting for is the opposite of this: someone who is prepared to confer the "you" upon them. Within this original and important account of what it means to bear witness, the power to create subjectivity is shifted from the first-person pronoun to the second and from the activity of speaking to that of listening.

Laub claims that the analyst is the interlocutor for whom the survivor is searching because he provides the "blank screen" on which events can be "inscribed."[39] However, the analyst is more a symbolic than a real listener;[40] she occupies the position of an empathetically analytical auditor until the analysand is able to occupy this position herself—to listen to her own language.[41] And although the analytic dialogue can renew the performative potential of the analysand's "I," it is of no use to those who died in the camps, and it does nothing to help those outside it become better listeners. Finally, although the analytic exchange may liberate the analysand from her traumatic past, it cannot resurrect what was incinerated by the camps. Works of art can do what analysis cannot: transform their viewers and readers into *real* listeners, restore memories that have been reduced to ash, and create a place in the world for those to whom they once belonged. This is Forgács's project in *Free Fall*.

Most of the footage in *Free Fall* was shot by György Petö, one of the three sons of a bourgeois middle-class Jewish father and mother, and not

only a talented photographer but also a violin impresario and successful business man. The title of this video film describes its narrative arc: the steep and inexorable decline of the Petö family from 1937 until 1945 due to the gradual implementation of the Final Solution in Hungary. György survived both his labor service in the Hungarian army and his subsequent imprisonment in a Soviet camp. His wife, Eva, also returned from Auschwitz at the end of the war. However, their infant son was killed in the Neukirchen camp, and many other members of the Petö family also died in a Jewish ghetto or a German camp.

Most of György's home movies give little or no indication of the calamity that was unfolding when they were shot. Prior to his engagement, he filmed such events as his aunt's birthday party, the holiday activities of friends and family at Lake Tisza, the childhood of his niece and nephew, a dance, himself playing tennis, his thirty-third birthday party, and his family shoveling snow in a residential area of Szeged. He also shot a lot of footage of the Hungarian labor camp to which he and a number of his friends and relatives were sent in 1940, but the excerpts included in *Free Fall* are almost festive. The guards are clearly on excellent

Figure 6.4 *Free Fall*. This loving image of Eva clearly acknowledges the camera but not an instrument of surveillance or control. Behind the camera is Eva's lover and husband, György. Forgács restores what might have turned to ash and gives love, as well as memory, a place in the world.

terms with their prisoners, and the latter perform for the camera. Only the images documenting the construction and use of a primitive outdoor latrine and the guards' joking mimicry of the disciplinary measures that they know they should be enacting attest to the ever-greater encroachment of a hostile political order upon the private lives of its Jewish citizens.

Forgács intersperses György's home movies with newsreel footage dramatizing the very different events unfolding on the stage of history. He shows us images of Jews wearing the Star of David, a conversation between Hitler and Horthy, and the ghetto into which members of the Petö family were herded in 1944. He also provides factual information about such things as the annexation of Hungary to the Czechoslovakian highlands by Mussolini and Hitler, what happened to the Jews living in the parts of Yugoslavia that were appropriated by Hungary, the German occupation of Hungary, and the resulting atrocities suffered by György, Eva, and their families. But the most compelling way in which Forgács references what is absent from his source material is through Szemzö's liturgical score and the voice that accompanies it, which are situated somewhere between a Gregorian chant and a cantor. The voice recites the

Figure 6.5 *Free Fall*. The casual posture of the Jewish men forced to work in labor camps presided over by fellow Hungarians poses an unsettling quality since it is at such vivid odds with the brutality of the Nazi death camps.

anti-Semitic laws that were implemented during the German occupation of Hungary.

These laws effected an increasingly draconian expropriation of the bases of Jewish subjectivity. This expropriation began with restrictions on the numbers of Jews who could serve in various political offices and ended with decrees mandating the confiscation of all private property, the creation of a ghetto, and finally deportation. At first, there were a significant number of exemptions. War widows and those who had been soldiers in World War I were not to be included in the 20 percent limit placed on Jewish membership in the Chambers of Theatre, Film, Lawyers, Engineers, and Doctors that constituted the substance of the first law. This left Jewishness a rather amorphous category. However, over time Jewish identity was defined in more and more racial and biologically encompassing terms, until it held a substantial percentage of the Hungarian population in tight pincers. Race was also moralized; all non-Jewish Hungarian women were later deemed to be automatically righteous, who should under no circumstances copulate with Jewish men. In the event that they had already done so, their offspring were to be sacrificed for the sake of racial purity.

Figure 6.6 *Free Fall*. This scene of Eva caring for her and György's child, Andris, is one of several scenes in Forgács films that contrasts the innocence of and love for children with brutal anti-Semitism.

Although the Petö family was largely assimilated not just to Hungarian culture but also to the customs of the haute bourgeoisie, they moved through life as a collective unit for most of the period covered by *Free Fall*. After György married Eva, though, he began to focus his photographic energies on her, and after the birth of their first child, Andris, he also produced many baby portraits. Since much of this footage dates from the period in which the three of them were confined to a Jewish ghetto, the narrowing of György's photographic frame of reference could be read as the beginning of the process of atomization that the camps would complete. Forgács does the exact opposite. He dwells lovingly upon the images of Eva washing and feeding Andris, playing with him, and strolling with him in a baby buggy, and in an extraordinary sequence late in the film, he establishes the strongest-possible opposition between National Socialism and this little nuclear family.

This sequence begins with a shot of Andris in a tub of water. Eva lifts him out of the tub, dries him, and places him on a table. As she does so, Szemzö's singer recites the words of a law ordering all Jewish children over the age of six to wear a Star of David when leaving their homes and describing what form it should take. Since the child at whom we are looking is well under this age limit, he should be exempt from this barbaric law, but history has taught us otherwise; in the camps, babies were immediately separated from their mothers and put to death. We are therefore unable to prevent ourselves from attaching an imaginary Star of David to Andris's tiny, vulnerable body. And since all the infants we have ever known were also washed, dried, and placed on a flat surface afterward, and footage of these activities is a standard component in home movies,[42] we are unable to restrict this fate to him; what happens to Andris happens to all babies.

Before long, though, we begin to notice that Andris has a unique way of holding himself up with his arms when lying on his stomach and of interacting with his mother when she plays with him. He also manifests his vulnerability through a special kind of unsteadiness. The words sung by the cantor are now nullified not only by the typicality of this scene but also by the individuality of the baby who appears in it—and the two are really only variations of the same principle, since all children are unique and irreplaceable. Forgács does not end this sequence until Andris's idiosyncrasies are etched as sharply and ineradicably on our minds as they were on his parents'. If I have unconsciously slipped from the past tense to the present tense when describing this sequence, that is not only because it is standard practice when talking about films and novels but also because by securing a place within our memories, Andris has found his way back into the world.

Since György was the photographer who shot and edited "The Lover," Forgács shows it to us again in *Free Fall*. This time the sequence is a bit shorter, and some of its images are tinted or presented in a negative rather than a positive form. It also carries the date "1939," and it has a very different soundtrack. The first few shots are silent, but the rest are accompanied by liturgical music and a cantor singing the words of the most recent anti-Semitic law. Although this law purports to offer a religious definition of Jewishness, it is in fact completely biological. "That is Jewish," it reads, "who himself was or at least one of his parents was or at least two of his grandparents were, members of the Israelite denomination."

By communicating this definition of Jewishness through the cantor, Forgács both ironizes it and reinstitutes the subjectivity it was created to destroy. He also replaces it with another definition of Jewishness: one based on cultural practices and values. But the greatest challenge to the anti-Semitic laws comes from the liturgical music. It begins while the still-unnamed woman is making the bed into which she will later climb, and the singer joins in a moment later. Since we register the sonorous

Figure 6.7 *Free Fall* and *Bourgeois Dictionary*. This sequence, shot by György Petö and occurring in both *Free Fall* and *Bourgeois Dictionary*, contrasts sharply with the erotic shots of nude women used by Forgács in *Kádar's Kiss* and other films.

qualities of his voice before we hear the words he is chanting, its addition heightens the sacral qualities of Szemzö's score, and this effect is not diminished when the libretto becomes audible. In addition to ironizing the law, reinstituting the subjectivity it was meant to abolish, and redefining Jewishness, the cantor and the music continue to assert the holiness of this place where flesh will soon meet flesh. They also tell us that since there is "a reversibility of the seeing and the visible,"[43] we, too, will be in that bed.

The ellipses Forgács introduces into the rest of the sequence cast the woman's corporeality into an even sharper relief. This focuses our attention on all the aspects of her physical being that cannot be genetically calibrated: how she accommodates herself to the space of the bathtub, the curious way she gives herself to the photographer but withholds herself a bit from the camera, and the surprising self-confidence with which she holds up her glass to her lover and summons him to bed. This sequence consequently does even more than permit the still-unnamed woman to say "I was there," and "I was loved." It also broadens the range of exceptions to the law that is being sung. Indeed, it suggests that there can never be anything in relation to it but exceptions.

Forgács ends *Free Fall* with another poem by János Pilinszky. As we look at green-tinted, handheld footage of mountains and tree, we hear the poet say,

> Earth is not earth.
> Number is not number.
> Letter is not letter.
> Sentence is no sentence.
> God is God.
> A flower is a flower.
> A swelling is a swelling.
> Winter is winter.
> The fenced-in area of indefinite shape
> Is a concentration camp. ("Poem")

Through this poem, Forgács points to the tautological nature not just of National Socialism's definition of Jewishness but of *every* category through which we attempt to expel others—or exempt ourselves—from being.

NOTES

1. Walter Benjamin, "The Work of Art in the Age of its Technological Reproducibility" (3rd version), trans. Harry Zohn and Edmund Jephcott, in *Selected Writings*, vol. 4 (Cambridge, Mass.: Harvard University Press, 2003), 258.
2. This has changed dramatically in the last few years, as can be seen from films like *Capturing the Friedmans* (2003) and *Tarnation* (2003), and the phenomenal success of so-called reality television.
3. Benjamin, "The Work of Art," 258.
4. Siegfried Kracauer, "Photography," in *The Mass Ornament*, trans. Tom Levin (Cambridge, Mass.: Harvard University Press, 1995), 48–49.
5. These remarks come from "The Replica and De- and Re-Constructive Life Recordings," a lecture given by Forgács at the Getty Museum.
6. Jean-François Lyotard, *The Postmodern Condition: A Report on Knowledge*, trans. Geoff Bennington and Brian Massumi (Minneapolis: University of Minnesota Press, 1984).
7. Not surprisingly, the Germans thought of such relationships in racial terms—as *Rassenschande* (miscegenation).
8. André Bazin, "Ontology of the Photographic Image," in *What Is Cinema?*, vol. 1, trans. Hugh Gray (Berkeley: University of California Press, 1967), 9. My frequent invocations of photography in this chapter might seem odd, given that Forgács works with moving images, but I think that his video films are more under the sign of the former than the latter. As he says in his conversation with Deirdre Boyle, "I see each frame almost like a photograph. My background is as a visual artist" (*Millennium Film Journal* no. 37 [Fall 2001]: 53–66).
9. I am quoting here from the famous passage about the madeleine in Marcel Proust, *Swann's Way*, trans. C. K. Scott Moncrieff, Terence Kilmartin, and D. J. Enright (New York: Modern Library, 2003), 59, and using it to forge a link between photography and involuntary memory. I explore this relationship at greater length in *Je Vous*, *Art History*, no. 30–33 (January 2007): 451–67, and in my book, *Flesh of My Flesh* (Stanford, Calif.: Stanford University Press, 2009). The title of the present essay derives from a closely related passage: "But when from a long-distant past nothing subsists, after the people are dead, after the things are broken and scattered, taste and smell alone, more fragile but more enduring, more immaterial, more persistent, more faithful, remain posed a long time, like souls, remembering, waiting, hoping, amid the ruins of all the rest; and bear unflinchingly, in the tiny and almost impalpable drop of their essence, the vast structure of recollection" (*Swann's Way*, 63–64).
10. Maurice Merleau-Ponty, *The Visible and the Invisible*, trans. Alphonso Lingis (Evanston, Ill.: Northwestern University Press, 1968), 134.
11. Ibid., 133.
12. Ibid., 139.
13. Scott MacDonald, "Péter Forgács," in *A Critical Cinema 4: Interviews with Independent Filmmakers* (Berkeley: University of California Press, 2005), 311.
14. This also comes from Merleau-Ponty; see *The Visible and the Invisible*, 141.
15. For a detailed and highly knowledgeable account of these shifts, and of their relevance for Forgács's film, see Whitney Davis's chapter in this volume, "The World Rewound: *Wittgenstein Tractatus.*"
16. MacDonald, "Péter Forgács," 7.
17. Michel Foucault includes this list in the preface to *The Order of Things: An Archaeology of the Human Sciences* (London: Tavistock, 1970), p. xv. He takes it from Borges, who found it in a "certain Chinese encyclopedia."
18. There is one sequence in *Bourgeois Dictionary* where Forgács's lip-reading is productive of some kind of meaning—the sequence called "The Lover."
19. As Merleau-Ponty says in "Indirect Languages and the Voices of Silence," in *The Merleau-Ponty Aesthetics Reader*, ed. Galen A. Johnson (Evanston, Ill.: Northwestern University Press, 1993), "perception already stylizes" (91).
20. Merleau-Ponty imputes this remark to Cézanne in "Cézanne's Doubt." See Johnson, *The Merleau-Ponty Aesthetics Reader*, 67.
21. Merleau-Ponty, "Indirect Languages and the Voices of Silence," 91.
22. I am again using this word in an ontological sense.
23. In his conversation with Boyle, Forgács relates in a similar way to his source material. He says, "It calls to me."
24. Merleau-Ponty, *The Visible and the Invisible*, 142.

25. Lawrence L. Langer, *Holocaust Testimonies: The Ruins of Memory* (New Haven, Conn.: Yale University Press, 1991), 63.
26. Primo Levi, *Survival in Auschwitz*, trans. Stuart Woolf (New York: Simon & Schuster, 1996), 116–17.
27. James E. Young, *Writing and Rewriting the Holocaust: Narrative Consequences of Interpretation* (Bloomington: Indiana University Press, 1990), 189.
28. Proust, *Swann's Way*, 260–61.
29. Charlotte Delbo, *Auschwitz and After*, trans. Rosette C. Lamont (New Haven, Conn.: Yale University Press, 1995), 112.
30. Primo Levi, *Moments of Reprieve*, trans. Ruth Feldman (New York: Summit, 1981), 10–11.
31. Terrence Des Pres, *The Survivor: An Anatomy of Life in the Death Camps* (Oxford: Oxford University Press, 1976), 29–38.
32. For a discussion of the uses of language to bind trauma, see Sigmund Freud, *Beyond the Pleasure Principle*, in *The Standard Edition of the Complete Psychological Works*, vol. 18, trans. James Strachey (London: Hogarth, 1955), 12–17.
33. Langer, *Holocaust Testimonies*, 9.
34. Levi, *Survival in Auschwitz*, 90.
35. Dori Laub, "Bearing Witness or the Vicissitudes of Listening," in *Testimony: Crises of Witnessing in Literature, Psychoanalysis, and History*, ed. Shoshana Felman and Dori Laub (New York: Routledge, 1992), 70–71.
36. Dori Laub, "An Event Without a Witness: Truth, Testimony, and Survival," in Strachey, *Testimony: Crises of Witnessing in Literature, Psychoanalysis, and History*, 82.
37. Martin Buber, *I and Thou*, trans. Walter Kaufmann (New York: Simon and Schuster, 1970). For another excellent account of the second-person person, see Mieke Bal, "First Person, Second Person, Same Person: Narrative as Epistemology," *New Literary History* 24, no. 2 (1993): 302–3.
38. Giorgio Agamben explores the implications of this practice in *Remnants of Auschwitz: The Witness and the Archive*, trans. Daniel Heller-Roazen (New York: Zone Books, 1999).
39. Laub, "Bearing Witness or the Vicissitudes of Listening," 57.
40. I am not saying that the analyst doesn't *really* listen or that the *real analyst* is of no consequence. It makes all the difference in the world who models the listener for the analysand.
41. I am drawing here upon both Lacan's early seminars and my own analytic experience. See *The Seminar of Jacques Lacan, Book I: Freud's Papers on Technique, 1953–1954*, trans. John Forrester (Cambridge: Cambridge University Press, 1988); and *The Seminar of Jacques Lacan, Book II: The Ego in Freud's Theory, 1954–1955*, trans. Sylvana Tomaselli (Cambridge: Cambridge University Press, 1988).
42. Forgács comments on the ubiquity of this kind of footage in home-movie collections in his conversation with MacDonald ("Péter Forgács," 302).
43. Merleau-Ponty, *The Visible and the Invisible*, 154.

MALIN WAHLBERG

[7] *The Trace*
Framing the Presence of the Past in *Free Fall*

In phenomenology and classical film theory, "the trace" relates both to the materiality of an imprint and to the experience of an irrevocable past. It is conceived of as an indexical sign, an existential operator interrelating image, history, and memory. Traditionally it is an object, a mark inscribed, or a photograph that bears witness of life or events in the past.

In the extensive project of Péter Forgács, to evoke individual and shared histories of the Hungarian and European past, the trace materializes in the fragmentary and scratched feature of collected amateur films. In *The Bartos Family*, *Free Fall*, and *The Maelstrom: A Family Chronicle*, which all offer family sagas in the shadow of the Holocaust, the existential relationship between image and death finds stark illustration.

In Forgács's work the trace points also to the social and communicative possibilities of the moving image as a "technology of memory."[1] The silent witness of compiled home movies suggests a possible microlevel historiography, an archaeology accomplished by research and interviews to gradually unmask the anonymity of these pictures. Sequences are being plucked out of context and reorganized, the image performing as a thought-provoking objet trouvé.

With specific reference to *Free Fall*, the purpose of the following discussion is to provide a deepened account of the trace. In Forgács's videos, it offers a complex figure of time that brings attention to one of the most archaic issues in the scholarly debate on documentary: the conception of the image as an indexical sign.

Free Fall is based on the work of Hungarian and Jewish amateur filmmaker György Pető, called Gyuri, who documented his life with friends and family between 1937 and 1945. A Hungarian counterpart to the story of the Dutch Peerebooms in *The Maelstrom*, this film pictures the everyday life of a Jewish family at a point when the Nazi *Endlösung*

still would have seemed a monstrous fantasy. Presenting a world that was soon to disappear, Forgács orchestrates the home movies into an uncanny evocation of historical experience. Color, sound, and music are added to Petö's images as they unfold, split, and freeze, accompanied by text, song, and voice-over, as well as contrasted to the official record of archival material (both images and sound).

Before a more detailed account of *Free Fall* and the reframing of home movies, the philosophical notion of the trace and its relationship to the theory of film and photography begs for clarification.

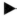

The Trace

The trace is a recurrent theme in French phenomenology.[2] Jean-Paul Sartre, Maurice Merleau-Ponty, Emmanuel Lévinas, Paul Ricœur, and Roland Barthes all address the semiotic hybridity of this notion between materiality and experience.[3] As a philosophical matter, the trace originates from Martin Heidegger, who strongly emphasized that time is something intrinsically shared and, if separated from the dialectic of future, past, and present, would be nothing but a misleading abstraction. Instead, transition characterizes every moment into a constant split of now, not yet now, and no longer now because our existence as human beings is marked by our knowledge of a coming death: we come, we die, but our actions and work remain.[4] The trace becomes an intentional object in which mode of being is equivalent to its function as inscription of the past within the present. In Paul Ricœur's discussion on historical time, the trace turns into an ethical trope where the temporal status of the vestige is linked to our responsibility toward the "historical other."[5]

The phenomenology of the trace reverberates in the theory of photography. The photo trace not only implies a nostalgic mode of past tense but also indicates something about our socioculturally motivated attitude toward photographic representation. A definition of the photographic image as a mechanical inscription presupposes an acknowledgement of its technological prepositions: the camera inscription and the photochemical process of the dark room. It also evokes the photographic image as a conceived image object with an important claim for veracity. Hence, it may involve our experience of, and fascination with, a photograph as a trace of what actually was caught by the camera eye. To recall Susan Sontag's famous essay, the photograph, this "neat slice of time," preserves the historical referent by making the captured instant exceed its actual duration.[6] Our attitude toward the photographic image is marked by

its evidential efficacy as a trace of the past. As such, it not only justifies the truth claim ascribed to photographic representation but also evokes the photograph as a phantasmagoric, paradoxical, imaginary space of "pseudo-presence and a token of absence. Like a wood fire in a room, photographs—especially those of people, of distant landscapes and faraway cities, of the vanished past—are incitements to reverie."[7]

With Roland Barthes's description of the photographic image as a manifestation of "that-has-been" it not only obtains a status of past time but also is essentially connected to our reception of it as an artificial memory as the presence of an irrevocable past.[8]

The film image has been considered an automatic inscription and an analog mode of representation, too. In this context, André Bazin stands out as the most enthusiastic advocate for the image trace as an indexical sign. We may recall his famous metaphor of the "mummy complex," which mirrors a basic motivation for all art and is ultimately attested through the invention of photography. Bazin celebrates the possibility of photography "to preserve, artificially, his [man's] bodily appearance . . . to snatch it from the flow of time, to stow it away neatly, so to speak, in the hold of life."[9] Instead of juxtaposing the photograph and the film image, Bazin thus accounts for the complex status of the indexical trace in cinema. As a result, and to quote Philip Rosen, the subject is caught "between a time-filled objectivity and a desire for the timeless, between materiality (the real) and a transcendence (psychology, aesthetics)."[10]

From an aesthetic point of view, Bazin stressed the transgression between past and present and the existential relationship between image and death evoked by the photograph. Hence, the phenomenological discourse of the trace is implied in his writings. What Bazin totally overlooked, though, were the potential significations of an *audio*visual trace in film.

The phenomenological notion of the trace is grounded upon a visual a priori—that is, it is associated with visual vestiges and imprints. However, in the diversity of images that characterizes contemporary media culture, a trace of the past may also result from the filmic framing of a testimonial act or sound recording. For example, in *The Bartos Family*, Forgács uses the auditory record of Zoltán Bartos's popular songs (his first record appeared in 1928). Zoltán's voice adds to the haunting presence of the past, to our recognition of individual histories, and to the overall rhythm of the film. In Forgács's video compilations, sound effects are commonly added to the silent home movies. As further exemplified in *Free Fall*, these auditory inserts may not be traces of the past in any material sense, but together with the music, they add to the sensory animation

of the visual record while accomplishing a poetic staging of historical experience.

Apart from the inscriptive status of the sound and image strip of film, video and digital technology realize an aesthetic of reframing and overlapping that may both assert and question the ascribed trace status of photography.[11] Furthermore, in regard of documentary film and video, the trace demands a critical redefinition to meet with general sociocultural meanings of archive and preservation.

▶ ─────────────────────────────────────

The Trace of the Trace

In the art of moving images and film narration, the existential and semiotic dimension of the trace may be subject to poetic treatment. Staged by the expressive possibilities of film and video montage, the indexical sign may be evoked in photographs, compiled archival sequences, recorded voice, and sound. To this we may add the trace status of testimonial acts and the filmic possibilities to map marks and scars in landscapes and bodies. However, the staging of the trace may also lead beyond the meaning of the imprint, vestige, or record as an enigmatic presence of the past. In this sense, a compiled image trace may point to the practice of preservation and classification in contemporary visual culture.

As a radical alternative to the common use of archival material "reduced to the textual authority of the documentary fact,"[12] Forgács's personal approach to the material provided by the Private Photo and Film Archives Foundation results in a project where the archive is manifest in both a material and metaphoric sense.[13] Here, the compiled visual or auditory fragment is not only a trace of the past but a trace of another trace.

In Forgács's work, the compiled home movie is initially a beginning for possible stories. At the moment when it is reframed by narration and video montage, it is less a transparent link to the past than the productive distance between an image object and the activity of looking at, of recollection, and of imagination. From this perspective, *Free Fall* exemplifies how the trace may turn into a critical discourse of documentary film and video, offering a self-referential recognition of the shortcomings and difficulties involved in representing the past.

This alternative historiography of audiovisual narration relates to the poetic possibilities that Paul Ricœur ascribes to the treatment of memory and history in novels. Ideally, the narrative may provide the means of "telling history alternatively."[14] He refers to narratives where, beyond the macroperspective of historiography, experiences of the past find an

alternative articulation. Different from the relativism of Hayden White, Ricœur does not suggest that all historical narratives are equally remote from the actual event of the past. To stress the inevitable construction of every narrative is not to claim that they are equally fictive or untrue. Rather, the communicative ethos of narration is related here to the possibility of poetic narration to give voice to historical experience and to impinge a microperspective on the linear axis of official history.

▶ ───────────────────────────────────────

Traces of a Vanished World

Free Fall, ninth in the Private Hungary series, deals with the Hungarian Holocaust, which was finally accomplished in the spring of 1944. The fact of this extermination is a haunting presence throughout the film. In the sound image reframing of Petö's films and other archival material, the unbearable ending of the Petö saga is as present in the compiled sequences from 1938 as in the images of György and Éva in 1944. Here, the trace stresses the archeological aspect of found footage, although the compiled films remain a discourse of loss that inevitably marks each attempt to represent Shoah.

Similar to the literary work by Hungarian author and Nobel Prize–winner Imre Kertész, *Free Fall* appeals to our empathy with an individual microlevel of history while simultaneously challenging any reduction of the narrative into enclosed drama. Where Kertész uses the novel and his personal experiences as a survivor of the Holocaust, Forgács uses the expressive possibilities of video montage and the affective power of Tibor Szemző's music for other people's visual record of the past. Although narration and the process of reframing dislodge the inserted home movie from its trace status as an anonymous image object, the materiality of these images are being subject to poetic articulation. Petö's films, not to forget the handmade intertitles, stand out as traces of the past, their silent witness being articulated by added textual remarks and the scratched texture of each frame. Viewing the film, a literal process of seeing people in free fall, one is moved and disturbed by traces of a vanished world.

Bazin's emphasis on the relationship between image and death echoes throughout the film. On one occasion, there is even a discursive marker to pinpoint the meaning of the photo trace as loss: a classic iconographic motif of death and decay common in Baroque painting, an image of a peeled apple. This example occurs when the fourth Jew law established in 1939 is chanted in Hungarian and translated in English by voice-over. The still image of the apple is simultaneously accompanied by text: "March

15, 1939, as a result of the first Vienna resolution, Carpathia-Rutenia was incorporated with Hungary." Moving images appear in a box, partly covering the apple and labeled as "Pictures from Carpathia-Rutenia shot by Dr. T. T., 1940." "The number of people amounts to 665,000, of which 78,000 are Jews. A year later, the Hungarian authorities transfer 18,000 'stateless' Carpathian Jews to the SS, who execute them in Kamenec-Podolskij, Ukraine." In significant silence and heartbeat rhythm, the image of the apple becomes a palimpsest through which peacetime street scenes from a Jewish community in Carpatha-Rutenia are shown. Moreover, the inserted film sequence is halted by stop-motion, which further interlinks the omniscient narrative, the symbolic power of a baroque motif, and the film sequence of a vivid street scene, uncannily restrained in the shadow of death.

▶────────────────────────────────────

To Animate the Trace

"The document sleeping in the archives is not just silent, it is an orphan. The testimonies it contains are detached from the authors who 'gave birth' to them. They are handed over to the care of those who are competent to question them and hence to defend them, by giving them aid and assistance."[15] Forgács reframes, layers, and repeats the film fragments in a way that poses the materiality of the image object as a trace of the past. However, in line with Wittgenstein, there is another salient theme: "Everything we see could also be otherwise. Everything we can describe at all could also be otherwise." The quote was spelled out in the video *Wittgenstein Tractatus*, which was produced for Hungarian television in 1992. But it could be taken as a fundamental paradigm throughout Forgács's work because the compiled amateur films are marked by missing information, unanswered questions, and the invisible conflicts and complex relationships that always hide beneath the apparent coherence of domestic self-representation.

There is another author, mentioned earlier in this text, in reference to whom this theme could also be elaborated. Let us return to Roland Barthes's book-length essay "Camera Lucida," but this time I would prefer to emphasize its semiotic premises. It is a common misunderstanding that Barthes's reflection on photography first of all would support the existential aspect of the photo trace as a transcendence of the past. The famous notion of *punctum* certainly addresses the photograph as an uncanny presence of the past, but it is a pastness that inevitably results from an extratextual knowledge of what the image represents. This is a

phenomenology of the photograph, but it is a phenomenology radically modified by a semiotic perspective, implying the recognition of the social and ritual function that photographic representation obtains in our culture. *Punctum* is dependent on imagination, extratextual knowledge, not to mention the desire and affective interest employed in the act of looking at the image. Hence, the photo trace offers an indication of something that has been, although the meaning of that "has been" is is never a given. It is a context filled in by the incomplete and reversal flux of memory, as well as by historical knowledge and significant events that change its meaning in retrospect. At this point, the trace opens up to meanings and sensations encountered with *certain* images. The emphasis on "certain" is important in this context because the meaning of the image cannot be disconnected from our attitude toward it. This idea was crucial to earlier existential concerns with image and memory, such as Jean-Paul Sartre's famous example on "Pierre" and "the image of Pierre": "And if that photo appears to me as the photo 'of Pierre', if, in some way, I see Pierre behind it, it is necessary that the piece of card is animated with some help from me, giving it a meaning it did not yet have."[16] Hence, what matters here is the process that turns the trace into a sign effect. In film, images are transformed into significant image memories by means of the moving gaze of a film camera, music, sound effects, text, or a narrator who interprets what we see, as well as indicating what the images fail to show. In *Free Fall*, this process of animation and rhythmic structuring is finally achieved by an efficient work of music, voice, and sound effects.

▶

The Sensory Soundscape

It was suggested earlier that the phenomenology of the trace is both affirmed and questioned in Forgács's work. The material trace status and potential historiography of home movies unveil in the fragile surface of inserted amateur film. Yet the ambivalent relationship between image and meaning stresses the pragmatic process through which the image turns into image memory. In this context, there is reason to comment on the trace not only as a visual imprint of that which is no more but also as an imaginary realm where historical time is evoked as experience. Forgács's orchestration of the silent images demands recognition in this context because it clarifies a crucial aspect regarding the viewer's affective response to the trace in film. In documentary, fiction film, and video art alike, our emotional response to the screen is dependent on, or at least directed by, the use of music, sound, and moments of silence.

Forgács shows that the photo trace is more than a potential piece of visible evidence. It is a contemplative site of imagination and intersubjective memory. Throughout the Private Hungary series, music and sound effects are used to increase our affective response to the narrative. The compiled images are not only being colored, layered, and contrasted. The eerie presence of the past is reinforced by the musical drama of Tibor Szemzö's score, as well as by the sensory impact of added sound that offers auditory illustration to the screened motif: a splash of water as György's girlfriend dives into the river, the disciplined steps of a military boot march, or the aggressive sound of gunfire added to images of autumn hunting. In another chapter of this book, Roger Odin accounts for the discursive function of music and the significant play of added sound and oppressive silence in *The Bartos Family*. In similar ways, the symbolic meanings of Forgács and Szemzö's soundscape are crucial to the animation of the trace in *Free Fall*.

The minimalist yet highly dramatic music is a prerequisite for the film's sensory engulfing of the viewer, as we engage in the privacy of domestic scenes and moments that already were threatened by Nazi politics. Music completes the unfolding of drama, distancing the viewer from the calm routines of everyday life. In *Free Fall*, music upsets the act of viewing by means of disquieting shock effects. Accordingly, the anti-Semitic Jewish laws in Hungarian politics are chanted in alarming contrast to the peaceful and happy images of Petö's home movies. Aside from the function of music and sound as discursive markers, the soundscape in *Free Fall* reminds us of the fact that the trace may perform beyond the parameters of the visual. The inserted fragments of political history in wartime Hungary involve not only archival images but also recorded speech. Voices of political leaders, representing both Nazis and the Jewish community in Budapest, offer auditory traces that, of course, emphasize the material aspect of cinema as a technology of memory.

Finally, the intimacy achieved by the added sound of, for example, water, heartbeats, or the lighting of a cigarette may be said to highlight the trace as an imaginary realm of historical experience. This may be compared to the similarly intimate, although reflexive, sounds of representation and inscription. Now and then, the soundtrack offers nothing but the rattling sound of the home-movie projector. These are important moments when we are invited to share Forgács's fascination with the found footage, this adventure of peeping into the private archive of home movies. It is also a sound that posits the ghostlike appearance of a vanished world. In the recent *A Bibó Reader (Bibó Brevariá)*, these two sound functions meet in the auditory theme of typing. The intellectual

passion and social concern of politician and author István Bibó (1911–79) comes through symbolically in the clatter of typewriting, which simultaneously seems to mirror the narrative drive and poetic passion of Forgács's own work.

▶──

Between the Moment of Inscription and the Moment of Recollection

In *Free Fall*, the pragmatic relationship between image and meaning becomes a dramatic tool, an incentive for the creation of a shared image memory: The destiny of the Petö family concerns us. A crucial principle for the mise-en-scène of home movies seems to be the interval between the past of photographic inscription and the present moment of contemplating these images. We watch an ordinary event, such as a mother bathing her baby, and her ignorance of the future is violently contrasted to the threatening shadow of increased Nazi politics. The threat materializes through inserted fragments of official history, which contaminate the intimate sphere of family pictures. A range of expressive elements helps to accomplish this contamination: inserted archival images, a radio broadcast of a historical speech, inserted text that indicates what is going to happen, Nazi laws transmitted as song, a symbolic use of sound effects and color, and the significant manipulation of speed. The music accomplishes the apocalyptic beat, beyond sentimentality or narrative enclosure.

Hence, the imprint is decontextualized, and its referent is subject to reflection: Who is this? What is shown and what is not? Another important dimension of this distance, between the moment of inscription and the moment of contemplation and interpretation, is the fact that the meaning of an image may change depending on who is looking at it. The meaning of images may also change over time, such that what seemed insignificant at the moment of inscription and recording may strike us as very important today. This problem is a recurrent theme in the work by another compilation filmmaker, Chris Marker. For example, in *Le fond de l'air est rouge* (*Grin without a Cat*, 1977), Marker inserts a sequence shot at the Olympic games in Munich in 1972. To these images of a successful rider dressed in military fashion, the voice-over concludes, "When I filmed the master of the Chilean team, I thought that I filmed a horseman, a rider, but in fact, I had filmed a 'Putschist'—the lieutenant Mendoza who was to become General Mendoza, one of the four leaders of Pinochet's junta. . . . You never know what you actually are filming."[17] In Forgács's work, Marker's dictum that "you never know what you actually are filming" is again illustrated by the mode of contrasting private

moments in the past with archival footage, or, which is the unique case of *The Notebook of a Lady* (*Egyurinö notesza*), altering between images of Baroness Jeszenszky (a fierce Hungarian aristocrat and anti-Semite) in the 1930s and 1940s, and her elder self and commentary of the 1990s. The home movie also offers a representation where the pragmatic relationship between image and meaning is especially poignant. In the banal ritual of ideal self-representation, the domestic documentation is always haunted by what is not shown, such as forced smiles, anger, and secret passions.[18]

In *Free Fall*, the gap between the moment of inscription and the present act of looking at these images today is a prerequisite for the narrative and audiovisual structuring of Petö's films. Forgács plays with the apparently insignificant detail on the screen while at times revealing a secret relationship by imposing one image on another. The staging of this gap also coincides with a sinister foreboding of the Holocaust: a dark shadow invades the happy images of a birthday party, such as the no-longer-now of photographic inscription turns into the not-yet-now of a coming disaster.

▶────────────────────────────────────

Evoking the Future of the Past

Textual and verbal notes structure the narrative and identify people and places in the images. A partly chronological ordering of home movies (some sequences are repeated with slight modification of speed and color) meets with the realization of *die Endlösung* in 1944. Hence the official history and the life story of the Petö family are juxtaposed in a movement toward the end of the war, but the mode to literally contaminate the family pictures with archival material, and to indicate what will eventually happen, creates a mode of apocalyptic foreboding.

To specify, inserted text, as well as György Petö's own intertitles, help to contextualize the home-movie material. An added note, such as "Szeged . . . where this story takes place," offers an indexing of particular sites, and another, "Life at Tisza 1938," indicates what the pictures show, whereas "Paula, Éva's mother, Lajos Lengyel's wife, who died in the camp of Neukirchen in 1944" identifies people in the footage while indicating what eventually was going to happen to them. However, it is not simply the text itself that contributes to the animation of the photographic trace but the ways in which sentences appear on the screen, the filmed individuals are framed, and their gestures are frozen into imprints of the past. The following example illustrates how the family circle is introduced while also allowing individual portraits and life stories.

Figure 7.1 *Free Fall.* Forgács's addition of a superimposed statement to this home movie shot of a family meal peels away the banal exterior to reveal what the image cannot: the secret, emotional bond between the two subjects.

In this scene, we see a home movie from a birthday party in 1938: music has been added to silent, black-and-white footage that has been video filmed, colored, and rhythmically halted by stop-motion just before each cut. Short explanatory texts (similar to those in photo albums) identify the women and men in focus: "Gyuri's aunt Henrietta Krausz on her 78th birthday." The text is displayed vertically on one side of Henrietta, who is sitting at a table, laughing. The image freezes and cuts to a scene of some men playing cards, and a thin white line circles a man on the left, "Sándor Súgar, the son-in-law of Henrietta." The camera pans right and another circle is drawn to emphasize "Laci, Gyuri's bother, who recently separated from his wife." The pan is completed when the face of the next man is shown in stop-motion, as a new line reads, "the brother-in-law, Laci Osváth, the lieutenant."

The next sequence presents Henrietta and two other women, and the camera pauses for a while on one of them, presented as "his wife Rózsi, Guyri's sister." The camera moves slightly to the right, with the text "and her cousin, married to Sándor Súgar," to frame the two women. Suddenly the image freezes and a small frame of blue-tinted footage is inserted within the image, showing Sándor in a swimming suit. Then a small

image box appears between the cousins, a text spelling out that "Rózsi was secretely in love with Sándor Súgar." As the music fades out, the pan continues rightward and freezes at the smile of Gyuri's mother, "the wife of Ernö Petö."

This sequence illustrates Forgács's video treatment of home movies, where the frame suddenly multiplies and textual indications are not limited to naming but also allude to details beyond the shown. Hence, brief textual markings and the use of stop-motion contribute to the mise-en-scène of the photographic trace, but the animation of historical time in this work involves an even more complex sound-image process.

▶

Frame Breaking and Layering

It is striking how the trace status of film may be emphasized in the juxtaposition of different image contexts. This is not a subject unique to documentary because related events can be found in any context of moving images. In Forgács's work, however, the effects and functions of compiled images are especially poignant, reflecting aspects of image materiality and medium specificity.

In *Free Fall*, this is accomplished by the plastic elaboration of the screen and the sound track into multiple layers. Aside from the filmic regulation of tempo and rhythm, this technique also establishes different significations of the documentary record: home movies, recorded speech, letters, newsreel, and photographs.

Through sound, wipes, fade-ins, and inserted boxes, official history literally invades the happy pictures of family life, friendship, and love. For example, Guyri's record of his summer holiday at the riverside in Tisza in 1938 is accompanied by music and song and culminates in a harsh line reading, "On May 25, 1939, both houses of the parliament accepted with great majority 'the first Jew law,' proposed by count Pál Teleki." The content of the law is chanted (and translated in voice-over) as we look at images of Gyuri and his friend Bandi Kardos in a boat. There is a cut in Gyuri's film to other images of beach life and swimming. We hear a recording of Samu Stern (partly dubbed by another voice), the head of the Jewish community in Budapest, protesting against the maltreatment of farmers in the Bratislava province. His discourse is contrasted by a shot in slow-motion of Kardos diving into the water, along with the synchronized splashing sound as he hits the water.

A similar example of auditory and visual contamination of home movies is offered in another reframing of a birthday representation, dated

1939. The sequence begins with a close-up of a menu, which is explained by inserted text: "The menu of Gyuri's 33th birthday." A continuous take, tinted in a mauve color, reveals the guests presented as "Ica and Gábor Szantó . . . Rószi Petö . . . Ila . . . the brother-in-law Laci Osváth . . . and Gyuri Petö." A black-and-white sequence suddenly wipes in from the right, partly overlapping the home movie. The text reads, "Hungary's Head of state inaugurates the new parliament with pomp and splendor." The inserted footage is then narrowed to a small box in the upper right of the frame and then to a rectangle at the bottom. A new text reads, "Head of state, Horthy," whose speech is interpreted as voice-over. The contrast between a birthday party and a parliamentary meeting is further stressed by the flickering image quality that results from the changing position of the inserted box, as well as from the play with stop-motion in the reframing of Petö's home movie.

This process of juxtaposing different image contexts and sounds not only contributes to the historical narrative of *Free Fall* but also results in a poetic score that evokes the metaphoric signification suggested by the title: at the moment of celebrating a birthday, or enjoying their summer vacation, Gyuri's family, as well as innumerable others, were already doomed by the gradual and meticulous realization of the Holocaust. The textual implications of an irrevocable disaster (which is already confirmed as a historical fact but appears even more striking from this microperspective) are emphasized by the mosaic of images, music, sound effects, and song, as well as by manipulations of speed and rhythm. As exemplified by the Carpathia-Rutenia sequence that was referred to earlier, Tibor Szemzö's score completes a powerful staging of mute film images, which also directs the pulsating montage of overlapping image boxes within the frame.

Indexical Sign Effects

In *Free Fall* stop-motion and slow-motion are crucial devices that thematically stress the irrevocable destiny of the Petö family. This manipulation of image movement contributes to the staging of family pictures as found footage while also stressing the trace as indexical sign.

Aside from the figure of restrained motion, there is another device even more symbolically tied to Barthes's "that-has-been" and Bazin's notion of the photograph and death—the inverted image. In this narrative context, the use of negative to suggest the foreshadowed disaster contributes strongly to the formal and symbolic intersection of found footage and

official record. The powerful appearance of the inverted image is completed by the use of repetition and color. For example, the second time we see the inverted, slow-motion sequence of Eva (Gyuri's fiancée) diving into the river, it is colored red (blood) and the added sound of splashing water breaks into the chanting and recitation of another law. Regarding the content of the Jew law, it is impossible not to associate the sequence with the sinister drama a few years later that forever would mark the story of this and other doomed families.

Gyuri's films are unusually well organized and ambitiously produced with painted intertitles. The quality of these films as a historical source and a testimony of everyday life is perhaps most apparent in the movies shot during the filmmaker's stay at Kiszombor in 1940 and 1941. Together with friends and many other Hungarian Jews, Gyuri was ordered to work at a camp. Titles, such as "Souvenirs from the work company," "Formation," "March," and "The Washing Department," structure the footage from this period, but the images of smiling and joking friends are radically disturbed by the symbolic indications of concentration camps. One of the sequences showing the men marching to their work is suddenly inverted and decelerated into slow-motion. A melancholic song dominates the soundtrack, and the verse is subtitled, "I cannot get a wink of sleep tonight, silent, silent night . . . without any comfort." Again, the negative image and the altered speed emphasize the photographic trace while reinforcing the narrative foreshadowing of Nazi genocide.

However, other stylistic devices block the distancing of footage into static image objects. An ambiguous present tense (in Christian Metz's sense of presence being the appropriate tense of identification) is created by applied sound effects, such as the heavy, disciplined sound of coordinated marching to a sequence from the forced labor camp or the peaceful sound of birds and the lighting of a cigarette, which is synchronized with a sequence of Gyuri in Szeged during one of his rare leaves from the camp. Again, sound is crucial to the haunting presence of historical time in *Free Fall*, as it is performed in a mnemonic overlapping of the past, the presence, and the future.

▶

Private Archives and Shared Memory

The ambiguous meaning of the trace between materiality and experience is conceptualized in Forgács's work. In *Free Fall*, the subject of which automatically evokes the relationship between image and death, it

becomes particularly clear how video art and documentary film may display the cultural meanings and philosophical implications of this notion. The amateur filmmaker's project is offered as an important source for an alternative historiography, as well as for a video poetics on historical experience. By means of Szemzö's score, added sound effects and song, manipulation of speed, and significant moments of silence, the image traces of a vanished world stand out in their eerie magnitude.

However, Forgács's aesthetics of compilation also demarcates the limitation of a phenomenological notion. The relationship between image and meaning is continuously subject to reflection, and the mode of reframing and orchestrating home movies presents us with a self-referential trace of the trace, with broader implications for the cultural practice of archive and historical representation. The imprint remains a discourse of loss yet a node for public imagination and memory work.

In this sense, *Free Fall* relates to Ricœur's suggestion of "telling history alternatively." Here, the communicative ethos of narration is paralleled with the sensory becoming of film as image memory. The existential impact of the trace is subject to thematic treatment. It becomes a powerful means to appeal to the viewer's interest in an individual and shared experience of the past, which potentially may reduce the distance between us and the destiny of the historical other.

▶

NOTES

1. I borrow this idea of cinema "as a technology of memory" from Bernard Stiegler who, in a critical reconsideration of Husserl, discusses the mnemonic potential of films and sound recordings as a *tertiary memory*, beyond the limits of our personal memory. Bernard Stiegler, "The Time of Cinema/On the 'New World' and 'Cultural Exception,'" *Technema: Journal of Philosophy and Technology* 4 (1998): 62–113.

2. *French phenomenology* stands for the intersection between phenomenology and existentialism that resulted from the French appropriation and critical interpretation of Edmund Husserl's work in the early 1950s. Maurice Merleau-Ponty, Jean-Paul Sartre, Paul Ricœur, and Mikel Dufrenne represent a philosophical diversity that was unified by a fascination for perception, memory, and imagination but questioned the notion of the subject and "the transcendental Ego" of Husserl's phenomenology. From the 1960s, the existential phenomenology of Merleau-Ponty, in particular, reverberates in the semiotic context, too, where Roland Barthes is a telling example. Today, "French phenomenology" is a semiotic phenomenology, where the classical issues of phenomenology meet with the premises of poststructuralism, hermeneutics, and pragmatism.

3. For example, in Lévinas's work the trace is transformed into an ethical metaphor, designating a potential intersubjective encounter that bridges the experience of past and present time. See, for example, Emmanuel Lévinas, *Humanism of the Other*, trans. Richard A. Cohen (Urbana: University of Illinois Press, 2006).

4. "The 'end' of being-in-the world is death. This end, belonging to the potentiality-of-being, that is, to existence, limits and defines the possible totality of Da-sein. . . . But as far as Da-sein goes, death is only in an existential being toward death." Martin Heidegger, *Being and Time*, trans. Joan Stambaugh (Albany: State University of New York, 1996), 216.

5. Paul Ricœur, *Time and Narrative*, vol. 3, trans. Kathleen Blamey and David Pellauer (Chicago: The University of Chicago Press, 1990), 119–26.

6. Susan Sontag, *On Photography* (New York: Penguin Books, London, 1977), 17.

7. Ibid., 16.

8. Roland Barthes, *Camera Lucida: Reflections on Photography*, trans. Richard Howard (New York: Hill and Wang, 1981), 94.

9. André Bazin, "The Ontology of the Photographic Image," in *What Is Cinema?* vol. 1 (Berkeley: University of California Press, 1967), 9.

10. Philip Rosen, *Change Mummified: Cinema, Historicity, Theory* (Minneapolis: University of Minnesota Press, 2001), 136.

11. In the contemporary context of visual art and documentary, we may also think of the nonanalog status of animated images, which, nevertheless, may provide a strong sense of indexicality. For example, *His Mother's Voice* (1997) by Dennis Tupicoff exemplifies the imaginative in documentary, as well as the important indexical function of recorded sound (see Michael Renov, "Animation: Der Imaginäre Significant des Dokumentarischen," in *Texte Zur Kunst*, jahrg 13, no. 51 (September 2003): 36–45. Furthermore, real-time representations in contemporary media thoroughly question the past tense of camera inscription, offering new meanings to the discourse of the image trace.

12. Catherine Russell, *Experimental Ethnography: The Work of Film in the Age of Video* (Durham, N.C.: Duke University Press, 1999), 240.

13. The Private Photo and Film Archives Foundation (PPFA) was established by Forgács in Budapest in 1983.

14. Paul Ricœur, "Memory and Forgetting," in *Questioning Ethics—Contemporary Debates in Philosophy*, ed. Richard Kearney and Mark Dooley (London: Routledge, 1999), 9.

15. Ricœur, *Memory, History, Forgetting* (Chicago: University of Chicago Press, 2004), 169.

16. Jean-Paul Sartre, *The Imaginary: A Phenomenological Psychology of the Imagination*, trans. Jonathan Webber (London: Routledge, 2004), 19.

17. This sequence is from the second part of the film, titled "Les mains coupées" ("The cut off hands").

18. For the complex psychology of home movies, see Marianne Hirsch, *Family Frames: Photography, Narrative, and Postmemory* (Cambridge, Mass.: Harvard University Press, 1997); Michelle Citron, *Home Movies and Other Necessary Fictions* (Minneapolis: Minnesota University Press, 1999).

*Part III Other Films/
Other Contexts*

ROGER ODIN
Translated by Bill Nichols with the assistance
of Claudia Leger

[**8**] *How to Make History Perceptible*
The Bartos Family and the Private Hungary
Series

With *The Bartos Family* (1988), Péter Forgács inaugurated a series of
films dedicated to the history of Hungary. All these films take up the
tradition of the montage or archive film,[1] also known as the found-
footage film.[2] More precisely, they belong to a particular current in this
tradition: compilations based on home movies. This current includes
different styles of production, which can be grouped roughly into four
broad categories: films with a psychological tendency (intimate jour-
nals, letters, autobiographies), which utilize home movies to increase a
sense of lived experience;[3] montages designed to be spectacular, comic,
or dramatic (such as the series of accidents in *Real TV*); experimental
and artistic productions (films, videos, installations);[4] and documen-
tary films.[5] The films of Forgács exist at the intersection of these last
two categories: Forgács is an avant-garde artist—he has directed perfor-
mances, installations, and videos such as *The Case of My Room* (1992),
Two Nests (1992), *Hungarian Totem* (1993), and *The Visit* (1999)—who
has also dedicated a portion of his work to film documents. We will see
what arises at this intersection.

Rather than survey the totality of the films that constitute the Private
Hungary series, I have chosen to analyze the first film in the group, *The
Bartos Family*, in which Forgács establishes the principles behind his use
of the home movie as document.

The use of home movies as documents is without a doubt the fac-
tor that contributed most significantly to the legitimacy of this scorned
genre. Today, this phenomenon has reached incredible scope: innumera-
ble documentaries make use of home movies, particularly on television.[6]
On the initiative of André Huet, the creator and director of the first
daily program of this type of home-movie-based films (on Belgium
Radio/Television), an international association (Inédits) was created,

bringing together everyone (directors, researchers, archivists) with an interest in the particular question of home movies as documents.[7] As further proof of the importance of this subject, the Fèdèration Internationale des Archives du Film (International Federation of Film Archives [FIAF]) introduced the subject of the amateur film as document in two of its conferences (in 1984 and 1988) and dedicated an issue of its journal to the topic.[8] Almost everywhere in the world film archives are opening collections of amateur cinema, even specializing in the preservation of these films.[9] Forgács himself created the Foundation of Private Photograph and Film in Budapest in 1983.

The creation of this type of archive often occurs in places where questions of national identity exist (Brittany, the Basque Region of Spain, Scotland, etc.). This is precisely the case in Hungary, a nation confronted with the question of its existence in the heart of an empire and subjected to multiple occupations over a number of years. Without a doubt, Forgács's choice to speak of Hungarian history through a reediting of amateur films has something to do with this situation: if what Pierre Nora says is true, that "there are places for memory because there is no longer a social context for memory,"[10] it is understandable that to live in a country with heartrending memories like Hungary would prompt a director investigating the history of his nation to turn toward amateur films as places for memory in order to transform them into history.

It remains the case that amateur film is a particular place for memory, a place of private memory to which we are outsiders. Thus Forgács devotes himself to giving us the elements that rapidly allow us to locate ourselves in relation to the Bartos family. We are first located by a long shot (the family is playing with their dog in a garden) in the course of which the voice-over commentary (by Forgács himself) introduces us to the different family members: "the head of the family" (framed in the middle of the shot, the senior Bartos is in the midst of exercising with a set of coiled springs, which he then passes to the youngest child, Ottó), and "at his side, the mother . . . and there, the two brothers, Ödön and Ottó"; "Zoltán is behind the camera." Then, after a brief interlude (always in the garden, where Ödön takes several turns waltzing with his mother), we see a series of individual close-up shots. These shots put into play a three-part presentational structure. At the level of the commentary, deictic statements introduce each family member: "the head of the family, Ármin Bartos," "his wife," "and here is Zoltán, the oldest of the boys; during thirty years he shot more than five hours of films," "Ödön, the second oldest" (a sturdy man who poses beside his horse), and "this is Ottó, the smallest of the three." At the

level of the images shot by Zoltán Bartos, following a recurrent motif in home movies, the characters look toward the camera, which is to say, toward us.[11] Some of them address us directly: Armin and Zoltán greet us by tipping their hats, and the small Ottó blows a series of kisses with his hand. Finally, each shot ends with a direct intervention by the enunciator: a freeze-frame. Thus Forgács intends to signify to us that these social actors look at us (i.e., they concern us).

But in what way could these individuals actually concern us? Why should the Bartos family be of interest to us? Can the images of a single family constitute a valuable corpus? Shouldn't one think they constitute too limited a sample? What can they teach us that could be generalized? And is a family a favorable locus to reflect and prompt reflection on the history of Hungary? One recognizes here the classic questions posed by microhistory,[12] a genre in which this film inscribes itself: "The Bartos epic is a mirror of private history, a Hungarian family saga." One also knows the response made by the theoreticians of microhistories: the change of scale introduces as evidence those things left unperceived at the level of a macrohistory, either by allowing us to see new things or by allowing us to see things differently. But what are these things that Forgács wants us to discover?

Right from the outset, the film's introductory sequence proposes a point of departure: "The world as seen by Zoltán Bartos."[13] Let us comment briefly on this programmatic statement. It not only shows a respect on the part of the amateur filmmaker, contrasting strongly with montage films where one makes a lively mix of images from different sources without reference to their creators but also marks the desire to make the process of *mediation* the central subject of the film. Suddenly, the habitual functioning of the cinematographic reference is modified: instead of the present reality, these are *representations* that are made available for us to see, representations assigned to a *subject*.

The films of Zoltán Bartos display the desire of their maker to display his world. Even if they retain certain characteristics, these films take up less the traditional home movie—shot without forethought,[14] poorly filmed and shown as is, and without montage—than that of amateur filmmaking,[15] in the sense that they display a genuine desire to make movies. Certain sequences are visibly orchestrated; others rely on little staged scenarios or are nicely staged for the camera. Titles introduce the sequences or locate and date what is filmed. Sometimes we are not far from testimony or documents. One senses that Zoltán Bartos took an interest in changes that affect the world in which he lived and that he utilized the cinema to preserve their trace. We understand that Forgács

has been enthralled by these films and that he would like to make them available for us to discover.

"We will see," Forgács invites us to explore with him, "the world seen by Zoltán Bartos." At the same time a contract is proposed for reading reflexively on two levels of enunciation: Forgács's intervention functions as a metacommentary in relation to the discourse of Zoltán Bartos on his world. In a way, one could say that Forgács achieves a poetic semiological analysis, by his film, of the films of Bartos. It would be convenient to study how Forgács works with the films of Bartos so as to bring out the deeper significance, the hidden meaning (i.e., what the films say beyond the explicit intention of the filmmaker): this includes not only the social or historical sense but also, sometimes, the intimate truth of individuals. Second, Forgács specifies two points to which he wants to draw our attention: on the one hand, a description of the private life of a bourgeois family ("We will see some extracts from the eventful life of a bourgeois family"), and on the other hand, the relationship between history and private life ("from the Depression to the death of Stalin by way of World War II"). These are the two points that I will attend to in the following sections.

▶───────────────────────────────────────

The Life of a Bourgeois Family in Budapest in the 1930s

The world seen by Zoltán Bartos is above all his family. By multiplying, not only at the start of the film (as we have already seen), but also throughout the film, indications of the family status of each individual and by giving to these indications an unrelenting form (the redundant combination of commentary and subtitles), Forgács has us almost physically experience the weight (the pressure) of the bourgeois family structure. Moreover, it is this structure that informs the entire film through the principal titles that establish the main parts: "the father and his three sons," "the father," "the brothers, Zoltán, Ödön and Ottó," "Ödön," "Klára Varsányi, the second wife of Ármin Bartos," "Ottó," and so on. The way in which Forgács introduces the different members of the Bartos family aims to make us aware of the hierarchical nature of the bourgeois family. It is first the father, "the head of the family," then the three sons, Zoltán, Ödön, and Ottó (a shot lets us see them walking together in our direction). The women, on the other hand, are somewhat withdrawn. In the opening sequence, the mother appears almost from the back, and when she is the subject of a close-up, it is very brief, in a shot that seems hastily shot; she is the only one not to conspicuously pose

Figure 8.1 *The Bartos Family*. Zoltán Bartos, our filmmaker, adjusts his hat with his younger brother, Ottó, at his side. Zoltán loves being in front of the camera as well as behind it. Forgács weaves some of the short narrative films Zoltán made throughout *The Bartos Family*.

directly for the camera as the men do. Moreover, in the commentary and subtitles, the women are never introduced by themselves but always in relation to the men: the mother, the wife, the second wife, the fiancée, and so on.

However, the film notes that a bourgeois could not live without a spouse. As soon as his wife dies, the bourgeois will remarry without delay: "But eight months after the sudden death of Mrs. Ármin Bartos," the narrator tells us, Armin marries Klára. Further, the commentary again notes that "the elder Bartos remarried a third time, after the war." The film also indicates that marriages are made within a circle of close acquaintances even if it means that one's social status will be altered (Klára is the former wife of an employee of Bartos, Devi, from whom she divorced) or to take the place of a friend (Zoltán will marry Klàri Sugàr, the wife of his friend, who died during the war). The essential thing is to be married: at the end of the film, one learns that Ottó, the youngest brother, "has married after the war."

The segment devoted to Ottó makes us witness to what one could call "the construction" of a bourgeois. The film chronicles Ottó's

Figure 8.2a *The Bartos Family*. Baby Ottó. These three images depict transitional stages in the growth of Ottó, whom we have already met as a young adult in Figure 8.1.

Figure 8.2b *The Bartos Family*. As a young boy Ottó often performs for Zoltán's camera; here he does the Charleston.

Figure 8.2c *The Bartos Family*. Now a somewhat older boy, but one without a full grasp of political reality, Ottó playfully gives a Nazi salute.

development from his birth to his entrance into the work force in the form of "summary": a succession of stages separated by temporal ellipses. The enumerative structure (a succession of statements and brief shots) produces a mechanical effect, as if it were simply a question of filling in the boxes of a questionnaire or an application form, as if everything was already predetermined. The shots appear as follows: Baby Ottó, with shot of a baby picture as found in any bourgeois family photo album; Ottó as child; Ottó with his grandfather (the latter invites him to salute the camera; from their youngest age, the sons of the bourgeoisie are trained in the art of self-presentation); and Ottó who has breakfast with his father. Then follow the first social apprenticeships: Ottó performing dance steps before the camera; Ottó "at a school of good manners" in a short, charming scene with his female friend Pirko (he offers her a deck chair, a cushion, a bonbon, etc.). The transition into adolescence is marked by his entrance into the lycée; the commentary underlines evidence of his "natural" character: "Ottó is *already* at the *lycée . . . with Edit*, the fiancée of his oldest brother" (all petit bourgeois of the same age group follow the same path). Then there is the military service (and a shot of Ottó in military dress saluting with his arm raised), the acquisition of a university education (filmed on the balcony of the family home, Ottó contemplates the

law diploma he has just received under the benevolent gaze of his brother Ödön), and the affirmation of his physical abilities: "Ottó was adept in fencing, horsemanship and gliding," the commentary tells us under images of glider planes (we see here the result of his grandfather passing on his set of coiled springs in the initial scene presenting the family). Finally, his entrance into the professional world closes this initiatory journey: "Ottó works in the business of his brother Zoltán." Henceforth, Ottó is an integral part of bourgeois society.

From the start of the film, Forgács points to the relationship between the economic and the familial as one of the characteristics of bourgeois society. The father, "the head of the family," is also "an upper middle-class bourgeois, with interests in wood, the chairman of Nasici, a Swiss–Hungarian timber industry firm in Hungary." In the segment of the film dedicated to him, we follow him conducting a guided tour of his lumber factory on the banks of the Danube in the company of his managers: "The father, the great bourgeois, during a working visit in a parquet factory and lumber yard," says the commentary. It is rare in a home movie to find scenes devoted to work. That Zoltán Bartos (possibly at the request of his father) decided to film such a visit is certainly revealing of the bourgeois mentality. Without actually insisting on it, the commentary equally notes that we are within the system of reproduction and inheritance: like his father, "Zoltán has also become a businessman in timber and wood," he has opened "a workshop and a lumber store," and "Ottó works for his brother as a traveling agent."

Most interesting is the manner in which we are shown this relationship to the world of work. At the time of the guided visit to the Bartos enterprise, the film has us enter into the workshop where the workers are busy sawing planks. Whereas, until now, the film has been content to have us attend to music, here it restores the noise of the workshop, in particular the noise of the saws. Later in the film, between two shots that show us Zoltán Bartos posing in front of his store, the film presents the workers hauling the enormous planks of wood to a cart. At this point again, the soundtrack restores the noise of the street and that of the planks landing in the cart. Since amateur films of this period were silent, the spectator knows that these sounds are the result of postproduction work and that there can be no other enunciator than Forgács himself. Suddenly, we are invited to seek an intentional meaning that exceeds simple diegetic anchorage, especially since the montage encourages the construction of a system of binary opposition: if the Bartos family is associated with music, in these two sequences, noise is associated with the workers' labor, as if suddenly we were falling back into concrete reality

(all sounds evoke their source in a concrete manner). Without explaining it, the film thus leads the spectator to an awareness that it is the real, concrete work of others that permits the bourgeois good life, as the commentary says apropos of Zoltán Bartos ("he had a factory and a lumber store that allowed him to live well").

And the film furnishes a description of this happy bourgeois life. It centers mainly around a certain number of objects that Zoltán Bartos's films exhibit as so many external signs of wealth: Ödön's horse ("Joli"), the father's Chrysler automobile (in passing the film links the automobile to amorous relationships: it is in the father's Chrysler that Ödön takes his fiancée to Marienbad, the fashionable resort of the wealthy), the trousseau that Zoltán offers to his wife (a mink coat, rabbit vest, dancing shoes, and bathrobe, which leads to a fitting session on the balcony), Zoltán's stopwatch (filmed in extreme close-up), and so forth. Zoltán's films also describe the leisure-time activities of the bourgeoisie: the beach, dances, meals on the terraces of fancy restaurants, the grand hotels, race-car driving, the tradition of honeymoons and foreign travel, the fashionable gatherings, and songwriting. Thanks to a recording of his own voice, Zoltán himself explains to us how he began to compose songs as result of a bet (the film lets us hear several of them). For a bourgeois, music is only a fashionable pastime.

Cinema belongs to these collective, leisure activities. Just as it amuses him to write songs, Zoltán amuses himself by having his family act. Thus Ödön performs in a little play "à la Méliès," making his coat, hat, and wife appear successively. The film provides several of these small amateur productions: Ottó's dance demonstration; that of Vera, the daughter of the second wife of Armin; and the sketch of "the school of good manners" by Ottó and Pirko. Sometimes cinema and musical composition join together to give birth to a filmed song (one of the great genres of amateur film). To a song of his own composition ("If love is a sin and it's a sin that I love you . . . but your kisses are no sin."), Zoltán directs himself. We see him first in a close-up (it is the shot that we have already seen of him in his introduction at the start of the film) as he waits on a bench; impatient, he takes out his stopwatch and activates it several times; finally, Bibus arrives, and Zoltán promenades with her but refuses to buy her anything at Gerbeaud, the best pastry shop in Budapest ("he refuses everything; by caprice, he says no to all," says the song); Zoltán consoles her by buying her a pretzel on the street, then he walks by another woman he knows who smiles at him, which arouses a sulkiness in Bibus; finally, he proposes a taxi ride to her. The last shot shows Bibus, who draws down the curtain of the cab's rear window as it drives away.

Cinema is integrated into the life of the Bartos family. It is a facilitator of family connections, a catalyst, a *go-between* among the family members. It is also, and Forgács makes this clear, a means for the bourgeoisie to perpetuate themselves. Zoltán appears particularly obsessed by a concern for self-preservation, since he goes so far as to record his own voice. But the correlation does not stop there: in the Bartos family, film and sound recording are the equivalents of the marble statue that Armin, the father, has commissioned from the most sought-after sculptor of the period for the tomb of his first wife. For the bourgeois, to film, to make a record, and to commission a sculpture repeats the same gesture, the same preoccupation: to inscribe the life of his family in physical matter for eternity.

From this perspective, the obsession with self-presentation takes a significance not recognized until now: in addressing the camera, Armin, Ödön, Ottó, Zoltán, and the others not only address the camera (or he who is behind it) but also address future spectators, us, and eternity. The presentational obsession indicates a specificity of the amateur, bourgeois film: one shoots in the present thinking of the future. When the bourgeois films or lets himself be filmed, he takes his bearings according to future criteria and begins to think, "This is how I will be seen in the future." Thus instead of fixing one's existence in the present, the home movie constructs for the future a state that will be experienced as consistent with the idea that the bourgeois wants one to have of him.[16] Thus considered, the film is an ideological instrument designed to perpetuate the bourgeoisie.

But Forgács does not simply content himself by pointing to this social dimension of Zoltán Bartos's films. He makes evident the moments where, beneath appearances (of these always dignified men with their hats and overcoats), the veneer cracks and where the repressed returns because there is always a moment in the home movie where the hidden reveals itself and where the filmmaker lets go.

A very curious sequence has us share the reaction of Ödön to the announcement of his mother's death. We begin by seeing Ödön, his wife Klára, and Ottó seated facing the camera; all three look at the camera; then Ödön takes out a letter that he puts in front of his eyes, which suggests he will tear it up. A quite long dissolve, accompanied by dramatic music, introduces a flashback: the family members come to greet their mother. Then the film returns to a shot that we have seen at the very beginning of the film in which Ödön dances with his mother in the garden; this time the shot is slowed down, the movement broken down, which gives it the status of a mental image, a somewhat disturbing

remembrance. There follow some really strange images showing the adult Ödön and his mother who gives him a spanking; then Ödön cries on a bench and holds his face in his hands. Once again, without commentary, the film seeks to have us share the drama lived by Ödön, pointing to his dependence on his mother, his regressive tendencies, his search for masochistic pleasures, and his uncertainty in the face of sexual difference (active vs. passive). This side of Ödön is in radical opposition with the virile side of his personality, which we have been presented with up to this point: Ödön posing, biceps bulging, beside his horse or crossing a meadow at a gallop while the commentary stresses his status as a lumber camp leader. The sequence ends at the cemetery, at the tomb of "Mrs. Armin Bartos, born Aranka Bleha . . . died at forty-seven years." All the family is there in tears; the image itself appears to decompose, to be attacked, scratched, and it swarms with bursts of whiteness that undermine it from within. The fragility of the cinematic substrate reveals the interior fragility of the members of the bourgeois family.

Another sequence is even more astonishing. It begins as a musical comedy based on a song by Zoltán Bartos, "Will you be my mate this summer, my little angel?" In front of the camera Zoltán gestures like

Figure 8.3 *The Bartos Family*. This extreme embrace occurs in one of Zoltán's narrative films. The pursuit and conquest of the woman provides the central plot element.

an orchestra conductor who is trying to animate his musicians or like a television show host who wants to increase the crowd's enthusiasm. Then the camera tracks along a row of young women's faces in close-ups as they greet the filmmaker and smile at him in passing. Next, the camera follows, in extreme close-up, at ground level, a roving hand that successively caresses the calves of the young women before ascending along the leg of the last woman. During this shot, disturbing music replaces Zoltán's light tune. The film then presents a series of violent kisses shot with an incredibly dim backlight. On a pier, a man assaults a woman whom he has bent backward over a stanchion; he then caresses her leg as he attempts to embrace her. Another man who walks alongside a woman on a sidewalk is suddenly overcome by an irresistible urge and hurls himself into an embrace. In a close-up, a man forcefully kisses a woman who resists him; the shot lasts interminably.

A seemingly unconnected short story conveyed in two shots follows: On a road, two women in fur coats meet a horse-drawn carriage in which two men dressed in hats and coats sit; the women turn their heads. In the following shot the men and women walk as couples along the road; the women are in short-sleeved blouses and the men in vests. Each carries his clothes at the end of a stick. What happened during the ellipsis? A series of disturbing shots follow: a shot of a lake, backlit, with, in the foreground, the silhouette of a man who looks at us; a train that hurtles through the night with a trail of white smoke; then again, a man comes and looks at the camera, followed by shots of a snow covered landscape; the shadows of trees cast stripes across the snow. Soon we catch a glimpse of the shadow of a woman and then that of a man (the cameraman?) who follows her. The sequence ends with the initials "ZB" traced in the snow.

In terms of structure, this sequence corresponds to what Christian Metz named "bracket syntagma":[17] a series of shots referring to the same theme. Here the sequence asks us to assemble a series of fictional fragments that all manifest the irruption of violent desire. The harsh quality of the contrasts, the backlighting, the shadows, and the tracking shots lend their force to the plastic dimension of the images, producing an effect of "specular seduction and terror."[18] Julia Kristeva remarks that "this effect is at its maximum when it is the image itself that signifies aggressivity," which is the case here, and that "the more animalistic the better,"[19] which is again the case here. What matters is that the specular works directly through its plastic intensity. The final shots of the snow are remarkable in this regard: one could think of film noir or expressionist film. The final signature ("ZB") would have us understand that the montage of this sequence is by Zoltán himself (but we cannot be

certain), nevertheless one thing is certain: the shots are by him and there is no question of a Freudian slip.[20] These very troubling shots have been consciously directed and shot by Zoltán Bartos of whom they reveal an aspect of his personality that the preceding images did not allow us to imagine: an obsessional side (in fact, Zoltán's films contain numerous shots of the calves or legs of young women) and a violent nature that is a bit disturbing. Another montage done by Zoltán himself points to an almost sadistic side to his personality: two hands (most likely those of Zoltán) hold two cute white rabbits in front of a black background, followed by a shot of these rabbits transformed into a fur coat worn by Zoltán's fiancé. These shots surely reveal to us something of the truth of Zoltán Bartos, the subject, a person split between order and disorder, appearances and passion, civility and violence.

The theoreticians of private history have often underlined the difficulty of knowing anything but the public, external face of the private. Ricœur even notes, "That which we can't see and can't expect to see, is the lived experience of the protagonists."[21] The film attempts here to pass to the other side of the mirror, to suggest intimacy, and to bring the unconscious to the surface, even if it is by means of symbolic reconstructions.

The Bourgeois World and History: Chronicle of a Death Foretold

Another major question regarding microhistory is how to understand the relationships between the micro and macro levels, between the private sphere and history. Zoltán's films show us history "seen from below" (from the everyday life of the Bartos family). From this point of view, the film is divided into two major parts: before and after the irruption of history (i.e., 1938; but, in fact, there are three movements that need to be distinguished).

In the first movement, Forgács introduces evidence of the indifference to history manifested by bourgeois society, an indifference that seems proportional to the attention that the bourgeoisie devotes to themselves and to their desire for a good life. This movement corresponds to the first part of the film (the description of the bourgeois life).

We can only be struck by the radical absence, during this entire movement, of all reference to any historical events. The only shot where a historical actor, Governor Miklos Horthy (filmed from a distance—without Forgács's commentary it would be impossible to know who is ascending the platform), appears is presented in a strictly anecdotal

manner and within a sequence that has nothing to do with history but, on the contrary, is focused on the private life of the Bartos family: they are attending an automobile race.

No less striking is the type of temporality established by the montage (it is a distinction of the cinema to be able to have us experience a temporal rapport directly): a nonnarrative and nonchronological temporality. We go from 1931, when Ármin takes his second wife, to 1922, at the start of the segment on Ottó, then jump to 1933, and so on: in sum, the opposite of historical temporality. Certainly, one finds fragments constructed chronologically (e.g., the summary of Ottó's life), as well as isolated ministories (Ottó and Piko), but one cannot say that this part of the film recounts the history of the Bartos family from 1928 to 1938. In fact, as we have seen, it is constructed thematically around the members of the family, with, in terms of syntagmatic construction, a distinct predominance of autonomous shots, of scenes, and descriptive or bracket syntagms.[22] This certainly does not indicate that this part of the film fails to manifest a temporal rapport, but it is not the linear and vectorized time of history.

As the repetition of numerous shots indicates (e.g., all the introductory shots are also to be found in segments dedicated to specific individuals), it is more a question of a circular time that, on occasion, takes on the form of an interior time and, above all, a *ritual* time (e.g., the return of the shots in which Ödön dances with his mother at the time of her death). The film is thus punctuated by certain characteristic scenes, like the honeymoon trips, the departures by train, and above all the scenes at the cemetery, that occur near the end of each segment. In the bourgeois family, notes Ariès, the tomb has become "the true family home."[23] For example, it is there that the engaged couple is brought together (we see Edit, the fiancé of Zoltán, "at the grave of the Bartos mother").

In the course of one statement, Forgács shows that the indifference to history sometimes leads to a certain complicity with what is to come: incidentally, the commentary tells us that "Armin Bartos, following the urging of his new wife, changes his name to the more Christian sounding Andor." This little cowardice helps us better understand why there was hardly any resistance to the rise of fascism.

More generally, the film shows that the bourgeoisie saw nothing coming, not even Nazism: at the start of a European tour by Zoltán, Forgács's commentary notes, in a neutral tone, "in Austria, after the Anschluss." Evidently, the images over which this remark is made are perfectly insignificant (Zoltán and his friends posing in front of their

cars). They also did not see the rise of Communism: two short sentences in the commentary are enough to let us understand that the bourgeoisie have learned nothing from the war and that they blissfully continue to concern themselves only with their own small affairs: "1948: the shop of Klári Sugàr *before* nationalization" and "1948: the shop of Zoltán *before* nationalization." The film's conclusion is directly centered on this omission of history. While we attend a communist May Day parade shot by Zoltán, Forgács gives us a song by Laszlo Kazal, the words of which, beyond the derision that they manifest toward such celebrations, are explicit on this point: "When did Napoleon win / when did he lose a great battle / in which year was he a great emperor / when did he anoint himself. . . . You ask me in vain / I cannot answer because I never memorized a historical date."

In the second movement, at the same time as he has made us experience this indifference to history by the bourgeoisie, Forgács seeks to make us aware that even if one does not attend to it, history itself is always there and attends to us. The film opens with an eminently symbolic image: a zeppelin slowly crosses the screen, traveling above the city of Budapest. The fact that it is a silent shot of some duration gives a strong coefficient of disturbing strangeness to this image that is, in and of itself, already unusual. What announces the intrusion of this flying object in the sky above Budapest? What menace does it bode for the city? The future thus inscribes itself in the present. But it is above all the music that is entrusted with this function. Whereas the images demonstrate that no one shows any concern, the music is the voice of history. With its throbbing rhythm, it kindles a strong sense of expectation and anxiety: it gives us a sense that something tragic will occur. The entire description of the bourgeois life is based on this type of contrast: happy images undermined by the music. Quite evidently, we recognize the effect of the music because we know the course of history, and we know history (even if minimally).

At times, the process is even more complex, as with the numerous images of trains that function as a veritable leitmotif throughout the film. Here, it is the play with sound that is determining: by contrast with the remainder of the film where sounds are rare, these images of trains, with their intensely insistent sound design, evoke heartrending memories of more sinister trains. At the same time, an appeal is made to cinematographic memory: all viewers carry within themselves the sounds and images of trains that transported deportees to the concentration camps. Thus images of banal, or even happy, events (images of vacations, of honeymoon trips, or trips to foreign countries) are transformed into images endowed with a strong, dramatic coefficient.

In the third movement, in opposition to the first part, the second part of the film attends to the intrusion of history into the life of the Bartos family. This begins during the trip around Europe by Zoltán and his friend Miska Grósz, a trip that the film describes as pleasant, mixing sailboat excursions, city tours, games between friends to the lively rhythm of an Italian song. Suddenly, the song that accompanies the classic vertical view of the leaning tower of Pisa is cut off, replaced by an oppressive silence. Next come two shots, still silent, of a street demonstration in Rome before the Victor Emmanuel monument. With a panoramic shot, Zoltán sets the scene and then frames the crowd as they perform the fascist salute. They constitute the first bluntly historical shots in the film. But why did Zoltán shoot them? The shots that follow—a shot of waves breaking on the shore and of Zoltán in a bathing suit and sunglasses on a terrace facing the sea (during these two shots one actually hears the sound of the sea)—leave us to suppose that this demonstration hardly disturbed his vacation nor changed his good humor and that he filmed it without any particular purpose, as one might film a folkloric event in a foreign country. We then attend a departure by train shot with a subjective camera, with the sounds of the train and whistles and a hand that waves from the train window while, on the platform, a band plays a fanfare and soldiers salute. A title card announces, "Home Again"; they say good-bye and embrace while the commentary states, over bucolic images where we see Miska among a herd of sheep, "Miska Grósz, vanished on the Russian front line in 1944 as a Jewish forced laborer." Anticipating the future, the commentary allows us to understand that which is manifest in the images shot by Zoltán Bartos: they testify to his extreme obliviousness of the historical moment. Thus Forgács allows us to sense that it is the conjunction between this bourgeois unconsciousness and the rise of fascism that yields "the moment of tragedy."[24]

At this point everything changes. The construction of the film becomes chronological. Subtitles and commentary begin to mark the dates. Each date corresponds to a historical fact of which we see the consequences for the everyday life of the inhabitants of Budapest. "Right-sided traffic was changed to left-sided in 1940, following German demands." We then see a shot of an accident between a tram and a truck (the image is itself damaged by flares of torn film). "1941: Hungary goes to war against the Soviet Union. The private cars are requisitioned by the Army": here we see a shot of Zoltán and his son on bikes and views of crowds on the trams.

But the most interesting thing to notice is that Zoltán himself has changed his way of filming: from here on, he acts as a witness to history.

He begins, for example, to film war posters and public events with a political dimension: the Hungarian international armaments fair (shots of tanks and planes) and a military parade with participation by the clergy. The rhythm then accelerates and the consequences of what happens at the level of macrohistory become more and more dramatic at the level of microhistory. A sequence shows the results of the bombing of Budapest (1941), while the commentary draws up an overwhelming assessment: "The Germans blew up every bridge. Sixty percent of the houses were destroyed. They killed six hundred thousand Hungarian Jews. The Second Hungarian Army was destroyed." Curiously, Zoltán, whose camera is in general perfectly stable, seems overcome here by a sort of frenzy, roaming in every direction over the devastated homes, the piles of rubble, and the razed sections of the city, as if the situation did not permit him to preserve his very subdued style appropriate for an amateur, bourgeois cineaste. Thus through the mediation of the camera, we witness the transformation of Zoltán by history. At the same time, Forgács's soundtrack incorporates more and more noise: the sound of boots, planes, and bombardment. The message is without ambiguity: reality takes over the world dreamed of by the bourgeoisie.

Figure 8.4 *The Bartos Family*. Budapest in ruins. As the author notes, Zoltán's movies become more public documents after historical events intrude into the very heart of family life.

Then another reckoning follows, this time at the level of the Bartos family, a mixed assessment that marks at once the perpetuation of the bourgeois traditions and the upheavals introduced by history: "Ödön died in Mauthausen concentration camp," "his wife Klári and his son Tomas survived the war," "Ottó got married after the war," "Zoltán returned from forced labor, divorced Edit, and married Klári Sugàr," and "The old Bartos married for the third time after the war." His death in 1948 gives us the chance to witness one final cemetery scene.

Here, a slight recollection is necessary. From the start, Forgács overlaid shots of the cemetery with the sound of the running camera; the spectator has thus acquired the habit of associating death with the noise of the camera. Yet later in the film, we hear the same camera sound in an entirely different context: it accompanies all of the sequence dedicated to Budapest after the bombardment (with the enumeration of the resulting deaths by the commentary). With this variation, Forgács makes us aware that if death was until then strictly a family affair then it has now become a public affair. Thus history menaces the very heart of bourgeois society: even death has lost its private dimension.

Two shots seem to indicate that Zoltán had an intuition of this evolution: at Christmas in 1943, in an extreme close-up, he films himself spinning a revolving globe of the earth (we see only his hand) and then, still in an extreme close-up, the act of kissing his wife squarely on the lips. How could one indicate more clearly the relationship between history and private life or, more precisely yet, indicate the menace that the worldwide effects of history would impose on individual relationships and on the most intimate of relationships?

The very foundations of bourgeois society find themselves menaced. The final images of the film show us the Bartos family in defeat: these bourgeois, so preoccupied with their bodies, have lost their imposing presence and self-confidence. Zoltán, for example, who at the start of the film stylishly saluted us with a heartfelt tip of his hat, now hesitates interminably at the moment of putting on his hat; after brushing and rebrushing his hair, he seems to have difficulty putting it on and must start over several times. The breakdown of his movements also adds to the effect of a loss of corporeal mastery. Lastly, Zoltán hides his face beneath his hat. This marks the end of the film. Without a word, Forgács signifies the end of bourgeois society.

Chronicle of a death foretold, such could have been the title of *The Bartos Family.*

Conclusion

We can now attempt to characterize Forgács's method. Above all, it consists of shaping his films in order to make apparent relationships, interactions, and latent significances—in short, to construct the historical facts that he wishes to place into evidence. In this regard, it is certainly a question of the historian's task.[25] However, it is clear that *The Bartos Family* does not inform us of anything new about the history of Hungary.

This is because the film's essence lies elsewhere: in the manner in which the film seeks to make history affectively perceptible. Forgács has well understood the full emotional potential contained in these images filmed by ordinary people (like us) and endowed them with a specific *aura*. One can here pit Walter Benjamin against himself and acknowledge that if the aura lets itself be defined as "the unique phenomenon of a distance, however close it may be,"[26] home movies certainly have an aura; they are the unique trace of a family's past (home movies consist of original footage, and there is no negative; if they are damaged, they are forever lost).

At the same time, Forgács is conscious of the traps that these images harbor: they encourage a drift toward nostalgia, toward an emotional state, no longer posing questions (this is what I have elsewhere called the "regime of authenticity").[27] All his efforts aim toward putting the affective in the service of the reflexive. The music, for example, thanks to Tibor Szemzö, has a role, as we have seen, that is essential; it touches us in our very depths and, as the voice of history, prompts us to ask questions about the future. The sounds also function on two axes: their presence not only strikes us with great force, in direct proportion to their rarity, but also invites us to anticipate what will happen (e.g., in the train sequences) or have us notice problems that, without them, we would not see, such as the problem of the middle class's relationship to reality, the problem of class relations, and so forth.

The image track is also at the junction of these two movements. Forgács avails himself of these sometimes overexposed and scratched images that have passed before us and have come from the past in order to liberate their figurative dimension and their affective powers. At the same time, he introduces a series of distanciation procedures (intertitles, subtitles, breakdowns of movements, frequent freeze-frames), which force us to become aware of the presence of an enunciator who seeks to direct our reading. The commentary, which is not very abundant (we are far from the prolific and excessive commentary of some montage films),

is without a doubt the least affectively marked aspect of the film. At a discursive level, it often takes the form of simple introductory, nominal sentences. But it should not be considered neutral: these short sentences are never innocent. By saying too much and too little at the same time, they prompt us to construct the discourse on our own. More generally, the film's construction suggests to us a text filled with gaps, fragments, and deficiencies, sometimes apparently muddled, that we must complete and organize. Thus all of Forgács's cinematic work is done to oblige us to ask ourselves questions and to implicate us. *The Bartos Family* belongs to the category of films of *stimulation*.[28]

Even if Forgács's interventions will be made more strongly in the latter films in the series, he will never abandon this communicative posture. His films will never become more explicit in terms of their discourse; they will never become like those militant films that convey a predetermined message. Forgács's films belong to a general movement in the evolution of the document toward the subjective and the artistic.[29] Today the document finds itself in a new situation: how to direct attention to the real, and in particular to history, in the context of a saturation of images, of "widespread fictionalization" ("fictionnalisation généralisée"[30]), and of extreme mediatization and dominant individualism. Forgács has well understood that only artistic work on the speech of a subject[31] has some chance of being heard. It is important to emphasize that although Forgács has been very influenced by the experimental movement Fluxus, and despite a pursuit of formal effects that are more and more evident,[32] the Private Hungary films will never become truly experimental. They never, for example, deconstruct amateur films to the degree manifest in the "analytical camera" of Angela Ricci-Lucchi and Yervant Gianikian.[33] The situation in Hungary is not the same as in Italy. Forgács is dealing with a country that has to reconstruct itself, in terms of both its identity and its politics, which leads to a greater respect. Above all, Forgács's films continue to reach an ever-expanding audience, awakening in them a consciousness of history. In this regard, the films of Forgács achieve a universal dimension.

▶———————————————————————————

NOTES

1. In *Films Beget Films: A Study of the Compilation Film* (New York: Hill and Wang, 1964), Jay Leyda examines the different types of such films: *archive film, documentary archive film, montage film, montage chronicle film, stock footage film, library film, found footage film*, etc.
2. On the *found footage* film, see William Wees, *Recycled Images* (New York: Anthology Film Archives, 1993) and D. Hibon, *Found Footage* (Paris: Galerie Nationale du Jeu de Paume, 1995).

3. An example of this type of production is *A Song of Air* (1987) by the Australian Merilee Benet. An analysis of this film can be found in Roger Odin, "Le film de famille dans l'institution familiale," in *Le film de famille, usage privé, usage public*, ed. R. Odin (Paris: Méridiens Klincksieck, 1995), 37–39.

4. Home movies were projected or exhibited (filmstrips were hung from the ceiling) in the eminent space for contemporary art, the Cartier Foundation, in the context of its "Soirées Nomades" in April 1996.

5. See, for example, the European series *La guerre filmée par ceux qui l'ont fait* or *La guerre filmée en couleur*. Some productions compile documentaries on history as seen by amateurs and documentaries on the history of amateur cinema. See, for example, the series *La vie filmée des Français*, conceived by Jean Baronnet in 1975.

6. L'Association Inédits has edited a catalogue of television productions using amateur films: *Les Inédits à la television* (Paris: Inédits, 1993).

7. This association has also edited a book, *Rencontre autour des inédits: Jubilee Book: Essays on Amateur Film* (Belgium: AEI, 1997).

8. See the dossier, "The Amateur Film/Le cinéma amateur," *Journal of Film Preservation* 25, no. 53 (November 1996): 31–59.

9. For example, Le Forum des Images in Paris, the Cinematheques of Brittany and of Monaco, the Basque Cinematheque, the Andalusian Cinematheque, the Ethnographic Museum of Conches in Switzerland, the Northwest Film Archive in Manchester, the Scottish Film Council in Glasgow, the Small Film Museum in the Netherlands, and so on. A sign of the recognition of this question in the realm of cinema: *Cahiers du Cinema*, in its special issue, "At the Frontiers of Cinema" (May 2000), featured comments by two archival conservationists: Vincent Vatrican from the Cinematheque of Monaco and André Colleu of the Cinematheque of Brittany. On the question of amateur film archives, see L. Allard, "Du film de famille à l'archive audiovisuelle privée," *Médiascope*, no. 7, 132–38; and François Porcile, "Récupérations restitution: la chasse aux archives privées," *Images Documentaries*, no. 28 (1997): 9–13.

10. Pierre Nora, "Entre mémoire et histoire," in *Les lieux de mémoire*, ed. P. Nora (Paris: Gallimard, 1984), xvii. [*Realms of Memory: Rethinking the French Past*, 3 vols., trans. Arthur Goldhammer (New York: Columbia University Press, 1966)—trans.]

11. The camera gaze, Christian Metz notes, "introduces a reversal that takes away the innocence of the cinematic apparatus" in *L'énociation impersonnelle ou le site du film* (Paris: Méridiens Klincksieck, 1991), 40.

12. These are the types of questions posed by Jacques Revel in his preface to a book by Giovanni Levi, *Le Pouvoir au village: Histoire d'un exorciste dans le Piémont du XVI° siècle* (Einaudi, 1985; French trans. Paris: Gallimard, 1989). On microhistory, see, among others, Jacques Revel, ed., *Jeux d'échelles: La microanalyse à l'expérience* (Paris: EHESS, Gaillimard-Seuil, 1996).

13. Later, the commentary will insist again, "It is his recordings which constitute the epic that follows."

14. In *L'Intentionnalité: Essai de philosophie des états mentaux* (Paris: Minuit, 1985) [*Intentionality: An Essay in the Philosophy of Mind* (Cambridge: Cambridge University Press, 1983)—trans.], John R. Searle distinguishes between "prior intention" ("intention préalable") and "intention in action" ("intention en action"), 107–9. With home movies, one finds "intention in action"; the family filmmaker does not say to himself, I am going to tell such and such a story (if there are stories, they are those which are provided to him directly by the family: a marriage, a communion, a family meal, etc.). He films, that is all.

15. On this distinction between family cinema and amateur cinema, see R. Odin, "La question de l'amateur," *Communications*, no. 68 (1999): 47–90.

16. Following up on a comment by Robert Musil apropos family photography (R. Musil, "Hier ist es schön" in *Prosa und Strück* [Reinbek, 1978], 523), K. Sierek notes that the home movie "constructs for the future a state that will be experienced as beautiful" (K. Sierek, "C'est beau ici. Se regarder voir dans le film de famille," in *Le film de famille, usage privé, usage public*, ed. R. Odin [Paris: Mérids Klincksieck, 1995], 75–76).

17. Christian Metz, *Essais sur la signification au cinema* (Paris: Klincksieck, 1968), 128. [See C. Metz, *Film Language: A Semiotics of the Cinema* (New York: Oxford, 1974), 126–27—trans.]

18. Julia Kristeva, "Ellipse sur la frayeur at la séduction spéculaire," *Communications*, no. 23 (1975): 74.

19. Ibid., 75.

20. In "In Defense of Amateur," Stan Brakhage notes that home movies often contain Freudian slips: he indicates, for example, the case of a husband who, finding that his wife exposes too much of herself to other men, tends to film her in shots that are themselves overexposed. "In Defense of Amateur" was initially published in *Filmmakers Newsletter* 4, no. 9–10 (Summer

1971) and reprinted in Robert Heller, ed., *Brakhage Scrapbook* (New Paltz, NY: Documentext, 1982), 162–68. The French translation occurs in a pamphlet edited by Yann Beauvais and Jean-Michel Bouhours, *Le JE filmé* (Paris: Centre Georges Pompidou, Scratch Projection, 1995), 1969–60; the pagination of this work begins at 1990 and returns to 1897, the date of the invention of the cinema.

21. Paul Ricœur, *La mémoire, l'histoire, l'oubli* (Paris: Seuil, 2000), 275. [Kathleen Blamey and David Pellauer, trans., *Memory, History, Forgetting* (Chicago: University of Chicago Press, 2004)].

22. These types of sequences were specified by Christian Metz in his "large syntagmatic categories of the image track" ("la grande syntagmatique"). See Christian Metz, "Problems of Denotation in the Fiction Film," chapter 5 in *Film Language: A Semiotics of the Cinema*, trans. Michael Taylor (New York: Oxford University Press, 1974), 108–46—trans.

23. Philippe Ariés, *Essais sur l'histoire de la mort en Occident du Moyen Âge à nos jours* (Paris: Seuil, 1975). [Patricia M. Ranum, trans., *Western Attitudes toward Death: From the Middle Ages to the Present* (Baltimore, Md.: The Johns Hopkins University Press, 1975)—trans.]

24. "How to capture the moment of tragedy," a sentence uttered by Forgács, July 8, 2001, during a debate at the Forum des Images (Paris), organized on the occasion of a retrospective of his work. It is cited by Laetitia Kugler in her master's thesis, "La modalisation du discours dans le documentaire de compilation: Displaced Person by Daniel Eisenberg, Free Fall by Péter Forgács" (master's thesis, University of Paris 3, IRCAV, 2002), 94.

25. "It is the question that constructs the historical object, by constituting an original assemblage from a limitless universe of facts and available documents." Antoine Prost, *Douze Leçons sur l'histoire* (Paris: Seuil, 1996), 79.

26. Walter Benjamin, "Petite histoire de la photographie" in *Œuvres II*, Folio, 2000, 311 (Hannah Arendt, trans., *Illuminations* [New York: Schocken, 1969], 222—trans.)

27. Roger Odin, *De la fiction* (Brussels: De Boeck, 2000), 163–67.

28. This is the term used by Alain Resnais to characterize *Muriel*. See Marie-Claire Ropars, Michel Marie, and Claude Bailblé, *Muriel, histoire d'une recherche* (Paris: Editions Galilée, 1974).

29. This movement has been well examined by Jean François Chevrier and Philippe Roussin in "Le parti pris du document," *Communications*, no. 71 (2001).

30. Marc Augé, *La guerre des rêves* (Paris: Seuil, 1991).

31. In *The Bartos Family*, the subject is Zoltán Bartos; the great majority of the films in the Private Hungary series are based on the work of a single author: Jenö (*Dusi and Jenö*), Mr. G (*Either-Or*), Mr. N (*The Diary of Mr. N*), György Petö (*Free Fall*), Nándor Andrásovits (*Danube Exodus*), and so forth.

32. To the figures already noted, Forgács adds the work of coloring or tinting. One can measure the evolution of Forgács's work by reading the remarkable analysis that Laetitia Kugler has devoted to *Free Fall*, in her master's thesis previously cited ["La modalisation du discours"—trans.]. See also Catherine Blangonnet, "Projection de la mémoire à propos de *Free Fall* by Forgács," *Images documentaries*, no. 28 (1997): 13–21.

33. See, for example, *Images d'Orient—Tourisme vandale, Sur les cimes, tout est calme*. On the work of these authors, see Yervant Gianikian and Angela Lucchi, "Voyages en Russie. Autour des avant-gardes," *Trafic*, no. 33 (2000): 47–65; Christa Blümlinger, "Cinéastes en archives," and Raymond Bellour, "Des instants choisis de l'espèce humaine," *Trafic*, no. 38 (Summer 2001): 68–78 and 79–85, respectively.

CATHERINE PORTUGES

[**9**] *Found Images as Witness to Central European History*

A Bibó Reader and Miss Universe 1929

In the masterful style that has become his artistic signature, Péter Forgács performs the task of a clinical archivist, evoking fragments of life stories, intercut with minimal explanatory material, through found footage and home movies in much the same way as psychoanalysis creates a narrativized intertext of continuities and discontinuities, of transference and countertransference, and of resistance and free association. The filmmaker's approach recalls that of Alain Resnais in *Les statues meurent aussi* (1953), in which archival images intervene in history in a cultural dialogue that critiques the French colonialist project.[1] The resulting alchemy for Forgács is not merely a reassembled reconstruction of historical images, refashioned by technical manipulation and reprocessing from archival discoveries, but rather an original, independent work. To achieve his objective, Forgács deploys techniques of cutting, slow-motion, freeze-framing, and subtitling, together with original sound, in a style that gestures toward that of the Hungarian experimental filmmaker Gábor Bódy, whose film *Private History* (1978), made in collaboration with Péter Timár, was constructed from some of the same material as one of Forgács's films, using the same amateur footage.[2]

Forgács's multipart series, Private Hungary, encompasses a complex spectrum of Hungarian experience, constituting at once a valuable contribution to the growing archive of testimony—whether inadvertent or intentional—and a cinematic representation of formidable artistic originality. These image texts—home movies shot by amateur photographers in the context of daily life—acquire new life while restoring the past, thereby becoming retrospective narratives that interrogate personal and cultural memory, inviting reconsideration of the meaning and the construction of national selves and others.[3] The witness of the title of this chapter is meant at once to evoke the amateur filmmaker behind the home

movies; the vast archive of newsreel and found footage; the author of this reassemblage, Péter Forgács; and the viewer positioned, after the fact, as historicized spectator bearing witness to those images initially intended for other audiences, now long disappeared.[4] The overall project suggests the powerful dislocations that were the fate of so many Central Europeans, leaving the viewer to ponder the extent to which trauma remains in the unconscious for generations, affecting—albeit in different ways—not only the participants themselves but also successive generations as well.

An art-school graduate and media artist at the Budapest Academy of Fine Arts before studying cinema, the political dissident Péter Forgács initiated links with the Hungarian artistic underground and undertook intensive photography and teaching in an elementary school experimental class, preferring performance-centered methodology instead of abstract theoretical analysis to emphasize students' experience in the present from 1979 to 1985. He collaborated on performance studio art events with the music group known as Group 180 and, in conjunction with the Hungarian social psychologist, Ferenc Mérei, correlated archival material with his performance pieces. In 1988, Forgács began his first complete film constructed entirely of archival footage, *The Bartos Family*, which constituted the basis (and part 1) of the Private Hungary series. Over the course of numerous interviews, the director emphasizes elements of his work, including the magical power of the archival image, the creative role of editing, and his sense of himself primarily as a pictorial artist rather than solely a filmmaker, expressing the wish to have his films read as visual artworks rather than feature films or documentaries.[5]

By transforming private documents of everyday life into haunting narratives of European history, Forgács recontextualizes these archival home movies, found footage, and amateur film diaries through a unique process of visual archaeology that enlists the audience who then occupy the position of witnesses to those histories. In this way his oeuvre problematizes the spaces between Communism and post-Communism by engaging with the politics of contemporary representational modes within the axes of Central European culture, in a radical critique of Hungarian complacency during both eras. "The past," he has suggested, "is an always re-written history: this is a common identity crisis in East Europe or, in other words, in Mitteleuropa."[6]

At the same time, it reassesses the modernist, Eurocentric affiliation of art cinema in its historical continuity by focalizing the interplay between the subjectivity of his protagonists and the wider horizons of the historical and documentary landscape. Assembled and reassembled entirely from found images and amateur film by interweaving images

and text, letters and diaries, official records and archival documents, the oddly paradoxical effect of this layered, nonnarrative method is in the end a richly detailed, vivid narrative that more closely approximates that of the novel in the indeterminacy of its varied points of view and ellipses.

In *A Bibó Reader* (2001, official selection, Quinzaine des Réalisateurs, Cannes), Forgács deepens his investigation of historical figures, public and private, through home movie and amateur footage compiled and recombined with archival materials, both solicited and discovered by chance.[7] Positioning individual private bodies against the corpus of history writ large, particularizing and intensifying them through austerely spoken texts in an audacious and mesmerizing juxtaposition, *A Bibó Reader* evokes avant-garde practices from the surrealists to the Fluxus movement. Committed to the principle that "the audience should have to work," Forgács's own commitment to this credo is prompted by a specifically Central European sensibility—in this case, a radical critique of an officially sanctioned history in which the voices of victims had been silenced or unheeded. A cineaste without a camera, so to speak, the film stock itself is transmogrified into the space of memory as resuscitated images that challenge the official (often nationalist) discourse recited by off-screen voices in the signature incantatory style of Forgács's longtime artistic partner and composer, Tibor Szemzö.

▶───────────────────────────────────────

A Bibó Reader

The thirteenth segment of Private Hungary, *A Bibó Reader*, investigates the life and times of the esteemed twentieth-century Hungarian scholar István Bibó (1911–1979).[8] His methodology, drawing upon both private and public archives from a period predating digital photography and multimedia, elicits a contemplative reflection on the connection of amateur film to private and public interpretation, thereby interrogating the very notion of collective memory. We are left wondering to what extent the social actors enjoying the pleasures of life or enduring its hardships were indeed aware of the fate that awaited them, and this reflection instills in the spectator an anxiety and empathy that in some sense echo the ambiguous space of their identity, positioned between belonging and exclusion.[9]

With *A Bibó Reader*, Forgács focuses on the intellectual processes of a single individual, in contrast to the ensemble quality of much of Private Hungary's preceding episodes, recalling his earlier work on another philosopher, Ludwig Wittgenstein (*Wittgenstein Tractatus*, 1992). An eminent scholar and towering intellectual figure whose contributions

the filmmaker has described as a synthesis of the writings of Alexis de Tocqueville and the novels and essays of Albert Camus, István Bibó regrettably remains little known in the West.[10] Conceived in 1996, the project devolves from Forgács's own concerns and misgivings with regard to the political evolution of Eastern Europe after the end of Communism and his conviction that, far from being resolved, the troubling issues of this period might be usefully addressed by a work with the potential to engage what he has referred to as the "collective hysteria" that endures in parts of the region, a term echoed in Bibó's writings.[11] Perhaps the reserved tone and steadfast gaze of this homage suggest Forgács's qualification of *A Bibó Reader* as a meditative piece, a term he has used previously but seldom so appropriately as here, given the film's solemnity, subtlety, and restraint.

A Bibó Reader portrays the unwavering commitment of its subject's social and political vision and the implacable lucidity of his body of work, dedicated as it is to a sustained analysis of the political evolution of Hungary between the wars.[12] The titles of his essays are suggestive: "On Personal Responsibility," a lament on the consequences of failure to come to the aid of those in need and a brief in favor of a personal code of ethics; and "The Jewish Question in Hungary, 1944–48," a disquisition on Jewish awareness of being the target of hatred and a denunciation of those seemingly decent citizens whose behavior placed them in tacit complicity with the moral nihilism of persecutors.[13] Had Forgács not repeatedly demonstrated the rigorous archival research and layered compositional processes for which he is known, one might well question the cinematic viability of such seemingly abstract subjects. Yet the material comes unexpectedly and passionately alive, as these extracts from Bibó's works are read aloud and inserted as intertitles, while the biographical narrative functions as an occasion to articulate Hungarian political and social history.

The visual materials are reworked through strategies of slow-motion, freeze-frames, extracts of decomposing 8 mm film, scratching, inserted inscriptions, and the use of negative and inverted images, the primary footage having been drawn extensively from Bibó's personal family archives and credited to his son-in-law, László Ravasz Jr. Additional newsreel footage and scenes from Hungarian daily life are from the Private Photo and Film Archives Foundation Forgács established in 1983 in Budapest, a collection of amateur film footage that serves as source material and raw data for his unique reorchestrations of history. Here as elsewhere in Private Hungary, home movies and found footage perform, in counterpoint to the audio, an ongoing monologue that alternates

Figure 9.1 *A Bibó Reader.* István Bibó at work. The 9.5 mm sprocket hole is clearly visible in the middle of the filmstrip.

between biographical documents of marriage and family life and selected readings from Bibó's influential works.

In the opening shot, Bibó is seated at his typewriter, as we hear the keys striking in an acoustic device that accompanies the mute image track, all original footage having been originally shot without sound. In the subsequent scene, a corps of forced laborers tamp down a dirt road using crude wooden tools, followed by other workers retreating from the camera, shovels held aloft. The film's first intertitle, "On the Rule of Law," signals Bibó's voiced text exhorting readers to heed the consequences of hypocrisy and distortion of social laws that threaten Hungarian society. Setting the tone for the alternating image–sound sequence that follows, "On the Rule of Law" segues to "On Human Dignity" and "On the Crisis of Hungarian Democracy" (1945), both spoken in counterpoint to sequences of a family at leisure on a terrace in a country villa, raising glasses of *pálinka* (fruit brandy) served by the family housekeeper. The narration next turns to Bibó's proposition that a safe society requires that any violation be experienced as being of concern to the polity as a whole, whether the subject of the infraction be a Jew, a Communist, a sheriff, a carpenter, an artist, a member of a sect, or a bourgeois. Extracts from "On Hungarian Public Life" take to task Hungarians of the postwar period for their acceptance of a system of public lies on which social life was based. At this point, the core of the filmmaker's argument begins to take shape, as the viewer is invited to reflect upon a constructed video essay that, again in the spirit of avant-garde art, seeks to engage the spectator in a process of conscious awareness of its own production while calling attention to the subject it foregrounds. This dynamic is buttressed by the subsequent topic, "The distortion of the Hungarian character, the dead-end street of Hungarian history" (1948), spoken in counterpoint to stock footage of images of Budapest's Heroes' Square, its stone sculptures of the leaders of the Magyar tribes standing at mute attention, suggesting the enduring power of foundational national mythologies in the foreclosure of open debate of such troubling issues.

The question of reverse selection, Bibó next argues, replaced the leadership of the community and led to the ethical degradation of the Hungarian ruling class, resulting in a realism based on fake criteria that in turn brought about a retreat into closed communities and a mood of sulking offendedness. This terminology and indeed a focus on this vexed subject may resonate uncomfortably for audiences positioned in the post-Communist space of east Central Europe, struggling to come to terms with a tumultuous and often unreconciled past while facing an uncertain future as partners in the market economies of the new Europe. No less

problematic is its resonance in the socialist era of János Kádár when the realities of Holocaust history and memory were shrouded in silence or altogether eluded in favor of presumptions of Hungary's status as a victim of events beyond its control.

The oddly compelling experience of being sutured within the schema of a voyeuristic gaze, as if through a forbidden keyhole, contemplating anonymous figures from a safe if disturbing distance, exerts its seductive power here. For these intimate, domestic moments were not, after all, intended primarily for a global audience—not even, in most cases, for eyes other than those of the family and friends who are the camera's subjects. Scenes of young men wrestling, little girls playing aquatic sports on Lake Balaton, friends and families canoeing on the Danube, and beautiful young women performing calisthenics are sutured with a montage of private home movies of Bibó's elegant Budapest wedding to the daughter of László Ravasz, the Calvinist bishop of Hungary, the subject of a corollary film, *The Bishop's Garden*.[14] Summer holidays in the countryside and dancing couples on the terrace of a villa are accompanied (in the English-language version) by a British-inflected voice-over reading from Bibó's essays on anti-Semitism and the willingness of nations to surrender personal freedom in times of crisis. The philosopher's critical, analytic voice, both spoken and written, echoes uncannily across the generations to engage contemporary debates on these urgent topics, which are far from resolved in public and private memory. Consistent with Forgács's artistic commitment, and challenging the accepted wisdom of some historians and theorists, this project reconsiders the still-contested terrain of the historical record on Hungary's reluctance to confront its responsibility for the persecution and deportation of Jews and the sequelae of the revolution of 1956. The lives of the filmmaker and his subject thus may be seen in certain ways to intersect and fuse, each bearing testimony to the importance of nourishing and sustaining a deeply felt vision in spite of the harsh circumstances endured by both as Central European intellectuals articulating a critical vision, each in his own genre and generation.

In contradistinction to certain explanatory or sentimental tendencies of documentary filmmaking, Forgács seeks to engage and perhaps ultimately to move the viewer by the power and juxtaposition of the images he selects, which at the same time fill in certain gaps in historical awareness. Avoiding didactic or ethnographic intentionality, interwoven footage nonetheless dialectically contrasts the lives of the peasantry with those of the bourgeoisie. The heroism of a man who never renounced his faith in a free Hungary and in the liberty of the individual to think and act for himself is underscored on the soundtrack by Szemzö's melancholic

sound design and Béla Bartók's modernist compositions.[15] Like his fellow composer Zoltán Kodály, Bartók traveled through Hungary and Eastern Europe learning folk music from rural peasants, discovering a wellspring of unvarnished, pungent idioms that he incorporated into an ingenious musical style that was both of a place yet strikingly modern.

The viewer learns at intervals from photographs and textual material placed throughout the film of Bibó's brilliant yet tragic destiny: born in 1911 to Irén Graul and István Bibó Sr., he attended the Collegium Hungaricum in Vienna from 1933 to 1934, where he met his future wife, Boriska Ravasz, daughter of Bishop Ravasz. He studied at the École des Hautes Études Internationales in Geneva and at the Académie de Droit International in The Hague, earning a doctorate in law and politics from the University of Szeged in 1934. In 1941, he became a court judge and then secretary in the Ministry of Justice and was arrested in October 1944 by the Fascist Arrow Cross Party for forging papers to save Jews, was released, and survived the Siege of Budapest in hiding. From 1946 to 1950 he was professor of law at the University of Szeged, where he was suspended in 1949 from his post as university professor and from the Institute for Regional Planning, which he directed, and stripped of his membership in the Academy of Sciences, not unlike other intellectuals committed to an independent or contestatory ideological stance. On November 4, 1956, he was appointed minister of state in the new government of Imre Nagy, arrested on May 23, 1957, and, in August 1958, sentenced to life imprisonment, along with Arpád Göncz, later president of Hungary.[16] He was granted amnesty in April 1963 and died in 1977.

As the film suggests both insistently and poetically, Bibó believed deeply in the rigorous observation of and respect for the principle of separation of powers in the modern social state, finding "the demoralizing impact of concentration of power" to be the most destructive element in the realm of intellectual and cultural life. He foresaw the increasing practical and ideological significance of the sciences for the modern contemporary world while warning of the dangers to democracy of excessive control of intellectual and cultural resources by politicians who subject it "to a relation of dependence to the objectives of state power and, on the other hand, [by] making state power a prisoner of its own propaganda." For the quintessentially Central European Bibó, being a democrat was tantamount to living in the absence of fear: a democrat, in his perhaps somewhat idealizing view, is not intimidated by those whose opinions differ from his, who speak other languages, or who belong to another race; nor is he prey to suspicions of revolution, conspiracy, hostile propaganda, or the unknown or malicious intent of others—in other words, the

opposite of the accommodating party cadre ready to sacrifice in service to a totalitarian regime. Writing in the late 1940s, he considered the nations of east Central Europe to be trapped in the tautology of a vicious circle, fearful because they were not yet fully developed mature democracies, and unable to become so because of their fear.

Despite the turmoil of his epoch and the constant persecution he suffered, Bibó never felt "that I was seriously in the shadow of a death sentence."[17] Nonetheless, the film makes clear that, while uttering these words, he did yet not know that Imre Nagy, prime minister during the Hungarian uprising of 1956, had indeed been sentenced to death and subsequently executed by the time Bibó himself was brought to trial. His experience, at once thwarted and shaped by the reversals of history, might not have been sufficiently readable by contemporary audiences to have made of this film the compelling and provocative document that has clearly emerged. Yet Péter Forgács succeeds in conveying the impact of his subject's penetrating intellect and generous spirit by virtue of the sheer diversity and viscosity of the images and citations illuminated through the editing process, making them seem—like Private Hungary as a whole— somehow resistant to the inevitable passage of time. As the original title, *Bibó Breviarium* (*Bibó Fragments*), indicates, this is a fragmentary and even elliptical work, a haunting piece based on footage that combines documentation with sequences, both quotidian and extraordinary, shot by amateur photographers, of Bibó's private moments with friends, family, and associates. Thus does *A Bibó Reader* become at once a visual and aural poem interlaced with repetitive, inverted, and reframed images that narrates, by the very artifice of its direct intervention upon the film stock itself, the realities of the drama of the Hungarian nation during the twentieth century and the heroism of a single individual who, risking his life, never renounced his faith in his particular conception of freedom.

Consequently, and thanks to the innovative image-making process that has come to be identified as Forgács's own, the power of István Bibó's political mind offers lessons in history that far surpass the spatial and temporal context of the period in which he lived and worked. In an essay published in 1948 but little known until some four decades later, he addressed the consequences of the imposition of the Jewish laws as marking the moral decline of Hungarian society: "These laws gave a large section of the middle and petty bourgeoisie the possibility of making profitable headway in life without any personal effort, thanks to the state and at the expense of the livelihoods of others. Large sections of Hungarian society got to like the idea that one could make a living not only by work and enterprise, but also by seeking out someone else's position,

denouncing him, researching his ancestry, having him dismissed and claiming his business, *ergo* by the total usurpation of that person's existence."[18] This statement echoes uncannily over the two post-Communist decades as Hungary and the region struggle with the legacy of such denunciations and of contemporary preoccupations with ancestry and ethnicity. In selections from "Ordinary People" and "Life and Social Sensibility" (1942), Bibó warns that decadence derives from a hazy nostalgia heard in the tendency of élite circles to worship the uneducated ancient crafts, cautioning against a ruling class that dwells on the emptiness of its own way of life, incapable of "tailoring their own lifestyles to the values of the simple way of life." Within the larger scope of Private Hungary and its documentation of the silencing of those betrayed by history, as we listen to the reading of these exhumed passages, both the narrator's and the original subjects' voices acquire the radical status of a living testimonial. In "Romantic Patriotism: on Stability and Peace in Europe," for instance, Bibó argues against a notion of patriotism as defined by excessive identification with the nation's accomplishments and failures, based solely on "the strength and purity of [the patriot's] feelings." This textual reference continues presently with a warning on the dangers of a putative Hungarian tendency to see themselves as eternal victims of injustice, a disposition that is far from eradicated today.

Through its pale, at times tinted, images and its uncompromising spoken texts, Forgács's filmic essay on the philosopher brings to light the pertinence of Bibó's analyses: enunciated off-screen or inscribed on-screen, the textual fragments embody the dynamic flow of a richly complex thought process through the apparatus of visual media, combining the aristocracy, the bourgeois gentlemen class (minor nobility and bourgeoisie), the Fascist, the Communist, the peasantry. The filmmaker's vision joins the voice of Bibó the Calvinist moralist in deconstructing and dismantling the mental mechanisms of a deep-seated anti-Semitism, linked to the counterrevolution of 1918 and transmitted to succeeding generations.

A Bibó Reader's closing sequences include a declaration, made in the forced absence of the prime minister, Imre Nagy, by Bibó in his short-lived capacity as minister of state in Nagy's government on November 4, 1956, when Russian tanks made their way from Rákoczi Square to lay siege to the parliament building in Pest: "I, Bibó, alone remain in Parliament as a representative of the legitimate Hungarian government." We hear his own voice live (as in only a few other moments on the soundtrack)[19] during the fateful broadcast on Kossuth Radio calling upon his fellow citizens to reject the occupation army and its puppet

government, captured in powerful counterpoint to the slow tracking shots of the destruction of the urban space of Budapest and its streets in rubble. In a sequence of particular significance following the fiftieth anniversary of the Hungarian uprising, which some have seen as hijacked by right-wing, nationalist and populist segments of the population, Bibó calls upon the Hungarian people not to regard the invaders as legitimate authority and to practice passive resistance: "I am not in a position to give the order for armed resistance—I joined the government only one day ago. . . . [We] have shed enough blood—now the world must show its commitment in the interest of the freedom of my oppressed people."

Forgács the filmmaker is inevitably in solidarity with Bibó the historian–philosopher, the Hungarian Christian writing powerfully about anti-Semitism, practicing an analogous resistance to foreclosure of public debate about these momentous events. The subsequent segment unfolds after the shock of 1956, without music or other audio, representing images of city trams ornamented with the Communist red star during a May Day parade in 1957, when the restoration of the dictatorship of the proletariat was followed by brutal reprisals, a disillusioned populace was resigned to its fate, and "a cynical country struggled for short-term gains after its brief moment of the most exciting social-political experiment of the twentieth century." István Bibó was arrested on May 23, 1957, incarcerated and sentenced to life imprisonment in August 1958, and granted amnesty in April 1963. The political and social analysis, the rigor and intellectual conviction of this prestigious humanist resisted the temptations of repression, as suggested by the inscription on a photograph of Bibó at his typewriter: "To be a democrat is to be free of fear." Far from being merely illustrative, these images of gardens, rivers, lakes, and urban spaces serve to expand the intimate field of vision beyond that of private, domestic space. The mosaic of images—forced labor battalions (*munkaszólgatás*), Bibó and his bride's ecstatic wedding embrace, a couple sitting on the roof of their home under construction, hunters and urban sophisticates, the élite and the working classes—mark the traces of Central European history for a new generation, inviting reflection on the social, cultural, and political forces and conventions that have displayed indifference or even hostility toward artists and intellectuals such as Forgács.

Miss Universe 1929

With his nonfiction film *Miss Universe 1929* (*Lisl Goldarbeiter—a Szépség útja*, in Hungarian, or, *Lisl Goldarbeiter—a Queen in Wien* [2007]),

Forgács departs somewhat from the register that characterizes his investigation of Bibó's biography and philosophy. Winner of the documentary film competition prize of the Thirty-Eighth Hungarian Film Festival in Budapest (February 2007), Documentary Selection for the 2006 Viennale (Vienna), and nominated by the UK Federation of Commercial Audiovisual Libraries International Award for Best Use of Footage in Factual Productions, *Miss Universe 1929* screened at the 2007 Canadian International Documentary Festival and was an official selection at the Sixth Annual Tribeca Film Festival, New York City, in the World Documentary Feature Competition, where Forgács's 2004 film, *El Perro Negro: Stories from the Spanish Civil War*, had won first prize for best documentary.[20]

Vienna, capital of the Austro-Hungarian Habsburg dual monarchy, is described by the controversial Austrian writer and journalist Karl Krauss as "the laboratory of the apocalypse,"[21] the city visited by the four horsemen of the apocalypse—the young Stalin, the young Hitler, the young Trotsky, and the young Mussolini. Little wonder, then, that Forgács chose the "capital of ambiguity," the home of Sigmund Freud, as the principal setting for his emotionally resonant, poignant reflection on the fate of the beautiful young Lisl Goldarbeiter.[22] It is an apt metaphor for the fate of the long-forgotten Viennese girl of modest circumstances who rose

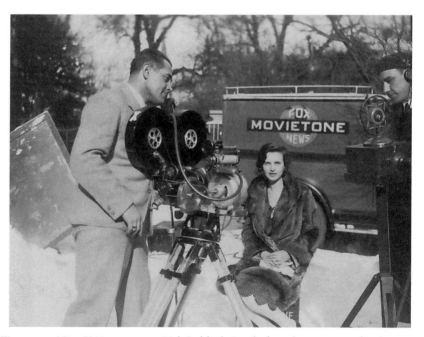

Figure 9.2 *Miss Universe 1929*. Lisl Goldarbeiter before the cameras after becoming Miss Universe 1929.

through the ranks to win the title of Miss Austria 1929 over six hundred contestants, moving on to the competition for Miss Europe, where she came in second to the Hungarian beauty, Böske Simon. In that fateful year, the world's beauty queens set sail to the United States to compete against their American counterparts at the first such pageant (from which the public was excluded, as the film wryly notes) in the unlikely seaport of Galveston, Texas, where Lisl was crowned the first Miss Universe in history by unanimous vote, at the age of nineteen.

But her consecration was not without incident, foreshadowing the anti-Semitic climate that was to play a decisive role in her life. In its report, *Time Magazine* conveyed both an all too modern preoccupation with the female sexuality, desirability, and a beauty queen's ideal measurements and the surfacing of latent interethnic violence, an aspect of the historical event not included in the film that offers a revealing insight into its backstory:

> Slimmer than most sylphs is Austria's fragile Fraulein Lisl Goldarbeiter, recently crowned "Miss Universe" by Galveston, Tex., judges (TIME, June 24). Hard-boiled correspondents had to grope for adjectives to describe her famed "air of ethereal purity."
>
> Rumanians are an earthy people. Last week, as lovely Lisl Goldarbeiter stepped off the Vienna Express at Bucharest, she was met by an ogglesome throng of youths whose reaction soon became riotously negative. "Give us someone our weight!" roared voices from the crowd. "A bent pin for the Austrian Jewess! Give us Magda Dimitrescu—Magda is our weight!"
>
> Magda Dimitrescu was also at the station. She is not really a buxom girl, but beside ethereal "Miss Universe" her dimples looked their deepest, her curves and bulges fulsome. In the Galveston pulchritude tourney as "Miss Rumania" she was not even runner up. Magda had come, hired by a Rumanian roulette syndicate, to welcome her successful rival and shepherd her to smart Sinaia Casino, where she was to be featured as "guest beauty" for a month.
>
> Uglier grew the crowd. "We want no underfed beauty queens here!" cried a roughster. "Let's make her eat some pork!" As the rowdies rushed, even saucy Magda Dimitrescu became frightened, seized Lisl Goldarbeiter by the wrist, dragged her through a baggage room and out by a back alley to sanctuary in the Bucharest Rumanian Orthodox Cathedral.
>
> Thwarted, furious, the now frankly anti-Semite crowd rushed howling to demand that the Cathedral authorities refuse to harbor a Jewess. In the riot a traffic policeman was knocked down, trampled, bloodied. Finally with 300 police rescuers holding back the mob, the sobbing, hysterical "Miss Universe" was sped in a limousine with blinds down, to a place of refuge undisclosed.[23]

Conversely, the mother of one of the contestants was reported by the *New York Times* as having said of the ethereally demure Lisl, clad in a

green silk bathing costume, "Miss Austria's beauty gives me an impression of holiness, something not belonging to this world!" In his leather goods and luggage shop where Lisl worked as cashier and salesgirl, her father proudly boasted to clients and neighbors that his daughter had been warned not to enter the contest by no less a personage than the bishop of Galveston:[24] although reportedly chastened by the cleric's warning, Lisl was not to be deterred from entering the pageant. Having claimed her title, the demure young Jewish woman appears overwhelmed when offered a $15,000 theatrical contract that required appearances in revealing outfits four times daily. "Papa must decide," she says, in an unmistakable echo of patriarchal Viennese society and her middle-class Jewish family of origin. And indeed it is to be her father's decision that she return home at once from the United States, by way of Cuba.[25]

Forgács portrays Lisl's sudden fame, the numerous offers of marriage pouring in from amorous suitors, the flurry of invitations from Hollywood (director King Vidor, a native of Galveston, offered Lisl a two-year contract), the opportunities for social interaction with world-famous celebrities, and the admiring letters from Ferenc (Franz) Léhár, the Hungarian composer of operettas, lieder cycles, and symphonic poems whose renowned operetta, *The Merry Widow*,[26] became an iconic Central European cultural phenomenon. It is perhaps worth recalling that operetta itself is of Viennese origin, as immortalized in the *echt* Central European dénouement of Strauss's *Die Fledermaus*: as the champagne flows and glittering jewels bedeck the throats of ravishing dancers, the waltz strikes up as the tenor sings, "Happy is he alone who forgets what can no longer be changed," injecting into an otherwise brilliant theatrical staging the darker tone of a Freudian moment.[27]

To narrate this international story from a post-Communist perspective that traverses Austrian, Hungarian, and American borders from the 1920s through the Holocaust and the Communist era, Forgács utilizes extensive home-movie footage shot over many decades by Lisl's cousin from the other side of the fading Austro-Hungarian Empire—Marci Tenczer, an amateur filmmaker from Szeged and her determined suitor. Clearly smitten by his subject, he obsessively and continuously captures the events with his own 9.5 mm movie camera, unobtrusively entering her in a competition for Miss Austria. Supplemented by readings from Lisl's diaries and letters and an extraordinary wealth of family photos and archival footage, the film suggests that the moving image and the cinematic apparatus are in themselves linking devices that join the destinies of Lisl and Marci, although on opposite sides of the camera. The pair's trajectory unfolds as Tenczer, still alive while Forgács was working on the

film, lovingly presents the tiara that once crowned Lisl's reign: "Never a woman so beautiful has walked this earth."

The dual monarchy is readable in screen memory, reflecting the Habsburg era's social and material dualities in the latter-day fate of two families: in Vienna, the Goldarbeiters, part of the middle-class Austrian branch of a large Austro-Hungarian Jewish family, and, in Szeged, the Tenczers, the more modest Hungarian branch. We recall that to be "Magyar" and observantly Jewish depended upon a strong identity under the dual monarch of the Austro-Hungarian Empire when Jews participated in large numbers in the nation's modernization process, beginning in 1848. In the face of seemingly insurmountable obstacles, the families manage to maintain contact as the political upheaval closes in upon them. Marci moves to Vienna in 1926, to continue his studies, the Hungarian Numerus Clausus of 1922 (the first anti-Semitic law in Europe) having prevented Jews from entering University in Hungary, among other proscriptions. Marci lives with the Goldarbeiters during his studies at the Technical University from 1926 to 1936, secretly in love with his cousin, beginning to shoot amateur footage of Lisl, her family, and their city shortly after his arrival, and financing his filmmaking by walking the city streets instead of taking the tram. In 1929, he instigates Lisl's entry onto the world stage of beauty pageants.

Following an extravagant courtship played out in footage of luxury automobiles and fashionably elegant parties and balls, in 1930 Lisl marries a playboy, Fritz Spielmann, fond of gambling and heir to the silk tie manufacturing family, having rejected dozens of suitors, including the smitten Marci himself. Not long after the Anschluss, their marriage disintegrates, ostensibly in part due to Fritz's infatuation with a friend of Lisl's, portrayed in scenes suggestive of a ménage à trois. Marci remains a bachelor. Lisl's husband disappears during World War II. In 1949, Marci's enduring romantic love triumphs: he and Lisl, both born in 1907, having survived the Shoah, are reunited, marry, and live together in Szeged.

Yet the scars of history—whether the Hungarian Holocaust or 1956—are never absent from their lives and those of their families. *Miss Universe 1929* concludes with Lisl's death in 1996 (Marci passed away in 2003, shortly after sharing with the filmmaker the rich details of his life and that of Lisl Goldarbeiter). Forgács excavates these memories from the tarnished images of Marci's home movies, shot between the 1900s and the 1980s. Within these stained, marked pictures lies a history of twentieth-century Hungary, a document of Jewish life before and during the Nazi era, and, most unforgettably, the story of a love between two individuals. The director has called this "a little film about big-time fame and eternal

love, set against the background of 1930s Vienna. . . . In the past twenty years, I have found that old amateur films are the unconscious diaries of life, of history. . . . These film diaries tell us something about what we can no longer touch or feel, and also show us the other side of official history."[28]

In March 2007, Péter Forgács was awarded the Merited Artist Prize by the Hungarian Ministry of Education and Culture and the prestigious 2007 Erasmus Prize by the Dutch nonprofit foundation for his "original contribution to the process of cultural memory and the transmission of culture, thereby furthering and deepening our understanding of the past," joining the company of other distinguished Erasmus colleagues including Adam Michnik, Jacques Delors, Simon Wiesenthal, Vaclav Havel, Ingmar Bergman, Charlie Chaplin, Marc Chagall, and Martin Buber. Remappings of the memorial topography of contested temporalities, personalities, and histories, Forgács's role as critical mediator in the representation and afterimages of these traumatic events invites reflection on the role of the camera and the reliability of memory, nonetheless affirming histories that perhaps can never be fully claimed, even—or perhaps especially—in the face of indifference and destruction.[29]

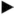

NOTES

1. *Les Statues meurent aussi,* directed by Alain Resnais (Paris, France: Présence Africiane, Tadié Cinéma, 1953). The film's proposition (i.e., why is African art in the Musee de l'Homme while Greek and Egyptian art are in the Louvre?) invites reflection on the mechanisms of oppression and acculturation, suggesting that that there is no discontinuity between African civilization and the West. So inflammatory was this documentary considered to be by the authorities that it was refused a visa on account of its explicitly articulated anticolonialist discourse. In 1964, a truncated copy was finally released. It is worth noting that, more than fifty years later, the Musee du Quai Branly was inaugurated in Paris.
2. András Forgách, "The Destruction of Closed Gardens," *Metropolis* (summer 1999): 58–74.
3. A nation of multiple ethnic, linguistic, and religious identities—speaking a language of Finno-Ugric origin with elements from Turkish, Slavic, Latin, French, Italian, and German—Hungary has, throughout its thousand-year history, been the site of a mosaic of migrations including those of Serbs, Czechs, Romanians, Slovenes, Germans, Croats, Bosnians, gypsies (Roma), and others.
4. See Shoshana Felman and Dori Laub, *Testimony: Crises of Witnessing in Literature, Psychoanalysis, and History* (New York: Routledge, 1992); James Young, "Holocaust Video and Cinemagraphic Testimony: Documenting the Witness," in *Writing and Rewriting the Holocaust: Narrative and the Consequences of Interpretation* (Bloomington: University of Indiana Press, 1988).
5. "Borderline Cases: *Privát Magyarország-sorozatáról,*" *Metropolis* (Summer, 1999), 108–28.
6. "At the Center of Mitteleuropa, A Conversation with Péter Forgács," by Sven Spieker, ArtMargins.com, May 20, 2002, accessed June 12, 2011, http://www.artmargins.com/index.php/5-interviews/354-at-the-center-of-mitteleuropa-a-conversation-with-peter-forgacsok.
7. Heartfelt gratitude to Péter Forgács for the privilege of inviting me to witness the editing process of the final stages of interactive installation for the Getty Center Museum, "The Danube Exodus: The Rippling Currents of the River," in May 2002 at the Annenberg Center, University of Southern California, and for generously sharing with me conversations about his life and work as it has continued to evolve since 1989.

8. A corollary piece, *The Bishop's Garden* (*Püspök a Kértje*, 2002), crafted from footage originally assembled for *A Bibó Reader* and awarded best documentary at the Thirty-Fourth Annual Hungarian Film Week, extends the filmmaker's exploration of the status of Hungarian identity at the onset of World War II. In the opening sequence of *The Bishop's Garden*, a solitary elderly man walks the grounds of his home; he is the retired Calvinist church bishop László Ravasz, a renowned orator who has occupied this property since 1950, when he was sent into inner exile by Communist dictator Mátyás Rákosi in an attempt to neutralize the church's independent status. Since acquiring the house in 1929, Ravasz had summered there with his family. Between 1921 and 1948, he was one of Hungary's most influential and powerful clergymen, the first bishop of the Calvinist (Reformatus) church and a member of the Upper House of Parliament. His archconservative personality and controversial ambivalence toward Jews marked the history of the Hungarian Holocaust.

9. Jacques Mandelbaum, "István Bibó, a Fragment: Rhapsodies of an exemplary anti-totalitarian, plunged in the troubled waters of the Hungarian past, filmed by Péter Forgács," *Le Monde*, May 25, 2002. Later in the season, Forgács was honored by a major retrospective organized by the Forum des Images (Vidéothèque de Paris, Forum des Halles).

10. The neglect of Bibó's work by the West may be attributable only partly to the politics of translation and is more than likely the result of the marginalization of so-called minor national cultures, a phenomenon that would apply equally to the cinemas of east-central Europe, where the censorship of the global market has determined the politics of distribution. See Bibó's "The Distress of the East European Small States," in *Democracy, Revolution, Self-determination: Selected Writings*, ed. Karol Nagy and trans. András Boros-Kazai (Boulder, Colo.: Social Science Monographs, 1991), 18–86.

11. In conversations with the author, Budapest, February 2002 and 2003, in the context of the Hungarian Film Week. Thanks to Magyar Filmunió Budapest for the opportunity to be present each year for this vital event.

12. According to historians such as Paul Lendvai, *Hungary, the Art of Survival* (London: I. B. Tauris, 1990), the perils of nationalism and its many ramifications in nineteenth- and twentieth-century Hungarian politics were analyzed only after 1945 by distinguished intellectuals, including Bibó.

13. These reflections prompt connections with Hungary's resistance to facing aspects of its own history, such as the series of projects under the aegis of the Ministry of Cultural Patrimony that include a controversial exhibition in 1999 devoted to Auschwitz that promoted revisionist perspectives that minimized the role of Horthy and the Arrow Cross, the fascist militia of the period.

14. The couple had three children: István, Anna, and Bori; Anna (whose photo we see as a charming blonde girl) died of heart disease in 1953 at the age of nine.

15. See Medieval website, accessed June 12, 2011, http://www.medieval.org/emfaq/performers/ hungarica.html.

16. See Péter Sugár, Gábor Hanák, and Tibor Frank, eds., *A History of Hungary* (Bloomington: Indiana University Press, 1990); György Litván, ed. *The Hungarian Revolution of 1956: Reform, Revolt and Repression, 1953–1963* (New York: Longman, 1996). The Hungarian Revolution of 1956 began on October 23 with a peaceful manifestation of students in Budapest demanding an end to Soviet occupation and the implementation of true socialism. The following day, commissioned officers and soldiers joined the students on the streets of the city. The statue of Stalin was toppled as the crowd chanted, "Russians go home" and "Long live Nagy." Shocked by these events, the Central Committee of the Communist Party forced Ernő Gerő to resign from office and replaced him with János Kádár. Imre Nagy broadcast on Radio Kossuth, promising the "far-reaching democratization of Hungarian public life, the realization of a Hungarian road to socialism in accord with our own national characteristics, and the realization of our lofty national aim: the radical improvement of the workers' living conditions." On November 3, Nagy announced details of his coalition government, to included Bibó, János Kádár, György Lukács, Anna Kethly, Zoltán Tildy, Béla Kovács, Géza Lodonczy, István Szabó, Gyula Keleman, Joseph Fischer, and Ferenc Farkas. On November 4, 1956, Nikita Khrushchev sent the Red Army into Hungary, and Nagy's government was overthrown. Bibó was arrested and sentenced to life imprisonment; after his release in 1963, he worked as a librarian until his death in 1979.

17. *A Bibó Reader*, 2001.

18. Paul Lendvai, *The Hungarians: A Thousand Years of Victory in Defeat* (Princeton, N.J.: Princeton University Press, 2003), 416. In *The Jewish Question in Hungary: Democracy, Revolution, Self-Determination: Selected Writings* (Boulder, Colo.: Social Science Monographs, 1995), Bibó assesses "an alarming image of greed, unscrupulous mendacity and, at best, calculating pushiness by a considerable section of this society. This was an unforgettable blow not only

for the Jews affected by it but also for all decent Hungarians." Quoted from Bibó's writings and biographical details on the soundtrack of Forgács's film, *István Bibó, Fragments, English version, 2002.*

19. Bibó's own voice is also heard reflecting on Christ's faith and humility, arguing in "Reflections on the Social Development of Europe 1971–72" in *Democracy, Revolution, Self-Determination* (New York: Columbia University Press, 1991), 543. The concept of turning the other cheek was in fact not a helpless gesture but rather a disarming one, suggesting that the omnipotence of humility leads to greater good than aggression.

20. I wish to acknowledge the Hungarian Cultural Consul, New York City, for cosponsoring the New York City premiere of *Miss Universe 1929* with the American Hungarian Educators Association in a public screening that I was invited to present in April 2007.

21. *Die letzten Tage der Menschheit: Tragödie in fünf Akten mit Vorspiel und Epilog* [The Last Days of Mankind: Tragedy in Five Acts with Preamble and Epilogue] (1922) in Edward Timms, *Karl Kraus: Apocalyptic Satirist, Volume 2: The Postwar Crisis and the Rise of the Swastika* (New Haven, Conn.: Yale University Press, 2005).

22. I thank the organizers of the conference "Freud and His Jewish World," held in New York City, for valuable interventions on the role of Vienna as a site of Jewish life, including Inge Strasser's reminder of the importance of particular coffeehouses in the life of intellectuals (e.g., Café Landtmann and Café Central).

23. "Rumania: Miss Universe Mobbed" Monday, September 9, 1929, accessed June 12, 2011, http://www.time.com/time/magazine/article/0,9171,737822,00.html.

24. "International: Lovely Lisl" (no author credited) *Time Magazine*, Monday, June 24, 1929, http://www.time.com/time/magazine/article/0,9171,732515-1,00.html.

25. *Miss Universe 1929: Lisl Goldarbeiter, A Queen in Wien*, directed by Péter Forgács (Hungary: Lumen Film/Mischief Films, 2006, 70 min. video).

26. Produced for the Theater an der Wien on December 30, 1905, with libretto by Viktor Leon and Leo Stein after Henri Meilhac's comedy *Der Gesellschaftsattache.* Two years later, the operetta celebrated its four hundredth performance, having made Lehar a wealthy man. Although Lehar cooperated with Jewish librettists, and his wife, Sophie, was of Jewish origin, Hitler's admiration of *The Merry Widow* allowed the couple to escape the brutality of the Nazi regime; his librettists, Fritz Grunbaum and Fritz Lohner, were eventually murdered in concentration camps.

27. Premiered on April 5, 1874, at the Theater an der Wien, Vienna.

28. Tribeca Film Festival catalogue, New York City, April 2007.

29. See Catherine Portuges, "Home Movies, Found Images, and 'Amateur Film' as a Witness to History: Péter Forgács's *Private Hungary*," *The Moving Image* 1, no. 2 (fall 2001): 107–24.

TYRUS MILLER

[**10**] *Reenvisioning the Documentary Fact*
On Saying and Showing in *Wittgenstein*
Tractatus and *Bourgeois Dictionary*

> *And from nothing* in the field of sight *can it be concluded that*
> *it is seen by an eye.*
> :: Ludwig Wittgenstein, *Tractatus Logico-Philosophicus*

In 1992, Péter Forgács made two films that utilize, like other of his Private Hungary films, amateur film footage but also stand out in his corpus for their explicitly reflexive, metapoetic treatment and their innovative, nonnarrative formal structure: *Wittgenstein Tractatus* and *Bourgeois Dictionary*. Both films, in fact, share overlapping film materials, with *Bourgeois Dictionary* generally presenting lengthier, contextualized versions of some passages that appear in *Wittgenstein Tractatus* in more pontillistic, fragmentary form. Both films also, notably, explore linguistic and quasi-mathematical frameworks for organizing the found images and motivating their potential meanings. Image, voice-over, music, and text stand in a highly complex and often explicitly divergent or paradoxical relationship to one another. Through Forgács's selection and constructive montage of heterogeneous imagistic and verbal materials, the films suggestively parallel Wittgenstein's philosophical meditations on the disjunctions of saying and seeing, on the complicated interreference between names and pictures, statements and things.

In a more specific sense, too, Forgács's construction of these two interlaced films parallels the doubleness in Wittgenstein's thought and life's work. At the most obvious level, reading Wittgenstein, we confront this doubleness in the distinction between the early and late writings, between the *Tractatus* and the *Philosophical Investigations,* and the continuities and breaks that can be discerned between them. Forgács, too, refers to this double corpus of work, spanning more than two decades, by utilizing not only text from the *Tractatus,* as might be expected in a

film bearing this title, but also, without specific notice, many quotes from notebook writings that come later and contemporaneous with much of the film footage shot in the late 1930s and during World War II. Hence, the private thoughts of the philosopher in Great Britain and the private registrations of everyday events by anonymous filmmakers are juxtaposed and made to resonate with one another *synchronically,* even as the *Tractatus* resonates *diachronically* with its chronological posterity in the later writings and, implicitly, the film images from the 1930s and 1940s. *Bourgeois Dictionary* even more explicitly connects the earlier period with the later, with its materials dating back to the 1930s and up to the consolidation of Communism in Hungary in 1949.

A less evident, though more literally *generic,* parallel, however, exists as well between Wittgenstein's corpus of writing and Forgács's paired films *Wittgenstein Tractatus* and *Bourgeois Dictionary.* Following the publication of the *Tractatus* in the early 1920s, Wittgenstein himself also published a dictionary in 1926, the *Wörterbuch für Volkschulen,*[1] which he had initially dictated to elementary school students as an aid to better orthography while working as a teacher in an Austrian village. The treatise (*tractatus*) genre and the dictionary share analogous pedagogical functions while also exhibiting similarly nonnarrative, schematic, logical frameworks of organization. Both generically conjoin analysis of their subject matter into elementary units—propositions in the *Tractatus,* lexical entries in the *Wörterbuch*—with an architectonic form, numerical or alphabetical, extending from cover to cover of the book. Both of Wittgenstein's small volumes, the only two published by the philosopher during his lifetime, were moreover, in their ways, epistemically *therapeutic* in their intentions. The *Tractatus* was intended to clear the field of propositions of nonsensical expressions and give clear, picture-like formulation to what could genuinely be said in philosophy (hence, too, circumscribing that which must be apprehended in silence), while the *Wörterbuch* was meant to help his schoolchildren, who spoke rural dialect, form a clear picture of written words and their proper spelling.[2] In turn, in their respective fields of activity, both the Austrian philosopher Wittgenstein and the Hungarian filmmaker Forgács explore these two genres, treatise and dictionary, as formal vehicles of their ideas and as instruments of broadly pedagogical, culturally therapeutic goals.

About thirty minutes long, *Wittgenstein Tractatus* is organized into seven sections, each of which alludes to Wittgenstein's book, which offers seven basic propositions and a series of elucidating comments that are numerically subordinated to the main propositions. Although Wittgenstein's words and, to a more limited extent, his photographic image and

his handwriting are constant presences in the film, *Wittgenstein Tractatus* is neither a wittily artful biographical fiction like Derek Jarman's very different *Wittgenstein* (1993), nor a conceptual art video like Gary Hill's 1994 *Remarks on Colour*, nor a typical classroom or public television documentary presentation of Wittgenstein's philosophy. Instead, it could be characterized as a poetic montage of verbal statements and visual documents that resonate with the historical pathos of the Central European, bourgeois, Jewish lifeworld that Wittgenstein shared with the filmed subjects of Forgács's found footage. In this sense, Forgács's film might be understood not only as an homage to Wittgenstein's *Tractatus* but also as a historical critique of its eponymous source, revealing Wittgenstein's uncompromising splitting of the human subject between the logically speakable and the mystically inexpressible to be a profoundly *historical* artifact of a specific culture, traceable to the contradictions of everyday life of Central European Jewry in the twentieth century.[3]

In addition, *Wittgenstein Tractatus* can be understood as a metapoetics of Forgács's Private Hungary documentary project as a whole. One discerns in Forgács's film very little of the Wittgenstein who, rightly or wrongly, is taken to be the inspirer, first, of Vienna Circle logical positivism and, later, of British ordinary language philosophy. Rather, the Wittgenstein of Forgács's film is the theorist of the facticity of the world as it is ("what is the case"), its composition from matters of fact and the relationships between them. In analogy to the filmmaker himself, this Wittgenstein is concerned with picturing the world in the arrangement of his statements and with understanding the conditions of their meaningfulness. He is the explorer of the limits of language and the indicator of a configurational and gestural realm that can be seen rather than said. He is the paradoxical voice of an aesthetic and ethical realm that can only be pointed to in silence because nothing sensical can be said of either suffering or pleasure. He is a mystical witness to the ontological wonder that the world is and that it is in order as it is. He is the author of that strange, brilliant treatise, the *Tractatus Logico-Philosophicus*, that Ernest Gellner once characterized as a "poem to solitude,"[4] a poetic assemblage of gnomic propositions that poignantly bespeak, in their very austere and ascetic denial of worldliness, the solipsistic isolation of the early Wittgenstein in the world. And finally, metonymically, lacking a national-cultural home and seeking it despairingly in logic, war, labor, and eventually everyday speech, Wittgenstein is a singular instance of the Central European Jewish bourgeoisie that constitutes Forgács's primary focus in his documentary explorations.

"Everything we see could also be otherwise," Wittgenstein wrote in arguing against an a priori order of things. "Everything we can describe

at all could also be otherwise" (5.634). Forgács quotes this passage in the film and has identified it as a kind of summation of his documentary project. Each section of his film is marked by a video representation of a torn image, which carries on its other side another image from another context, thus offering a successive, alternative direction for the image flow to proceed. In this way, Forgács underscores the material contingency of what we are seeing on the screen, a contingency that is partially ascribable to the archive of available film material and partially to the necessarily limited selection the filmmaker must make. His visual trope of the torn, double-sided image implies that we might have seen other images, which remain hidden from view, like invisible facets of a cube, lurking behind the limited totality of the visible.

The emphasis of Wittgenstein's statement, however, is somewhat different. He glosses his refusal of an a priori order as a denial of any psychological agency lending necessity to the fact that things appear as they do. He emphasizes instead the sheer contingency of the world's advent to a subject. That subject, he notes, is not part of that world, a "constitutive ego," as phenomenologists would have it, but is rather a nonpsychological edge at which the interpenetration of world and thinking reaches its limit. "Here," Wittgenstein concludes, "we see that solipsism strictly carried out coincides with pure realism. The I in solipsism shrinks to an extensionless point and there remains the reality coordinated with it" (*Tractatus* 5.64).

In light of Wittgenstein's meditations on solipsism, the peculiar, repeatable anterior present of Forgács's filmed subjects appears a kind of anonymous eternity in which these individuals dwell in the film world as sheer facts, extending their earthly life to the limitless measure of the visual field: "If by eternity is understood not endless temporal duration but timelessness, then he lives eternally who lives in the present. / Our life is endless in the way that our visual field is without limit" (6.4311). More ominously, in a notebook passage that Forgács quotes against a disturbing image of a pig writhing beneath a booted foot—apparently being tormented by its keepers, but in fact, according to Forgács, expressing symptoms of its own internal, nervous disorder—Wittgenstein also consigns individual suffering to an analogous, negative sort of eternal present, the eternity of hell:

> The horrors of hell can be experienced in a single day. That's plenty of time.[5]
>
> No cry of torment can be greater than the cry of one man.
>
> Or again, *no* torment can be greater than what a single man may suffer.[6]

Figure 10.1 *Wittgenstein Tractatus*. This shot of a sick pig has attracted much interest among critics, partly for its allegorical power and partly for its testament to the inability of any one image to convey interiority or a broader social context.

Forgács's image of the writhing pig provokes an immediate sympathy in the viewer yet this sympathy is paradoxical because it is based, almost necessarily, on misrecognition of the *inner* nature of the suffering that provokes this response. We confront in this animal image an extreme case of Tractarian solipsism as a function of limits: pitiably an expression of boundless suffering, yet closed off within the wordless inarticulateness of the sufferer. Even if, like the filmmaker, we know that this pig is not being physically tormented or destined for imminent slaughter, what can we humanly know of how a pig with a nervous disorder feels? Does our sympathy here have any genuine object, or is this an ethical relationship that discloses itself in the absence of any stateable knowledge of that creature with which we sympathize? Raising these questions across the human-animal divide, the nervously disturbed pig serves here as a metaphor for the eternal present of hell in the inner world of human beings as well. Hell is at once singular and impersonal, internally infinite because it is unbounded by words, existing for one being eternally within the creaturely inarticulateness of present suffering.

As an editor of found film footage, Forgács must deal with traces of a visual world that he cannot enter except at the tangent of the film material itself. He is working with an intimate world that he was literally never in and can never directly see. As archivist and editor, he is the nonpsychological limit of that past world's factual advent from possibility to actuality in the present, a relationship that also marks the relationship of the viewer of Forgács's film to the filmed subjects of his found material. The banality of many of the images, indeed, is Forgács's standard for demonstrating that he has disclosed, with a minimum of distortion, the sheer causality of what is the case: "There is no catharsis in banality land. Banality, when we just throw out the sand of our shoes. Banality is when nothing *happens* and it is just there. It is just existence."[7] Highlighting this banal factitiousness and bracketing his own person in the use of found footage, Forgács tends toward a pure realism in Wittgenstein's sense. This realism is based less on the mimetic veracity of the images, which like all home movies are often quite awkward and hammy, than on the sheer existentiality of the film material itself, from which the living subject of experience has withdrawn into death, anonymity, or oblivion.

Nevertheless, neither the original filmmaking nor Forgács's editing appear anything like impersonal. On the contrary, there is a strongly personal quality to many of the images. The viewer is led to ask, Who is that? In what relation do these people stand? To whom is she speaking? What caused him to glance away a moment? Is he angry or just bored? For whom is she waiting? Why does he look sad? In many cases, we simply cannot discover it from the filmed footage. Although the archived interviews that Forgács conducted with still-living people connected to his footage may suggest some clues, many times probably not even the filmed subjects themselves could tell us now. The films evoke a zone of irreducible hiddenness that lies beyond the limits of the visually manifest, a perhaps permanent solipsistic veiling of whatever personal meanings and motivations the images might once have possessed. What is left is only a set of signs that can be seen and, as seen, seem to possess a meaningful character; but what they mean one cannot really say. It is as if the answers to the questions that the images evoke were held in a space of privacy— but a paradoxically impersonal space, a privacy belonging to no one in particular.

Forgács's interest in the noncorrespondence of the visual and the verbal extends to a different Wittgensteinian conception of documentary mimesis. In the opening propositions of the *Tractatus,* Wittgenstein introduces a range of terms including "Ding" (thing), "Gegenstand" (object), "Sache" (a matter, an affair), "Tatsache" (fact), and "Sachverhalt" (which

I translate, rejecting C. K. Ogden's confusing "atomic facts," as "state of affairs"). "The world is the totality of facts," Wittgenstein writes, "not of things." And "the world divides [better translated "dissolves," "decomposes"] into facts" (*Tractatus* 1.2). A state of affairs is a "combination of objects (affairs, things)" (*Tractatus* 2.01). Facts (*Tatsache*) are composed of states of affairs (*Sachverhalte*), which either exist (positive fact) or do not exist (negative fact). Facts, therefore, are combinations of objects, affairs, and things as viewed in light of their existence or nonexistence. And the world can be analyzed down to these existing or nonexisting combinations, not down to objects, things, and affairs as such. It is the facts—existing or nonexisting combinations—not objects, things, and affairs that we picture: "Wir machen uns Bilder der Tatsachen" (We make to ourselves pictures of facts) (*Tractatus* 2.1). In turn, pictures can organize facts in logical—or transgressing Wittgenstein's rigor, I would add *analogical*—groups, insofar as these facts are covered by a "common form of representation" (*Abbildung*): "The picture can represent every reality whose form it has" (2.171).

I do not wish to get lost here in the complexities of Tractarian semantics, nor am I suggesting that Forgács is simply depicting or applying ideas derived from Wittgenstein. I do, however, think that formal attention to Forgács's composition of images in *Wittgenstein Tractatus* suggests his Wittgensteinian rekeying of the question of documentary realism. To formulate it broadly, Forgács shifts documentary realism away from a conception of correspondences of the film image to an object, event, person, or social category (*Sachen, Dinge,* and *Gegenstände*) in favor of an analogical circumscription of cultural, historical, and anthropological facts (*Tatsachen*) and states of affairs (*Sachverhalte*). The existence of a configuration—its factuality, its facticity of being the case in the world as captured at the moment of filming—*is* what is presented by Forgács's film in the first instance. Only derivatively is he interested in the object, event, or matter as such, the names of people and occasions that may, in fact, be lost in time. The resistance of the image to identifiable meaning, thus, is not merely a matter of missing information, as if watching the film with an archival finding aid would yield a better viewing. It is the very lack of identifiable reference in many of the scenes that allows its analogical, *formal* linkage to other images to be made, thus revealing a common cultural–historical–social fact beneath continually varying objects, things, and affairs.

Moreover, Forgács's distinction between the documentary *fact* and the referential object foregrounds the role of the artist or historian in constructing historical truth. In describing this "recontextualizing construction," Forgács suggests that it is "more like parts of a dreamwork"

rather than "an illustration with/by" the lives of those who appear in the films (Forgács/Spieker Conversation). According to Freud's *Interpretation of Dreams* (another exemplary product of the intellectual, bourgeois, Mittel-European Jewish cultural milieu that was Wittgenstein's habitus), the "dreamwork" was not a *content* of the dream, whether manifest or latent. This term, for Freud, rather designates the traces of unrepresentable forces that silently yet violently deform the symbolic materials that compose the dream.[8]

To illustrate these points I have identified three prominent image clusters from *Wittgenstein Tractatus* that suggest how Forgács's selection of materials represents contingent instantiations of basic situations. In other words they suggest how, through different objects, he presents the same facts:

1. Scenes of animal suffering. These include the writhing pig already discussed, a rat being dissected alive, and a horse that has fallen in the street, seemingly from a collision with a street car.
2. Scenes of dancing. These appear at numerous points, including a man seemingly leaping for joy in front of the camera, a little girl performing a dance step, and a segment of ethnographic film from a Roma (gypsy) encampment, where the filmed subjects appear to have been put up to performing, somewhat hesitantly, their typical cultural behavior for the ethnographer's gaze.
3. Scenes of transportation. Many shots are seen from moving carriages, such as the scenes early in the film of a horse-drawn vehicle progressing across fields and the traveling shots in streetcars and a taxi near the end of the film.

One can relate the scenes of suffering and of dancing to the limits of representability that Wittgenstein assigns to the ethical and aesthetic realms respectively. Neither suffering nor pleasure falls, for Wittgenstein, within the *logical* form of the world and hence remains unspeakable, though silently apprehensible. The scenes of transportation are less easily interpretable in this sense but evoke the more general problems of relating the world as seen and said. What all these elements have in common, however, is that they trace out relationships in space that are tangential to propositional language. If, however, movement is integral to the film medium, then we may read Forgács's concentration on these variably realized facts as making the case for the ethical and aesthetic relevance of the documentary cinema and as providing a crucial way of silently acknowledging that which it is not possible to speak.

Throughout *Wittgenstein Tractatus*, Forgács offers a world in which language and image, word and diagram, object and movement, and sound and silence are complexly and enigmatically intertwined. The different symbolic and semiotic dimensions in which meaning takes place meet at shifting tangents, interacting contrapunctually rather than lining up in relationships of correspondence. Meaning *appears* constantly—it can be seen—yet it resists being stated in proposition form. Forgács is at least as concerned with depicting this resistance of his film material to explicitly speakable meaning, to map out the edges and limits of what can be said about it, as he is with motivating and formulating meaningful interpretations of the footage.

Thus, for example, Forgács overlays a geometrical diagram on the image of a fallen horse and a clocklike diagram over the image of a topless woman at a sewing machine. Such juxtapositions demonstrate not that the world can be reduced to a logical picture but rather precisely that such a logical reduction hardly exhausts what is essential about these images. Indeed, the diagrams, which abstract away from the historical, ethical, social, and aesthetic features of the images, indicate the incommensurability of the various ways in which the world can be apprehended. For example, one might ethically commiserate with the animal's suffering or the woman's literally naked toil or, alternatively, aesthetically appreciate the curve of the woman's moving arm and its contrary direction to circular rotation of the sewing machine wheel. As Wittgenstein writes near the end of the *Tractatus,* "We feel that even if *all possible* scientific questions be answered, the problems of life have still not been touched at all" (6.52). So, too, a geometrical, diagrammatic, physical understanding of the images leaves their ethical and aesthetic aspects out of consideration.

Similarly, throughout both *Wittgenstein Tractatus* and *Bourgeois Dictionary,* words and letters appear as visible features of the urban environment in ways that emphasize the indefiniteness and mobility of their meanings. Signs such as words and letters may signify in a quasi-algebraic way within formal systems of relationships; for example, in *Wittgenstein Tractatus,* the number six appears on a streetcar, indicating a certain segment of the urban transportation network.[9] Yet for those who know the city of Budapest, this tram number bears a more concrete content, perhaps even highly personal associations. The *hatos* (number six) streetcar is one of the most important and busy tram lines in Budapest, following the main circular boulevards and connecting Buda and Pest over two bridges that span the Danube River. At once individually and collectively, it is part of many private lives, connected to work, entertainment, love, and consumption. For those who recognize it—and several other locales

Figure 10.2a *Wittgenstein Tractatus*. As the author indicates, the lines superimposed on the image of the man and horse generate puzzlement more than clarity.

Figure 10.2b *Wittgenstein Tractatus*. Forgács again superimposes a line and numbers but makes no reference to their significance, prompting an awareness of the inexhaustibility of meaning in an image.

in *Wittgenstein Tractatus* and *Bourgeois Dictionary* are similarly identifiable or tantalizingly familiar for a resident of Budapest—the spatial trajectory of the number six tram also bridges the gap in time between the past of the film footage and the present of the viewer. As one remarks from its presence among the old footage composing Forgács's film, for decades this same numbered tram has run every five to fifteen minutes on its appointed route, thus becoming one of the constants of collective everyday life in Budapest. The number "6" visible in Forgács's film, then, hovers between abstract and concrete, collective and individual meanings, depending on which configuration of facts and events and memories it enters into.[10]

Bourgeois Dictionary also turns the ciphers of numbers and letters around, reducing complex images to alphabetic tokens, which refer to more or less directly represented topics. In this film, Forgács moves through a series of topically organized images linked to a set of words alphabetically marked. These words, which appear briefly, sometimes only once, sometimes repetitively, as captions to the images, range from "jeweler" to "life" to "annexation" and "amnesia." Together they illustrate, in this index-like form, the drift of Hungarian society toward collaboration and Nazi occupation, with its connotations of both bureaucratic classification and racial exclusion. There is no single principle of organization, however; the alphabetic conjunctions bring together terms and images in a number of different ways, as if even a formalized genre such as a dictionary can be ultimately decomposed into a heterogeneity of language games. In his preface for the 1926 dictionary, Wittgenstein himself noted the difficulty of adhering to a single principle of selection and arrangement of the entries: "Again and again psychological principles (where will the student look for the word, how does one guard him against confusions in the best possible manner) clash with grammatical ones (base word, derivative) and with the typographical utilization of space, with the well-organized appearance of the printed page, etc. Thus it happens that the superficial critic will meet with seemingly arbitrary inconsistencies everywhere, but those inconsistencies are caused by compromises between essential viewpoints."[11] In Forgács's dictionary film, sometimes the entries themselves read like ironic haiku-like emblems of a historical process, as with the entry "H → Hétköznap Haza Hoppla!" (workday/homeland/whoops!) or the entry "A → Amnézia Annexió (1938 Graz) Aranyér" (amnesia/Annexation Graz 1938/hemorrhoids). The letter *z* (in Hungarian one letter pronounced like a *j*) yields the word "Zsinagóga" (synagogue) but shows only a brief clip of two little girls dancing, with the lower ornamented stones of a building behind them. The named

object appears in the image in as reduced and fragmented a form as the alphabetical entry. Some of the lettered entries serve to make complex conceptual rhymes, such as the entries for *c* (pronounced "ch"): *Cseléd* (servant) and *Csonkamagyarország* (rump-Hungary, reduced by over two-thirds of its historical territory by the Trianon treaty after World War II). The rhyme of these two terms conjures up a gentry holding on to old privileges in an epoch in which their real power and influence had been lost. It also more faintly resonates with the footage showing the writer Dezső Kosztalányi and his family; one of this novelist's greatest and best-known works is *Anna Édes*, which centers upon a servant in a Budapest household during the restoration of 1919 and 1920.

Finally, the *o* entry for "Orásmester" (watchmaker) appears in the film as the self-reflexive figure of filmmaking itself. The footage includes close-up shots of delicately hand-rotated, geared instruments, clearly suggesting an old-fashioned film camera of the sort that Forgács's amateur cinematographers would have carried. In these depictions of the watchmaker's rotational handiwork, there is even a sort of underlying verbal rebus in which the filmmaker signs his name and remarks his own, related craft: in Hungarian, the expression "to shoot a film" uses the verb "forgat" (to turn, revolve, spin), which is also linguistically related to the name Forgács, equivalent to the English name Turner. Moreover, the common noun "forgács" refers to the shavings and turnings that fall from the lathe: an appropriate name for an artist who makes his films out of montage bits and pieces of celluloid. The watch shop appears both early and late in the film, literally marking the passage of time and history and remarking the circular figure of its alphabetical token *o*. The earlier sequence is pre–World War II, while the passage at the end is from 1949, with the signs revealing that the clock business has been incorporated into the nationalized, collectivized organizations of the newly imposed Communist dictatorship. For our watchmaker, one might say, what goes around comes around; if the restorationist Horthy regime wanted to turn the clock back to an age of gentried domination, the Communist Rákosi revolutionary dictatorship sought to reset the clock, through Stalinist terror, to an assembly line future of five-year plans.

Visible images of letters, numbers, names, and words communicate a variety of contents, which in turn refer to various sorts of larger meaning systems or forms of life. Place names conjure up systems of geography and territoriality; personal and family names refer to kinship, friendship, erotic relationships, and business; names of stores refer both to families and to the social division of labor and crafts. Verbal signs in the films may also serve to cue practical functions such as forbidding or inviting

Figure 10.3 *Wittgenstein Tractatus*. A single word, "szabad," on a taxi flag. Such words and images carry more ambiguity than first meets the eye.

certain actions. The word "Szabad" (free), for example, appears in the seventh section of *Wittgenstein Tractatus* and in a longer version of the same sequence in *Bourgeois Dictionary* in the window of a moving taxi from which street scenes were shot. This word signifies something humbly practical in this context (that the taxi will pick up riders).

But were we to see the same word in a different context, on a banner in the streetcar pushed down the tracks by the people of occupied Budapest in István Szabó film *25 Fireman Street* or an image from the 1956 uprising, it could mean something quite different. Its meaning holds for a world in which it is contingently the case, but it could be otherwise.

Even between the contexts in *Wittgenstein Tractatus* and *Bourgeois Dictionary*, where the same footage is used, the sense of the depicted word "Szabad" (free) is inflected in somewhat different ways. In *Bourgeois Dictionary*, we see that it is part of a sequence entitled "Gréti utazik" (Greti travels), and it is juxtaposed to the dictionary entry "Admiral," which corresponds to footage of the post–World War I military dictator Admiral Miklós Horthy. Moreover, the Budapest dweller will recognize the cab's path as the prominent avenue named after seventeenth-century Hungarian independence fighter Ferenc Rákóczi,

which leads to one of the main train stations. Thus, using the same footage, *Wittgenstein Tractatus* presents a relatively decontextualized sequence of movement through the city, while *Bourgeois Dictionary* implies a set of binary pairs, charged with historical and political connotations: the difference between private and public forms of freedom, the ironic coexistence of restricted political freedom and freedom to travel and consume, the historical trajectory of Hungarian nationalism from its revolutionary origins (Rákóczi) to its fascistic, counterrevolutionary outcome (Horthy). None of this content is, strictly speaking, *in* the images, but it can be expressed through them, as a sort of potential fact inhering in their configurations and juxtapositions.

Earlier in the film, Forgács quotes Wittgenstein that language clothes the thought in such a way that the thought cannot be recognized from the clothes: "Language disguises the thought; so that from the external form of the clothes one cannot infer the form of the thought they clothe, because the external form of the clothes is constructed with quite another object than to let the form of the body be recognized" (4.002).

Figure 10.4 *Wittgenstein Tractatus.* A man carries a sign reading "An Invisible Man Returns," an apt film title for Forgács's interest in Wittgenstein's exploration of the limits of language.

Another detail from the final section refers this Wittgensteinian disjunction of thinking and speaking, of seeing and saying, to the images of Forgács's own film and his editorial tailoring of them to quotations from Wittgenstein. As if recalling this passage and providing a self-reflexive illustration, Forgács includes in the final section a bizarre, masked sandwich-board man who is walking around the city carrying words that literally cloth and hide his body. The signboard, which one can barely make out, reads, "A láthatatlan ember visszatér"—*The Invisible Man Returns*.

This film, a sequel to the James Whale classic filming of H. G. Wells's novel, was released in 1940 in the United States, but in most of Europe it appeared only after World War II; Forgács's footage likely dates from the later 1940s. Like a cinematic ghost who walks the streets of Budapest, this odd figure is literally clothed in the Hungarian language, advertising for a film made up of images originally synchronized with English words. Moreover, the image holds other possible connotations for the Hungarian viewer. *The Invisible Man* is the title not only of an H. G. Wells novel, on which the *Invisible Man* films are based, but also of Géza Gárdonyi's popular historical novel dealing with one of the founding fathers of the Hungarian national myth, the nomadic conqueror Attila the Hun. The signboard, moreover, allows one briefly to catch a glimpse of the name of the cinema advertised, the Hunnia, which remains part of the historic cinema network in Budapest even today. Despite this embeddedness in various cultural and linguistic contexts, the thought the sandwich-board man's image expresses in Forgács's film is not at all evident from his outer appearance; he remains an enigmatic, haunting sign that can hardly be read by a present-day viewer. That thought has evaporated with the passage of time and become invisible, much like Vincent Price's character in the film. In his very emptiness, however, in the ghostly evanescence of his embodied meaning, the sandwich-board man becomes a weird allegory of a brief historical moment of hiatus, in which the invisibility and indefiniteness of Central Europe itself becomes perceptible. Sandwiched between the reign of Fascism under the hegemony of Germany and the imposition of a Stalinist dictatorship under Soviet domination, the invisible man of Central Europe, that phantom of Hungarian liberty,[12] makes a brief reappearance on film.[13]

In conclusion, I will refer to one brief, moving sequence from *Bourgeois Dictionary*. In this sequence, Forgács edits together a series of images of a Jewish man in a number of different scenes, in which his appearance is captioned with the logical variable "X." Throughout the sequence, the man is referred to simply as "X ur" (Mr. X). This section is

linked to the previous segment, about two girls who grow up to adulthood in the footage, by images of marriage: the weddings of the two Christian girls are followed by Mr. X's wedding at the opening of his section (a Jewish wedding, we soon discover). Mr. X is seen in a variety of settings, from domestic to business to ceremonial occasions. In some of the footage, a knowledgeable viewer may be able to recognize what appears to be the Dohány Utca neighborhood of Budapest, the old Jewish quarters, though the settings are never explicitly identified. Toward the end of the sequence, however, Forgács interpolates one of the more standard dictionary entries of the rest of the film, "J Jewish labor service—train," which suggests Mr. X's ultimate fate as a victim of Nazi racial policy.

Here then, Forgács's historical fact becomes truly representative, a picture of a world in which what was the case could have been otherwise but in the historical case we know to be the case: that many thousands of people stood in the factual place of Mr. X.

Figure 10.5 *Wittgenstein Tractatus*. Forgács deploys images such as this to simulate a dictionary, but it is a highly selective set of words this dictionary contains.

Figure 10.6a *Wittgenstein Tractatus*. Mr. X, who is never identified, seems to stand in for the millions who embarked on train trips from which they did not return.

Figure 10.6b *Wittgenstein Tractatus*. Mr. X approaches the train. These images may or may not refer specifically to the transports that carried Jews to the death camps, but they evoke such events in any case.

NOTES

1. All quotations from Wittgenstein's *Tractatus* refer to the paragraph numbering of Ludwig Wittgenstein, *Tractatus Logico-Philosophicus*, trans. C. K. Ogden (1922; London: Routledge, 1985); and Ludwig Wittgenstein, *Wörterbuch für Volksschulen* (1926; Vienna: Verlag Hölder-Pichler-Tempsky, 1977).

2. In his preface composed for the publisher of his dictionary, Wittgenstein insists on this key distinction between the word as sounded and heard and the word as a visual gestalt to be seen and reproduced in writing: "Oral information leaves a much weaker imprint on the memory than a word which one has seen" (*Wörterbuch*, xxxi).

3. The notable tension between Wittgenstein's logical universalism and his specific cultural-historical locus is evocatively reflected in the recorded version of Tibor Szemző's musical score for *Wittgenstein Tractatus*. The CD insert notes that Szemző took both text and piano fragments from Wittgenstein's *Tractatus Logico-Philosophicus* and *Vermischte Bemerkungen*. These are combined within a spare, repetitive musical scaffolding typical of Szemző's minimalist compositions. Seven different voices, male and female, read text passages in Japanese, Spanish, Slovak, German, Hungarian, Czech, and English. The written text passages are printed, in various languages, including Japanese characters, in numbered groups corresponding to the seven sections of the *Tractatus* from which they were drawn. (CD LR 227 [United Kingdom: Leo Records, 1995]).

4. Ernest Gellner, *Language and Solitude: Wittgenstein, Malinowski, and the Habsburg Dilemma* (Cambridge, UK: Cambridge University Press, 1998), 46ff.

5. Ludwig Wittgenstein, "Note from 1937," in *Culture and Value*, ed. G. H. Von Wright, trans. Peter Winch (Chicago: University of Chicago Press, 1980), 26e.

6. Ibid., 45e.

7. Sven Spieker, "At the Center of Mitteleuropa: A Conversation with Péter Forgács," *Art Margins*, May 20, 2002.

8. For a discussion of Walter Benjamin's utilization, in the late 1920s and early 1930s, of dream as a model for historical writing, see my article "From City-Dreams to the Dreaming Collective: Walter Benjamin's Political Dream Interpretation," *Philosophy and Social Criticism* 22, no. 6 (1996): 87–111. For an analogous attempt in Britain in the 1930s and 1940s to interpret dreams as indices of collective consciousness, see my article "In the Blitz of Dreams: Mass-Observation and the Historical Uses of Dream Reports," *New Formations* 44 (2001): 34–51.

9. A case in point about the way that contextual knowledge shapes perception: when I first saw this film, prior to an extended residence in Hungary, I misread the number 6 as the letter G.

10. The number two tram, another old and prominent streetcar line running along the Danube, appears in character in a sequence in *Bourgeois Dictionary*.

11. Wittgenstein, "Preface," in his *Wörterbuch für Volksschulen*, xxxv. Translation corrected.

12. I allude here to an important work of the Hungarian conceptual artist Tamás St. Auby, who in 1992 covered a symbol of the postwar Soviet domination in Central Europe, the Liberty statue atop Buda's Gellert Hill, in a white shroud, renaming it the "Phantom of Liberty." Notably, during the first years of the transition after the fall of socialism, both Forgács and St. Auby would draw upon a spectral image of Hungarian independence using a shrouded figure. This spectral imagery would subsequently also play an important role in post-Communist and postcolonial discussions of Marxism, internationalism, and nationalism, inspired by Jacques Derrida's influential "hauntological" deconstruction of Marx in *Spectres of Marx: The State of the Debt, the Work of Mourning, and the New International*, trans. Peggy Kamuf (New York: Routledge, 1994). For further elaboration of the idea of spectrality, see the recent study by Pheng Cheah, *Spectral Nationality: Passages of Freedom from Kant to Postcolonial Literatures of Liberation* (New York: Columbia University Press, 2003).

13. In his *Art Margins* interview with Sven Spieker, Forgács accepts this idea of emptiness as crucial to his vision of Central European history:

 Spieker: I wonder if Andy Warhol's films do not in some sense teach you a lesson precisely about this sort of, the emptiness of history. I wonder if this spleen of Central Europeans isn't the spleen of people who think that there is something to be recovered from history. That, never mind how accidental it all is, how banal, how much banality there is still something there, something that we need to hang on to, something to salvage and to recover. This brings us back to the beginning of the conversation of course. I wonder if you find the analogy at all useful, if you could perhaps, maybe it inspires you?

 Forgács: Well, I think this is a very inspiring analogy, the emptiness. Because with the notion of banality we are in the heart of emptiness, there is no feast. There is no catharsis in banality land.

WHITNEY DAVIS

[**11**] *The World Rewound*
Wittgenstein Tractatus

> *A right hand glove could be put on the left hand, if it could be turned around in four-dimensional space.*
> :: Ludwig Wittgenstein, *Tractatus Logico-Philosophicus*

> *When I came home I expected a surprise & there was no surprise for me, so, of course, I was surprised.*
> :: Ludwig Wittgenstein, *Culture and Value*

In his study of the "ontology of film," *The World Viewed*, Stanley Cavell writes that "Wittgenstein investigates the world ('the possibilities of phenomena') by investigating what we say, what we are inclined to say, what our pictures of phenomena are, in order to wrest the world from our possessions so that we may possess it again."[1] Cavell takes Wittgenstein's investigation to propose, perhaps to characterize, the deepest project of film conceived not only as art but also (and more important) as a mode of being in the world in which we inhabit a relation *to* the world—namely, viewing. Cavell's remark specifically concerns Ludwig Wittgenstein's posthumously published *Philosophical Investigations*. But it points to a deep theme in Wittgenstein's entire body of philosophical work.

Re-Viewing

How and why do we seem to know the world with perceptual clarity, practical familiarity, and existential certainty despite its contingency and ambiguity? How might we understand the world again, or afresh, in light of seeing its contingency as such—if we can do so at all? What would things look like as it were on the other side of the conventional habits and

customs of seeing—and of viewing—that we ordinarily bring to them? To "possess the world again": although Cavell does not pursue the matter in material or technical terms, it is worth asking how we might take the suggestion attributed to Wittgenstein (a fan of Hollywood cinema) quite literally in the case of film. How might film help us to possess the world *again*? In the form or mode of mere footage, especially film produced simply to document what is going on in the world in front of the camera, it *already* presents us with a picture of phenomena. In what way, then, can it suggest that the things captured by the filmic index—ostensibly they were really there to be seen—might be seen to be quite different, or really could be otherwise, from what they are shown to us, and therefore seen by us, to be?

In this chapter, I suggest that Péter Forgács's remarkable film *Wittgenstein Tractatus* (1992) proposes a subtle approach to these questions. The film uses Wittgenstein's terms. But for reasons that we must explore it goes beyond what Wittgenstein claims we can actually *say* about the motivating situation—about the possible otherwiseness of the world that is shown to and seen by us in film footage. In the end, then, *Wittgenstein Tractatus* endorses the particular capacity of film (especially in remaking film footage as it might be found in order to draw out its immanent recursions, reversions, and revisions) to *re*-view the world as seen (or found) by us: it is as much a filmic meditation on Wittgenstein's thoughts about world picturing as it is a Wittgensteinian meditation on cinematic or other pictorializations of our knowledge of the world.

As a collation of filmed footage, *Wittgenstein Tractatus* is an elusive, often cryptic, montage of ordinary but often suggestive and unsettling images. Almost all of them were derived from sequences of historical found footage located by Forgács in private archives and public collections in Hungary. They are accompanied by voice-overs, subtitles, and interleaved titles entirely drawn from writings by Wittgenstein. To be sure, the film could be approached by way of established art-theoretical or film-critical frameworks. For example, in *Wittgenstein Tractatus* Forgács appears to be interested in certain classic texts of iconography, notably Erwin Panofsky's studies of the layering of the habitual, expressive, and conventional meaning of motifs.[2] I will return to specific parallels between *Wittgenstein Tractatus* and Panofsky's model of iconographic understanding (on the part of inhabitants of a lifeworld) and interpretation (on the part of its historians and critics or what we might call its reviewers). But I will concentrate on the philosophical point of reference indicated in the very title of *Wittgenstein Tractatus*. Needless to say, the film presents itself explicitly as an engagement with Wittgenstein's

Tractatus Logico-Philosophicus—the title adopted in the English translation of his *Logisch-philosophische Abhandlung* of 1921.

The precise nature of this engagement requires exploration. It would not be enough to say that the film sets forth certain propositions enunciated in Wittgenstein's *Tractactus*, though it does do this. Wittgenstein's words appear throughout the film, and the film deploys Wittgenstein's ideas (first promulgated publicly in the *Tractatus*) about the triangulations between picturing, language, and the world. In addition, however, the film *philosophizes* along Wittgensteinian lines in a way that discourse—the spoken or written word, including Wittgenstein's own words—cannot do for the very reasons suggested by Wittgenstein in the *Tractatus*. To be specific, *Wittgenstein Tractactus* relays a philosophy in the way that the *Tractatus Logico-Philosophicus* suggests philosophy might be possible but cannot itself *show* us or *do* for us so long as it remains discursive—and even if such showing and doing constitutes world knowing as Wittgenstein understands it. In this sense, Forgács's film does not so much supplement Wittgenstein's philosophy as complement it in a manner that helps to complete it in the essential but specifically *nondiscursive* recursion required by Wittgenstein's philosophical insight in the *Tractatus*—an intuition about philosophical representation that Wittgenstein himself (a mechanical engineer, architect, sculptor, and film buff, as well as a teacher and writer) seems to have taken seriously throughout his life. Indeed, at several points in his life Wittgenstein embraced the notion that he could and should, and perhaps that he must, conduct his work of thinking, his philosophy, in nondiscursive media and practices of making, doing, and living.[3] As we will see, *Wittgenstein Tractatus* alludes to this context; indeed, the existential context of Wittgenstein's practice evidently warrants Forgács's own practice in *Wittgenstein Tractatus*. In this regard we must remember the manifest absence of the genitive in Forgács's title: the film is not *Wittgenstein's Tractatus* but rather *Wittgenstein Tractatus*. The film does not *illustrate* the *Tractatus;* it is more like an *incarnation* of the mode of being in the world, of knowing, that Wittgenstein recommends in the *Tractatus*.

Needless to say, however, my own remarks on these matters must translate the filmic philosophy relayed in *Wittgenstein Tractatus* back into discourse by relating the film to Wittgenstein's *Tractactus*—trying to suggest *in* language what had been conceived, along Wittgensteinian lines, as the essentially visual–pictorial constitution *of* world knowledge. Striking and obvious structures and effects in the visual–pictorial field of the film can only be indicated clumsily, and by way of highly rhetorical devices, in speaking about them. But if language or world knowledge is essentially

pictorial or has an essential pictoriality, as the *Tractatus* urges, it follows that epistemology must in the end address picturing and perhaps might or must do so precisely *as* a picture—that is, as a painting, film, or other nondiscursive pictorial representation *of* language *as* pictorial. And in so doing it might be able to show not only what language speaks *about* but also *how* it does so; it might be able to show what language *is* in speaking of a world at all.

I will begin my description of these interrelations (in the next two sections of this chapter) by addressing the ways in which the visual–rhetorical structure of *Wittgenstein Tractactus* finds a specifically filmic complement for the discursive–rhetorical structure of the *Tractatus Logico-Philosophicus*. This will enable me to suggest (in the succeeding sections) how the kind of worldview relayed in *Wittgenstein Tractatus* might be the kind of view that would best justify and enable the philosophy stated in the *Tractatus Logico-Philosophicus:* making us *see* the limits of the language that are the limits of my world, as the film tries to do, is to help us to see that the limits of my world are the limits of my language's picture of it. We might conclude that in Forgács's view the kind of visual–pictorial world experiences relayed to us filmically in *Wittgenstein Tractatus* might have suggested Wittgenstein's picture theory of meaning as it was discursively proposed in the *Tractatus Logico-Philosophicus*. In this regard, *Wittgenstein Tractatus* proposes a phenomenal and historical context, a context of imaging and its uses, abuses, recursions, and reversions, for Wittgenstein's *Tractatus*.

I will not speculate in any extended way on the possible circumstantial reasons for the striking contiguities between Wittgenstein's *Tractatus* and Forgács's *Wittgenstein Tractatus*. In large measure the formal parallelisms and substantive interrelations, once identified, should speak for themselves. To be sure, Forgács has often noted his intense and sustained interest in Wittgenstein's life and philosophy, an interest consolidated and communicated in *Wittgenstein Tractatus*. And a case could well be made that Wittgenstein and Forgács have shared historical and cultural horizons: notably, Wittgenstein's experience of the destruction of the Austro-Hungarian Empire during and after World War I (and, toward the end of his life, the annihilation of his own family in the Holocaust) and Forgács's experience of life in Eastern Europe during and after World War II, throughout the Cold War, and in the more recent period of the disintegration and reintegration of the emergent post-Soviet polities. It is important to note, however, that *Wittgenstein Tractatus*, unlike other films by Forgács, does not represent this history explicitly despite the fact that it deploys period footage. Instead, twentieth-century European

history, a history that could definitively localize the found footage used in the film, subsists as one implied figurative horizon constituted in the film, one ground of its images.

Indeed, in *Wittgenstein Tractatus* Forgács wants to consider how one might even begin to represent—to see, to show, to speak—historical events that in great measure might seem to be unspeakable (in every sense of the term) and certainly were largely unseen and unknown to participants documented by the found footage. The impending obliteration of unknowing victims—the imminence of their trauma and death recollected only by the happenstance survival of footage of their living existence—is one of Forgács's recurrent themes in his reuse of found footage in several of his films. But the point of the reuse or re-viewing in *Wittgenstein Tractatus* is not simply to *recollect* participants, subjects, and victims otherwise consigned to oblivion, a project conducted in many of Forgács's other films. Rather, *Wittgenstein Tractatus* asks how human understanding *at the time*—how understanding *at any time*—might have seen things differently or even *could* see things differently. If a twentieth-century European history of the dislocation and destruction of families, societies, and nations has constituted the manifest subject matter of many of Forgács's films, *Wittgenstein Tractatus* meditates on the very grounds of these representations when mobilized by Forgács, the filmmaker standing for any and all observers of history, acting as their re-viewer. How can Forgács, or any film artist, claim insight into the possible *reversibility* of the history documented by the footage he has found? To revert to my opening quotation from Cavell, in *Wittgenstein Tractatus* we might take Forgács to propose an ontology of film not, or not only, as the world *viewed* but also, and more important, as the world *re-viewed*. But what is this reviewing?

▶ ──

Reworlding

Like the text of Wittgenstein's *Tractatus Logico-Philosophicus*, Forgács's film has been divided into seven parts. There is no continuous narrative in the film, but it has a rigorous structure; it becomes increasingly obvious, and increasingly subtle, on repeated viewings of the film. Each part of the film has been constituted from found footage showing seemingly ordinary people engaged in seemingly mundane activities. Each shot lasts only a fraction of a minute and sometimes only a few seconds. And each shot tends to depict a single, simple event: a woman walks toward us with a dog on a leash; an elderly man gets ready for bed; a man seats himself

at a café table and tips his hat to the camera. The identification of these people and the places and times depicted—that is, the historical origin of the found footage—remains uncertain throughout the film. Hungary before or after, or before and after, World War II seems to be the usual location, though one series of shots has been taken in ski country (the Austrian Alps? Switzerland?) or in Scandinavia (Wittgenstein's house in Norway is explicitly recalled in this part of the film). The seventh and last part of the film includes several shots set in Budapest in the 1950s: horse-drawn carts mix with trams and taxis in the streets and television has appeared in the home.

Preceded by a short pause separating it from the previous part, each one of the seven parts of the film begins and ends with a freeze-frame of the initial shot or the final shot in the sequence of shots in that part. As we watch, the frozen image comes together like a jigsaw puzzle or mosaic being assembled (at the beginning of the part) or comes undone like a jigsaw puzzle or mosaic being pulled apart (at the end of the part). And as each piece of the puzzle floats into the frame or floats out of it, building up or reducing the whole image, we see the fragment of the image from *both* or maybe *all* sides—our front and its back (though in reality we cannot see what is in back of what we are in front of) or maybe all the way round. As the film unfolds—and as we can rewind it to pull apart the image that has been put together or to put together the image that has been pulled apart—we come to see that these framing sequences thematize the most general visual interests, and most prominent filmic effects, of the entire montage of shots.

The seven parts of the film are roughly equal in duration—about three or four minutes each for a total running time of thirty-two minutes. Whatever the image track might show us, each part of Forgács's film quotes—in interleaved titles, in voice-overs, and in overlaid titles and images—from individual passages in the corresponding part of Wittgenstein's text of numbered sentences. That is to say, the first part of the film quotes from the *Tractatus* 1 to 1.121, the second part of the film quotes from the *Tractatus* 2 to 2.225, and so on.[4] In the film this complex stratigraphy of words and images to some extent replicates the labyrinthine lemmata of the *Tractatus*—though in the end, as the film tells us in quoting Wittgenstein's words, *der Gegenstand ist einfach*—"the object is simple" (2.02).[5]

When Wittgenstein's words are quoted in the film, sometimes Forgács displays Wittgenstein's numeration of the lemmas of the text (e.g., 1, 1.1, 2.02, 4.002, 5.634, 6.36311, and so on). Provided with this information, we can see that as the film unfolds or unwinds it goes deeper into Wittgenstein's text and its nesting of propositions and therefore further

and further into its special and specific derivations. And it would seem to travel certain tracks *within* the text. The first part of Wittgenstein's *Tractatus* consists simply of seven sentences numbered 1, 1.1, 1.11, 1.12, 1.13, 1.2, 1.21—sentences therefore indicated to have different levels or degrees of conceptual scope or "logical importance" (*logische Gewicht*), as Wittgenstein tells us in his footnote to 1, even if "all propositions are equally valuable" (6.4). The entire seventh part of the *Tractatus*, by contrast, is only one short sentence in length, as it were one-seventh the discursive size of the first part (even if its claim is the broadest of all). But in Forgács's *Tractatus* the first and the seventh parts of the text receive nearly as much film time as the second through the sixth parts of the text, which occupy several dozens of pages of printed text. This is certainly as it should be. The movement from one to seven and equally important the movement from seven to one constitute the essential burden of Wittgenstein's text, pursued in an organization conceived to be lemmatic rather than narrative or argumentative: though not exactly in a series of syllogisms, one can read from statements that appear to be more general and comprehensive to statements that appear to be more narrow and derivative and vice versa.

As Wittgenstein says at one point (6.54), his lemmatic labyrinth of sentences might be regarded as a "ladder" (*Leiter*). This statement has usually been taken to mean that the reader can discard the text once the ladder has been climbed—that is, once the text has been read and understood. To some extent Wittgenstein clearly intended his metaphor to be taken in this sense. But a ladder can, and sometimes must, be used to climb *down*, or to climb up and down again, and to move between or around various lower and higher levels of a structure. This route of reading might be more like a loop or a circle than a one-way street—a possibility Forgács aligns with the material identity and screening of projected film stock. And it is unclear, of course, whether Wittgenstein meant or expected that his text *could* be fully understood in ordinary discursive terms; what a reader supposedly attains upon finishing a reading of the text, after climbing the ladder, has been a matter of debate. Certainly most readers' experience of the text of Wittgenstein's *Tractatus* (a phenomenon relayed filmically in *Wittgenstein Tractatus*) involves a complicated peregrination: moving back and forth and around an array of propositions (however they are sequenced and hierarchically ordered as a written text) that can be read and that can be scanned or viewed in several ways or even, in the most literal sense, in more than one direction.

Consider, for example, the first sentence of Wittgenstein's text—that is, the first of the seven most important lemmas (1): *Die Welt ist alles, was*

der Fall ist ("the world is all that is the case"). A more literal translation—"The world is all, what the case is"—would relay a crucial connotation that tends to be lost in the published English translations. For Wittgenstein it is not only that the world is everything "that is the case," a kind of impersonal general logicity characterized preeminently by its truth, however that might be defined or constituted. In his formulation Wittgenstein manifestly avoided the predicative structure absorbed into the English translation so that he could recognize what we might call a *juxtapositive* relation between the world and our representation of it: *die Welt* and *der Fall* occupy grammatically parallel positions in the statement of what is. All the world is/what the case is: *der Fall* was Freud's, and the common word (well known to Wittgenstein) for a "case" (as in a Freudian case history) or, better, for an "affair"—as in those things and events (*Gegenständen*), however simple (*einfach*—single, homely, ordinary), pictured and preserved in found footage, and whether or not they might be a "case in point"—*ein vorliegende Fall*—of a general truth "in any case," *auf alle Fälle*. *Ein Fall* is also, of course, a falling—an actual waterfall or any kind of general failure or downfall. Indeed, Wittgenstein's verbal formulation of his first sentence would seem to have been carefully crafted as it were semantically—though not literally or typographically—in a palindrome. The formulation permits the parallelism and potential recursion suggested in the worldview developed in the further propositions of the text: the world is all what the case is; the case is all what the world is.

Most important, Wittgenstein's verbal formula—and not only as a logical or philosophical argument but also as an experience of *reading* or even *seeing* that tries to enable us to read or to see *differently*—encourages us to start (and also to end) with "what is the case," what it is we see, when we ask what the world is even though asking what the world is (i.e., what we see) might challenge our view of what is the case. As the linguistic structure (if not the argumentative substance) of the first sentence of the text might suggest, we are embedded in a continuous inescapable loop in which our representation or picture of the world, our image statement of what is the case, recursively threads through itself; though the world can perhaps be seen differently at different times and in different contexts, it is always seen as what is (seen as) the case. What is the case in or as the world, then, must be contingent on the seeing, or our use of pictorial techniques, habits, and motifs, or (following Panofsky) our iconology.

As such, the world could readily be (seen to be) otherwise in the same way that a picture—after a *change* of pictorial techniques, habits, and motifs—might be different from what it is initially seen to be

and indeed seen to show: if what we take to be the case about the world were somehow revisioned or repictured or (to draw the metaphor from Wittgenstein's own favorite medium) *refilmed*, the world itself must be changed in the same sense in which we would say that apples painted by Paul Cézanne and by Henri Matisse, even if both painters had used the very same real apples as models, show us quite *different* apples. This notion, this feeling we have in relation to actual pictures and to our world picture as such, seems to be captured in an enigmatic proposition quoted by the film at one point: "Feeling the world as a *limited* whole—it is *this* that is mystical" (6.45, my emphasis). At the same time as the picture gives all that is the case (i.e., the world) to us, we can feel (if we cannot actually see) the contingency of the picture or what might be called pictoriality, or the fact that *as* a picture it must have certain limits—that is, a particular degree of resolution, certain occlusions or foreshortenings, and select devices of framing and focusing. We might suspect that the world continues *beyond* these limits: as we might say, the world is out there. Nevertheless, we cannot speak about this "out there" readily because our world picture, our language, does not show it. Our awareness of the world outside, if we can come to have any such awareness *within* the picture seeing that gives us the world, remains a mystical one.

How can we revision, repicture, or refilm the world when all the world, everything that is the case for us, is constituted *by* the picture that we use to see it? Forgács's film recalls and reiterates the quasi-palindromic linguistic, logical, and structural devices of Wittgenstein's text (read for its literary or imagistic force as well as its substance) in order to *visualize* or *picture* Wittgenstein's imagination of the world in the propositions of the *Tractatus*—namely, *as* visualized or contingently pictured—in a way that might be unavailable to its standard written exegesis. Although the standard written exegesis can *say* that the world (the world as a picture or as pictured) might be different from what it is, it cannot easily *see* or *show* this world if it is a world outside its own pictorial purview. For example, and perhaps most notable, as discursive language our knowing cannot *reverse* itself, except in literal typographic palindromes, without falling into a nonsense or unintelligibility (*der Fall*) that will not permit us to see and to show any world (*eine Welt*) at all. By contrast, as Forgács realizes in *Wittgenstein Tractatus*, in certain ways film might show the possible reversals, inversions, and recursions of world picturing suggested in the first sentence of the *Tractatus* and carried throughout its philosophy as its own worldview.

To help bring out the possibilities and difficulties for Forgács's specifically filmic representation of Wittgenstein's philosophy, especially in relation to discursive representations, it is worth recalling Max Black's remarks on the order or sequential logic of Wittgenstein's text. For my purposes, Black's well-known commentary can stand for the wider reception and understanding of the *Tractatus*, a reception challenged by Forgács's film.[6] Black begins with Wittgenstein's title in translation ("probably suggested by Spinoza's *Tractatus Theologico-Politicus*, it is said to have been proposed for the English edition by G. E. Moore"[7]). He ends with Wittgenstein's final sentence (i.e., 7), *Wovon man nicht sprechen kann, darüber muß man schweigen*: "What we cannot speak about we must pass over in silence." Black here recalls the more euphonious, and more famous, English translation by C. K. Ogden: "Whereof one cannot speak, thereof one must be silent."[8] Both English translations, however, lose an echo in the German—"whereof" or "about what" one cannot speak, one must be silent *darüber*, "over it" or "over there." Wittgenstein had summoned this connotation in the immediately preceding remark (6.54) when he asserted that his reader must "overcome" (*überwinden*) the philosopher's—that is, his own—propositions in order to see the world rightly. "Over there," where we cannot speak about the world even if (or maybe precisely because) we *see* it, we must be silent.

This picture of things (for the text represents what it imagines the world to be) tends to be occluded when it is said, as Black himself does at the very beginning of his commentary, that "Wittgenstein treats the famous concluding remark [i.e., 7] as summarizing 'the whole sense of the book.'"[9] This is certainly what the English translation of Wittgenstein's preface says: "The whole sense of the book might be summed up in the following words: what can be said at all can be said clearly, and what we cannot talk about we must pass over in silence." With the exception of the substitution of *reden* (to talk) for *sprechen* (to speak), the word Wittgenstein actually uses in 7, the final phrase of this remark in the preface does reproduce (though textually it anticipates) the text of 7. But in his preface Wittgenstein himself does not say, as the English translation would have it, that 7 "sums up" the "whole sense of the book." Rather he says *Man könnte den ganzen Sinn des Buches etwa in die Worte fassen: Was sich überhaupt sagen läßt, läßt sich klar sagen; und wovon man nicht reden kann, darüber muß man schweigen.* "One could *comprehend* the whole sense of the book *somewhat* in the words." Taking him at his word, then,

the single sentence of the seventh part of the text cannot be so much a conclusion, in the sense of a derivation, or a *full* summary as simply one part of a serviceable understanding of what the entire book says. The *other* part of the book asserts that what one can say in general—for example, 1 to 6—can be "clear" (*klar*); *where* we cannot speak clearly, *there* we must be silent.

Wittgenstein's last sentence (from the point of view recommended in the text it could also be the *first* sentence) prompts the well-known question with which Black completes his own commentary: "Is the 'Tractatus' self-defeating?" Black assumes a series of propositions that one might take to develop in sequential consequentiality *from* 1 *to* 7, for he wants to rescue Wittgenstein from the charge that his text fails itself (*ein Fall*)—that is to say, that 7 *does not* follow from, and even undoes, everything leading up to it from 1 onward.[10] Even if Black thinks Wittgenstein does not contradict himself, he has to assume a text in which contradiction could be a feature of its sentences in total relation to one another. This does not always sit easily, however, with the lemmatic conformation of the text itself. Presumably a sentence numbered 1.2 has "equal value" (as Wittgenstein puts it in his preface) to a sentence numbered 4.2, and a sentence numbered 1.21 or 4.21 can be regarded as stating an aspect, or pursuing a particular implication or giving a partial elucidation, of 1.2 or 4.2, even though it would seem to have less scope or generality. Nevertheless it does not follow that 4.2 derives—as aspect, implication, or elucidation, let alone as logical consequent—from 1.2 through any number of intermediate sentences, even though 1.11 follows or, better, flows from 1.1, which follows or flows from 1. To read the first part of the *Tractatus*, for instance, one could read,

1—1.1—1.11—(1.1)—1.12—(1.1)—1.13—(1)—1.2—1.21,

but with equal cogency one could also read,

1.11—1.12—1.13—1.1—1.21—1.2—1.

To ask how sentences ordered in this way might conclude in narrative or argumentative sequence, and especially what they might prove or how they might be summed up, does not seem apposite to the assertion of 7 itself—"whereof we cannot speak, thereof we must remain silent." Part 7 seems explicitly to draw our attention to the fact, obvious throughout the series of sentences flowing to this point, that there are many gaps—as it were "nothing there" over there—in their representation of a world said to have this very structure (see especially 2–2.225). More important, the text offers a showing (but cannot be a telling) of something endless or

infinite, or maybe *nothing* endless and infinite, extending in all directions before and after and around and between all the sentences actually given. In the first short part of the text alone, for example, there's a 1.11 but no 1.111, a 1.2 and 1.21 but no 1.22 (though there is a 1.12), a 1.1 and a 1.2 but no 1.3, and so forth. To notice these gaps or places of nonspeaking or (from another point of view) to make these discoveries (*here* is a density of elucidatory representation, *there* is a thin overlay of general understanding, and *out there* we cannot speak at all, like a blank space on a map), we must continually *read back* through or *rewind* the text: after absorbing 1.13 following 1.12 following 1.11, we reconsider 1.1 (and maybe even 1) before flowing to what follows *it*, namely, 1.2.

As Wittgenstein says in his penultimate remark in the text (6.54), his sentences (*Sätze*) can "at the end be known as nonsensical" (*am Ende als unsinnig erkennt*): after going "through" them and "on them" and "over them" (*durch, auf, über*), one can "get out of them" or "dismount" or "alight from" them (*hinausgesteigen; steigen* refers not only to climbing but also to riding). In parentheses, Wittgenstein adds that the reader *muß sozusagen die Leiter wegwerfen, nachdem er auf ihr hinaufgestiegen ist* ("he must, so to speak, throw away the ladder after he has climbed up it"). The English translation just quoted conflates *hinausgestiegen*, Wittgenstein's initial word, and *hinaufgestiegen*, his parenthetical elucidation; *steige aus* and *steige auf*—in the metaphor of a *Leiter*—would have to be climbing down (the other side?) and climbing up (whatever side one's on?) respectively. According to the translation, a reader must "transcend these propositions," the sentences of the text. Wittgenstein actually says, however, that *Er muß diese Sätze überwinden*: one must *overcome* these sentences. In fact, one must literally "overwind" or "twist over" them. In this *Überwindung* we might be able to *see* the world, "everything that is the case," more clearly. Re-viewing, then, might be conceived, as a material activity or literal function of consciousness, as a replaying that is not just another viewing but also a rewinding and overplaying. Something like this *Überwinden* is imaged—*shown* or almost *filmed*—in lemma 1. By the same token, in *Wittgenstein Tractatus,* "overwinding" is not just the propositional content but the very representational mechanism of the film, a film devoted, at the same time, to the preservation of what is viewed as found.

▶ ───

Turning Around

I belabor these points in relation to the text of the *Tractatus* and its reversion in *Wittgenstein Tractatus* because the particular directionality or

orientation, and the general reversibility, of world perspectives lay at the heart of Wittgenstein's philosophy and his constructive practice in written and other media.[11] (Indeed, Forgács's film makes explicit pictorial reference to the house Wittgenstein built for himself in Norway—at one point we see an image of his hand-drawn sketch of the site, bearing various directional and cardinal indications—and makes many allusions to the operation, again in terms of the direction and possible reversal of movement, of the mechanical devices that had fascinated him since he had been a student of engineering at Manchester University.) As film, Forgács's representation turns out—we can use that verb advisedly—to be peculiarly capable of showing and of doing the philosophy that it engages. Replaying, rewinding, and reversing all constitute the *Leitmotif* of Forgács's films—his *Leiter.*

Like Wittgenstein's text, Forgács's film has constant refrains. Two ubiquitous motifs complement one another visually and relay the fundamental theme of changing and even reversing direction. First, we are constantly presented with shots and scenes of people going (going on) in a particular direction—taking a road, following in line, making or riding a track. For example, the first part of *Tractatus* opens with a shot of the wheel of a cart or a carriage, seen from above, churning over muddy ruts in a road ("the world is all that is the case" [1]).[12] Next we see the cart trundling along the road itself, running through a flat farmland, then poled across a river by a ferryman; an intervening shot shows a rowing man in a single scull rowing downstream ("the world is the totality of facts, not things" [1.1]). Second, these motifs are frequently followed, or inflected, by shots or scenes of a person or people dancing or otherwise going or turning around. Different people doing different kinds of dances appear throughout the film. For example, the first part of the film ends with a brief shot of a man walking in a circle upside down on his hands followed by a scene of a group of men and women dancing in a round with joined hands (again, we are told, "the world is the totality of facts, not things" [1.1]). As these descriptions suggest, both motifs—going somewhere in particular, going round and round—embed images of going backward (the rower sits facing away from the direction in which he is rowing) or being upside-down (like the man walking on his hands). More important, then, the motifs support the film-philosophical investigation of Wittgenstein's world picture—his suggestion that if the world is everything that is the case (in our picture of it), it could also be otherwise (in another picture or from another direction of view). As the film goes on, as it unwinds before our eyes, the viewer (especially in re-viewing) becomes increasingly aware of the possibility that these people could change their

direction or orientation or even reverse or invert it and that what they are shown to be doing could seem to be going the wrong way or being wrong way up—at least from *our* point of view as (re)viewers of the world in which *they* are pictured to us. We must grant, of course, that from *their* point of view they could be doing it right. And if from their point of view they are *not* doing it right, moreover, how would *we* see them to be doing it wrong from *our* point of view, when their *wrong* action might look *right* to us? We, like them, are embedded in a loop of reversions.

The middle sequences in the first part of the film suggest Forgács's approach to these seeming logical impasses, even though it takes the entire duration of the film to secure the viewer's sense that they have been seen there at all. After the sequence of the carriage traveling the road and ferried across the river in the first part of the film, we see a striking scene of what seems to be a dying pig rolled over and over on itself in its own blood and feces, prodded first by a human leg and foot encased in a polished jackboot and then by a leg and foot wearing a heavy workboot. In the fourth part of the film, Forgács briefly repeats a segment of this shot; here, the voice-over quotes Wittgenstein's remark that "the horrors of hell can be experienced in a single day."[13] The owners of the boots are not shown and the situation of the pig's traumatic disorder remains vague, and we are left to speculate on their historical Austro-Hungarian or other identity as suggested by the *conventional* meaning of jackboots and what seems, given the *apparent* actions or gestures of the people wearing the boots, to be the humiliation, torture, and slaughter of a defenseless animal. Elsewhere Forgács has proffered scathing condemnation of German and Austro-Hungarian Nazism and Soviet-satellite Communism alike, and the scene, especially given its reiteration and commentary in the fourth part of the film, tempts us to accept an association with these contexts. But the facts of the matter might be quite different; we have no definitive means to say exactly what we are seeing. In an interview with Scott MacDonald, Forgács remarks on this sequence:

> I don't know how to be "true" to archival material if you touch it with an intention to do more than restore it. Of course, one tries not to create lies, but one can use a film, or the meaning of a film, for purposes very different from whatever the original purposes were. In my *Wittgenstein Tractatus*, for example, the pig you see rolling on the ground is *not* killed or harmed, though you might assume the pig is about to be killed; the imagery was from a veterinary school documentation of a case of nerve disease in a pig.

Documentary facts aside, however, in *Wittgenstein Tractatus* Forgács works hard to avoid or eliminate visual material in the found footage that might definitively identify and localize the situations and actors. To

use Panofsky's terms, we see them at the level of "primary expression" and with a degree of ambiguity that does not easily permit "secondary" or conventional interpretations. But willy-nilly we will make such interpretations—underscoring the very difficulty of constituting actual alternate *pictures* of what *could* be otherwise. Substantively, and precisely because we are not completely sure of what we are seeing, the scene of the pig's trauma introduces elements of horror and foreboding into nearby scenes of ordinary, even joyous, human activities. Our certainty of contingency shades imperceptibly into our fear of catastrophe. At the least, unexpected recursions and reversals lie in wait for us at every turn.

In succeeding sequences in the first part of the film, for example, we see a group of dancers (though it is hard to tell, the dance seems to reverse itself partway through) and then a group of people—clearly they are friends if not relations or lovers—seated in rows in a mountainside meadow, relaxing and having a meal. The camera pans from left to right across the group, showing each person in turn, smiling, smoking, looking at the camera, looking elsewhere. Then it reverses itself, though whether

Figure 11.1 *Wittgenstein Tractatus.* The final shot of the film. As with so many shots, we do not know how or why this image first was made and it now takes on a charge of mystery as well as authenticity. As Davis argues, uncertainty, ambiguity, and indeterminacy underlie much of Wittgenstein's understanding of language; Forgács uses found footage to make a parallel argument.

the person originally holding the camera has simply panned back or whether the filmmaker using the footage has rewound it partway through remains an open question. (It is difficult to resolve this matter even after repeated viewings of the film. The very fact that the film includes instances of the image track as if it were going backward, being played in reverse, makes it difficult to decide whether what seem to be continuous sequences of filmed events going forward, whether or not they include a *filmed* action of looking back, belong to the original participants, to the original filmmaker, to the film artist using the found footage, or even to ourselves, the latest viewers of the footage as reworked by the artist.) Either way, however, when the camera returns to where we thought it began, the scene now reveals two women, one leaning intimately against the other (Are they strangers? Sisters? Dear friends? Lovers?). These are women we *did not* see in the initial scan, even though one of the other women in the group (we have seen *her* twice) appears to have been look-ing right at them. ("How hard I find it to see what is right in front of my eyes."[14]) Though it's hard to tell, this group of men and women appears to be the same as the group of people dancing hand in hand, already noted, that concluded the first part of the film ("the world is the totality of facts, not things" [1.1]). We would need nothing more than all this—neither the brief close-ups of Wittgenstein's face (taken from well-known portrait photographs) nor the occasional overlays of his handwritten texts nor the quotations from his writings—to grasp that the film tries to show (though it would be difficult or impossible to speak or discursively to describe) the contingency of the depicted world or to show the world *as* a picture, specifically, a *film*-like picture in which its unpredictable reversibility can be shown.

▶ ───

Circulus Methodicus: From Picture Worlds to World Pictures and Back Again

"When an acquaintance greets me on the street by removing his hat, what I see from a formal point of view is nothing but the change of certain details within a configuration forming part of the general pattern of colour, lines and volumes which constitute my world of vision." With this example, Erwin Panofsky introduced his distinctions between factual, expressional, conventional, and intrinsic meaning in turn, underwrit-ing his theory and practice of the iconography and iconology of works of pictorial art.[15] Panofsky wrote thirteen years after Wittgenstein in response to many of the same ideological currents that shaped Wittgen-stein's thought. Like Wittgenstein, he sought an antidote to the pervasive

skepticism—in turn it might lead to moral paralysis or, equally danger-
ous, to irrational prejudice or fascist delusion—that one might derive from
recognizing the essential contingency of human knowledge understood
as world picturing (or what Panofsky's interlocutors called *Weltanschau-
ung*). Panofsky provided a positive answer to the question of the indefinite
meaning of the man's gesture; it prefigures Wittgenstein's own later
approach to the problem of the significance of behavior and speech in the
Philosophical Investigations. According to Panofsky, we have a natural
method of understanding the man's gesture—that is, of interpreting the
material or physiognomic, the traditional, and the conventional aspects
of his behavior and in so doing of localizing it historically and under-
standing it culturally. This ordinary method of negotiating the world
pictorially can be formalized as *Kunstwissenschaft* (a discipline that
retraces the ordinary functions of human consciousness in making sense
of things we see around us in the world and in so doing [re]discovers—
but need not be epistemologically defeated by—their historical contin-
gency now seen as such).[16]

At the level of factual meaning, we see that the configuration in
our world of vision is our friend, a gentleman in the street, and that the
change of detail in it, in him, is an event, his removing his hat. At the
level of expressional meaning, we perceive our friend's friendly intention;
we apprehend this not by "simple identification" but "by 'empathy.'"[17]
In fact, Panofsky does not say whether the man has "a good or a bad
humour, and whether his feelings towards [us] are indifferent, friendly or
hostile." But in principle we will be able empathetically to grasp such psy-
chological nuances. According to Panofsky, both factual and expressional
meaning are preiconographical: we require no knowledge of conventions
or cultural traditions to understand them. Thus he wants to call them
"*primary* or *natural* meanings." They devolve from our intrinsic abilities,
identificatory and empathetic, to see what is going on in our world.

By contrast, the conventional meanings of objects and events—what
Panofsky calls iconographical meanings—depend on our historically
specific knowledge and our culturally particular situation. "My realization
that the lifting of the hat stands for a greeting . . . is peculiar to the western
world and is a residue of medieval chivalry: armed men used to remove
their helmets to make clear their peaceful intentions and their confidence
in the peaceful intentions of others." According to Panofsky, these his-
torically and culturally particular meanings can be called "secondary or
conventional"; they represent a local coordination of the primary meanings
devolved from our ability to see the world. Someone who does not belong
to the world of the postmedieval Western world (Panofsky imagines an

"Australian bushman" or an "ancient Greek") might not and perhaps *cannot* see the greeting even though he or she might see the man lifting his hat to occur in an indifferent, a friendly, or a hostile way.

Now we might wonder whether and how an acquaintance could or would remove his hat to us in a *hostile* way—Panofsky has already said that we might empathetically apprehend this psychological nuance, if the postmedieval custom or tradition of greeting means "peaceful intention." There could be a deep conflict, though Panofsky's cultural history rarely addressed it, between expressional nuances and cultural conventions: by tipping his hat perhaps my friend really wants to blow me off. Indeed, some historical cultures might evolve a different convention in which one can acknowledge someone's presence by lifting one's hat *as* a warning or threat. Would this be a greeting at all in the postmedieval Western world? Moreover, our friend in the street might *not* remove his hat when he meets us "were he not conscious of the significance of this feat." Panofsky notices, then, that it might be odd to encounter the hat removing in worlds that do not include the greeting *as* and *in* the hat tipping, an oddity at the heart of Wittgenstein's identification of the peculiarity and the contingency of our (picture) worlds. (A typical observation: "Suppose that 2000 years ago . . . someone had constructed the complete mechanism of the steam engine without having the least idea how it could be used as a motor."[18]) Still, it remains an empirical and a logical possibility that hat removing in its primary or natural meanings, both factual and expressional, might transpire in a way, and thus in a world, that differs from *our* postmedieval world of pseudochivalrous greetings. This world would be essentially different from ours. But it would *look* just the same to us in our world of vision in the morphological or formal configuration of the visual image and the change of detail in it. And here lies the epistemological problem: How would we know, and would it matter?

According to Panofsky, an essential meaning, the object of what he calls iconological analysis, resolves the primary and secondary meanings. In his account, the "intrinsic meaning or content" of a configuration ensures that primary and secondary meanings converge in a unified ("synthetic") meaning. We know that our acquaintance lifting his hat to us is greeting us in a friendly way—that he is being our *friend*, that he is *greeting* us, and so forth—because his action "can reveal to an experienced observer all that goes to make up his 'personality.'"[19] We know and we *see* what we need to know of his "national, social, and educational background [and] the previous history of life and present surroundings" and even of "his individual manner of viewing things and reacting to a world which, if rationalized, would have to be called a philosophy."

Of course, perhaps we can only *see* our friend's personality and philosophy, and they can only be shown to us, in the fact that he greets us in a friendly way. And we have already noted that this friendly greeting can look just like its opposite, like a threat or warning. Panofsky assumes our experience of our friend and our ability to "coordinate a large number of similar observations" about him, possibilities Panofsky builds into his thought experiment in advance insofar as the man in the street has been said to be our acquaintance. But can't someone we have never seen before greet us in a friendly way? And can't our acquaintance sometimes blow us off? Panofsky provides no reason to suppose that an intrinsic meaning or content solves the problem of what is going on in what we see. In the end, and as he acknowledges, he can say only that "content" offers a resolution of the "form" of what we see in a *circulus methodicus*—a looping recursion of interpretation of our pictures.[20] Panofsky's iconology proposes to interpret actual pictures, picture worlds, on the basis of the presumption that the world in our seeing is a picture, a world picture. The picture world supposedly inherits and interprets the form of the world picture (i.e., discovers its content). For this reason, Panofsky thinks, it can be understood with considerable confidence or what Wittgenstein later came to call "certainty"—even though the world picture itself can be nothing but a picture world that has conventionally resolved possible otherwiseness. But it is equally necessary to see, and to show, that the loop must be *all the world is:* "everything that is the case" in or as the world (*Die Welt ist alles, was der Fall ist*) lies in its constitution in recursions of re-viewing it. Here Wittgenstein's perspective, especially in Forgács's pictorial formalization, recalls us to primordial questions of fact, culture, and value that Panofsky's or other positive documentary projects of historical "contextualization," however laudable, must often forget.

As if in a direct engagement with Panofsky's iconology, in the final shot of *Wittgenstein Tractatus*—closing the seventh and last part of the film—a middle-aged man dressed in a street suit approaches a small round table in what seems to be an outdoor café. We don't recognize the man; he hasn't appeared earlier in the film. The scene gives us few clues to his identity. He seats himself facing the camera, tips his hat toward it, and blows his cigarette smoke sideways out of his mouth, almost as if trying not to blow it in our eyes and almost as if we are in his way. It appears that he does not know and maybe does not want to know the person behind the camera. To revert to the psychological nuances recognized in Panofsky's thought experiment, the man might be studiedly indifferent, possibly even slightly hostile. The tip of the hat seems sardonic. Indeed, we feel the force of the man's exhalation between pursed lips and almost

hear the vigorous *hppphhh*. Just before the shot begins, a title gives us the full text of the final lemma of Wittgenstein's *Tractatus*: "What we cannot speak about we must pass over in silence." The silence denoted here is not the silence of a silent movie or the found footage in Forgács's film, in which we do not hear the filmed human beings saying anything. Rather, the film investigates what "we must pass over in silence"—it might be unspeakable—in the fact that "what can be *shown* cannot be *said*" (4.1212). It is the easiest thing in the world to miss what the film shows in what it cannot say about the world, about everything that is the case—that is, to overlook the fact that the world it depicts, and because it depicts it, might be entirely otherwise at the same time as it is nothing other (and for us can be nothing other) than what it is. In Forgács's hands, this insight becomes beautiful and optimistic—a matter of Wittgensteinian faith or certainty or of Panofskyan confidence—even as it might be ominous and horrifying. When he tips his hat to us, the man in the film incarnates an open range of possibilities.

▶ ───

Circulus Methodicus: Rewinding and Reversing the World

Wittgenstein Tractatus belongs to Forgács's broader project to figure the consubstantiality between everyday human happiness and an unsayable, and in some historical cases an unspeakable, futurity and fatality shown to be entirely outside it, turning everything upside-down or inside out. The film repeatedly proffers a congruence between the two major motifs already noted; as it unwinds or replays the found footage before our eyes, overwinding it, we come to see that they are the same thing viewed from within or from one side, and from without or from another side. On the one side, people join hands and dance side by side, in a line, or in a circle. On the other side, a dying pig rolls over on itself in its own blood and waste, prodded by booted human feet. (The film solicits us to wonder whether we see the *same* boots on the dancers *and* what seem to us to be the torturers, but we would have to rewind and replay to be sure. Even then, we would not be *entirely* sure no matter what we thought we had finally been able to see.) In the opening shot in the fifth part of the film, a dying rabbit, neck or back seemingly broken, crawls round itself in a backward circle as if trying to put its head back on: "The limits of my language are the limits of my world" (5.6); "whatever we see could be other than it is" (5.634).

As suggested already, however, it might be the easiest thing in the world to miss the deeper fact, distributed throughout the film footage as

replayed, that an essential two-wayness or multisidedness and an inherent reversibility characterize the whole of the human dance itself: if the dance is not the *Totentanz* or Dance of Death, then maybe it must be, or will be; and if it is a *Totentanz*, then maybe it will not be or need not be. (In one of the series of highly enigmatic shots that close the last part of the film, a Death-like figure, a street hawker in black cloak and skull mask, wears a placard that says the same thing, "The Invisible Man Returns," whether he's coming or going.[21]) In *Wittgenstein Tractatus*, it is the essence of the world we are in that we are never quite sure whether we are seeing things going forward or going backward or right way round, whether there is a change of direction in the middle of things or another side to them, whether things are going the right way or going the wrong way, or what exactly and whether anything will turn out. "I am my world—the microcosm" (5.63): A woman enters a swimming pool (she is walking backward facing us), she comes around in a circle, always facing us, and she steps out of the pool. At any point has she turned around to go another way? Or is she always turning around and backing up and going another way *as* she goes her way? ("The limits of my language are the limits of my world" [5.6].) Toward the very end of the film, an elderly couple prepares a bedroom for use; the old man undresses and goes to bed reading his newspaper ("the world is independent of my will" [6.373]). Is he going to die? The camera seems to zoom in and go into a photograph in the newspaper and within it to see scenes shown to be televised (a ping-pong game) and then to come back out again (*hinausgestiegen*) into the bedroom, where the old man's wife is now shown to be dancing with a younger female companion and touching hands with the old man sitting by her side. Have we gone back in time? Forward? In and out of interconnected worlds? Are we somewhere else altogether? Having a dream? ("Death is not an event of life: we do not live to experience death" [6.4311]; here Wittgenstein's text continues, though it is not quoted in the film, "Our life has no end in just the way in which our visual field has no limits.") The final fact of the matter always seems to be at, or perhaps just over, the horizon of what we see—the very edge, or just beyond the edge, of what seems to be shown to be going on. The final horizon of this loop, death, must frame it absolutely. But this is not the same thing as supposing that death *defines* the directions of our life, its being *in* the world. The very unpicturability of our death means we cannot live toward it.[22]

To be sure, at several points in the film we certainly can and do see that what is said in a *language* of describing the world is not at all what is shown—what is actually going on in what is depicted. For example, the early shot of a rowing man (because he is seated backward, he seems

to be going forward in reverse) finds a supplement in a later close-up, seemingly drawn from the same or a similar sequence, of a man's action of rowing. On a shot of an arm and hand pushing the oar up, over, down, and around, Forgács has superimposed a graphic notation of a movement *going in the opposite direction*. The contradiction in representations is actually quite hard to see—"how hard it is to see what is right in front of my eyes"—and a viewer could easily overlook it. (At a recent screening, several well-prepared observers of the film, even after multiple viewings, replayings, and rewindings, had difficulty seeing the effect.) But the cumulative effect of all the footage in the film provokes a sense that something is not yet wholly aright in what we have seen in relation to what has been said.

As I have intimated, Forgács deploys an inherent *material* and *logical* property of the picture world of cinema to show the contingency of its world picture. It is clear at points in the film that in making it Forgács has *actually* replayed the rewound footage, as it were running its backward forward, even though we think we are seeing something going on in one and the same continuous way.[23] In one notable sequence, we see a man dancing and leaping in a circle; the footage clearly speeds up (i.e., fast-forwards) at a certain point and at another point, even though everything seems to be one continuous shot and seems to be playing (though now at expected or normal speed) in rewind. This next-to-final shot in the second part of the film, like earlier shots, explicitly deals with pictures—"it is impossible to tell from the picture alone whether it is true or false" (2.224)—and implicitly with our world *as* a picture ("we picture facts to ourselves"). In another shot, a young woman standing behind a fence bordering the track at a train station looks one way, then the other: is she really doing this, or has the film rewound her movement? Is she expecting something to arrive from *both* directions, or do we see something like a reversal of her single and directed expectation? Is everything an effect, a trick, of the found footage, or of its manipulation by the film, or of our viewing? Similarly, a man and a girl standing at the same fence (they seem to be strangers to one another) seem to look toward the same point between them, though there is not anything there, then to look in opposite directions. Are they waiting for the same thing, or has the film, rewound and replayed, shown that they could be waiting for different things or vice versa? ("What is thinkable is also possible" [3.02].) In the third part of the film, we see a series of shots of a group of people in a bright snowy landscape who are skiing; they put on lotion, they rub the snow into their mouths, they stretch. "Their inner life will always be a mystery."[24] Or yet again, a man fires a revolver while a female companion

clutches his arm (they seem to be at a house party in a country chateau, as if in a scene from Jean Renoir's *Rules of the Game*); we see the man pull the gun from his inner coat pocket, extend his arm, a flash, and then the whole movement in reverse. Did he really pull the gun on someone or something? Or did he fire it and put it away? We are never quite sure, even if and perhaps especially when we rewind and replay, that we are seeing something all the way through, or the same thing different ways through, or different things the same way through, or the same thing both ways, or different things the same way. The film asks us to rewind and replay *as* the indefinitely extended condition of coming around to understand things next time around: maybe *then* we will see, maybe *there* things will turn out differently.

In much of *Tractatus* it is as if the very same things are simultaneously being seen, or could be seen, from the *other side* of the film stock actually projected before us. Thus in the end *Tractatus*, like other films by Forgács that proffer more overt moral-political perspectives, tends to ask us what side we are really on. To some extent Forgács organizes this question in the film as a formal or structural matter, recognizing intrinsic problems in speaking, seeing, and showing. But it is palpably connected in an enigmatic and elusive way to immediate questions of our moral, social, and cultural affiliations, allegiances, and commitments, the identity of our side or sides. These commitments inherently contain the possibility of being on another side, of changing sides, and so forth. But at the same time they can also, and they *must*, appear to be the only way to look at things. In this respect, *Tractatus* explores the conditions of possibility of the concrete psychic and political histories explored more explicitly and in relation to particular historical events in other films by Forgács, notably the dislocation and destruction of Central European Jewry and the rise of totalitarian ideologies recorded and remembered in the found footage. I cannot take up this matter in any detail here. But it is worth remarking that *Wittgenstein Tractatus* does not present a readily apparent *political* perspective; its multisided images are too ambiguous for any overt commitment to a specifically political side to be inferred by the viewer.

To be sure, the film appears to be sympathetic toward and to identify with ordinary human beings conducting their ordinary affairs or (as Wittgenstein would have said) simply "going on" in their form of life. To some degree it mourns the fragile existence, seemingly the absolute loss, of these people and their worlds. Indeed, the people shown in the film do not have to die for us to mourn them. As in other films by Forgács, *Wittgenstein Tractatus* enunciates a proleptic or anticipatory mourning: *we* already know, and in watching the film we dread to see, their destruction.

Do *they* also know—do they dread—it, too? Again as in other films by Forgács, the simplest and most mundane activities (a glance, a gesture, a word) seem to harbor movements of shattering consequence; they seem to relay forces of change so vast and pervasive yet so subtle and impalpable that we cannot quite see them as they occur all around us. In such a world, in a world where the unspeakable might occur because it is not *sayable*, perhaps it is necessary to take sides after all simply in order to see and to say anything, even though this might come to the same thing as being utterly unable to see things in any other way and as saying things that can result in something unspeakable. It is this horrifying yet inescapable condition and structural consequence of moral identification, cultural affiliation, and political commitment as such—rather than any *particular* historical identification, affiliation, or commitment—that concerns Forgács: *things cannot be otherwise.*

When a man walks from left to right in front of us, swinging his arms left and right, his right arm swinging before him is on *our* right, and it is also on *his* right. But if the action is the same for him, *our* right is *his* left. But if we mimic his action, walking left to right in front of him and swinging our right arms ahead of us, from his point view *our* right is *his* left. Is it *all the same* to him and us? When a man lifts his hat up and down to us, his hat goes up for him *and* for us. But *his* up is not necessarily ours. Is it a friendly greeting? A neutral courtesy? An obsequious obeisance? An irritated put-off? A sardonic put-on? A hostile condescension? *Wittgenstein Tractatus* exposes such incoincident congruences in their unavoidable recursion, asymmetry, and intransitivity and thus, in turn, skeptically solicits the empathetic morality of the deeper human identifications they require. To understand the man we must know what it is like *for him* to tip his hat in the way that he does—even though we are on the other side. To discover this, we feel we would have to lift our hat, purse our lips, and vigorously blow our cigarette smoke sideways just as he does. But to do this *just like him*, to feel and to understand the gesture as he does and as it were from within his world, we would already have to know what he is doing within his own world and his picture of things— that is to say, we would already have to be on his side. No mere rewinding and replaying—a mere mechanical *Überwindung*—can get us "over there" (*darüber*). The man's "inner life will always be a mystery": we can show this place only as another side of where *we* are.

In the end Panofsky identified this *circulus methodicus* only in order to dismiss it. He believed it could be controlled, even overcome, in the documentary, experimental method of cultural history. In particular, the historical–cultural localizations of iconological interpretation would

try to guarantee an understanding of our hat-tipping man (Panofsky's or Forgács's) in our experienced observation of his personality and philosophy. But when Forgács immerses us in the historical and cultural situation of filmed worlds, however vague their locations, ultimately he means to call up our primal empathetic identifications—our visceral appreciation of the meaningfulness of people's lives—precisely because he recognizes their limited vision. Like Wittgenstein before him, then, Forgács admits a leap of faith: since what I see could be entirely otherwise, what I see—it is how things *must be* for me, the "totality of the facts" (1.1), the "limits of my world" (5.6)—partakes of the "mystical" in the fact that it exists at all in the seemingly particular and certain way that it does for me (*Nicht w i e die Welt ist, ist das Mystische, sondern d a ß sie ist*—"It is not *how* the things are in the world that is mystical, but *that* it exists" [6.44]). In his filmic repossession of the world—rewound, overplayed, and reversed—Forgács's found footage, sometimes unsettling, often ambiguous, is always sacramental: "Feeling the world as a limited whole—it is this that is mystical" (6.45).[25]

In *Wittgenstein Tractatus*, the happenstance incidence, the astonishing preservation, the manifest unlikeliness of the found footage becomes a representation of human consciousness. In its blithe and deadly existence it is a reminder of everything that could have been pictured that was never actually filmed. In *my* world it is the greatest surprise of all that the world—everything that is the case, my affair, my failure, my downfall (*alles was der Fall ist*)—isn't a surprise at all, for it would be a surprise beyond measure (certainly unsayable, maybe unspeakable) that the world *is* a surprise. As Forgács shows, however, it is all there *in* the world at the press of a button.

▶

NOTES

1. The ideas developed in this chapter germinated while I was a scholar in residence at the Getty Research Institute in Los Angeles in 2001 and 2002. I am especially grateful to Péter Forgács for several discussions about his work and for answering my queries and to Bill Nichols, Murray Smith, and Thomas Wartenburg for incisive comments on drafts of this chapter. Steven C. Seid of the Pacific Film Archive, University of California–Berkeley, helped with technical issues. *The World Viewed: Reflections on the Ontology of Film*, enlarged ed. (Cambridge, Mass.: Harvard University Press, 1979), 22.

2. Erwin Panofsky, *Studies in Iconology* (Oxford: Oxford University Press, 1939), and *Meaning in the Visual Arts* (New York: Doubleday, 1955).

3. For Wittgenstein's activities in these nondiscursive media, see especially Paul Wijdeveld, *Ludwig Wittgenstein, Architect* (Cambridge, Mass.: MIT Press, 1994).

4. Forgács's film also sometimes quotes from writings by Wittgenstein other than the *Tractatus Logico-Philosophicus*, namely, the short remarks (mostly written in the 1930s and 1940s) selected by Georg Henrik von Wright from Wittgenstein's *Nachlass*; these were edited by Wright in collaboration with Heikki Nyman and first published in 1977 as *Vermischte*

Bemerkungen. I have quoted them from the revised edition of the original German texts selected by von Wright, edited by Alois Pichler, translated by Peter Winch under the English title *Culture and Value: A Selection from the Posthumous Remains* (Oxford: Blackwell, 1998). The textual origins of these particular remarks are nowhere cited in the film.

In Forgács's original version of *Wittgenstein Tractatus*, the quotations from Wittgenstein, whether written or spoken, are given in Hungarian translation. I cannot evaluate this translation or Forgács's use of it. In the English-language version, also produced in 1992, many of the Hungarian titles have been preserved, but English titles have been added. Naturally this addition changes the sequence and layering of certain pictorial images in relation to accompanying text. Moreover, the Hungarian voice-over has largely been replaced by an English voice-over spoken by Forgács himself. At a few points in the English film there are brief quotations spoken in Hungarian by a female voice, as if to recall Wittgenstein's strange and self-revealing question—cited in the film itself—whether there might be "something feminine about this way of thinking," namely, the way of thinking recommended by Wittgenstein in the *Tractatus*.

5. Unless otherwise indicated, I quote the German text of Wittgenstein's *Tractatus* (it differs in small ways from the German original of 1921) published with a facing English translation by David F. Pears and Brian F. McGuinness (2nd imp. with corr., Oxford: Blackwell, 1963). This translation replaced the influential translation by C. K. Ogden (assisted by Frank P. Ramsey) published in 1922 and corrected in 1933—the translation used by Forgács in preparing the English version of his film. I have used Pears and McGuinness's translation. But as the quoted sentence reminds us, Pears and McGuinness's translation is not always literal or fully accurate. In 2.02, Wittgenstein clearly says, "The object is simple."

6. Max Black, *A Companion to Wittgenstein's "Tractatus"* (Cambridge: Cambridge University Press, 1964).

7. Ibid., 23.

8. Ibid., 377. Forgács uses this translation in the English film.

9. Ibid., 23.

10. Ibid., 378–86.

11. Photographs and discussions of these artifacts and activities can be found in Wijdeveld, *Ludwig Wittgenstein, Architect*.

12. My quotations cite the quotations from Wittgenstein's writings that the film offers alongside the image track in the interleaved or superimposed titles or in the voice-over. In the present discussion it is not possible to distinguish between these methods of quotation, but a full consideration should differentiate the passages that are spoken by a human voice and those meant to be read (by our eyes) as part of the image track—the pictured world. The full calibration of image and soundtracks—and of saying and seeing and of picturing and hearing (both visual scenes and spoken words)—is extremely complex. In part the film aims to *show* the dense nesting of seeing and speaking.

13. Wittgenstein, *Culture and Value*, 52e.

14. Ibid., 44e.

15. "Zum Problem der Beschreibung und Inhaltsdeutung von Werken der bildenden Kunst," *Logos* 21 (1932): 103–19, heavily revised and translated by Panofsky as the first part of "Studies in Iconology: Introductory," in *Studies in Iconology*, 3–17 (quotation from p. 3; italics in original).

16. It would take me too far afield to consider the similarities and differences between Panofsky's iconology (in its German and English variants) and Wittgenstein's early picture theory of meaning and later doctrine of language games woven into a natural and cultural form of life. Despite striking convergences in their phrasing, I can find no evidence that Panofsky had read Wittgenstein in the 1920s or that Wittgenstein had read Panofsky in the 1930s or later. Panofsky opposed the existential phenomenology of Martin Heidegger—a feature of Wittgenstein's thought that remains to be fully investigated.

17. Panofsky presumably used quotation marks because empathy had played a controversial role in German and Anglo-American philosophical psychology since the 1890s. Typically, it referred to the transfer of subjective states of irritation of the organism to its interpretation of objective conditions. As such, empathy is an identification, virtually a transference—but it is not simple.

18. Wittgenstein, *Culture and Value*, 49e. For the best explication of "seeing-as" and "seeing-in" in pictorial representation, see Richard Wollheim, *Art and Its Objects*, 2nd ed. (Cambridge: Cambridge University Press, 1980), 205–26; Wittgenstein's principal discussion can be found in *Philosophical Investigations*, ed. G. E. M. Anscombe (Oxford: Blackwell, 1953), book II, section xi.

19. Again, Panofsky enclosed a tendentious psychological term in quotation marks. Sometimes Panofsky's iconology has been taken to be a disguised form of *Geistesgeschichte* or even *Volksgeistesgeschichte*—the interpretation of historically specific cultural conventions in terms of essential (even ethnic or racial) habits, sets of mind, or worldviews. But Panofsky used the term "personality" in a strictly psychological sense to denote the matrix of resolution of the potential disjunction and conflict in the network of relays of primary and secondary meanings acquired and coordinated in individual consciousness.

20. See especially *Studies in Iconology*, 11n3. For discussion of the *circulus methodicus*—in visual recognition and in *Kunstwissenschaftliche* retracing of its operations—see Whitney Davis, "Visuality and Pictoriality," *Res* 46 (2004): 9–31.

21. Although it is one of the few examples of writing or speaking captured in the film's found footage, the placard is not readable to the English-speaking viewer. According to Forgács, the street hawker is advertising the 1940 American film *Return of the Invisible Man*—sequel to the original *Invisible Man*, released in 1933 and starring Vincent Price—on the Grand Boulevard in Budapest. Though presumably the hawker is supposed to look like the bandaged invisible man in the films, he is dressed in the traditional garb of Death as we would see it in medieval woodcuts or in films like Ingmar Bergman's *The Seventh Seal*.

22. This is not the place to address Panofsky's—or Wittgenstein's or Forgács's—dispute with the founding terms of Heidegger's existential phenomenology and its interpretation of world disclosure in relation to "being-towards-death." For intimations of the perspectives—as it were humanist—that Panofsky (and conceivably Wittgenstein and Forgács) might wish to counterpose to Heidegger's, see Ernst Cassirer, "Heidegger and the Problem of Death," *The Philosophy of Symbolic Forms*, vol. 4 of *The Metaphysics of Symbolic Forms*, ed. J. M. Krois and D. P. Verene (New Haven: Yale University Press, 1996).

23. Needless to say, Forgács's work here and elsewhere examines traditional or analog pictorial representations (e.g., painting, photography, and classic film) in view of effects constructed in, and by now fully associated with, computer-driven manipulations of *video* presentation— forward, pause, rewind, (re)play—in turn dependent on digitization. I cannot pursue this topic here, but we should not fail to remark the historical world-making role of *television* as documented in some of the found footage used in *Wittgenstein Tractatus*—at least as the footage is re-viewed by Forgács. One might say that in *Wittgenstein Tractatus*, as in several other films, Forgács tries to repossess our world—a world now inherently self-televising—as it were *outside* television by attempting technically to overwind or reverse the one-wayness of institutionalized televisual broadcasting. For parallel projects in photography and painting, see Whitney Davis, "How to Make Analogies in a Digital Age," *October* 117 (2006): 71–98.

24. Ludwig Wittgenstein, *Culture and Value*, ed. G. H. von Wright, trans. P. Winch (Oxford: Blackwell, 1980), 74.

25. Wittgenstein writes *begrenzte*—bounded, fenced, frontiered, or framed. My world is bounded and framed by my language, by the structure of the visual field, and by the logical–mystical configuration of facts or propositions—this is, by pictures.

TAMÁS KORÁNYI
Translated by David Robert Evans

[**12**] *Taking the Part for the Whole*
Some Thoughts Inspired by the Film Music of
Tibor Szemző

Péter Forgács and Tibor Szemző first became acquainted through stage
and concert productions in the 1980s, the time of *Snapshot from the Island*
(*Pillanatfelvétel a szigetröl*). This 1987 record also includes another of
Szemző's compositions, *Water-Wonder N2* (*Vizicsoda*), which Forgács had
previously used in a 1984 video work, *The Golden Age* (*Aranykor*). This
was, in fact, the first occasion on which he employed Szemző's music. They
later met as part of the Group 180 (*180-as Csoport*), of which Szemző was
a founding member. It was here that Forgács participated (as narrator) in
the performance of Frederic Rzewski's composition *Coming Together and
Attica* (1972). This two-part Rzewski piece for narrator and band is one of
the early classics in the history of minimalist music, and the fact that Group
180 played this in Hungary as early as 1983 was also crucial for Szemző's
career. His aforementioned work *Water-Wonder N2* can be found on the
same record, as well as Steve Reich's 1973 composition *Music for Pieces of
Wood*. It was this that formed the basis for a collaboration that would later
come to full fruition in Szemző's collaboration on Forgács's films.

We might say that from a foundation in classical and early music,
Tibor Szemző eventually arrived at minimalism as a favored style. Pop
music has also had a defining influence on him, while his improvisational
ability owes much to jazz. At the same time his music is conceived as per-
formance, akin to modern opera. Szemző stepped into yet another arena
by composing music to accompany films, yet his music never turns into a
workmanlike, commissioned product—its sound is always unique, always
referencing and complementing other art forms.

So what compositional effects are there to be found in Szemző's
work? If we look for his inspiration among minimalist (or repetitive)
music, we immediately happen upon Steve Reich and a world that openly
originated from *Perotinus*. Szemző also reminds us of the approach taken

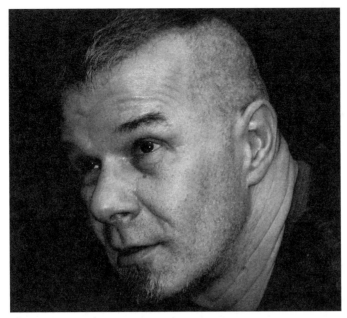

Figure 12.1 Tibor Szemző, the composer of music for many of Forgács's films.

by the early creations of Philip Glass, such as *Einstein on the Beach*, the joint stage production with Robert Wilson, and the music for his films with Godfrey Reggio (*Koyaanisqatsi, Powaqqatsi, Anima Mundi*) or the early work of John Adams (*Harmonium, Harmonielehre*). We might also find affinity to the work of Romanian-born but Germany-based Adriana Hölszky, whose latest operas have no human performers: the music accompanies nothing but objects arranged on the stage.

The most formative influence, however, must be John Cage. The influence of Cage's approach—the combination of accident and strict design (in Cage's series Imaginary Landscape, for example) can be felt throughout Szemző's work. Cage's imprint can also be seen in Szemző's fascination with philosophy, whether we think of the performance inspired by the texts of philosopher Béla Hamvas, or, above all, Szemző's score for Péter Forgács's *Tractatus*, based on the famous work by Wittgenstein.

Some resemblance also exists to one or two of Harry Partsch's writings (e.g., *Barstow: Eight Hitchhikers' Inscriptions from a Highway Railing at Barstow, California*) and the world of Conlon Nancarrow. This is not to say that Partsch had a direct effect on Szemző; Szemző may not even be aware of his music. For Szemző the potential for music lies everywhere. Partsch makes music out of graffiti, while Szemző, to accompany the Forgács film *Free Fall* (*Az örvény*), gives sound to the text

of Hungary's pre–World War II anti-Jewish laws in such a way that their effect and ambience are those of a liturgy. Something unique is created by such music. A family's home video movies receive a social context even though Forgács provides only fragments of the pertinent historical documents via this musical form. Amateur filmmaker György Petö was a talented violinist, and when after World War II the situation in Hungary robbed him of his opportunities in banking, he began to earn his living by playing the violin. Szemzö's musical treatment of these anti-Jewish laws arrives at an oblique angle to Petö's images of everyday life, just as the musical rhythms of Thomas Bernhard's novels such as *Wittgenstein's Nephew* or *The Loser* achieve a similar disquieting effect.

Szemzö's music of chanted words fuses with *Free Fall*'s idyllic pictures to generate the film's astonishing power. This is one of the reasons why, if we insist on classifying it, we can say that this film has an opera-like effect. This is further demonstrated by the fact that so-called classical film music cannot survive if devoid of the film it accompanies (and this is even true of such cinema composers as Nino Rota and Miklós Rózsa or, to take a more modern example, Michael Nyman). In Szemzö's case the opposite is true, so much so that there have been examples of the process taking place in reverse—of a film being edited to fit to music he had already composed.

According to Cage, the validity of any question about the nature and status of music is open to debate. Which is more musical—the noise of a truck passing a factory or that of a truck passing a conservatory? For Cage, music has no intrinsic meaning. But if he can ask the question "Which is more musical?" then we must answer the question of what its intentions and effects are. This issue, however, is not purely a musical one but a philosophical one, since it can equally well be raised with regards to the work of Samuel Beckett or Thomas Bernhard, whose musicality is hardly in doubt. The influence of the miniatures of Morton Feldman can also be felt here. (I have in mind Feldman's attraction to Beckett in, among other works, his opera *Neither*.) So can the influence of the New York School. In addition to those already mentioned, this primarily refers to French-born Christian Wolff, who, especially in his early compositions, was a master of music produced from a minimal range of sounds and later went on to become a composer of Cage's caliber.

▶ _____

"I Am Not a Film Composer"

The first film for which Szemzö composed music was not, however, one by Forgács. In 1981 he prepared what he called a structuralist plan for

the film *Train Journey* (*Vonatút*) by Miklós Erdély (1928–1986). Szemzö says in an interview, "Traditional film music is illustrative; it is manipulative in a premeditated way. In this sense, I am not a film composer, for I have no such skill. Neither can I compose in any particular prescribed style. I have no affinity for that, and, thank God, neither have I ever been obliged to do it."[1]

Szemzö has himself shot films—*The Other Shore* (*A túlsó part*) and *Cuba*, for example—accompanied by his own music. Given that such a significant part of his work has been associated with film, what is it that inspires him to write film music? This question is made all the more interesting by the fact that Szemzö does not let himself be influenced by films. The music for *Tractatus*, for example (which also enjoyed independent success), came into being purely by chance. When he was making a film about Wittgenstein, Péter Forgács asked Szemzö to compose some music. The starting point came from the minimalist lullaby that Szemzö happened to sing to his son at the time. This reuse of repetitive, bedtime music was well suited to quotations from Wittgenstein and to the visual world of the film. Konrad Heidkamp is quite right in likening this work to Laurie Anderson's *O Superman* or the British Gavin Byars's composition about lost property, *Jesus' Blood Never Failed Me Yet*.[2] For Szemzö, this rich tapestry is built around a minimalist core. From certain points of view, the same is true of Forgács's 2001 film *A Bibó Reader*, which uses the writings of the eminent Hungarian thinker and social and political scientist István Bibó, as well as Szemzö's music. What is certain is that there is one musical sensibility at the heart of both films. Further, unlike most episodes of the Private Hungary series, these two films are not mute. Although the text of Wittgenstein's *Tractatus* does not emanate from the screen, it can still be likened to the Bibó film in which Bibó's words primarily relate to the pictures rather than to the music.

The story behind *Free Fall* was quite different. Here it is far less significant which pictures accompany the text of the anti-Jewish laws: it is the dramatic contrast between the laws set to music and the idyllic home-movie footage that shocks the viewer. This effect works on different levels. Every detail of the family pictures involves history, but only in an indirect fashion. In retrospect we know the fate of those portrayed, but as the movies were being shot, these individuals had no idea of their impending doom. And this was true even after the introduction of the anti-Jewish laws. However, when Szemzö places these laws in a real musical framework, their fate, for the contemporary viewer, becomes synchronous with the original images. A simple test can prove this to be true. It is worth watching the film mute: in this way, its concerns are quite different. And

if we only listen to the music, the shocking contrast between the holy sounding music and the brutally matter-of-fact legal words remains.

▶───

Modes of Presentation

There are three ways in which Szemző's so-called film music appears before the public: (1) as stand-alone music with no visual accompaniment, (2) as part of a film soundtrack when we watch a movie in the usual way, and (3) as a live orchestral performance with the now-silent film projected on a screen behind the performers. The relationship between the picture and the accompaniment and the resulting affect differs for the three different modes of presentation—although the essence of the music is identical in each case. Exciting variations in the apperception of the music can also be effected by whether the spoken words in the film are linguistically comprehensible or incomprehensible to the audience. This is further proof that Szemző's works of film music, although an integral element of the film, nevertheless possess a life of their own: they cannot be classed together with film music in the traditional sense.

It is said that good film music goes unnoticed by the viewer. In this sense Szemző's film compositions are not good: they are decisively, noticeably present in every moment of the film. Although they are primarily minimalist or monotone in style, they refuse to leave viewers in peace, forcing them continuously to link the impression generated by the usually silent excerpts of home-movie footage to the music. It is also true, of course, that Szemző's film works, with few exceptions, accompany other than conventional films. Péter Forgács's creations themselves depart from traditional films, and the episodes of the Private Hungary series, all of which enjoyed Szemző's participation, developed a genre all their own. These are silent films with hardly any spoken words. And when there are words, it is Szemző's music that animates them for the film. The cinematographic concert that put the writings of philosopher Béla Hamvas to music also accompanies the images of a Forgács film.[3] "You have to hear the music in these words. It was the lyrical nature of the words that grabbed me," the composer says.[4] Szemző has also said, "I hear spoken language very much as I do a musical part, with its unquestioned and purposeful rhythm and tune. And that is not to mention the speech's meaning. I find the musicality of spoken words very exciting, especially when it is not an actor that delivers them but someone who only represents him- or herself and in whose voice an authentic life can be heard."[5]

This admission is an almost direct reminder of the conception behind the works of Steve Reich. In *Different Trains* or the video opera *The Cave*, Reich's composition is based on the rhythm of previously recorded narratives, discovered artifacts, if you will. It is particularly in *The Cave* that the technique becomes plastic, for it is here that Reich employs noise, rendering it musical music in the traditional sense, so that the rhythm is dictated by the text in question. We also ought to mention here one of Szemzö's important verbal compositions, *Death's Sex Appeal* (*A halál szexepilje*), inspired by the writings of Tibor Hajas, in which we learn how to get from silence to an unbearably loud noise in the least perceptible and most surreptitious way. But there are other things at work here as well. At the beginning of the piece, it is mostly the unusual style and childlike delivery of the words that fascinates the listener. In the course of the ten or so minutes of the piece, however, the music, initially squeezed into the background, comes to take precedence over the words, and what seems like aggressive articulation almost disappears. This is all worth knowing when becoming acquainted with Szemzö's film compositions; as he himself says, "I have referred to film music as 'aural pictures,' which create some kind of appropriate sound and then within that sound remain totally static. They play a role in the construction of acoustic space. I would not call it adapted music, because nowhere has anyone given any kind of instructions. Motivations come and go; there is always an intellectual background of which I am not the originator."[6]

We can, of course, find a whole list of contradictions in all this. Text is vital to Szemzö, but is it necessarily text that he is so fond of? "Certainly not," he says. "I did not use Wittgenstein's text because I found it pleasant, but because the presence of the verbal factor gives a completely different structure to time."[7] So it is here that we can grasp the difference to be felt in Szemzö's music, depending on whether we look at its relationship to text or image. Since text can be perceived as a kind of music, it necessarily displays a greater degree of dependence for Szemzö than the image does. That is to say, he feels far more independent of images than he does from texts. And this makes much clearer the contrast I recognized in *Free Fall* in terms of images, words, and music.

It has become something of a trend to set originally silent films to music. Eminent composers write new scores for well-known silent films. An example of this from the 1990s is the music composed by Alfred Schnittke for Vsevolod Pudovkin's 1927 film *The End of Saint Petersburg*. Like so many other similar productions, his score prompted controversy. Since at first glance there would seem to be an analogy with the films of Forgács and Szemzö, it must be stressed emphatically that this is an

entirely different state of affairs. These films were originally silent feature films, mostly produced from a preconceived script and performed by professional actors. Their silent nature was the product of technological circumstances. Nor were these films entirely silent in any case, since their stories were told not only with the help of gestures but also with specific dialogue inserted on the screen. The original musical accompaniment was usually in the form of an ad hoc live performance, which is of significance more for assessing the tastes and customs of the period than from any artistic perspective.

Péter Forgács's films, on the other hand, are so-called reconstructed artifacts, which come to possess their stories as a result of his direction and creative editing. The home movies, for the most part, did not originally have stories, let alone scripts. Their characters are usually family members, their stories normally those of family life or the local surroundings. Thus the first creative stage involves Forgács placing the collected material in the correct context. The second, musical stage stands in stark contrast to the customary musical accompaniment for silent films. With Szemző's work the process is not just about providing an accompaniment or about ensuring that the sequence of images is no longer silent but about a creative contribution and intervention that changes the meaning of the images and contributes content of its own. This is what, in my opinion, differentiates it from established film scores. It also underpins the power of the oratorical (live) performance of the music together with a projection of the film or even the performance of the music as a stand-alone event. The three different modes of presentation involve different experiences in terms of form, content, and emotional response.

Szemző's music cannot be termed nostalgic. It is comparable, rather, to some kind of dream, a dream that follows a sort of meditative process, whatever its subject might be, whether a peaceful memory, or something quite abhorrent.

▶———————————————————————————

NOTES

1. *Filmvilág*, March 2001.
2. *Die Zeit*, October 25, 1996.
3. *Kadar's Kiss (A Csermanek csókja)*, Private Hungary series, part 11, 1997.
4. Interview with Hungarian state radio, May 29, 2002.
5. *Népszabadság*, December 20, 1999.
6. *Magyar Narancs*, May 18, 1995.
7. *Irodalmi Szemle (Literary Review)*, Bratislava, December 1993.

LÁSZLÓ F. FÖLDÉNYI
Translated by David Robert Evans

[**13**] *Analytical Spaces*
The Installations of Péter Forgács

The installations of Péter Forgács are life spaces. In them, things evolve
into space and inhabit it. Objects are brought to life that at first sight
are completely inert. These installations are spaces of the soul. They
make the invisible visible. Yet in the meantime, life falls into pieces, and
its elements, far from being put together, are carefully spread out. These
spaces are alive, yet whichever of them I step into, I am filled with a
deadly sort of numbness. They hit me right in the face. Péter Forgács's
installations are disquieting; some are outright moving. Even in those
that are more noteworthy for their irony or humor, I find something
unsettling. Their most unnerving aspect is the keen stare concentrated
on me the whole time I am in these installations, these spaces, that the
whole time I am unable to place. Someone is watching me, but I know
not who or from where.

This stare accosts me, but I am unable to reciprocate. This is the
most unsettling aspect of all. For all stares await a response, and while
I listen to my stomach and my heart, I also feel the need to answer.
Forgács's installations demand painstaking, circumspect attention. Their
space is there to be occupied, step by step, like so much *spiritual* space.
The space is distributed with precision: the objects create a logical, as well
as emotional, web. There is a system I have to grasp. I have to reconstruct
the will that built this space. Within my head, I have to design the collec-
tion of items anew. It is only then that I can allow myself to listen to my
stomach and my heart. And by then I see them with the same expression
that was previously focused on me.

They are rousing, analytic installations. They have taken life to
pieces in order to construct a new parallel life out of them. In *Hungar-
ian Kitchen Video Art* (1992), for example, the process of deconstruction
produces a new space that becomes natural by way of unnaturalness.

This byroad is reminiscent of an infinite spiral. The floor is covered with natural grass, which here, in an installation inside a museum, is far from natural. But on the television screen in the corner, where the grass appears not as an element of an installation, but as grass, it will be. Yet the image relayed by the television loses its naturalness precisely because of its relayed nature, like everything that appears on a television screen. The television set, as a domestic object, is nevertheless a natural part of our everyday lives. The installation—as a slice of life space—brings this naturalness into question. And this goes on for eternity—an eternity that appears thematically in the endless alternation between the relayed grass and the yoga routines that, again and again, interrupt their broadcast.

"Natural" gains its quotation marks thanks to its relayed nature. But the term "relayed" awaits a similar fate, also falling between inverted commas, almost perversely becoming natural. In the installations of Péter Forgács, "reality" and the "simulacrum" enter a unique symbiosis. What makes his art unique is that neither is sacrificed for the sake of the other. He does not insist on perpetuating the illusion of reality, for reality—as we know from psychoanalysis or from Wittgenstein—was never neutral but always full of relayed components;

Figure 13.1 Hungarian Video Kitchen Art installation, Budapest and The Hague, 1992. Forgács uses a corner in which to install his "kitchen art," an ironic reference, perhaps, to the use of corners to display religious icons in Russian culture; after the Soviet Revolution images of Lenin and Stalin came to replace the religious icons, a fact no doubt all too familiar to any Eastern European who grew up under Communism.

it is precisely this relaying that makes it reality. Yet his installations do not demonstrate the recent view, of which Jean Baudrillard is a key exponent, that reality has long been a sheer illusion and that the process of imaging is more true than what is imaged. In Péter Forgács's video installations, reality and the simulacrum are realized *at one and the same time.* Neither attempts (with the help of irony) to pull the carpet from under the other; it is the two together that produce a combined unit that is theoretically inconceivable. This lifts both reality and the simulacrum to a higher power, generating a third, the genre of which it is not a simple task to assign. This is what makes Forgács's work *art*, for art is the place where everything is allowed, or more precisely, everything is allowed that is suitable for the evocation of an experience that rids the world of its naturalness in such a way that light is poured on an as yet unimagined focus of its viewer's own existence.

The approach to this assumed focus appears thematically in a number of the installations. *Dream Inventory* (1995), for example, takes psychoanalysis as its starting point. While the armchair, the couch, the carpets, and the pillows evoke the fin de siècle atmosphere of the Berggasse in Vienna, the video technique used, together with the monitor itself, put this atmosphere in inverted commas—without quenching or destroying it. In this instance the quotation marks do not throw their subject into doubt; rather, they help us to approach it by distancing us from it. This *analytic* method is what suggests the procedure of psychoanalysis to the spectator. As so often in art, that which is *depicted* and the *nature* of the depiction generate a tension to which the viewer in the foreground succumbs. This allows him to experience the layering of his own being. (This work was one of the most important items in the *Psychoanalysis and Viennese Actionism* section of the 1996–1997 exhibition *Beyond Art*, together with Miklós Erdély's installation *Similis Simile Gaudit* [1985] and Hermann Nitsch's 1990 statue *Oedipus Partitur.*) *Dream Inventory* is part of the wide-ranging exhibition "Inventory," which literally dismantles the soul, opening its *drawers*, providing the viewer with a kind of *descent*. The *darkness* of the exhibition in its own way pours light on the inner gloom of the soul. The visible becomes invisible, while what was previously out of sight comes unexpectedly into the limelight. It is two diametrically opposed movements that provide enlightenment—just as in the case of the pig in the exhibition, which can watch its slaughter taking place in reverse on a monitor, dead in life, alive in death.

Analysis originally meant dissection. The installations of Péter Forgács are analytic in the literal meaning of the word. This is helped by the very nature of installations as a genre or medium. In looking at his

installations we can always find some *eventuality* in the collection of various articles, which is all the more evident the more *united* the effect of the work. It is as if Forgács's passionate preparation creates video installations that induce onlookers to the most conflicting actions. The installation entitled *The Case of My Room* (1992), for example, divides one single space into two rooms reminiscent of the two halves of the brain. But as the video prevents any fast or immediate identification (direct, sentimental involvement), the viewer is forced on a tour of the soul, the final destination of which is a differentiated self-understanding. In the installation *The Hung Aryan* (*A kaszt o!*; 1997), the *unity* of the space is split into *three*: the members of the family, who should belong together, find themselves the furthest apart from each other. Yet the work as a whole nevertheless reinforces the feeling of togetherness, which in this instance refers not to familial bonds or to relations between mutual (or conflicting) interests but to a sort of existential interdependence, which—as a powerless force— suggests the monotonous yet tragic nature of life itself.

Péter Forgács cuts to pieces, takes to pieces, dissects, and analyzes, and at the same time he puts something together. What there *is* (the visible) he dismantles in order to make visible the ground of things, which would otherwise be invisible, in the same way it is not simply the original, immortalized images that give his Private Hungary films their real power but the invisible scratches Forgács himself forces onto every frame. It is thanks to these scratches (acts of defacement or manipulation) that something appears on the film screen similar to what Freud called the optical unconscious (*Optisch-Unbewußte*). This is invisible but at the same time highly perceptible. The films, rather than remaining simple documentaries, come to life. As I watch them, it is not only a lost world that I see; I also penetrate my *personal* layers I had thought lost. I continue a dialogue with myself, and as a result what is long gone (history) suddenly becomes present and private, just as the spaces of the video installations are alive and personal, partly because the monitors often leap into action from the *presence* or *movement* of the visitor, by which the installation is also turned into a *stage* and the reception of the work into a *performance*.

According to Freud, the objective of analysis is the deconstruction and dissection of dreams. The unity of the world is self-evident, he wrote, and thus there is no need to give it special emphasis: "What interests me is to separate and take to pieces that which would otherwise blend into one in the primeval sludge (*Urbrei*)." In the end, though, this procedure means we have to ignore dreams: as the elements of dreams become conscious, the images disappear and are replaced instead by words—something Lyotard argues can be traced back to Moses's suppression of images.

Freud brings into the *light* what would otherwise be *locked away* in the darkness. In other (Greek) words, the *mystery* (which is locked away) is revealed within the *profane* (the visible).

It is at this point that the analytic techniques of Péter Forgács's installations break away from the methods of psychoanalysis. Their undoubted foreground allows us to conclude that they have an *aura*. It is important to emphasize this because it is precisely since the spread of media and technical reproducibility that it has become a cliché to quote Walter Benjamin's conception that the aura of a work of art disappears in the age of technical reproducibility. There is, however, a fundamental difference between a duplicated work and duplication itself as a technique. Benjamin is right that in the course of duplication a work loses its aura, the authenticity brought to it by the here and now. He makes no mention, however, of whether the technique that actually brings about the reproduction can also generate a previously unimagined aura all its own. The here and now of Forgács's video installations are capable of creating that very aura. It is evident that the *oil stains* on the wall of *Hungarian Kitchen Video Art* and the furniture on its floor, brought directly from its original surroundings, do not have their own aura. But objects robbed of their own aura are still suitable as elements of a new aura, one composed not of the objects themselves but of the nature of their arrangement. Duplication and multimedia are also capable of producing their own here and now. In the installation *Pre-Morgue* (*Pre-Pro-Seca-Tura*; 1991), video and computer techniques create an overall effect not so far removed from a Baroque passion: the viewer is simultaneously introduced to suffering and punishment (demonic whipping) and to mortality and immortality; the experience of *entry* (into a tunnel or cave) and *passage* (bridge) is as much aroused as that of *arrival* (on a sunset or beach).

At first glance, the elements of this Baroque passion resist any kind of aura. Yet once they leap into operation and interaction, they produce a mysterious, closed foreground. The viewer, on stepping into the installation, while directing its movement with his own body, does not just receive; he interacts. And this is when we see what we can call mystery— the prerequisite for every aura. This is when the word "analysis" has to be put into quotation marks. For while Forgács uses the *technique* of Freudian analysis—that is, he takes to pieces and dissects into elements—he does not exactly bring mystery into the profane. On the contrary, he takes the profane into a realm of mystery. This analysis makes us sensible to an account much older than Freud's—that of Aristotle. For Aristotle, the ultimate objective of analysis is ascension: things (reality and nature) must

be broken up into their elements, he argues, so that we can use them, like steps of a staircase, to rise ever higher, right up to first principles.

It is in this sense that I refer to the video installations of Péter Forgács as analytical. He picks apart the world, just as Freud did the images of dreams, and he allows words and rationality to assert themselves. But instead of exposing these images to plain conceptuality, he raises them to a higher level. He creates art from them. In his installations, understanding is not an objective; it is a working tool, just as in analysis the act of understanding has to be followed by something else. Coming close to the aforementioned center of existence is more important than any act of comprehension. It is the presence of this invisible focal point that brings Forgács's work to life. And this is what from the first moment I feel as a keen stare focusing itself on me.

MARSHA KINDER

<table>
<tr><td>[14]</td><td>*Reorchestrating History*
Transforming *The Danube Exodus* into a
Database Documentary</td></tr>
</table>

▶

Overture

In 2000, the Labyrinth Project (an art collective and research initiative on interactive narrative)[1] embarked on a collaboration with Hungarian media artist Péter Forgács to turn his sixty-minute, single-channel film, *The Danube Exodus*, into a large scale, multiscreen immersive installation. Forgács's film (which was aired on European television in 1997) provided intriguing narrative material: a network of compelling stories, a mysterious river captain whose motives remain unknown, a Central European setting full of rich historical associations, and a hypnotic musical score that created a mesmerizing tone.

Although our expanded adaptation drew on forty hours of footage, both the film and installation still present the same transnational narrative that interweaves three stories: those of Jewish refugees, German farmers, and a Hungarian river captain. As an amateur filmmaker, the captain documented both the journeys of the Jews fleeing Hitler and the German farmers leaving Bessarabia on film, footage that was remixed by Forgács with other archival material in his sixty-minute film and then reorchestrated by Forgács and Labyrinth with more additional material in the installation. Titled *The Danube Exodus: The Rippling Currents of the River*, our installation premiered at the Getty Research Institute in Los Angeles, from August 17 through September 29, 2002, and has been traveling ever since—with exhibitions thus far in Karlsruhe, Barcelona, Helsinki, Ulm, Budapest, Berlin, Berkeley, and New York.

The adaptation called for a reorchestration of history—in some ways analogous to the one Forgács had earlier performed on the original found footage of the captain. We were now using Forgács's own film as found

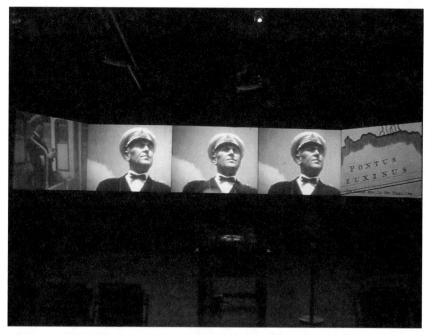

Figure 14.1 *The Danube Exodus: The Rippling Currents of the River.* The main installation features five screens that can each project the same or different scenes from *Danube Exodus.* Viewers can select images from a computer installed in front of the screens, in a similar position to the bridge of a ship.

footage, just as our interactive installation would later function as found footage for museum visitors who would bring their own associations, memories, and desires to these historic images—a chain of appropriations that raises interesting questions about agency and authorship.

As the user mode in the museum became increasingly immersive (with its multiple rooms, large multiple screens, and immersive 5.2 sound system) and the scale of the montage dramatically enlarged, we hoped to retain or even intensify the emotional power of the original film. Yet we also wanted to make the user experience interactive, a dimension that could possibly undermine the emotional impact. If we were correct in assuming that the emotional power of Forgács's works was largely dependent on their stunning rhythms of editing and music, then we could not let museum users freely control the pacing of the images in this interactive version, for we would then risk having the tone become playful as in an electronic game or merely informative as in a hypertext. Although an educational goal might help contextualize the captain's primary footage, mere pedagogy would fail to achieve the unique mesmerizing quality of Forgács's sixty-minute film, with its shadowy figures, its historical

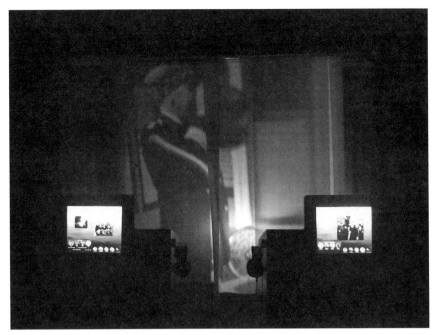

Figure 14.2 *The Danube Exodus: The Rippling Currents of the River.* In addition to the main installation, a set of computers allows viewers to search a rich database of additional, contextual information that goes beyond the material included in the original film.

ironies, and its melancholy rhythms provided by Tibor Szemzö's original minimalist score. That is why we turned to the musical term *orchestration* (a concept suggested by Labyrinth's interface designer Rosemary Comella) and to the poetics of rippling currents to control the pacing. Or, to put it another way, we turned to Sergei Eisenstein's ever-expanding notion of musical montage and to Heraclitus's trope of the river to evoke the constant fluctuations in subjectivity and history: "Everything is in constant flux and movement. . . . Nothing is abiding. Therefore, we cannot step twice into the same river. When I step into the river for the second time, neither I nor the river is the same."[2]

Given the number of versions through which this story of the Danube exodus has been retold, we believed that, despite any limits imposed on interactors, this ongoing process of reorchestration would still confirm that narrative is like the Danube: you can never step into the same river or the same history twice.

This collaboration on *The Danube Exodus* installation represented three important firsts for Labyrinth, as an art collective–research initiative working at the pressure point between theory and practice. For the first

time a joint project was being proposed to us by an independent artist we admired. In fall 2000, my University of Southern California (USC) colleague Professor Michael Renov organized a retrospective of Forgács's films and introduced us to the filmmaker, who was a visiting scholar in the Getty Research Institute's academic year on "Reproductions and Originals," working on a project titled "Rereading Home Movies: Cinematography and Private History." As soon as he saw our interactive DVD-ROM project, *Tracing the Decay of Fiction: Encounters with a Film* by Pat O'Neill, which enables users to navigate O'Neill's magisterial camera moves through a rich collection of archival materials on the Hotel Ambassador, Forgács was eager to collaborate with us on an interactive version of *The Danube Exodus*. And as soon as I saw his film *Maelstrom*, I wanted to work with Forgács. I was fascinated with the way he positioned his spectators—to be emotionally engaged with the vibrant Jewish family who would eventually be exterminated in the death camps (a violence committed offscreen) yet simultaneously distanced by our historical knowledge of their fate. Ironically, this hindsight was always made palpable in Szemző's melancholy minimalist music and in the rhythms of Forgács's reediting of the material, with its slow-motion gestures and periodic pauses.

This *Danube Exodus* project was also the first time that Labyrinth was setting out to build a large-scale museum installation rather than first making a DVD-ROM or website that eventually would be adapted to an exhibition. Forgács chose the Getty Center in Los Angeles as our premiere venue, for he brought to the project not only his original video (with the blessings of his producer Cesar Messemaker of Lumen Films), new video interviews with Jewish and Bessarabian survivors of the two voyages, and additional archival materials from a number of European archives but also the Getty Center with its brilliant design team headed by Merritt Price and Leon Rodriguez and his Getty research associate Zaia Alexander (who cocurated the overall exhibition and cowrote the catalogue with me). Labyrinth brought its core team of digital media artists—interface designer Rosemary Comella and graphic design artists Kristy H. A. Kang and Scott Mahoy—plus San Francisco sound designer Jim McKee, USC sound engineer Christopher Cain, and several former USC students as digital editors: Jesse Cowell, Broderick Fox, Adam King, and Rebecca Rolnick. We also provided funding from the Annenberg and Rockefeller Foundations and all the equipment, facilities, and technical consultants. At the institutional level, the Getty and Annenberg Centers were as eager to work with each other, as were we and Forgács.

By starting with an installation, we were forced from the outset to spatialize the narrative. This demand enabled us to see the exhibition as

a narrative field full of story elements that could be recombined in different ways. And it led us to design alternative pathways that influenced how users understood the interwoven stories and the complex connections between them.

Perhaps most important, this emphasis on the narrative field enabled us to realize for the first time that we were actually making what we now call database documentaries—a generic designation that could also be applied productively both to earlier films by Forgács and to earlier interactive projects produced by Labyrinth.[3] It was no accident that this realization came during a collaboration with an artist-archivist like Forgács, who owns his own archive that houses historical footage he has collected throughout Europe and that he draws on and remixes in most of his works. In his films there is always an awareness that whatever historical images you see on screen, they represent only a small percentage of the potential material that exists—in the public archives, in private collections, or in your own personal memory (based on other works you may have seen, heard, or read, or lived experiences you may have had). You are always made aware of what is omitted, as well as included, for you must read Forgács's images against a broader sweep of virtual history that you are partially responsible for bringing to the film.

Similar dynamics were operative in earlier collaborative projects by Labyrinth, where there is usually a competition between fiction and history for control over the narrative space. In *Bleeding through Layers of Los Angeles, 1920–1986*, you participate in creating the fictional story of a Jewish woman named Molly that cultural historian Norman Klein is spinning on the fly or investigate the ethnographic backstories of real-life individuals from various ethnic communities describing what life was like in this same narrative field—a three-mile radius of downtown Los Angeles that is one of the most ethnically diverse neighborhoods in the nation and the historic site of fierce battles over prime L.A. real estate. Loosely based on Klein's *The History of Forgetting: Los Angeles and the Erasure of Memory* (1997), the project also documents buildings and neighborhoods that are no longer there. The collection of data being used—stills, movies, maps, and news clippings—is visualized as a database of thumbnails you can navigate at your own speed, enabling you to see how the same archival materials and narrative space can be captioned and appropriated for both the documentary and fiction.

In *Tracing the Decay of Fiction*, the interface trope of the hotel functions as a repository of cultural memories, from both history and fiction, that are interwoven in subjectivity. The Hotel Ambassador (recently demolished to make way for a new high school in Los Angeles) was not

only the site for historical traumas like the Robert Kennedy assassination but also a Hollywood location for noir movies like *Barton Fink*. Designed to combine public and private space, hotels provide rooms that are occupied by successive waves of occupants, creating their own archive of story fragments, which helps explain why they are so frequently used as a narrative trope. But in our hotel, when you call up ghostly traces of fictional figures, you no longer have access to archival materials. With each navigational choice you make in both of these Labyrinth projects, you become aware of what you have lost, as well as what you have gained. Like Los Angeles real estate, the narrative space is a site of fierce competition.

This chapter explores how we brought these two conceptions of database documentary together in our collaboration with Forgács on the installation version of *The Danube Exodus*. It also examines what is at stake more broadly in this genre of database documentary.

▶ ───

Database Documentary: Orchestrating Knowledge Production, Ideology, and Desire

Database documentary is an empowering discursive form that provides access both to a series of rival narratives (whether truth or fiction) and to the underlying archive of materials out of which they are spun. It reveals what is at stake ideologically in the distinction between database (a dominant form in contemporary digital discourse, the politics of which tend to be disavowed) and narrative (the traditional form it supposedly displaces, the ideological baggage of which is well known). Yet by embodying their inevitable combination, database documentary exposes the ideological workings of both. As a genre, it is particularly effective for presenting archival cultural history. It also is an effective participant in the current cultural debate over the ideological implications of databases and their relationship to narrative, an issue of growing importance as the academic world increasingly turns to online archives as new modes of scholarship and learning. By dramatizing the archive (whether it is a physical collection of books and material objects in the library or a digital database online), database documentary focuses our attention on crucial questions: what kinds of information are we trying to archive and retrieve, in what genres, and for what ends?

Many new media theorists are cyberstructuralists who treat databases and narratives as a binary opposition, the neutral repositories of data versus the ideologically charged master narratives. For example, in *The Language of New Media*, Lev Manovich claims, "Any object in

the world—be it the population of a city, or the weather over the course of a century, or a chair, or a human brain—is modeled as a data structure, that is, data organized in a particular way for efficient search and retrieval."[4] The implication is that these efficient databases are objective structures essential to science that avoid the political pitfalls of narrative.

But as recent media events clearly attest, every database or archive is designed for a particular kind of knowledge production with specific goals. What items to include or exclude, what categories to use as structuring principles, and what metadata to collect for later retrieval—all these decisions serve master narratives with ideological implications. Since such decisions are made in social and historical contexts that inevitably have narrative content, the process of retrieval necessarily involves ideology and desire: where are we permitted to look and what do we hope to find? For example, when Google, the most powerful search engine on the Internet, recently made the move into China, they willingly accepted the Chinese government's censorship practices, a business decision that seriously compromised the dream of neutral access to all information. And in the United States we have seen how databases containing our financial records, which once were a sign of efficiency and progress, have now, in the name of the war against terrorism and the Homeland Security Act, become a disturbing source of political surveillance. Databases are frequently constructed to serve one master narrative but then are appropriated to serve others with very different ideological agendas. These are the dynamics that are exposed by database documentary.

In the case of *The Danube Exodus*, Forgács had appropriated the captain's amateur footage for a new narrative that relied on historical hindsight—one that took new ideological risks in comparing the displacements of the Jewish and German refugees as if they were equivalent, a comparison many members of the Jewish community would find difficult to accept. In the captain's original home movies, this comparison had been justified by his own personal presence in the narrative field and his participation as witness and documentarian for both groups of refugees, for he helped transport both groups into history. That is why Forgács insisted on the captain and the Danube River being the primary protagonists in the installation's central poetic space, a decision that may have been intuitive or aesthetic but had ideological implications.

In *The Archive and the Repertoire: Performing Cultural Memory in the Americas*, Diana Taylor acknowledges the political implications of all archives as active sites of knowledge production. She extends this concept to repertoires as an alternative form of embodied archive that recuperates ephemeral knowledge that would otherwise be lost and performers who

might otherwise remain marginal.[5] It is precisely this kind of historical recuperation that is central to the various versions of *The Danube Exodus*, as well as to all other films by Forgács and to Labyrinth's previous database documentaries.

By applying Taylor's approach to *The Danube Exodus*, we realize that the very act of turning this material into a museum installation had new ideological implications. For we were taking home movies of ordinary people in crisis—the kind of images that are typically displayed on a small scale within a modest domestic space—and enlarging them for projection within the kind of large-scale, multiscreen public venue that has traditionally been devoted to epic heroes or villains like Napoleon and Hitler. By moving them from the margins into the historical spotlight, we were insisting that amateur footage of ordinary people—the German farmers, the Jewish refugees, and the captain and his wife—deserves this kind of public attention.

Instead of perceiving the main competition being between database and narrative (which Manovich claims are "two essential responses to the world," with modern media as "the new battlefield" for the competition between them),[6] we at Labyrinth assume they always work together, a combination that is always made visible in our database documentaries. Instead, the main competition is among various rival narratives (both fiction and documentary) vying to explain the data, a choice that always has ideological implications.

We purposely made these ideological dynamics explicit in *The Danube Exodus*, where the database documentary dramatizes the rivalry among the three stories and where users are forced to decide which of the three they want to follow. This choice and its ideological implications become more complicated with historical hindsight, as one considers the current political status of Israel, Germany, and Hungary. We deliberately left room for these ambiguities because they get to the heart of the piece and to the ideological drive of database documentary.

While collaborating on *The Danube Exodus* installation with Forgács, we focused on six characteristics of database documentary, which proved crucial to our process of adaptation and to exploring the potential of this genre.

▶

Database Documentaries Are Selective and Open-Ended

In the broad cognitive sense, narrative contextualizes the meaning of perceptions and therefore is constantly under reconstruction because

it always needs to accommodate new data we encounter. Thus narrative acknowledges the existence of gaps, even if one of its goals is to smooth over these absences and to reduce the anxiety they arouse. The open-ended structure of database narrative, then, is not really strange or counterintuitive—as many people argue. Rather, it is essential to our own life stories and to history.

Database narrative raises an interesting paradox, one that is particularly central to database documentary where issues of knowledge production and truth value are important. On the one hand, its open structure ruptures the illusionary smoothing over of gaps by exposing the underlying databases out of which narrative elements are selected and combined. Yet by presenting this array of choices and exposing the process, it potentially introduces another pleasurable illusion of wholeness—as if all the possibilities were contained in the archive. As Gilles Deleuze acknowledges in *The Time-Image*: "Sometimes, on the contrary, it is necessary to make holes, to introduce voids and white spaces, to rarify the image, by suppressing many things that have been added to make us believe that we were seeing everything. It is necessary to make a division or make emptiness in order to find the whole again."[7]

What is clear is that database documentary enables one to emphasize either side of the paradox—the gaps or the illusion of wholeness.

Despite the fact that our adaptation of *The Danube Exodus* was based on a series of dramatic expansions (going from sixty minutes to forty hours of footage, from one screen to five, from stereo to a 5.2 immersive sound system), we chose to emphasize the gaps. As in all Labyrinth projects and all films by Forgács, we deliberately avoid the illusion of wholeness because we consider this epistemological tension to be one of the great ideological strengths of database documentary.

The power of Forgács's films depends primarily on two things: the rarity of the amateur home movies he collects and his brilliance as an editor, a combination that foregrounds the decisions of what is included and what omitted. By expanding the footage (with parts of the captain's footage that had been omitted from Forgács's film, with more footage selected from public archives, and with new interviews with the survivors of both journeys), we were able to show how countless narratives could be woven out of this material. Yet the archival material is still valued primarily for its rarity, which serves as a marker of the line between survival and loss—the loss and retrieval of images, memories, and lives.

A Database Documentary Is Composed of a Network of Interwoven Stories

This emphasis on the plurality of stories is crucial to database documentary because it prevents any of the versions from becoming perceived as a master narrative or the whole story. Thus it defies the cyberstructuralist's dream of totality for both databases and narrative models.

The key challenge for our *Danube Exodus* project was how to spatialize the narrative in a way that would emphasize the complex networked relationships among the three stories. The uncanny juxtaposition between the Jewish and Bessarabian journeys caused each to be read in a different way, with the third story of the captain and the river mediating between them as historical anchor. We knew many people would object to any comparison between what these two groups of refugees had suffered, yet the historical presence of the captain in their respective stories and his inclusion of both groups within his own travel documentaries necessarily created what Forgács calls "the incomparable duet of the German–Jewish exodus." We decided to focus both on the differences and similarities between these two diasporic tales as well as on the historical irony of their juxtaposition, a strategy that was made explicit in the catalogue I coauthored with Zaia Alexander: "The Bessarabian Germans mourned the loss of their homeland and possessions. The Jews danced and rejoiced; they lost everything but their lives had been saved. Still, the uncanny parallelism is a matter of record. These Jews and Germans were both transported to safety and documented on film by the same river captain, who ferried them into historical memory."[8] In all parts of the installation design, the primary emphasis was placed on the mediating image of the river, the rippling currents of which have interwoven many cultures and periods throughout Central Europe's stormy political history.

During the conceptualization phase, we quickly agreed that we needed three separate spaces. One would be entirely devoted to telling the story of the Jewish journey, which was organized by Aaron Grünhut (whose son attended our opening at the Getty). This story contained interviews with several fascinating survivors, including Else Friedlander and the Menzel and Ashkenazi families, who gave Forgács vivid narrative accounts of their family life in exile. A second parallel space would be dedicated to telling the less-familiar story of the Bessarabian Germans, their life in Paris, Bessarabia before the Soviet annexation, and the personal losses they suffered both during the exile and after their return to Germany and their relocation in Poland. This story was recounted by two surviving families, Helmut Fink and Ella and Guido Fano, whom Forgács

interviewed on camera. In both of these side spaces there were to be two seventeen-inch touch-screen monitors that enabled visitors to access the stories and interviews in any sequence, pattern, or rhythm they wanted to pursue. Here the primary drive was educational rather than emotive.

As soon as we began to discuss the third space, disagreements began to arise. I wanted to have the three stories vying for control over this central narrative space, which meant that visitors would be able to choose which of the stories to emphasize. Forgács wanted the room to focus primarily on the captain and the river and to simulate the experience of being on board a ship—with benchlike seats for the visitors and a captain's wheel or navigational map as an interface, a literalism that the rest of us wanted to avoid. Kristy Kang proposed the river itself as the main interface, with objects floating by in the rippling currents, each evoking one of the narrative segments. Though we adopted this idea, instead of the objects we decided to use a brief QuickTime movie from each of the orchestrations as an icon, which would periodically rise out of the depths of the river. This idea was proposed by Rosemary Comella, yet the concept was developed into an actual functioning interface by Scott Mahoy. Whatever the interface design or narrative emphasis, Comella wanted this central room to be a poetic space—immersive and essentially nonverbal. Although Péter was originally committed to including voice-over commentaries and printed captions, once we ran out of time he agreed to retain only a couple of voice-overs and to make the captions very minimal, choices that proved to be emotionally effective. Despite our initial disagreements, the final version managed to combine all these ideas into a coherent vision.

In the final version of the central poetic space, the three stories compete for control over the narrative, accentuating the comparison among them. Yet before any of these stories are chosen, visitors can watch default orchestrations that feature the captain's ship and other images he documented on his travels throughout Europe. The choices are made on one large (nineteen inch) touch-screen monitor, which is positioned in the center of the room and controls what is seen on the five large screens (each six feet by eight feet) that totally dominate the room. The five screens are arranged in a 180-degree half-circle, which helps to intensify the immersive nature of the viewer experience.

What users see on the touch-screen monitor are the rippling waters of the Danube. Periodically, a ring of six icons emerges out of the depths of the river, giving visitors a chance to select one or to choose an alternative ring. There are three rings in all, each with six icons, for a total of eighteen orchestrated narrative modules (each around five to ten minutes in

length). Six of the orchestrations feature an episode from the Jewish story, six from the Bessarabian Germans, and six from the captain and the river. Yet each orchestration incorporates images from the other two stories as well. Given that the orchestrations have minimal subtitles and only two of them have brief voice-overs, it is sometimes difficult to distinguish which characters on-screen are the German passengers and which are the Jews, an ambiguity that encourages visitors to compare them. No matter which sequence is chosen, the stories still compete for control over the central narrative space and the historical spotlight, and the user is still confronted with the difficult task of (what we called) comparing the incomparable. Thus instead of becoming totally immersed in one master story, visitors are always led to consider the relationship among them, yet they still have the freedom to read those relationships in a variety of ways.

Once a selection is made, the ring of icons sinks back into the water and there can be no other choices until that orchestration has finished playing. Although this limits the agency of the interactors, it ensures the emotional power of the orchestrations, which depends on the editing pace and rhythms. During the production phase, Forgács was editing these orchestrations on a computer with several monitors. The first time we were able to test them on the five large screens, he immediately realized that they had to be much slower or else they would lose their power. Consequently, he had to go back and reedit all the orchestrations he had thus far completed, which put us way behind in our production schedule and forced us to sacrifice many other orchestrations that we originally had intended to include. After this painful omission, there was no way Forgács was going to let the visitor change the pace, a decision we all supported.

▶ ─────────────────────────────────────

Database Documentaries Encourage Experimentation in Sound–Image Relations

Given its emphasis on plurality and its exposure of the underlying processes of selection and combination, the database documentary can easily treat sound and image as different databases in which the components can be remixed in a variety of ways, a dynamic we played with in our collaborative project with Pat O'Neill in *Tracing the Decay of Fiction*. These possibilities encourage experimentation with sound–image relationships, which can accentuate rather than smooth over the gaps between disjunctive spaces (e.g., past and present, landscape and mindscape) and dissonant drives (immersion and distantiation).[9] These kinds of

disjunctions can be particularly effective in a museum setting, which is composed of many different spaces.

In many ways, the immersive power of the *Danube Exodus* installation was more dependent on sound than on image, a realization that was partly acknowledged in our choice of the word "orchestration" as a central structuring principle for the piece. But it was only in the central poetic space that visitors shared a common immersive experience defined by sound—for the side spaces had headsets, which encouraged interactors to pursue their own individual lines of inquiry, and the outer spaces had the ambient sounds of the ordinary museum experience.

In the central poetic space, each time a selection of a new orchestration was made, we heard a subtle splash of water as if signaling that the ring of visual icons was returning to the depths of the river and a new sonic experience was about to begin. The interface became part of the music, for when the interactor stepped up to the touch-screen monitor, it was like playing a musical instrument or conducting an orchestra with each of the five screens functioning like a different section: the strings, the brass, the winds, the percussions, and the soloist. As the shadowy images rippled across the room, constantly making new rhythmic patterns, the haunting musical score—of engines, voices, water, music, and wind—performed its own mediating mantra.

Once Jim McKee joined our collaboration as sound designer, the sonic interplay between immersion and distantiation was greatly enriched. Drawing on Szemző's hypnotic score from Forgács's film, McKee combined this minimalist music with the melodic ambiance of the river and the percussive rhythms of the ship's engines. These are the acoustic elements that set the melodic base, yet the movement of the ship is evoked through discreet sounds linked to specific images moving across the screen—for example, the cries of birds flying overhead, a flag flapping in the wind, the marching music of the German soldiers striding across Europe, the droning prayers of the Jewish passengers, the galloping horses moving across the Bessarabian plains, and the authentic folk music from different locales along the Danube. Assisted by sound editor Adam King and sound engineer Christopher Cain, McKee was able to install a 5.2 immersive sound system, with equipment loaned by Miller and Kreisel Sound.

As in Forgács's extraordinary films, this sound design places visitors in a unique spectator position: sutured into the historical experience by the ambient sounds of the river, yet simultaneously distanced from the characters by the melancholy music that carries the weight of historical hindsight, all without sentimentality. Paradoxically, the distance does not

lessen the emotional nature of the immersion but actually makes it all the more moving. Forgács claims he lets Szemző's music orchestrate and rule the emotional story; his own editing rhythms become part of the score. That is why the concept of orchestration is so crucial to *The Danube Exodus* installation, for we realized we would be expanding the concept of editing not only across five large screens but also across an immersive surround sound system that would generate new sound–image relationships and bring greater attention to Szemző's mesmerizing score.

▶

Database Documentaries Combine a Series of Disjunctive Spaces

In database documentaries, it is the sheer diversity of materials that inevitably leads to a spatial discontinuity that is both external and interior, physical and mental, and that cuts across layers of time. These spatial disjunctures can be geographical, cultural, and historical. They also involve tensions between physical presence (what is actually included in the piece) and virtuality (what could have been selected from the database but was not chosen). Such disjunctures underscore both the cognitive and ideological functions of narrative as a way of processing and interpreting sensory data. Instead of being hidden or denied, these discontinuities can be leveraged to make ideological implications more apparent.

In *The Danube Exodus*, we were dealing with disjunctive spaces that were immediately apparent in the content. For example, the network of interwoven narratives contain historical representations of the interiors of the *Erzsébet Királyné* cruise ship, which is explored on a number of different journeys; the various stops along the Danube River for the Jewish and Bessarabian voyages; the touristic destinations of the captain on his earlier sightseeing journeys that enabled him to witness history, including events that led to World War II and the Holocaust; the Bessarabian farmlands that the German farmers were forced to abandon; the respective destinations of the Jewish and Bessarabian refugees in Palestine and Europe; and the various far-flung destinations, in Europe, the United States, and Israel, where survivors of these two journeys forged a new life. Though most of these spatial disjunctions in content also existed in Forgács's sixty-minute film, the move to the installation raised a much more serious challenge.

In *The Danube Exodus* installation, the most crucial spatial disjunction we faced was between the spatialized narrative we were conceptualizing and the physical space to which it had to be adapted—a process repeated each time it is exhibited in a new museum but was most

intense at the premiere venue.[10] Before we could move beyond the conceptual phase, we had to examine the exhibition space at the Getty Center. We discovered to our dismay that the two connected exhibition spaces available to us in the Getty Research Institute (GRI) were far too small for what we were conceptualizing. To our great relief, we were told by GRI director Tom Crow that we were welcome to use the institute's lecture–seminar room, which was connected to the other two exhibition rooms, even though it had never previously been used as an exhibition space. Yet it was tentatively scheduled to be remodeled sometime in the near future.

As soon as we entered that room, we all breathed a sigh of relief, for here was the perfect space to construct what we were imagining. Not only did this oddly shaped room create the sense of being on board a ship, but on the north wall it had a curved rear-screen projection system and on the south wall, a projection booth. Here was our central narrative space where we could have large screens on which to project the interplay among the three stories. We imagined creating two temporary walls, one on each side, which would serve not only as borders for the separate Jewish and Bessarabian spaces but also as support for two of the large screens, which could be two-sided. Each of these two-sided screens could be devoted to one of the journeys. In this way, no matter what was being projected on the central screens (which would now give greater emphasis to the third story of the captain and the Danube River), we would always be reminded of the separate stories of the Germans and Jews and (because of the two-sidedness) would be able to see part of what was being projected in the two side spaces.

Another great advantage of using the lecture space for the immersive video installation is that it freed the other two exhibition spaces for a more traditional display of material objects—historic encyclopedias, maps, and vintage camera and film equipment used by the captain—and for more extensive signage and didactics, including an illustrated written introduction to these three interwoven narratives, with a detailed graphic timeline. We began looking for literary quotations that would help weave the various parts of the exhibition together. From our very first meeting, we had agreed on the quotation from Heraclitus as a means of establishing the Danube River as a trope for both history and memory. And as soon as we decided to use the seven-volume Reuters map of the Danube, the pages of which ingeniously unfold to depict in great graphic detail the river's fascinating undulations across Central Europe, I found a perfect quote from Joseph Conrad's *Heart of Darkness*: "There was . . . one river especially, a mighty big river, that you could see on the map, resembling an immense snake uncoiled, with its head in the sea, its body

at rest curving afar over a vast country, and its tail lost in the depths of the land. And as I looked at the map . . . it fascinated me as a snake would a bird . . . I went on . . . but could not shake off the idea. The snake had charmed me."[11] Although Conrad's Congo was far removed from the Danube, his fictional Captain Marlow suggested a parallel with Andrásovits, a connection we noted in the signage and extended into a series of comparisons that challenged the distinction not only between history and fiction but also between professionals and amateurs.

No one knows why Andrásovits accepted the commission for the Slovakian Jewish transport of 1939 or let his cruise ship, the Erzsébet Királyné, help repatriate the Bessarabian Germans in 1940. Was he merely a captain-for-hire? Or was he a humanitarian like Schindler and Grünhut, a curious objective observer like Joseph Conrad's fictional Captain Marlow, or a persistent filmmaker like Péter Forgács?

We were also able to devote considerable space to selections from the eighteenth-century, six-volume encyclopedia on the Danube by Italian naturalist Luigi Fernando Marsili, which Zaia Alexander had found in the Getty collection. Functioning like a modern database, it provided another analogy with our own project and demonstrated that database documentary has several antecedents. Each volume gathers information concerning a different aspect of the region, showing both the richness of the river and the breadth of Marsili's interests. Perceiving a striking parallel to both Captain Andrásovits's documentation of daily life on the Danube and his own gathering of vintage found footage from the same region, Forgács wove Marsili's volumes into his expanding narrative about the river.

In these outer rooms there was also space for a website, which was designed by Hungarian multimedia company C3, the Center for Culture and Communication in Budapest. Providing another interactive experience, this informative website gave visitors access to additional archival information (stills, voice-overs, video footage) related to the three stories. It also enabled visitors to contribute any information they might have about the captain or the two voyages and to record their reactions to the exhibition.

Although we had been warned that the GRI lecture room was going to be remodeled, its repeated delays led to a postponement of the exhibition from August 2001 to August 17, 2002. While we welcomed having additional time to complete the installation, we were worried that the new spatial configuration might not be compatible with our design. These anxieties were not unfounded, for we were forced to make adjustments. A new wall was built close to where we had originally intended to place our temporary border, which forced us to abandon our two-sided screens.

This meant we now had to rely entirely on the large projections in the central space to interweave the three stories. Far more troubling, the new wall destroyed the symmetry we had wanted for the two side spaces. The German space on the right was now much narrower than the Jewish space on the left, allowing us to have only one computer with touch screen for the former in contrast to two computers with two touch screens for the latter. This change obviously had ideological implications, for it privileged the Jewish experience over the German—even though we had purposely avoided this in our original conceptual design and would need to rectify it in future venues. At one point the Getty staff tried to convince us to combine the computers devoted to the Jewish and German interviews in one space, but we refused to give up the division into three, which we considered crucial to our conception.

Although our installation brought these diverse spaces together within a single narrative field, it never disguised the gaps between them. Each of the adjacent rooms provided access to the complex network of stories in a quite different way. Museumgoers could move through these disjunctive spaces any way they chose. Some moved directly to the poetic space for the emotional impact and then went to the other rooms to find out more about what they had just experienced. Others went directly to the website. Others systematically digested all the information in the outer rooms and side spaces before stepping into the poetic space. Others shuttled back and forth. Each sequential order created a different experience, but there was an advantage in retaining the gaps and keeping them visible—for in database documentary, these are the spaces that most strongly arouse our speculation and desire.

We realize this structure is not unique. In fact, our installation purposely demonstrates that virtually every museum exhibition functions as a narrative field that invites some form of interactivity from visitors, who move through these disjunctive spaces, deciding where to linger.

▶──

Database Documentary Invites a Performative Mode of Interactivity

Even in noninteractive forms of database narrative (such as movies like Chris Marker's *La jetee* and *Sans soleil;* Alain Resnais's *Night and Fog* and *Hiroshima, Mon Amour;* Luis Buñuel's *Milky Way* and *Phantom of Liberty;* Richard Linklater's *Slackers;* David Lynch's *Lost Highway;* Tom Twykwer's *Run Lola Run;* Agnes Varda's *The Gleaners and I;* Chantal Akerman's *Toute une nuit;* Pedro Almodóvar's *Talk to Her;* or any

film by Jean-Luc Godard or Péter Forgács), the audience is positioned as active spectators who are able to perceive the various narrative pathways available to the characters, camera, and filmmakers and to consider the implications of the narrative choices being made.[12] But once an interactive option is possible (online, or on a DVD-ROM, mobile device, or game console), the interactor then becomes a performer who pursues her own curiosity and desire while making those narrative decisions. The same dynamics apply to an interactive museum installation, except now there is an audience of other visitors who watch the interactor's performance. And when the database narrative is a documentary, where knowledge production could potentially be as important as pleasure, the performative style and choices become all the more significant.

In our *Danube Exodus* installation, we tried to intensify the interactors' experience as performers, even though their options were in some ways restricted. Visitors moved through the installation at their own pace, pursuing their own pattern of integrating the disjunctive spaces and deciding where, how, and for what period they would utilize the interactive options. This dynamic applied not only to selecting icons from the touch-screen monitors in the central poetic space and side spaces or using the website but also to reading the printed texts and maps from the more traditional nondigital museum displays.

Issues of time and sequence proved to be intriguing. Although we were told by the Getty staff that we could not expect most museumgoers to spend more than twenty minutes in the exhibit and we designed the length of the orchestrations accordingly, the time actually spent by most visitors was much longer. On the opening night, a number of visitors breezed through the outer rooms and then, drawn by the immersive sound, went directly to the central poetic space where they sat down on the benches or lay on the floors and remained there for well over an hour. Periodically individuals would drift to the side spaces, where they would await their turn on the touch screen and where they would recognize figures they had only briefly glimpsed on the five large screens in the central space. Once they listened to the personal stories and historical backgrounds of these individuals, they would then return to the central poetic space where they would now seek out these figures and watch them in a new way. While many of the younger visitors spent most of their time in the central space, some of the more elderly visitors became totally immersed in the side spaces, where they would systematically go through every single option. At times I would see middle-aged daughters or sons go to their parents and try to draw them away from the computers in the Jewish or Bessarabian space, but the elders usually refused until they had

listened to every personal account. Many visitors spent over two hours in the installation, which was a great surprise to us, as well as to the Getty staff, and the show broke all attendance records for a GRI exhibition.

Within the central poetic space, one could observe different performative styles of interaction. Sometimes young children would dart to the touch screen whenever the icons emerged from the river (an emergence that was also visible on the central large screen). Eager to push the buttons, these youngsters rarely paused to consider the options but seemed gratified to experience the immediate effect throughout the room—the splash of water followed by the sudden emergence of new images spreading across the five giant screens and the new rush of immersive sounds. Even if their choice merely repeated what had just gone before, they hardly seemed to notice. Adult interactors sometimes would hover over the touch-screen monitor as if to ensure their turn at mastery and would usually take a long time to choose a particular icon. Some users took a systematic approach, as if to ensure that they would see all eighteen orchestrations, no matter how long it might take. But this would mean barring others from making the choices, or expressing exasperation if someone chose to repeat an orchestration that had just been played. Others more interested in the pleasures of immersion rather than mastery were content to lie on the floor and experience the flow of images and sounds swirling around them, even if it was merely the transitional (default) interludes between the orchestrations. If no one else made a choice, they saw no need to rise to the challenge; as in cinema, they apparently were enjoying and reacting to the interactive potential inherent in the montage.

I was glad we resisted the impulse to make the piece more interactive simply for the sake of interactivity, as if agency were some ultimate fetishized goal, always to be pursued regardless of the ends of the particular piece. We were gratified that so many people seemed to find the installation emotionally powerful; we knew we had a hit once we observed the reactions of the museum guards. They got it because they tuned into its pleasures. But there were others who were disappointed because they expected or wanted something else. Like the Hungarian literary scholar who thought we should have provided more historical background material on the Holocaust before letting anyone enter the central space. Or the freelance journalist for the *New York Times*, who wrote a flattering piece on the exhibition at the Getty and then called a few weeks after his article had appeared to ask whether he could borrow a copy of Forgács's original documentary so that he could pitch it to a studio as a fictional feature. He was apparently ready to perform another reorchestration of the material.

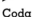

Coda

What I learned about Labyrinth's approach to performative interactivity, Forgács's approach to filmmaking, and the genre of database documentary is how largely all three depend on a performative approach to montage—one that is physically embodied, structurally dialectic, and conceptually musical, or what in this piece we have called *reorchestration*. This approach applied not only to those of us who had collaborated on the conceptual design of the piece (and who were interacting with the earlier performative filmmaking choices of Forgács and the captain) but also to visitors who were bringing their own repertoire of memories, associations, and expectations to the exhibit. Again, this was not a unique dimension of the installation but one that underscores an underlying truth about all movies, exhibitions, narratives, and database documentaries: the crucial role of montage in generating any form of active spectatorship, regardless of medium. That is why Eisenstein's theories of dialectic montage acquire new resonance in the context of digital media and database documentaries and why they exerted such an important influence on our interface design. I am thinking particularly of his essay "Methods of Montage," which takes a multitiered approach to theorizing an interactive form of spectatorship that extends across many art forms and beyond, into realms of mind and nature.

This borrowing from Eisenstein enabled us to challenge the unwarranted assumption of many new media theorists: that cinema spectatorship is inherently passive and incompatible with database forms. Rather, we think this conception of performative interactivity emphasizes the writerly potential of cinema spectatorship, where the collisions of dialectic montage detonate within the mind of the viewer with explosive effects on the registers of the body, the emotions, the intellect, and the spirit, a multitiered dimension that is always present in the films of Péter Forgács. This is precisely the dimension we strove to expand through our reorchestrations of history and database documentary in *The Danube Exodus* installation.

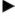

NOTES

1. In 1997, I founded the Labyrinth Project at the Annenberg Center for Communication at the University of Southern California (USC). As executive director, I assembled a core team of media artists—Rosemary Comella, Kristy H. A. Kang, and Scott Mahoy—and together we produced a series of multimedia projects (installations, websites, and DVD-ROMs) in

collaboration with artists, scholars, scientists, archivists, museums, and talented USC students from a wide range of departments. Since 2006, we have been housed in USC's School of Cinematic Arts.

2. Heraclitus, *Fragments: The Collected Wisdom of Heraclitus*, trans. Brooks Haxton (New York: Viking, 2001).

3. *Mysteries and Desires: Searching the Worlds of John Rechy* (2000), a collaboration with the novelist; *Tracing the Decay of Fiction: Encounters with a Film by Pat O'Neill* (2001), a collaboration with the filmmaker; and *Bleeding through Layers of Los Angeles, 1920–1986* (2001), a coproduction with ZKM.

4. Lev Manovich, *The Language of New Media* (Cambridge, Mass.: MIT Press, 2001), 233.

5. Diana Taylor, *The Archive and the Repertoire: Performing Cultural Memory in the Americas* (Durham, N.C.: Duke University Press, 2003).

6. Manovich, *The Language of New Media*, 233.

7. Gilles Deleuze, *Cinema 2: The Time-Image* (Minneapolis: University of Minnesota Press, 1989).

8. Zaia Alexander and Marsha Kinder, catalogue essay for *The Danube Exodus: The Rippling Currents of the River*, an interactive installation by Péter Forgács and the Labyrinth Project, Getty Research Institute, August 17–September 29, 2002.

9. This strategy violates the conventions that Mary Ann Doane was the first to theorize in her pioneering essay "The Voice in the Cinema: The Articulation of Body and Space," *Yale French Studies* 60 (1980): 33–50.

10. For example, both in Barcelona and Berkeley the installation had to be adapted to a much smaller exhibition space and to a larger space in Budapest, where an image of the captain's boat could be seen against the actual Danube River, which was visible through the window. Labyrinth designer Scott Mahoy oversees these adaptations to each new exhibition site.

11. Joseph Conrad, *Heart of Darkness* (New York: New American Library, 1902), 71.

12. For an elaboration on how these films can be read as database narratives, see my essay "Hot Spots, Avatars, and Narrative Fields Forever: Buñuel's Legacy for New Digital Media and Interactive Database Narrative," *Film Quarterly* 55, no. 4 (Summer 2002): 2–15.

Acknowledgments

This book's journey began when Michael Renov first proposed the idea at the end of the 1990s. Its timeliness has only grown since. Péter Forgács's work has come to the attention of more and more people. Michael Renov saw early on that Forgács's work deserved close attention, and this book is the result of that inaugural insight. Although Michael had to turn most of his effort to other projects in recent years, the book moved ahead, thanks in no small measure to the timely assistance of Péter Forgács himself. Péter provided the still images that accompany the chapters. Almost all of them are drawn from his films and installations, and they help give a vivid sense of how he has managed to transform the private intimacies and daily routines of home movies into public histories and social analyses.

Each of the contributors to this volume has worked long and hard and displayed admirable patience to bring this book to completion. Most chapters have undergone considerable revision over time, and they stand now as a superb midcareer review of Péter Forgács's oeuvre. Scott MacDonald and Ty Miller assisted in the acquisition of images from Péter Forgács's films for their chapters. I am grateful to all the contributors for their sustained commitment to this project.

The University of Minnesota Press has remained steadfast in its support of this project. Jason Weidemann has provided a steady, even-tempered hand to the complex process of shepherding this book to completion. Even before Péter Forgács became the recipient of the Erasmus Prize in 2007, Jason saw that he was an artist of exceptional ability, with a powerful perspective on the social turmoil of the twentieth century, and that a book on his work would be indispensable. His editorial assistant, Danielle Kasprzak, proved an enormous help in taking the manuscript through the many stages of production that led to its publication. My former graduate student, David Gray, helped enormously with

the final stages of organizing and formatting the chapters; his scrupulous attention to detail was indispensable.

All photographs are courtesy of Péter Forgács.

Finally, I want to thank Pascale Menconi for her generous support and abiding love. She makes it all worthwhile.

Filmography

Some works by Péter Forgács are available from Electronic Arts Intermix (EAI) at http://www.eai.org. Other works are available for institutional purchase by universities, museums, libraries, and other public agencies. Go to http://www.peterforgacs.com for further details, as well as a list of installations, exhibitions, and other activity by Péter Forgács. DVDs are not available for sale to individuals.

I See That I Look, video, 25 min., 1978

Golden Age, performance piece with *Iron Age*, 20 min., 1985

Iron Age, performance piece with *Golden Age*, 50 min., 1985

Spinoza Rückwertz, 35 mm film, 5 min., 1985

The Portrait of Leopold Szondi, television video, 60 min., 1986

Episodes from the Life of Professor M. F. (portrait of Ferenc Mérei), television video, 110 min., 1987

The Bartos Family, Private Hungary series, part 1, television video, 61 min., 1988

Dusi and Jenö, Private Hungary series, part 2, television video, 45 min., 1988

Either-Or, Private Hungary series, part 3, television video, 43 min., 1989

The Diary of Mr. N, Private Hungary series, part 4, television video, 60 min., 1990

Márai Herbal, FMS Interlude series, television video, 35 min., 1991

D-Film, Private Hungary series, part 5, television video, 45 min., 1992

Photographed by László Dudás, Private Hungary series, part 6, television video, 45 min., 1992

Bourgeois Dictionary, Private Hungary series, part 7, television video, 49 min., 1992

Arizona Diary, with poet György Petri, television video, 53 min., 1992

Wittgenstein Tractatus, Interlude series, television video, 35 min., 1992

Culture Shavings, television video, 43 min., 1993

Simply Happy, with Albert Wulffers, 16 mm, 52 min. video version and 72 min. film version, 1993

Conversations on Psychoanalysis, television documentary series, 1993: 1. *Freud and Vienna*, 53 min.; 2. *Sándor Ferenczi and the Budapest School of Psychoanalysis*, 53 min.; 3. *The Psychoanalytic View of Man*, 55 min.; 4. *Psychoanalysis and Society*, 53 min.; 5. *Psychoanalysis as Therapy*, 58 min.

The Notes of a Lady, Private Hungary series, part 8, television video, 49 min., 1994

Meanwhile Somewhere: 1940–1943, The Unknown War series, television video, 52 min., 1994

The Land of Nothing, Private Hungary series, part 9, television video, 62 min., 1996

Pauer Pseudo, video, 60 min., 1996

Free Fall, Private Hungary series, part 10, television video, 75 min., 1996

Class Lot, Private Hungary series, part 11, television video, 52 min., 1997

. . . Otherwise, with Zoltán Vida, video, 90 sec., 1997

The Maelstrom: A Family Chronicle, television video, 60 min., 1997

Kádar's Kiss, Private Hungary series, part 12, television video, 52 min., 1997

The Danube Exodus, television video, 60 min., 1998

Angelos' Film, television video, 60 min., 1999

A Bibó Reader, Private Hungary series, part 13, television video version and 35 mm version, 60 min., 2001

The Bishop's Garden, Private Hungary series, part 14, television video, 57 min., 2002

do you really love me?, three channel video installation, 33 min., 2003

Mutual Analysis, video, 12 min., 2004
El Perro Negro: Stories of the Spanish Civil War, television video, 84 min., 2005
Miss Universe 1929: Lisl Goldarbeiter, A Queen in Wien, video, 80 min., 2006
Own Death, video, 118 min, 2007
I Am Von Höfler, Private Hungary series, part 15, television video, two parts, 80 min. each, 2008
Video Active, European Union Television Heritage documentary, 10 min., 2009
Hunky Blues: The American Dream, video, 100 min., 2009

Contributors

WHITNEY DAVIS is professor of history and theory of ancient and modern
art at the University of California at Berkeley, where he has also been
a director of the film studies program and a founding member of the
Berkeley Center for New Media. He is the author of *A General Theory of
Visual Culture* and *Queer Beauty: Sexuality and Aesthetics from Winck-
elmann to Freud and Beyond*, as well as five earlier books on prehistoric,
ancient, and modern arts and on the history of psychoanalysis and theory
of sexuality.

LÁSZLÓ F. FÖLDÉNYI is a noted Hungarian intellectual. His books on
literature, art, and the history of ideas have been translated into several
languages and have won literary prizes, including the Blauer Salon Preis of
the Literaturhaus, Frankfurt am Main (2002), and the Friedrich Gundolf
Prize of the Deutsche Akademie, Darmstadt (2005). In 2007 he received
the highest state prize in Hungary, the Széchenyi Prize. He is member of
the Deutsche Akademie für Sprache und Dichtung. He lives in Budapest,
where he is professor and holds the chair of theory of art at the University
of Theatre, Film, and Television.

MARSHA KINDER is a University Professor and professor of critical stud-
ies in the University of Southern California's School of Cinematic Arts,
where she has been teaching since 1980. Since 1997 she has directed The
Labyrinth Project, a research initiative on interactive narrative, producing
database documentaries and new models of digital scholarship in col-
laboration with artists, cultural historians, and scientists. One of those
works was *The Danube Exodus: The Rippling Currents of the River*,
a collaboration with Péter Forgács. Many Labyrinth works have been
featured at museums, film and new media festivals, and conferences

worldwide. Labyrinth's current works in production are an online archive and museum installation called "Jewish Homegrown History: Immigration, Identity, and Intermarriage" and a science-education website called "Interacting with Autism."

TAMÁS KORÁNYI has acted in films and has written on a variety of subjects from public affairs to contemporary art, including "Under the Reichbeauty's Spell" in the online journal *AGNI*. He maintains a blog at http://koranyi.blogspot.com.

SCOTT MACDONALD is author of *Critical Cinema: Interviews with Independent Filmmakers,* now in five volumes, and of several books on avant-garde filmmaking and on institutions that have kept independent cinema alive, including *The Garden in the Machine: A Field Guide to Independent Films about Place*; *Cinema 16: Documents toward a History of the Film Society*; *Canyon Cinema: The Life and Times*; and *Adventures of Perception: Cinema as Exploration, Essays/Interviews*. He teaches at Hamilton College.

TYRUS MILLER is vice provost, dean of graduate studies, and professor of literature at the University of California at Santa Cruz. He is author of *Late Modernism: Politics, Fiction, and the Arts between the World Wars*; *Singular Examples: Artistic Politics and the Neo-Avant-Garde*; and *Time Images: Alternative Temporalities in Twentieth-Century Theory, History, and Art*. He is editor of *Given World and Time: Temporalities in Context* and translator-editor of György Lukács's *The Culture of People's Democracy: Hungarian Essays on Literature, Art, and Democratic Transition.*

BILL NICHOLS has lectured in many countries and written over one hundred articles. His two-volume anthology, *Movies and Methods,* helped establish film studies as an academic discipline. His widely used *Introduction to Documentary* is now in a second edition and his general introduction to film, *Engaging Cinema,* is the first introductory work to give equal priority to the social significance and aesthetic importance of film. He serves as a consultant to documentary filmmakers.

ROGER ODIN is emeritus professor of communication and was head of the Institute of Film and Audiovisual Research at the University of Paris III Sorbonne–Nouvelle from 1983 until January 2004. A communication theorist, he is the founder of the semio-pragmatics approach to films and audiovisual productions. He ran a European research group on the

documentaries of the 1950s and is one of the first scholars to work on home movies. Today, he conducts research on films made on mobile phones and is part of the steering committee of the European network City and Cinema.

CATHERINE PORTUGES is director of the Interdepartmental Program in Film Studies, professor of comparative literature, and curator of the Massachusetts Multicultural Film Festival at the University of Massachusetts, Amherst. In addition to numerous articles on European cinema, Hungarian cinema, and the Holocaust, she is the author of *Screen Memories: The Hungarian Cinema of Márta Mészáros*. She is the recipient of the Pro Cultura Hungaria Medal from the Hungarian Ministry of Culture. Her coedited volume, *Cinema in Transition: East-Central European Filmmaking after 1989*, will be published in 2012.

MICHAEL RENOV is professor of critical studies and vice dean of the University of Southern California School of Cinematic Arts. He is editor of *Theorizing Documentary*, coeditor of *Collecting Visible Evidence* (Minnesota, 1999), and author of *The Subject of Documentary* (Minnesota, 2004).

MICHAEL S. ROTH is president of Wesleyan University. He is an editor of several books of intellectual history and author of four: *Psycho-Analysis as History: Negation and Freedom in Freud*; *Knowing and History: Appropriations of Hegel in Twentieth Century France*; *The Ironist's Cage: Memory, Trauma, and the Construction of History*; *Irresistible Decay: Ruins Reclaimed* (with Claire Lyons and Charles Merewether); and *Memory, Trauma, and History: Essays on Living with the Past*.

KAJA SILVERMAN is the Keith L. and Katherine Sachs Professor of Contemporary Art at the University of Pennsylvania and the author of eight books, including *Flesh of My Flesh*; *World Spectators*; *The Threshold of the Visible World*; *Male Subjectivity at the Margins*; and *The Subject of Semiotics*. She is working on a book about photography titled *The Miracle of Analogy*.

ERNST VAN ALPHEN is professor of literary studies and director of the Institute of the Cultural Disciplines at Leiden University, the Netherlands. His publications include *Francis Bacon and the Loss of Self*; *Caught by History: Holocaust Effects in Contemporary Art, Literature, and Theory*; *Armando: Shaping Memory*; and *Art in Mind: How Contemporary Images Shape Thought*.

MALIN WAHLBERG is associate professor at the Department of Cinema Studies, Stockholm University. She is the author of *Documentary Time: Film and Phenomenology* (Minnesota, 2008), in which Forgács's work also is discussed. Wahlberg has been involved in several Forgács seminars and retrospectives organized in Sweden, such as a 2003 seminar at Göteborg Film Festival and a 2004 retrospective at Cinemateket in Stockholm.

Index

Fortunoff Video Archive for Holocaust Testimonies, 88
Foucault, Michel, 104
Foundation for Jewish Culture, 85
found footage, vii, 77, 84, 89–90, 126, 159, 160, 182, 202, 219; as archaeology, 123, 160; and *A Bibó Reader*, xvii; and *The Danube Exodus*, 235–36, 250; family pictures, 131; found footage film, 137; and history, 36, 199–200, 217; and manipulation, 216; and music, 10, 50; and "primary expression," 208; and *Private History*, 12–13, 40; and Private Hungary, 162; and *Wittgenstein Tractatus*, 177, 179, 196, 199–200, 209–10, 214
Fox, Broderick, 238
Franco, Francisco, xiii
Frank, Anne, 95n11
Free Fall, x, xi, xii, xvi, 25, 42, 47, 102, 110–16, 119–33, 223–24, 225, 227
freeze frame, xiv, 30, 39, 90, 101, 120, 129, 130, 139, 155, 159, 162, 200
Freud, Sigmund, xi, 59, 80, 170, 184, 202, 232–34
Friedlander, Else, 244

Gárdonyi, Géza, 191
Gellner, Ernest, 179
genocide, 45, 59, 63, 78, 132; Armenian Holocaust, 86; *See also* Holocaust
Getty Center, 238, 244, 249–53
Getty Research Institute, xx, 235, 238, 249, 250, 253
Gianikian, Yervant, 3, 36–37, 156
Glass, Philip, 9, 34, 50, 54, 223
Gleaners and I, The, 251
Godard, Jean-Luc, 92, 252
Goebbels, Joseph, 99
Goldarbeiter, Lisl, xii, xvii, 169–73
Göncz, Árpád, 166
Group 180, viii, 9–10, 50, 160, 222
Grósz, Miska, 152
Grünhut, Aaron, 244
Guevara, Che, 8

Hajas, Tibor, 227
Halbwachs, Maurice, 66
Hamvas, Béla, 223, 226
Havel, Vaclav, 174
Heart of Darkness, 249
Heidegger, Martin, xviii, 50, 120, 221n22
Hill, Gary, 179
Himmler, Heinrich, 41, 43, 63, 83, 92, 93
Hiroshima, Mon Amour, 251
historicism, 64–66, 68–69, 71, 73–74
historiography, 68–71, 73–74, 88, 119, 122, 125, 133
history: Hungarian, viii, 10, 18–19, 34, 126, 137–39, 155, 162, 164, 173; macrohistory, 139, 153; microhistory, 123, 139, 149, 153; as opposed to myth, 94; personal vs. political, 7, 40, 60–62, 68; private vs. public, xi, xvii, xviii, 36, 44, 78, 80, 139, 149, 154; "telling history alternatively," 122, 133
History of Forgetting: Los Angeles and the Erasure of Memory, The, 239

Hitler, Adolf, xiii, 62, 77, 81, 90, 98, 107, 112, 235
Holocaust, the, xiv–xv, xvii, 15, 31, 40, 41, 60, 81, 119, 128, 131, 172, 248; as "black hole of meaning," 76; Holocaust film as genre, 51, 85–86, 92; Hungarian Holocaust, 25, 123, 173; and the Jewish experience, 85; literature, 87, 123; and memory, 85, 94, 165; and narrative fetishism, 87; and remembering, 108; and representation, xv, 55n4, 72, 86, 253; survivors, 83, 123; testimony, 86, 87, 88; and trauma, xv, 59, 94; *See also* Shoah, Final Solution
Holocaust Testimonies: The Ruins of Memory, 107
Hölszky, Adriana, 223
home movies, vii–xx, 3–5, 7–14, 17–20, 23, 27–31, 33–36, 40–54, 59–63, 67–74, 76–84, 90–91, 96, 102–4, 111–14, 119–33, 137–39, 144, 146, 155, 159–62, 165, 172–3, 182, 225, 228, 241–43, 257
Horthy, Miklos, 112, 131, 149, 175n13, 189–90
Huet, André, 29, 137
Human Remains, 47
Hungarian College of Arts, viii
Hungarian Film Festival, 170
Hungarian Holocaust. *See* Holocaust
Hungarian Kitchen Video Art, 229, 230, 233
Hungarian Revolution of 1956, 13, 44, 101, 165, 175n16
Hungarian Totem, viii, 20, 137
Hung Aryan, The, 232
Hunky Blues, viii
Huyssen, Andreas, 63, 66

I Am von Höfler, vii
Inedit, 29
In Search of Lost Time, 107
installation art, viii, xii, xvi–vii, xx–xxi, 20, 137, 229–34, 235–54
internment camps, 3
Interpretation of Dreams, 184
intertitles, 14, 52, 123, 128, 132, 155, 162, 164. *See also* subtitles
Intimate Stranger, 37
Invisible Man, The, 191, 221n21
I See That I Look, viii
Ivens, Joris, 88

Janscó, Miklós, 11, 38
Jarman, Derek, 179
Jetée, La, 8, 251
Jewish Emigration Office, 90–91
Jewish Labor Force, 48
Jews/Jewishness, 25, 112–16, 173; Central European Jews, 179, 217; Dutch Jews, xi, xv, 32, 42, 81, 90–92, 94; German Jews, 25; Hungarian Jews, xi, xii, xiii, 41–42, 53, 132, 153, 162; Jewish middle class, 15, 40, 41; Jewish refugees, 23, 235, 241–42, 248; Jewish tradition, 86; Orthodox Jews, 23, 25, 101; Polish Jews, 32; Viennese Jews, xii, 171–72; *See also* anti-Semitism
Joyce, James, 47

Kádar, János, xiii, 165, 175n16
Kádar's Kiss, xiii, 41, 98, 99, 115

(continued from page ii)